T0094346

Climate Change in Popular Culture

Climate Change in Popular Culture

A Warming World in the American Imagination

JAMES CRAIG HOLTE

 GREENWOOD

An Imprint of ABC-CLIO, LLC
Santa Barbara, California • Denver, Colorado

Library of Congress Cataloging-in-Publication Data

Names: Holte, James Craig, author.
Title: Climate change in popular culture : a warming world in the American imagination / James Craig Holte.
Description: First edition. | Santa Barbara : Greenwood, [2022] | Includes bibliographical references and index.
Identifiers: LCCN 2022008387 | ISBN 9781440878077 (hardcover) | ISBN 9781440878084 (ebook)
Subjects: LCSH: Ecofiction—History and criticism. | Fiction—20th century—History and criticism | Fiction—21st century—History and criticism | Climatic changes in literature. | Climatic changes in motion pictures. | Climatic changes—Popular works. | BISAC: SCIENCE / Global Warming & Climate Change | PERFORMING ARTS / General | LCGFT: Literary criticism. | Film criticism.
Classification: LCC PN3448.E36 H65 2022 | DDC 813/.54093553—dc23/eng/20220331
LC record available at https://lccn.loc.gov/2022008387

ISBN: 978-1-4408-7807-7 (print)
 978-1-4408-7808-4 (ebook)

26 25 24 23 22 1 2 3 4 5

This book is also available as an eBook.

Greenwood
An Imprint of ABC-CLIO, LLC

ABC-CLIO, LLC
147 Castilian Drive
Santa Barbara, California 93117
www.abc-clio.com

This book is printed on acid-free paper ∞

Manufactured in the United States of America

Contents

Introduction: You Don't Need a Weatherman—Climate Change and Popular Culture

Earth's climate has changed dramatically over its estimated 4.6-billion-year history without the help of humanity. Since the beginning of the Industrial Revolution in the mid-eighteenth century, however, the scientific consensus holds that the current rapid (geologically speaking) climate change is driven by human activity. By deforestation and the burning of fossil fuels, among other activities, humanity has emitted approximately 375 billion tons of carbon in the atmosphere, creating a rise of 1.7 degrees Fahrenheit (1 degree Celsius) in global temperatures since 1750. As population has grown and demands for energy have increased, the rate of carbon production and heat rise are increasing more rapidly. Recent studies indicate that a temperature rise of 2 degrees from the 1750 baseline will have a serious impact on how humans live on the planet. A rise of over 2 degrees will be catastrophic, with sea rise, drought, increased storm activity, and the spread of disease causing worldwide economic and social insecurity. Previous shifts in Earth's climate have resulted in five mass extinctions. Humanity may be causing as well as facing a sixth.

Geological time runs exceedingly slow, but examinations of geological and fossil records reveal a pattern of extinctions throughout Earth's history. Named after the geological periods during which they have taken place, the five extinctions radically altered life on the planet. The first, the Ordovician–Silurian extinction, occurred about 440 million years ago and wiped out the small marine organisms that existed at that time. The second, the Devonian extinction, happened approximately 365 million years ago and destroyed much of the aquatic life in the warm oceans. The third, the Permian–Triassic extinction, occurred nearly 250 million years ago and destroyed 95 percent of all life on Earth. The fourth, the Triassic–Jurassic extinction, happened about 210 million years ago and destroyed much vertebrate life, allowing the dinosaurs to flourish. The fifth, the Cretaceous–Tertiary extinction that occurred 65 million years ago, destroyed the dinosaurs, and mammals took their place. In each case, geologists and climate scientists believe climate change, caused by changes in Earth's atmosphere that resulted in changes in the planet's global temperature,

made adaptation impossible for many species. Humanity is now facing a possible extinction event of its own making.

The dramatic increase in the amount of carbon dioxide (CO_2) in the atmosphere began with the Industrial Revolution and the increase in the use of fossil fuels to provide energy to support the growing demand for industrial and agricultural products. Likewise, the understanding of the nature of climate change and humanity's causal relationship to it began about the same time. In 1800, the population of the earth was approximately one billion people, and as the worldwide population increased, the demand for goods and services, as well as energy, increased as well. In 1824, French physicist Joseph Fourier identified and described the earth's natural greenhouse effect, and in 1861, Irish physicist John Tyndall demonstrated that water vapor and certain other gases trap heat and increase the greenhouse effect, which he believed was beneficial to a degree. Coal burning, the major source of energy for the steam engine, increased throughout the nineteenth century. In 1886, Karl Benz created and marketed the Motorwagen, which is considered the first automobile. This invention ushered in the age of automobiles as well as the age of oil and gas. Significantly, in 1896, Swedish chemist Svante Arrhenius presented a paper that asserts that the burning of coal, and other fossil fuels, will increase the greenhouse effect at the rate of several degrees for each doubling of the amount of CO_2 gasses in the atmosphere. Modern climate models confirm Arrhenius's estimates.

In the early part of the twentieth century, worldwide industrial growth as well as population growth continued. By 1930, emissions from burning fossil fuels had reached one billion tons a year, and the earth's population had reached two billion people. The demand for fossil fuels increased as sales of automobiles rose and electrification, powered primarily by coal, expanded globally. In 1938, British engineer Guy Stewart Callendar, tracking data from 147 weather stations around the world, recorded a rise in world temperatures as well as a rise in the amount of carbon dioxide in the atmosphere. He suggested the burning of fossil fuels was creating the global climate change, calling it the "Callendar Effect." His observations were mostly ignored.

In the 1950s, scientists continued to study climate change. Using early computers, U.S. researcher Gilbert Plass examined the infrared absorption of gases and concluded that doubling the amount of carbon dioxide in the atmosphere would raise global temperatures three to four degrees centigrade. U.S. scientists Roger Revelle, an oceanographer, and Hans Suess, a chemist, demonstrated that seawater will not absorb the additional carbon dioxide gases entering the atmosphere, placing limits on the earth's ability to self-regulate the atmosphere.

In 1960, the population reached three billion people. In 1962, Rachel Carson published *Silent Spring*, an examination of the use of pesticides. The popularity of Carson's book, as well as the attacks on it by the pesticide industry,

helped launch the environmental movement in the United States. In 1965, a U.S. President's Advisory Committee announced that greenhouses gases were a "real concern." In 1972, the United Nations held its first environmental conference in Stockholm, Sweden. Looking primarily at the issues of chemical pollution, nuclear weapons testing, and whaling, the United Nations established the United Nations Environment Programme (UNEP), which was also charged with looking at the production of greenhouse gases.

In 1975, the population reached four billion people. Demands for food, goods, and power increased worldwide to match the growing population, and the use of fossil fuels continued to rise, as did global temperatures. Also in 1975, U.S. scientist Wallace Broecker used the term "global warming" in a scientific paper, putting the phrase in the public domain.

In 1987, the population reached five billion people. In the same year, the United Nations convened a conference that resulted in the Montreal Protocol on Substances that Deplete the Ozone Layer. The protocol also impacted the production of greenhouse gases. In 1988, the United Nations established the Intergovernmental Panel on Climate Change (IPCC) and charged it with assessing the science related to climate change. In 1989, British Prime Minister Margaret Thatcher called for the creation of a global treaty on climate change. In the same year, carbon emissions from the use of fossil fuels and industry reached six billion tons.

In the 1990s, climate change became a matter of public debate as intergovernmental studies showed that climate change was driven by human action. In response, the petroleum and fossil fuel industries launched campaigns attacking the science behind climate change, denying that climate change was in fact occurring, and rejecting human causation for climate change. In 1992, the Earth Summit in Rio de Janeiro agreed to form the United Nations Framework Convention on Climate Change (UNFCCC). Its primary objective is "the stabilization of greenhouse gas concentrations in the atmosphere at the level that would prevent dangerous anthropogenic interference with the climate system." In 1995, the second IPCC reported that the balance of evidence suggested a discernable human influence on the earth's climate. In 1997, the Kyoto Protocol agreed with the IPCC report, and developed nations agreed to reduce greenhouse gas emissions by 5 percent by the period 2008–2012. In 1998, global warming and the El Niño effect made the year the hottest on record. The global temperature reached 0.52 degrees centigrade above the mean temperature for the years 1960–1990, a standard baseline.

In 1999, the population reached six billion people. In 2001, President George W. Bush removed the United States from the Kyoto Protocol. In the same year, the IPCC Third Assessment Report noted that there was new and stronger evidence that humanity's emissions of greenhouse gases were the main

cause of global warming in the second half of the twentieth century. In 2006, carbon emissions from fossil fuels reached eight billion tons per year. That same year, former vice president Al Gore released a documentary film version of his slide presentation on global warming and climate change, *An Inconvenient Truth*, which received the Academy Award for Best Documentary Feature the following year. Gore's film, and the book that quickly followed the film's release, attracted considerable attention as well as scientific and political debate. Political supporters of the petroleum and automobile industries and spokespersons for the fossil fuel industry attacked Gore's assertions about climate change and global warming. In 2007, however, Al Gore and the IPCC shared the Nobel Peace Prize "for their efforts to build up and disseminate greater knowledge about man-made climate change, and to lay the foundations for to measures needed to counteract such change."

In the decade and a half since the publication of *An Inconvenient Truth*, political debate about climate change continued. Democratic presidents Barack Obama and Joe Biden supported international efforts to combat climate change and global warming. Both democratic administrations supported the Paris Agreement and the Kyoto Protocol. Republican President Donald Trump did not support international efforts and withdrew the United Sates from both agreements. Meanwhile, the decade from 2011 to 2020 was the hottest on record in a persistent, long-term climate trend. The warmest six years in recorded history have all occurred since 2015.

The population reached seven billion in 2011. In 2012, Arctic Sea ice reached a minimum extent of 1.32 million square miles, the lowest summer ice cover since satellite measurements began in 1979. Hurricane frequency and intensity increased, with the United States being hit by two superstorms: Hurricane Katrina in 2005 and Hurricane Sandy in 2012.

Much of the debate about the nature and scope of climate change has been driven by beliefs about the relationship between humanity and nature. Many who believe in the human cause of climate change see humanity as part of nature; humanity shares the planet with other species, and all species interact with the environment. On the other hand, many who support the continued exploitation of nature see humanity as existing outside of nature. The planet is to be used for the benefit of humanity. This dichotomy in views about nature has been part of American writing from the very beginning. Thomas Hariot's report of Sir Walter Raleigh's 1585 expedition to Roanoke Island in what is now North Carolina, *A Brief and True Report of the New Found Land of Virginia* (1588), describes the wonders of a newly discovered land as a resource. William Bartram's *Travels* (1791) is also a scientific study of what is now the Southeast United States that describes the unusual flora and fauna to be found there as well as their potential uses. In his *Notes on the State of Virginia* (1781), Thomas

Jefferson describes the natural world of Virginia as being full of wonders, and he praises the size and utility of its plants and animals. In New England, Puritan writers and preachers saw nature in dualistic terms. In sermons, the new natural world was at times a Garden of Eden, a place of riches to be enjoyed; at other times, it was a wilderness or wasteland, a place of fear.

In the nineteenth century, Henry David Thoreau's *Walden* (1854) and Ralph Waldo Emerson's *Nature* (1836) depict nature in both utilitarian and spiritual terms. Although nature proves what is usual for human life—food, shelter, and clothing—it also takes on meaning as humans live in it and appreciate it as a representation of the divine. For Emerson and Thoreau, as well as other American transcendentalists, nature was in a real sense sacred and something to be appreciated and taken care of. During the Industrial Revolution in the United States, however, the spiritual side of nature took a back seat to its usefulness, and nature became a resource, something to be used for survival and profit. Both attitudes existed and still exist in American culture, and the many recent nonfiction books that examine climate change reflect these attitudes.

There is a growing critical consensus that Rachel Carson's *Silent Spring* (1962) is not only the first great modern example of environmentalist writing in the United States but also that it provided a model for many of the later works that argue that climate change is an actual ongoing event and that humanity needs to respond to this existential threat. Carson was not the first scientist to recognize the danger pesticides posed to the environment. She was, however, the first to address the problem in nonscientific terms to a general audience. The success of *Silent Spring* triggered an aggressive response from the pesticide industry, which only brought more attention to the subject. Carson discovered there was an audience for a book that demonstrated humanity's destruction of nature and suggested alternatives. Other environmental writers facing climate change and global warming, instead of pesticide use, followed Carson's lead.

One of the earliest writers to approach the topic of climate change itself was Bill McKibben, an American author and environmentalist. In his first book, *The End of Nature* (1989), McKibben presents a vivid account of the probable impact of greenhouse gases on both the environment and species of plant and animal life. McKibben writes in the style of a jeremiad, a passionate public statement of warning based on the biblical writings of the prophet Jeremiah and adapted as a sermon form in Puritan New England. In his book, he chastises energy waste and consumption and calls for a change in how humanity interacts with the planet. In 2007, he wrote *Fight Global Warming Now*, a handbook for climate activists, and in 2010, he published *Eaarth: Making a Life on a Tough New Planet*, a description of the rapid onset of climate change.

Although discussions of global warming and climate change continued in the latter years of the twentieth century, the topic rose to national prominence

with the publication of three books: *Hell and High Water* (2006), by Joseph Romm; *Field Notes from a Catastrophe* (2007), by Elizabeth Kolbert; and *An Inconvenient Truth* (2006), by Al Gore. In *Hell and High Water*, Romm provides an analysis of the science about climate change as well as an examination of its causes, which he believes are politics and consumerism. He then traces the history of climate change literature, including *The Epic of Gilgamesh*, Plato's myth of Atlantis, and Shakespeare's *Macbeth*. In *Field Notes from a Catastrophe*, *New Yorker* feature writer Elizabeth Kolbert expands her three-part series on climate change into a book, which became both a popular and critical success. Kolbert provides a concise overview of the science behind the study of climate change. She also introduces her readers to the specialists who are collecting data, such as a glaciologist in Canada and a herpetologist in Costa Rica. Each is studying something disappearing from the natural world because of climate change. One studies glaciers and the other frogs. Kolbert's description of the impact of climate change uses personal descriptions of scientists at work who are illustrating the specific data she provides. The result is a more engaging narrative than the mere reporting of data. The result is a book that both engages and enlightens the reader.

Al Gore's *An Inconvenient Truth*, a film documentary and book, brought the immediacy of climate change to the general public. The scientific information he presented was not new, but his presentation of the facts about climate change was clear, concise, and easily understood by people without scientific training. Until the release of *An Inconvenient Truth*, global warming and climate change were, for most people, a future possibility that only worried some alarmist members of the scientific community. Gore's clearly written and illustrated presentations spread the news about global warming worldwide. *An Inconvenient Truth* won an Academy Award, and Gore received the Nobel Peace Prize for his work. Climate change had become a hot topic.

In 2007, Mark Lynas, a British science writer, published *Six Degrees: Our Future on a Hotter Planet*. Unlike Al Gore's *An Inconvenient Truth*, which looks at a climate-changed future with, at times, clinical dispassion, *Six Degrees* reads much like a horror novel, or as Lynas himself notes, a trip through Dante's *Inferno*. Lynas walks his readers through the impact on the earth of each degree of global warming. Step-by-step, *Six Degrees* shows the earth on an accelerating decline into a future devoid of glaciers and ice caps in which massive storms roll over submerged coastal cities.

In 2010, Naomi Oreskes and Erik M. Conway published *Merchants of Doubt: How A Handful of Scientists Obscured the Truth on Issues from Tobacco Smoke to Climate Change*. The book, which later became a documentary film, looks at the role corporate-sponsored researchers played in raising objections to the harmful effects of their sponsors' products by challenging environmental research

and science. *Merchants of Doubt* drew a direct line between public critics of environmental science and their corporate sponsors.

Two popular nonfiction climate change works appeared in 2014: *The Sixth Extinction: An Unnatural History*, by Elizabeth Kolbert, and *This Changes Everything: Capitalism vs. the Climate*, by Naomi Klein. Kolbert sets the information that appeared in her earlier book, *Field Notes from a Catastrophe*, into a geological time frame. She argues that we are now in the Anthropocene, the current geological epoch in which humanity activity is shaping the nature of the planet. She sets the possible mass extinctions caused climate change against earlier mass extinctions that eradicated much of the plant and animal life on earth. Klein argues that the underlying cause of climate change is more than the increase of greenhouses gases. Instead, she believes that corporate capitalism, and the resulting demand by customers for more products and by industry for more profits, has created a political climate in which any attempt to scale back the use of fossil fuels is impossible.

The Great Derangement: Climate Change and the Unthinkable (2016), by Indian writer Amitav Ghosh, looks at climate change through an examination of fiction. Ghosh argues that realistic fiction has, for the most part, been unable to examine the dramatic nature of climate change, leaving it to genre fiction such as science fiction and horror. In addition, he notes that the underlying causes of climate change, industrialization, colonialism, and capitalism are not subjects usually treated in modernist writing, the most privileged form a contemporary narrative writing.

Recent popular nonfiction examining climate change builds on the work of earlier writers and makes links between the changing climate and the politics of consumption. In *The Uninhabitable Earth* (2019), David Wallace-Wells updates the lack of progress made on reducing greenhouse emissions since the dangers posed by global warming and climate change became known and lists the probable horrific outcomes unless radical change is made in how people live, beginning immediately. He calls for revolutions in both thinking and action as necessary for humanity's survival. Similarly, in *The Green New Deal: Why the Fossil Fuel Civilization Will Collapse by 2028* (2019), Jeremy Rifkin asserts that a third Industrial Revolution is underway, which will make the use of fossil fuels obsolete by bringing cheap, clean energy to people around the globe. In doing so, the power of the fossil fuel industry to control national and international politics will be broken, leading to a new and fairer political order. Finally, In *The Story of More: How We Got to Climate Change and Where to Go from Here* (2020), Hope Jahren, a self-deprecating "lab girl" who studies climate change, argues that humanity's desire to accumulate "more" of just about everything is the source of climate change and the solution is attainable with a change in attitude as well as a change in politics.

Statements calling for the abandonment of the use of fossil fuels, the restructuring of American life, and the abandonment of the philosophy that more is better have not been left unchallenged. Spokespersons for the fossil fuel industries and their political allies challenged the idea that the climate was changing and disputed the connection between the use of fossil fuels and climate change. They also attacked the data and scientific approaches used by climate scientists to form their opinions. Perhaps the best-known book attacking the idea of climate change is Gregory Wrightstone's *Inconvenient Facts: The Science That Al Gore Doesn't Want You to Know* (2017). Wrightstone presents the arguments against climate science, many of which have previously been examined and rejected, in a clear and concise form. Michael Shellenberger's *Apocalypse Never: Why Environmental Alarmism Hurts Us All* (2020) argues that aggressive economic growth and continued use of abundant resources will solve the problems caused by climate change, which Shellenberger believes are overstated. Finally, in *False Alarm: How Climate Change Panic Costs Us Trillions, Hurts the Poor, and Fails to Fix the Planet* (2020), Bjorn Lomborg argues that although the climate is changing, the degree of change and potential impacts are a media-created exaggeration.

Like American nonfiction, American fiction has always contained an environmental thread. James Fenimore Cooper's *Leatherstocking Tales* (1823–1841) are as much about the encroachment of civilization on an Edenic wilderness as they are about the adventures of one frontiersman, Natty Bumpo. Nathaniel Hawthorne's famous short story "The Maypole of Merry Mount" (1836) raises the question of whether the New World in which the Puritans found themselves is Edenic or demonic. Most significantly, Herman Melville's classic novel *Moby Dick* (1851) can be read as a long meditation on the impact of human activity on the natural world. Melville wonders whether whaling, which he depicts as a quintessentially American profession, will bring about the extinction of the sperm whale, which provided the essentials and luxuries of life, whale oil and ambergris, for tens of thousands of Americans.

Several novels written prior to the awareness of the impacts of climate change and global warming provided models for later writers who explicitly addressed the problems of climate change. Drought, hunger, disease, and mass migration are some of the predicted results of climate change, and John Steinbeck's *The Grapes of Wrath* (1939) is the most famous example of a climate-caused migration novel. Steinbeck not only shows the impact of drought on the people forced to leave their homes; he also dramatizes the hostility, including border checks and calls for the migrants to "go home," that they face. Similarly influential are two nuclear war novels, Pat Frank's *Alas, Babylon* (1959) and Walter M. Miller's *A Canticle for Leibowitz* (1959). Both novels depict postdisaster settings in which survivors struggle to find food, shelter, and security after society

breaks down because of the disaster. Much climate change fiction borrows settings and conflicts from nuclear apocalypse narratives. Although the cause of the disaster is different, the dystopian situation of illness, lack of food, and the need to establish security that survivors face remains the same.

One writer, British author J. G. Ballard, however, was writing climate change fiction as early as the 1960s. Ballard wrote four climate change novels during the decade: *The Wind from Nowhere* (1961); *The Drowned World* (1962); *The Burning World* (1964), retitled *The Drought* in 1965; and *The Crystal World* (1966). In each, he adopts the convention of the nineteenth-century British adventure novel in which a protagonist finds himself in a deteriorating environment and struggles against hostile survivors and psychological threats. Ballard is less interested in the causes of climate change than he is in the responses to it. In *The Wind from Nowhere*, a fierce wind begins to blow without ceasing, forcing people to live underground to survive. In *The Drowned World*, Ballard envisions London covered with water from sea rise as the few Londoners left alive suffer in a warming climate that is turning the earth into a Jurassic swamp in which survivors battle for security as well as whatever they can find of value beneath the water. In *The Burning World*, Ballard imagines a world in which rainfall ceases, causing a massive drought that forces people to migrate in hopes of finding water. Ballard's depiction of thousands of people fighting to get close to failing water supplies is horrific. Finally, in *The Crystal World*, Ballard creates a world where the earth itself has turned against humanity, slowly spreading a plague that turns all living things into a crystal-like substance. In all his climate change fiction, Ballard explores the psychological impact of deteriorating environments on people, developing an approach that later writers of climate change fiction will employ.

The major fiction writers that initially used climate change as an essential element in their narratives focused on the dystopian features of a world already experiencing the effects of climate change. As a result, those novels focus on the displacement, scarcity, and authoritarianism their characters experience in a changed world. In Margaret Atwood's *The Handmaid's Tale* (1985), for example, the theocratic Republic of Gilead was established after climate change created both shortages and disease that the overthrown government of the United States was unable or unwilling to rectify. Offred, the novel's protagonist, is stripped of her rights to vote and own property, as are all other women in the authoritarian state. She is also forced into sexual servitude after birth rates dramatically declined worldwide because of the environmental degradation. Her only hope, as it is for many facing climate catastrophes, is escape. However, as in other climate change narratives, the borders are guarded, and migrants are unwelcome.

In *The Children of Men* (1992), British author P. D. James also describes a dystopian world where fertility is threatened. Set in Britain in the year 2021, the

novel depicts a world in which children are no longer being born and humanity is facing the possibility of extinction. In response to the crisis, the British government imposes restrictions on immigration, suspends civil liberties, and encourages suicide. Indifferent to the plight of the old and migrant workers, most citizens accept governmental restrictions.

In 1993, Octavia Butler published the *Parable of the Sower*, a dystopian novel with elements of science fiction. The novel is set in California in the near future, where climate change has forced middle-class people into walled communities to remain safe from the poor and unemployed, who have resorted to drugs and violence in response to failed social and economic systems. The novel's protagonist, Lauren Oya Olamina, is gifted with, or suffers from, hyperempathy, an uncontrolled ability to feel the sensations of those around her. The novel follows Olamina as she is forced to flee her community after looters break in. She becomes a climate migrant and joins a band of other migrants as they head north along abandoned highways in search of a place to live.

Perhaps the best-known dystopian climate change novel is *The Hunger Games* (2008), by Suzanne Collins. That novel depicts Panem, a dystopian country in what was once the United States, that is divided into twelve regions. To ensure the loyalty and obedience of the citizens of the poorer regions, the rulers in the rich capital city require each region to send two young people to take part in a televised battle to the death. The novel's protagonist, Katniss Everdeen, comes from the poorest region. With the help of a clever media adviser, she manages to become a popular competitor, and by refusing to go along with the rules of the games, she not only manages to survive but also to become a popular figure throughout the country. The next novels in the series, *Catching Fire* (2009) and *Mockingjay* (2010), chronicle her opposition to the authoritarian government and her rebellion against it.

Canadian writer Margaret Atwood returned to the idea of climate change and its impact that she explored in *The Handmaid's Tale* in the *MaddAddam* series: *Oryx and Crake* (2003), *The Year of the Flood* (2009), and *MaddAddam* (2013). In the three novels, Atwood presents a dystopian vision of the future, when human civilization, stressed by climate change, corporate greed, and class divisions, reaches and passes a tipping point that leads to the extinction of humanity. Told from a variety of points of view, the novels in the series describe how a brilliant, bored young scientist introduces a virus into a wildly popular ecstasy/Viagra-like drug that when triggered kills almost all of humanity. The few survivors interact and try to teach genetically engineered humanlike creatures about the world they are about to inherit and humanity's role in destroying it.

Other contemporary writers have used climate change as a theme for multiple books. Among the most prolific and successful is Kim Stanley Robinson. Robinson has been praised for his literary science fiction. Throughout his career,

he has been concerned with ecological sustainability as well as economic and social justice. Robinson's *Science in the Capital* series, which includes the novels *Forty Signs of Rain* (2004), *Fifty Degrees Below* (2005), and *Sixty Days and Counting* (2007), is an extended examination of climatic disaster and the American government's response to it. After the world is devastated by sea rise, flooding, and a massive worldwide freeze, a newly elected president of the United States decides to trust his scientists, abandon the use of fossil fuels, and restructure society so that everyone shares both the hardships of climate change and the benefits of government action. Similarly, in *New York 2140*, which is set in a city inundated with sea rise, Robinson explores the conflict between financial manipulation by the wealthy and calls for social and economic justice by the citizens who live among the remains of Manhattan. At the end of the novel, the citizens of New York overthrow the power of new Wall Street and establish an equitable society in which risk and reward are shared.

Paolo Bacigalupi, an award-winning American science fiction writer, has also focused his writing on the impact of climate change. *The Windup Girl* (2009) is set in Thailand after climate change and global warming have caused humanity to abandon the use of fossil fuels. Bacigalupi explores how attempts at bioengineering create conflicts in a world where international corporations attempt to control nation-states through economic blackmail to which the only effective response is military action. In *The Water Knife* (2015), he looks at a future American Southwest in which cities and states battle over the water rights to the dwindling supply of water provided by the Colorado River. States close their borders to water migrants, and international corporations take over governmental functions in those areas with access to water. Bacigalupi has also written two young adult novels about climate change and its impact on young people: *Ship Breaker* (2010) and *The Drowned Cities* (2012). Both deal with the cost of environmental devastation, such as clear-cutting, and are set in a world where coastal cities have been destroyed and children work as laborers who salvage anything useful from preflood times.

In the last twenty years, a number of other novels in which climate change is a central figure have received considerable critical and public acclaim. Cormac McCarthy's *The Road* (2006) was awarded the Pulitzer Prize for Fiction in 2007 and was adapted into a successful film in 2009. In the novel, a father and son walk through an empty landscape after an unspecified disaster, which may be catastrophic climate change. The novel captures the dangers faced by migrants who must find food and shelter as they attempt to find a place of refuge. In *Salvage the Bones* (2011), which won the National Book Award for Fiction, Jesmyn Ward describes the impact of a super hurricane, based on Hurricane Katrina, on a poor African American family living along the Mississippi Gulf Coast. Her depiction of the impact of a major storm on those least able to prepare is

harrowing. In *Flight Behavior* (2012), which the *Washington Post* called the best book of the year, Barbara Kingsolver describes how the unexpected migration of millions of monarch butterflies to rural East Tennessee upsets the lives of the people who live there. The arrival of the butterflies, wintering in Tennessee rather than Mexico because of climate change, provides ordinary people with a lesson in climate science.

James Bradley's *Clade* (2015) is unusual in that it explores the long-term impact of climate change on one family by following three generations of the descendants of climatologist Adam Leith as they attempt to survive the impact of climate change. Lydia Millet's *A Children's Bible* (2020) is a story about a group of young people who must adapt to climate change as well as a monster hurricane that their parents refuse to respond to. The novel reads like a climate change–infused version of William Golding's classic *Lord of the Flies* (1954), in which the physically present parents of the young protagonists refuse to accept any responsibility for climate change or their own actions. Finally, in *A Friend of the Earth* (2000), T. C. Boyle creates a serious comic novel about climate change. Set in 2025, after greenhouse gases and global warming have destroyed the environment, the novel records the adventures of Tyrone O'Shaughnessy Tierwater, a radical environmentalist whose every good intention ends up in disaster.

Although many novelists have used global warming and climate change in their fictions, fewer screenwriters and directors have made use of the subject matter. The first two major Hollywood films dealing with environmental issues appeared in the early 1970s, partially in response to the growing public awareness of the human impact on the environment. *Soylent Green* (1973) is an ecological disaster and crime film set in New York in 2022, when environmental deterioration and global warming have reached a point where the population has outstripped the food supply. It stars Charlton Heston as a police detective investigating the murder of an executive of Soylent Industries. Soylent manufactures food out of plant-based protein and is the major source of food for much of the world's population. The film dramatizes the manipulation of people in the face of diminishing resources and growing heat. The final line of the film is "Soylent Green is people." Heston's character yells this announcement after he has discovered that Soylent Green is made from the bodies of people who have committed suicide. Another environmental detective film is *Chinatown*, directed by Roman Polanski and starring Jack Nicholson, Faye Dunaway, and John Huston. Set in Los Angeles in the 1930s, the film depicts corrupt businessmen and politicians manipulating the Southern California water supply for profit. The film also acknowledges the scarcity of water in the American Southwest, a growing climate change problem today.

Waterworld (1995), directed by Kevin Reynolds and starring Kevin Costner and Dennis Hopper, is the first Hollywood film clearly set in a world completely

changed by global warming. In the film, the oceans have risen to such an extent that only the tip of Mount Everest stands above the waterline, and the survivors of the great flood live on ships. Costner plays the Mariner, a loner who searches for a rumored piece of dry land while being chased by pirates. The film was a critical and financial failure, as it was the most expensive film made up to that time and did not recoup its investment.

A.I. Artificial Intelligence (2001), directed by Steven Spielberg and starring Haley Joel Osment, Jude Law, and Frances O'Conner, was a long-term project of Stanley Kubrick's, who turned the film over to Spielberg late in his life. The film is set in the future after global warming has destroyed the world's coastal cities and reduced the earth's population. The film is a retelling of *The Adventures of Pinocchio*, but in this case, the wooden puppet who wishes to be human is a Mecha, or genetically engineered robot capable of feeling love. The film was both a critical and financial success.

Avatar (2009), directed by James Cameron and starring Sam Worthington, Zoe Saldana, and Sigourney Weaver, was filmed in 3D, and in addition to receiving critical praise, it grossed over $2 billion worldwide. The film is a parable that tells the story of humanity's destruction of the earth's environment at another time and place. Set on a habitable moon in the Alpha Centauri star system, *Avatar* depicts how a resource development corporation from an earth already devoid of resources is about to destroy the planet to mine unobtanium, a rare essential mineral. The film dramatizes the moon's inhabitants as they struggle to protect their planet from humanity's greed.

Perhaps because of the visual possibilities of ice and snow, several popular climate change films depict a world where climate change has resulted in a frozen earth. The first was *The Day after Tomorrow* (2004), directed by Roland Emmerich and starring Dennis Quaid, Ian Holm, Jake Gyllenhaal, and Emmy Rossum. In the film, climate change disrupts the Gulf Stream's thermohaline circulation, which causes warm water to flow north and colder water to flow south. The result is a series of monster storms followed by global cooling and the beginning of a new ice age. In the film, Quaid, playing a climate paleontologist, must rush to a frozen New York City to save family members from death.

The second film about the future frozen earth is *The Colony* (2013), directed by Jeff Renfroe and starring Laurence Fishburne, Kevin Zegers, and Bill Paxton. In the film, set in 2045, humanity has created machines designed to control global warming. The machines malfunction, however, creating a new ice age in which human survivors must live in underground bunkers to survive. The film's plot revolves around an attack on a bunker by cannibals and the bunker's inhabitants' search for a place on the surface, where the ice may be melting.

Snowpiercer (2013), directed by Bong Joon-ho and starring Chris Evans, Song Kang-ho, Tilda Swinton, and Jamie Bell, is based on a French graphic novel

that also depicts a new ice age. In this film, however, the survivors do not live in underground bunkers but a specially constructed train that circumnavigates the globe. The film depicts the class inequities that arise and the inevitable violence that erupts as too many people fight for limited resources in an enclosed environment. The film was adapted for television and premiered in 2020.

Public awareness of the dangers posed by climate change has grown in part because of news coverage of the changing climate and a number of documentaries about climate change that have been produced and released in the twenty-first century. The most famous is Al Gore's *An Inconvenient Truth* (2007), which won an Academy Award and for which Al Gore received the Nobel Peace Prize in 2007. The documentary brings together the scientific information about climate change and addresses the threats of a global warming to a general audience. In 2017, Gore released a second climate change documentary, *An Inconvenient Sequel: Truth to Power*. In 2007, British director Franny Armstrong released *The Age of Stupid*, starring Pete Postlethwaite. Set in 2055, the documentary depicts a man living alone and asks the question, "Why we didn't stop climate change when we had the time." Also in 2007, Brian Williams released *The 11th Hour*, a televised documentary that put climate change in a political and social context. In 2012, Jeff Orlowski released *Chasing Ice*, a documentary about the impact of climate change on the earth's glaciers and ice caps. The film includes footage of the calving event that took place at the Jakobshavn Glacier in Greenland, when 1.8 miles of ice broke off from the glacier. The same year saw the release of *Greedy Lying Bastards*, directed by Craig Rosebraugh. The film explores climate denial and focuses on how oil companies and other special interests spread false information about global warming and climate change. In 2014, director Robert Kenner released *Merchants of Doubt*, which also explores how special interest spokespersons deliberately distort climate change information.

Climate change and global warming deniers also released documentaries that cast doubt on climate change science and disputed the connection between the increased production of greenhouse gases and global warming. In 2004, Lars Mortensen, a Danish director released *Doomsday Called Off*. The film asserts that the earth's climate is not changing. In 2007, Martin Durkin, a British filmmaker released *The Great Global Warming Swindle*. The documentary asserts that global warming and climate science are part of a political attack on the fossil fuel industry and conservative politicians by environmental radicals. *Climate Hustle* (2016) is an American documentary directed by Christopher Rogers and written and narrated by Marc Morano, a climate change denier. The film denies that the climate is changing or that humans have any effect on climate change. The film was funded by the Committee for a Constructive Tomorrow, a fossil fuel industry trade group.

Awareness of climate change is growing, and the debate about the potential impact of sea rise, global warming, crop failures, and mass migration continues. As a result, more writers and directors will continue to explore and exploit the subject for their narratives. Once upon a time, stories about rising seas drowning millions of people or mass starvation caused by a warming planet were subjects of myth and science fiction. Today, and in the future, they may well be the subjects of realistic films and fiction, and nonfiction.

Essential Climate Change Terms

Adaptation. Adaptation is the process of adjusting to current or expected climate change and its effects. Adaptation can be either incremental (actions where the central aim is to maintain the integrity of a system) or transformational (actions that change the fundamental attributes of a system).

Anthropogenic climate change. Anthropogenic climate change is an exacerbation of the greenhouse gas effect through the production of greenhouse gases emitted by human activities.

Cap and trade. Cap and trade is a market-based policy tool for protecting human health by controlling large amounts of emissions from a group of sources. A cap-and-trade program first sets an aggressive cap, or maximum limit, on emissions. Sources covered by the program then receive authorizations to emit in the form of emission allowances, with the total amount of allowances limited by the cap. Each source can design its own compliance strategy to meet the overall reduction requirement, including the sale or purchase of allowances, installation of pollution controls, and the implementation of efficiency measures, among other options.

Carbon capture and storage. Carbon capture and storage (CCS) is the process of capturing waste carbon dioxide and transporting it to a storage site where it will not enter the atmosphere.

Carbon dioxide (CO2). Carbon dioxide is the primary greenhouse gas emitted through human activities. CO_2 is naturally present in the atmosphere as part of the earth's carbon cycle (the natural circulation of carbon among the atmosphere, oceans, soil, plants, and animals). Human activities are altering the carbon cycle—both by adding more CO_2 to the atmosphere and by influencing the ability of natural sinks, like forests, to remove CO_2 from the atmosphere. While CO_2 emissions come from a variety of sources, human-related emissions are responsible for the increase that has occurred in the atmosphere since the Industrial Revolution.

Chlorofluorocarbons (CFCs). Chlorofluorocarbons are nontoxic, nonflammable chemicals that contain atoms of carbon, chlorine, and fluorine. They are used in the manufacture of aerosol sprays, blowing agents for foams, and packing materials and as solvents and refrigerants. Whereas CFCs are safe to use in most applications and are inert in the lower atmosphere, they may last

in the upper atmosphere several decades or longer and have a negative impact on the earth's ozone layer.

Climate change migrant/refugee. A climate change migrant or refugee is a person who has been forced to leave his or her home because of the effects of climate change. Climate refugees are a subset of a larger group of emigrants known as environmental refugees/migrants, who are forced to flee their homes because of natural disasters.

Climate modeling. Climate modeling is the use of quantitative methods to simulate the interactions of important drivers of climate change, including the atmosphere, oceans, landmasses, and ice. Modeling is used to study the dynamics of the earth's climate system and to develop projections of future climate.

COP21. The 21st Conference of the Parties (COP21) was an international conference of nations who signed the United Nations Framework Convention on Climate Change (UNFCCC), at which a 2015 intergovernmental agreement was signed to limit carbon emissions.

Deforestation. Deforestation, clearance, clear-cutting, or clearing is the removal of a forest or stand of trees from land that is then converted to nonforest use. The most concentrated deforestation occurs in tropical rain forests and increases the rate of global warming and climate change by limiting the ability of the earth to transform carbon dioxide into oxygen.

Drift ice. Drift ice is any sea ice other than fast ice, the latter being attached to a shoreline or other fixed object. Drift ice consists of floes, which are individual pieces of sea ice that are at least sixty-six feet across.

Emissions. Emissions refer to greenhouse gases released into the air that are produced by numerous activities, including burning fossil fuels, industrial agriculture, and melting permafrost. These gases cause heat to be trapped in the atmosphere, slowly increasing the earth's temperature over time.

Extinction. Extinction is the termination of a kind of organism or a group of kinds, usually a species. The moment of extinction is usually considered the death of the last individual of the species. Isolated extinctions are common, but mass extinctions, the extinction of a large number of species over a short period of geological time, are rare. There have been five mass extinction events in earth's history.

Fossil fuels. Fossil fuels are sources of nonrenewable energy formed from the remains of living organisms that were buried millions of years ago. Burning fossil fuels, like coal and oil, to produce energy is where the majority of greenhouse gases originate. As the world has developed and the demand for energy has grown, more fossil fuels have been burned, causing more greenhouse gases to be trapped in the atmosphere and the rise of air and water temperatures.

Glacial calving. Glacial calving, also known as ice calving or iceberg calving, is the breaking off of chunks of ice at the edge of a glacier. Warming and the resulting expansion of oceans are causing greater waterline melting of glaciers, increasing the rate of glacial calving.

Global average temperature. The global average temperature is a long-term look at the earth's temperature, usually over the course of at least thirty years, on land and sea. Because weather patterns vary, causing temperatures to be higher or lower than average from time to time due to factors such as ocean processes, cloud variability, volcanic activity, and other natural cycles, scientists take a longer-term view to consider annual changes.

Greenhouse gas. A greenhouse gas is a chemical compound found in the earth's atmosphere, such as carbon dioxide, methane, water vapor, and other human-made gases. These gases allow much of the solar radiation to enter the atmosphere, where energy strikes and warms the surface. Some of this energy is reflected back toward space as infrared radiation. A portion of this radiation bounces off these greenhouse gases, trapping the radiation in the atmosphere in the form of heat. The more greenhouse gas molecules there are in the atmosphere, the more heat is trapped and the warmer it will become.

Kyoto Protocol. The Kyoto Protocol is an international treaty that extends the 1992 UNFCCC, which commits state parties to reducing greenhouse gas emissions based on a scientific consensus that global warming is occurring and that human-made CO_2 emissions are driving it.

Methane. Methane is a chemical compound that is the main component of natural gas, a common fossil fuel source. Just like carbon dioxide, methane is a greenhouse gas that traps heat in the atmosphere. Methane accounts for 10 percent of all U.S. greenhouse gas emissions, second only to carbon dioxide. Methane absorbs 84 percent more heat than carbon dioxide.

Mitigation. Mitigation refers to an action that will reduce or prevent greenhouse gas emissions, such as planting trees to absorb more carbon dioxide. It can also include developing and deploying new technologies, using renewable energies like wind and solar, or making older equipment more energy efficient.

Ocean acidification. Ocean acidification is the ongoing decrease of pH levels in the earth's oceans caused by the increase of carbon dioxide in the atmosphere. An estimated 30–40 percent of the carbon dioxide from human activity released into the atmosphere dissolves in the oceans, rivers, and lakes. Much of the warming of the planet is stored in the world's oceans and bodies of water.

Paris Agreement. The Paris Agreement is an agreement within the UNFCCC on climate change mitigation, adaptation, and finance signed by 191 member nations in 2016. The goal of the agreement is to keep the rise in global average temperature to well below 2 degrees centigrade (3.7 degrees Fahrenheit).

Permafrost. Permafrost is a thick subsurface layer of soil that remains frozen throughout the year that chiefly occurs in polar regions. A warming climate contributes to melting permafrost, which has consequences for ecosystems.

Ppm. Parts per million (ppm) is the way of expressing the concentration of one component in a larger sample. Climate scientists use the term to describe concentrations of pollutants, like carbon dioxide or methane, in the atmosphere.

Preindustrial levels of carbon dioxide. Preindustrial levels of carbon dioxide refers to the carbon dioxide concentrations in the atmosphere prior to the Industrial Revolution. Scientists estimate these preindustrial levels were about 280 ppm.

Renewable energy. Renewable energy comes from naturally replenished resources, such as sunlight, wind, waves, and geothermal heat. By the end of 2014, renewables were estimated to make up 28 percent of the world's power-generating capacity, enough to supply 23 percent of global electricity. Because renewables do not produce greenhouse gases, shifting away from fossil fuels to renewables is considered to be the best path for maintaining a sustainable planet.

Saltwater intrusion. Saltwater intrusion is the movement of saline water, or saltwater, into freshwater aquifers, which can lead to the contamination of water sources.

Sea level rise. Sea level rise is caused by two climate change factors. First, more water is released into the ocean as glaciers and land ice melts. Second, the ocean expands as ocean temperatures increase. Both of these consequences of climate change are accelerating sea level rise, putting millions of people who live in coastal communities at risk.

Sustainability. Sustainability is the capacity to endure in a relatively ongoing way across various domains of life. It generally refers to the capacity of the earth's biosphere and human civilization to coexist. Environmentalists believe sustainability is possible through the balance of species and resources within their environment.

Tipping point. A tipping point is a threshold that, when exceeded, can lead to large changes in the state of a system. Potential tipping points have been identified in the climate system, in impacted ecosystems, and sometimes in both. For example, feedback from the global climate cycle is the driver for the transition between glacial and interglacial periods in the earth's history.

UNFCCC. The United Nations Framework Convention on Climate Change is an environmental treaty that nations joined in 1992, with the goal of stabilizing greenhouse gas concentrations in the atmosphere at a level that will prevent dangerous human interference with the climate system.

Weather and climate. Weather refers to atmospheric conditions in the short term, including changes in temperature, humidity, precipitation, cloudiness,

brightness, wind, and visibility. Climate is the average of weather conditions over a long period of time, usually thirty years or more.

Zero population growth. Zero population growth refers to a population that is unchanging, a population with a zero growth rate. Zero population growth is often a goal of demographic planners and environmentalists who believe that reducing population growth is essential for the health of the ecosystem.

AFTER THE FLOOD

After the Flood (2019) is a post–climate change dystopian thriller by Kassandra Montag. The novel is set in the future, when climate change has transformed the earth, covering all the world's surface, except for a few mountain peaks, with water. The concept is not new; the idea of climate change causing a flood of biblical proportions in a relatively short time has been used before, most notably in postapocalyptic action film *Waterworld* (1995) by Kevin Reynolds and the novel *Flood* (2008) by Stephen Baxter. What sets *After the Flood* apart from those narratives is that Montag centers her story on a mother and daughter and the mother's search for her other daughter, who is lost.

The prologue of the novel begins in Nebraska, during the period when sea levels have begun to rise but not yet inundated the world. The narrator, Myra, recalls the horrific moment when, as waters rise around the family's house, her husband, Jacob, grabs their daughter Row and leaves in a neighbor's boat. Myra, pregnant with her daughter Pearl, and Pearl's grandfather survive in a small boat, *Bird*, built by the grandfather against a flood time he hoped would never reach Nebraska. On the *Bird*, Myra, her unborn daughter, and Myra's father survive by fishing and trading fish for supplies. The grandfather dies, Pearl is born, and Myra raises her for seven years.

The novel itself opens with Myra baiting crab pots off the coast of what was once British Columbia. She recalls having to kill a man who attempted to steal her daughter to work as a slave on a raiding ship and worries about her lost daughter, who is old enough to be taken and sold as a sex slave to one of the raiders who prey on lone boats and small surviving communities. Montag, like many writers of climate fiction, emphasizes the lawlessness that accompanies dramatic climate change. In a small village, Myra hears a rumor that a girl who looks like Row has been taken to a place called the Valley in what is left of Greenland. She is determined to somehow get there and save her daughter.

What follows is a narrative of a survivor's journey through the world of water that is reminiscent of both *Moby Dick* (1851) and Errol Flynn's famous pirate film *Captain Blood* (1935). In a world in which climate change and global warming have left few survivors and no civilization, Myra undertakes a quest

as mad as Captain Ahab's and battles pirates on the very high seas in search of her daughter.

Myra's journey begins when she picks up Daniel, a survivor of a shipwreck and also an experienced navigator. He helps her plot her location and plan a course to one of the survivor villages in the high Andes, where she has traded fish for supplies before. Once there, Myra learns that Row was recently seen there and was rumored to be heading to the Valley, which is said to be a base for the Lost Abbots, a raider community that grew from a band of hired mercenaries and is attempting to gain power by capturing boys to raise to become raiders and girls to raise as sex slaves. Myra, Pearl, and Daniel are picked up by a passing ship after their small boat is wrecked in a storm. Fortunately, they are rescued by a peaceful ship, not the Lost Abbots or other raiders. They are welcomed aboard, as Myra is known as an expert in finding fish and Daniel's skill as a navigator is even more useful. In much climate fiction, any survival skill often creates acceptance.

Myra, Pearl, and Daniel soon become trusted members of the new ship's crew as their vessel travels around the communities in the Andes and Sierra Madre mountains, fishing, trading, and dodging raider ships. They eventually learn that the Lost Abbots have increased their presence in the area, and at Myra's urging, the ship's crew votes to sail to the Valley, in Greenland, where they hope to find a place to settle. On the trip across the Atlantic, the crew members discover that Myra had directed their ship to the Valley to search for her lost daughter, but having no alternative, they continue their journey. With the help of Daniel's navigation, they manage to locate the Valley and avoid icebergs near the Greenland coast only to find a Lost Abbot warship waiting.

What follows is a classic sea battle. With both the larger Lost Abbot ship and the smaller vessel with Myra, Daniel, and Pearl aboard under full sail, the ships race for the Greenland coast. When the Lost Abbot ship approaches with crew members preparing to board the smaller vessel, small arms fire commences from the yardarms, and handmade bombs are thrown. As Lost Abbots swarm across grappling lines to the smaller ship, crew members scuttle it, allowing them to board the larger ship, which they manage to take over with great loss of life on both sides. Even after climate change has raised the ocean level to unimaginable heights, classic Hollywood sea battles occur.

Myra, Daniel, and Pearl are among the survivors. They make their way up the Valley and find a nearly abandoned town. They also find Myra's husband, Jacob, who informs them that Row had survived the flood but had died a few days before they arrived from a plague that had wiped out most of the village. He also apologizes for leaving Myra, saying he had no choice if he wanted to save Row. Furious at her husband and mourning the loss of her daughter, Myra takes Pearl to visit her sister's grave. Afterward, they are attacked by survivors

from the Lost Abbot ship, who had also found and killed Jacob. Myra and Pearl defend themselves and kill the remaining Lost Abbots. They then find themselves alone but safe on land in a fertile valley.

After the Flood is a pure postapocalyptic adventure story, complete with courageous heroes, evil villains, furious battles, and great storms. Aside from the novel's depiction of a dramatic sea rise far beyond what climate change might cause, *After the Flood* employs many of the conventions used by writers of climate fiction. Montag dramatizes the fight over scarce resources, the end of civil order and the rise of private militias and gangs, the increase of disease, and the general sense of loss and despair that are staples of climate change fiction. Montag also breaks with convention by making a mother protecting one daughter and searching for another the center of her narrative. Many dystopian narratives employ traditional male heroes whose quests through ruined wildernesses are for justice as well as survival. Max Rockatansky from the *Mad Max* films and Rick Deckard from *Blade Runner* are two such examples. Montag's Myra demonstrates that gender is not determinative in dystopian climate change narratives.

See also: *Blade Runner*; *Drowned World, The*; *Flood*; *Mad Max* Series, The; *New York 2140*; *Odds against Tomorrow*; *Waterworld*

Further Reading

Andersen, Gregers. *Climate Fiction and Cultural Analysis: A New Perspective on Life in the Anthropocene*. London and New York: Routledge, 2020.

Hagelberg, Niklas. "How Climate Change Is Making Record-Breaking Floods the New Normal." UN Environment Programme. March 3, 2020.

A.I. ARTIFICIAL INTELLIGENCE

A.I. Artificial Intelligence (also known as *A.I.*) (2001) is a postapocalyptic, dystopian climate change film directed by Steven Spielberg and based on Brian Aldiss's short story "Supertoys Last All Summer Long." The film stars Haley Joel Osment, Jude Law, Frances O'Connor, Brendan Gleeson, and William Hurt. *A.I.* was originally developed by Stanley Kubrick, who planned to direct the film. Kubrick delayed production, waiting for improvement in CGI (computer-generated images) capability. In 1995, he turned the project over to Steven Spielberg. The film was both a critical and box office success.

A.I. is set in the twenty-second century, when climate change has increased temperatures to such a degree that the polar ice caps have melted and sea levels have risen, destroying coastal cities and killing millions of people. In addition, new diseases have ravaged the surviving population. Martin Swinton, the young son of Henry and Monica Swinton, has contracted a rare disease and

been placed in suspended animation in hopes of a future cure. The Swintons have been given a "Mecha" named David. The Mecha is a prototype of a robotic child capable of complex thought but lacking emotions. It is worth noting here that a number of writers who have set their stories in the future, after climate change has reduced the world's population, have imagined that human survivors will develop advanced robotics and that the development will have unintended consequences.

At first, the Swintons are disturbed by the realistic looking robot, but Monica eventually grows accustomed to David and turns on his imprinting protocol. As a result, David develops a deep and enduring childlike affection for her. After Martin is cured, he soon becomes jealous of David, and at a pool party, one of Martin's friends pricks David with a knife, triggering David's defense mechanisms. Both David and Martin fall into the pool. Henry Swinton convinces his wife to return David to the robotics company to be destroyed, but she abandon's him in the woods instead. Alone, except for Teddy, Martin's Mecha bear upon which David also imprinted, David remembers *The Adventures of Pinocchio* and decides to find the Blue Fairy who can turn him into a real boy.

As in *Pinocchio*, adventures await the would-be real boy. First, David and Teddy are captured at a flesh fair, where obsolete Mecha are destroyed by cheering crowds of humans. They manage to escape, along with Gigolo Joe, a Mecha sex toy that has been accused of murder. David, Teddy, and Joe then go to a resort town where a holographic answer engine known as Dr. Know tells them they must go to the top of Rockefeller Center, which is above the water covering the submerged ruins of Manhattan, to find the answers to his questions. At Rockefeller Center, David meets his creator, Professor Hobby, who tells him that his quest to be a real boy shows that he has the capacity to love and desire. He also discovers many versions of himself, ready to be sold to waiting buyers.

Shaken by what he believes is the loss of his individuality, David attempts to kill himself by jumping from the building into the sea below with Teddy. There he sees what he believes to be the Blue Fairy. David and Teddy are saved by Joe, who has taken an amphibious aircraft, but Joe is captured by the police and taken to be destroyed. David and Teddy return to the Blue Fairy, which turns out to be a sunken statue from the now submerged Coney Island. While David is asking to be turned into a real boy, a Ferris wheel falls on them. Trapped, David keeps asking until his power source runs out.

Climate change continues while David lies at the bottom of New York Harbor. The film picks up two thousand years later, and New York City is now under hundreds of feet of ice. Humanity has become extinct, and the Mecha have evolved into an advanced life-form called the Specialists. The Specialists revive David and Teddy. Soon after, David approaches and touches the Blue Fairy, which falls apart upon his touch.

The Specialists reconstruct the Swintons' home from David's memory bank. Although they cannot make him a real boy, they recreate Monica Swinton through one of hairs David had taken. The problem is that the new Monica can only live for one day. David spends a wonderful day with Monica, who tells him, before she goes to sleep, that she always loved him. The films ends with a narrative voice saying, "David falls asleep as well and goes to the place where dreams are born."

A.I. was greeted with much critical and academic interest, as the film represented the visions of two acclaimed filmmakers, Stanley Kubrick and Steven Spielberg, whose works suggest vastly different film sensibilities. Kubrick's major films, such as *A Clockwork Orange*, *Full Metal Jacket*, and *Eyes Wide Shut*, suggest a dark cinematic view. On the other hand, Spielberg's films, such as *E.T.*, *Hook*, and the *Indiana Jones* franchise, demonstrate a more playful outlook. Although some reviewers, such as Leonard Maltin, wrote that *A.I.* failed to work, most critics responded positively to Spielberg's treatment of Kubrick's idea.

A.I. Artificial Intelligence is an unusual climate change film. The narrative begins after life has been dramatically altered by rising temperatures and rising seas, and humanity finds itself in a precarious situation. It ends with the earth as a frozen ball and humanity extinct; yet, the film has a happy ending. Perhaps it is only in a narrative that combines science fiction and fairy tales that a story about a robot who outlives humanity and then dies can be considered happy.

See also: *Avatar*; *New York 2140*; *Odds against Tomorrow*

Further Reading

Bradshaw, Peter. "A.I. Artificial Intelligence." *The Guardian*. September 20, 2001. Retrieved January 30, 2021. https://www.theguardian.com/film/2001/sep/21/1

Ebert, Roger. "He Just Wanted to Become a Real Boy." RogerEbert.com. July 7, 2011. Retrieved January 30, 2021. https://www.rogerebert.com/reviews/great-movie-ai-artificial-intelligence-2001

Morris, Nigel. *The Cinema of Steven Spielberg: Empire of Light*. London: Wallflower Press, 2007.

ALWAYS NORTH

Always North (2019) is a climate change novel by Scottish writer Vicki Jarrett. It begins with an illegal search for undersea oil resources in the Arctic Sea after the Arctic Protection Agreement of 2020 banned all oil and gas exploration and drilling in the area. However, as the narrator, Isobel, a software engineer, says, "Big oil always finds a way." Despite worldwide protests with people dressed up as polar bears chanting, "Save the Arctic!" and "Save the bears!" exploration continues.

Always North begins as Isobel and Grant, the other engineer on the secret project, board the *Polar Horizon* on the island of Spitsbergen, Norway, home to permanent Arctic research stations from ten countries. Under the cover of being part of an icebreaker development team, the two are paid to perform seismic examinations of a potential oil deposit. As she boards the ship, she introduces herself to the captain by saying, "Call me Isobel," a direct reference to the famous opening line of Herman Melville's *Moby Dick* and an indication to the reader that this will not be an ordinary sea voyage.

As the *Polar Horizon* leaves her home port in Norway, she is joined by an old nuclear-powered Russian icebreaker—now owned by the sponsoring oil company—that has been assigned to assist the ship. In addition, the engineers are warned to look out for polar bears, which are known to board ships in the Arctic from ice floes in search of food. Before the actual surveying begins, the icebreaker must clear a narrow channel for the *Polar Horizon*. The ship's captain sees a huge polar bear following the ship along the ice pack and announces that he knows that bear. He tells Isobel and Grant that years before he and his brother were netting fish as the ice melted when the same bear attacked their small boat, killing the captain's brother and opening up the captain's face like a can of meat paste, leaving a permanent scar. The echoes from *Moby Dick* continue, with a maimed, vengeful captain and a huge force of nature stalking the ship.

As in other successful sailing narratives, the day-to-day operations of the ship provide a background for the characters' interactions. Isobel and Grant take turns monitoring the seismic sweep, the captain follows the icebreaker, and the crew maintains the ship. Isobel begins an affair with the ship's first mate, Jules, and Grant, Isobel's previous lover, sulks. Then the seismic scanners fail. To discover the flaw, Isobel, Jules, and another crewman take a small boat to check the seismic sensors and find one covered with ice. While clearing it, they see a polar bear approaching and soon recognize it as the captain's polar bear. They manage to make the repairs and return to the ship. The next day, they discover the Russian icebreaker has left them, and the *Polar Horizon* soon finds itself caught in the ice. Shortly thereafter, the bear appears again. It kills several crew members, slashes Isobel, and nearly kills the captain.

Always North then shifts twenty years into the future. The date is now 2045, and Isobel is working as a laborer in Scotland, moving government supplies and furniture about, as climate change has wreaked havoc on the world. Ocean rise has destroyed coastal cities, and industries and governments have failed. Migrations and food shortages abound, and gangs roam about searching for anything of value. Isobel carries a scar from the bear's attack. She has little memory of how she returned from the ice jam and spends her nights drinking until she passes out. David, whom she has not seen since the voyage of the

Polar Horizon, appears unexpectedly and offers her a job with a private research firm looking for former seismic engineers. Broke and broken, she accepts.

When Isobel arrives at the secluded research firm's headquarters, she discovers not only high-tech security but also that her job will not be in seismic engineering. Instead, researchers will pay her to undergo several weeks of MRI scanning. After the first week, she discovers that the research firm has tracked down all of the surviving members of the *Polar Horizon's* last voyage and has taken brain scans from all of them. Finally, while she is wandering about the research center, she comes across the bear that had attacked the ship sedated in a glass case hooked up to an MRI machine. Unsettled by the discovery, she leaves the center.

Later, David tracks her down and explains what was going on in the center. One year after the voyage of the *Polar Horizon*, the Arctic ice had disappeared, causing climate change to rapidly accelerate. Members of the research institute believe something happened during the voyage that triggered the catastrophe. Their guess, after reconstruction as much of the voyage as possible, is that something went very wrong with the Russian nuclear icebreaker, which never returned to its home base. They believe it may have sunk and released enough radiation to cause the sudden ice melt. David explains that some members of the research institute have discovered that animals do not experience time, that they live in a constant present. Researchers had hoped that by discovering all the events of the voyage and then linking the brains of one of the humans and the bear, they would be able to go back in time to undo what had been done. If successful, they would then be able to work to seriously combat climate change. So far, no link had proven successful. Isobel, only half believing what she has heard, agrees to return to the research institute and be linked up with the bear. The novel ends as the link up occurs.

Always North, which begins as an homage to *Moby Dick*, ends up as a prose version of *12 Monkeys* (1996), Terry Gilliam's acclaimed science fiction thriller in which Bruce Willis is sent into the past in an attempt to stop the spread of a virus that had wiped out much of humanity in the future. Despite the change in genre halfway through the novel, *Always North* works for a number of reasons. First, by referencing *Moby Dick*, in which the white whale is more than a white whale, Jarrett prepares the reader for a polar bear that will be far more than a polar bear. In addition, by suggesting that time travel may be the only way to reverse the inevitability of climate change, Jarrett is undercutting the hope that somehow science will come up with a magic bullet or amazing new technology that will allow humanity to continue to live extravagantly without costs to the environment. Finally, Jarret is insightful in creating Isobel, the narrator and central character in the novel. Isobel, as well as David and the people behind the seismic exploration for more oil, has no moral sense about her complicity

in climate change and her willingness to take part in an illegal and possibly climate-disrupting expedition. At the end of the novel, her acceptance to take part in an experiment linking her with the bear that had mauled her comes about only because there is no alternative. Unlike Ishmael, the narrator in *Moby Dick*, Isobel learns little on her voyage of discovery.

See also: *Colony, The*; *Ever Winter*; *Migrations*; *Moon of the Crusted Snow*; *South Pole Station*

Further Reading

Cade, Victoria. "Always North by Vicki Jarrett." *Strange Horizons*. March 30, 2020.
Roberts, Adam. "Best Science Fiction and Fantasy Books of 2019." *The Guardian*. November 30, 2019.

AMERICAN WAR

American War (2017), a novel written by Omar El Akkad, begins in the year 2074, shortly after catastrophic climate change has raised sea levels enough to obliterate much of southern Louisiana, Mississippi, and Alabama and turn Florida into a string of islands. Continuing climate change catastrophes cause major disruptions in industry, agriculture, and social life. In response to the crisis, the U.S. Congress passes a bill to outlaw the use of fossil fuels. As a result of the perceived usurpation of states' rights and the banning of what has become a beloved car culture, Mississippi, Texas, Alabama, Georgia, South Carolina, and what is left of Louisiana secede from the Union—again. The result is a second American Civil War, the subject of Akkad's dystopian novel.

Unlike most popular histories of the American Civil War (1861–1865), which tend to be descriptions of major battles or analysis of issues of race and slavery, *American War* focuses on the fortunes of one family, the interracial Chestnuts of Louisiana, and their experiences during the war. The result is a narrative that forces readers to look at the American experience in a new light, one that questions American exceptionalism, the belief that American values, political systems, and experiences are unique in world history and worthy of emulation. Instead, *American War* suggests that the United States will confront the disasters of climate change in the same manner as other countries, poorly.

As the novel opens, the new civil war has evolved into a stalemate. Climate change has decimated industry in both the North and South, and upon southern secession, the North launches a chemical attack on South Carolina, causing those infected to acquire the "slows," a rapidly spreading disease that slows metabolism, making it impossible for the infected to do more than barely move. The states surrounding South Carolina build a concrete wall around the infected area, trying to contain its spread. Most of Texas is reconquered by

Mexico. The North makes raids on the South through Tennessee and blockades the new southern ports—the old ports of Mobile, New Orleans, Wilmington, and Savanah now being underwater—as it had during the First Civil War.

The novel is told from the point of view of Sarat Chestnut, whose father died looking for work in Baton Rouge, Louisiana. Because of climate change, little industry remains in the South, and agriculture has been disrupted by drought and other severe weather. It is clear that in the post–climate change world, some political entities prosper while others do not. Sarat and her family—which includes her mother; her brother, Simon; and her fraternal twin sister, Dana—are sent to Camp Patience, a large refugee encampment along the Georgia-Tennessee border. They spend six years in the camp, and much of the novel describes political refugee life and the growing radicalization of Sarat and her family. Forced to live in overcrowded makeshift housing with poor sanitation and food provided by international aid organizations, Sarat develops a hatred for all things Northern.

Akkad models his detention camp on those in the Middle East, and like them, Camp Patience is fertile ground for radical political and military recruiters. Sarat meets Albert Gaines, a sometime recruiter for the Bouazizi Empire. After five failed Arab Springs, an Islamic Revolution swept through the Middle East and North Africa, creating a strong and unified Islamic political entity. Gaines and a Bouazizi agent named Joe direct medical and food aid from the International Red Crescent in addition to recruiting agents; they hope to keep the United States divided and weak. Sarat becomes a runner in the camp, providing funds and information to others, and after a Northern attack on the camp that kills her mother and badly injures her brother, she agrees to be trained as a sniper.

Joe provides Sarat with information that a high-ranking Northern general will be visiting the Northern soldiers at the Georgia-Tennessee border. She waits in ambush for two days before he arrives and then she kills him. Afterward, she is spirited away from Camp Patience. Sarat is considered a hero in the South, but the assassination hardens the North's determination to fight. Albert Gaines turns out to be a double agent and informs Northern spies of Sarat's whereabouts. She is captured and taken to a prison island in what was once Florida, now a dangerous shallow sea because of ocean rise, where she spends the next seven years.

Akkad based his descriptions of detention experiences on reports of the American treatment of detainees after the Gulf War. In fact, Sarat's experience would be recognizable to anyone familiar with the U.S. detention center at Guantanamo Bay. Considered a terrorist by Northern authorities, not a combatant, Sarat is subjected to a variety of forms of enhanced interrogation, including sensory deprivation, solitary confinement, and eventually waterboarding.

After the waterboarding, she confesses to everything she is accused of, whether guilty or not. She is eventually released.

After her release, Sarat is reunited with her younger brother and his family, who have been provided with a stipend because of Sarat's services to the South. She lives in a small one-room house behind the family home, where she writes in her diary daily and refuses to take part in the family's life.

Peace talks are eventually planned between the North and South, both sides having used up most of their industrial and military resources as well as much of their ability to command or control their armies. For example, the drones the North had been using during the war now fly without guidance controls, dropping bombs randomly. A reunification plan is finally accepted in which neither side claims victory.

Joe, the agent from the Bouazizi Empire, visits Sarat one more time and asks whether she has forgiven her old enemies. When she says she has not, Joe offers her a last opportunity to serve the southern cause and provides her with a deadly virus to release at the reconciliation signing in Columbus, Ohio, the North's capital, Washington, DC, having been long inundated by sea rise. Sarat travels to Columbus and releases the virus, which rapidly spreads throughout the North and the South, killing millions of people on both sides.

American War ends years later with Sarat's nephew Benjamin writing from the Free City of New Anchorage in what was formerly Alaska. He discovers his aunt's diaries and learns of her life during the Second Civil War. Appalled by her actions, which resulted in the deaths of millions, he destroys the diary, keeping one page in her memory.

American War is a disquieting novel. By its nature, dystopian climate change fiction is bleak, but often in formulaic ways. Climate fiction often depicts catastrophic environmental disasters; ocean rise and massive hurricane scenarios have become almost standard elements of the new environmental disaster fiction. Courageous heroes facing hunger from food shortages as well as infrastructure damaged by wind and water are also standard. Omar El Akkad's novel is disturbing in a different way.

In *American War*, the United States, the most powerful first world state in the world, is reduced to third world status by environmental disasters and political willfulness. Hungry civilian refugees flee war zones and end up in semipermanent relocation camps, which become breeding grounds for terrorists. This is supposed to happen elsewhere, not in the United States. In addition, while the United States is torn apart first by environmental disasters and then by a civil war provoked by a belated response to climate change, the Islamic nations, having had their wars prior to climate change, unite and become the world's new superpower, providing medical assistance and food in war-torn places around the world.

Omar El Akkad asks readers to examine a post–climate change future and see what American life could be like through the eyes of an angry, war-displaced refugee. He grounds his dystopian climate change novel in American history by not only repeating the geography and history of the American Civil War but also by linking the names of his characters to actual historical figures. Mary Boykin Chestnut is a well-known southern writer who left a diary of her experiences in the South during the Civil War, and Sarat is suggestive of Mary Surratt, the Washington innkeeper convicted of complicity in Lincoln's assassination and executed along with the other conspirators. Akkad's narrative is both peculiarly American and universal and a warning to complacent American readers.

See also: *Orleans*; *Storming the Wall*

Further Reading
Charles, Ron. "'American War' Follows Today's Vitriol to a Dystopian Future." *The Washington Post*. April 3, 2017.
Hamis, Shadi. "The Lessons of 'American War.'" *The Atlantic*. December 15, 2017.

AVATAR
Avatar (2009) is an American epic science fiction film written, directed, produced by James Cameron and starring Sam Worthington, Zoe Saldana, Stephen Lang, Michelle Rodriguez, and Sigourney Weaver. The film, which combines live action, CGI (computer-generated images) effects, and 3D photography, was an enormous critical and commercial success and became the highest-grossing film at the time of its theatrical run.

The film is an environmental parable in which humanity depletes the earth's natural resources, creating an energy crisis. Earth's Research Development Administration (RDA) discovers unobtanium, a crucial energy source, on Pandora, a habitable moon in the Alpha Centauri system. Unfortunately for the moon's inhabitants, the Na'vi, mining unobtanium will radically change the climate and culture on Pandora.

Avatar opens as Jake Sully, a paraplegic former Marine is awakened from a long journey through space to become an avatar, a human-Na'vi hybrid used by the RDA to explore Pandora. As an avatar, Sully now has use of his legs, and the first part of the film centers on Sully's enjoyment of his new Na'vi body. He is now ten feet tall with blue skin and long, strong fingers. He explores the wonders of Pandora and is accepted as real by the Na'vi. Sully is initiated into Na'vi society after he is befriended by Neytiri, a female Na'vi, on the advice of Neytiri's mother, Mo'at, the Na'vi's spiritual leader.

A narrative is more than beautiful settings, however. Conflicts begin to appear as Colonel Miles Quaritch, the commander of RDA's security force, tells

An *Avatar* character figurine. (Keremgo/Dreamstime.com)

Sully that RDA will provide him with new legs if he discovers information about the Na'vi gathering place, called Hometree, under which is the largest deposit of unobtanium on Pandora. Dr. Grace Augustine, the head of the Avatar Program, has discovered that Pandora has one neural connection connecting all living elements on the moon, including the Na'vi, Hometree, and a mysterious Tree of Souls. In addition, Sully is beginning to fall in love with Neytiri. While living among the Na'vi, Sully realizes that he is more at home among them than he is in his human form. He is initiated into the Na'vi clan, and he and Neytiri choose each other as mates.

Soon both Augustine and Sully are urging RDA to abandon its plans to extract the unobtanium under Hometree. Augustine argues that destroying the Hometree will adversely affect all life on Pandora by disrupting the neural network, and Sully disables a bulldozer sent to destroy a sacred Na'vi site. RDA gives Augustine, who lives on Pandora as an avatar, a last chance to convince the Na'vi to abandon Hometree, but she fails. Jake and Augustine confess that they have been spies, and the Na'vi imprison them.

As often happens when a sacred place of Indigenous people stands in the way the development of natural resources, RDA launches an attack on Hometree with the intent of mining the unobtanium beneath it and kills many Na'vi in the process. Augustine and Sully are taken by RDA security and separated from their avatars. They are helped to escape by one of RDA's pilots, who was disturbed by the company's brutality to the Na'vi. Augustine is wounded during the escape.

To regain the trust of the Na'vi and help them, Sully, using avatar technology, connects his mind to a toruk, a dragon-like creature feared and respected by the Na'vi. Sully pleads with the Na'vi to help return Augustine to her Na'vi body using the power of the Tree of Souls, but Augustine dies. Sully convinces the various Na'vi clans to join in a battle against the RDA security forces.

In the battle at the Tree of Souls, the heavily armed security forces nearly destroy the Na'vi clans. However, in the midst of the battle, the animals of

Pandora join the attack on the humans and together with the surviving Na'vi defeat them. Colonel Quaritch attempts to kill Sully by separating him from his avatar, but Neytiri kills Quaritch. Except for Sully and a few others, the humans are expelled from Pandora. The film ends as Sully is reunited with his Na'vi body with the assistance of the Tree of Souls, and as in all good fairy tales, Sully and Neytiri plan to live happily ever after.

The basic storyline of *Avatar* was familiar to most viewers, as it is essentially the reimagining of the European colonization of the Americas with a different ending. Although distancing viewers by using the conventions of fantasy and science fiction, James Cameron tells the story of how a technologically advanced civilization discovers a new world rich in natural resources and attempts to take possession of those resources, even if it means the destruction of the culture of those who live there and the devastation of their environment. From the point of view of the colonizers, genocide may be the price to be paid for profits.

Avatar is also a story about the willingness of corporations to engage in activities that cause major changes in the climate if the economic stakes are high enough. Cameron clearly sets up his narrative to be critical of the RDA and its security force, as he depicts it as a cold, ruthless corporate entity. The Na'vi, on the other hand, although depicted as "primitive" by their clan social structure and archaic weaponry, recognize that they are part of something larger than themselves. In fact, *Avatar* may be an example of the Gaia hypothesis, James Lovelock's theory that all living matter on the earth, or in this case Pandora, defines and regulates the material conditions necessary for the continuance of life. The planet, or the biosphere, is likened to a living organism.

Most of the critical response to *Avatar* focused on Cameron's cinematic achievement in creating a 3D film with enhanced computer graphics that were well suited for the story being told. The film's anti-colonial and pro environmental stances were noted, however. Most critics applauded the film's political stance, but some did not. Russell D. Moore of the *Christian Post*, for example, pointed out that much of the film was propaganda, and Michael Phillips of the *Chicago Tribune* wrote that the film was "the season's ideological Rorschach blot."

Avatar eventually become the second highest-grossing film of all time, earning over $3 billion, second only to *Gone with the Wind*, when that film's gross is adjusted for inflation. Although the film is clearly about the impact of human activity on the destruction of the environment, the root cause of climate change, Cameron's environmental, anti-colonial message may have gotten lost in the spectacle for some viewers.

See also: *A.I. Artificial Intelligence*; *WALL-E*

Further Reading

Armstrong, Jeffrey. *Spiritual Teachings of the Avatar: Ancient Wisdom for a New World.* New York: Atria Books, 2010.

Cameron, James, and Suzy Amis Cameron. "Animal Agriculture Is Choking the Earth and Making Us Sick. We Must Act Now!" *The Guardian.* December 4, 2017.

Huver, Scott. "James Cameron Wants His *Avatar* Sequels to Inspire Environmental Activism: 'Climate Change Is Happening Right Now.'" *People.* November 16, 2016.

B

BARKSKINS

Barkskins (2016) is a novel by American writer Annie Proulx, author of the successful and critically acclaimed novel *The Shipping News* (1993), which won the Pulitzer Prize for Fiction, and "Brokeback Mountain" (1997), which appeared in the *New Yorker*, won the National Magazine Award for Fiction in 1998, and was made into an Academy Award–winning film directed by Ang Lee in 2005. Proulx is known as an environmentalist, and *Barkskins* is a 736-page historical novel in which human beings interact and destroy the environment from the seventeenth century to the present. The novel follows two French indentured servants, who immigrate to Canada to work cutting trees, and their descendants for over three centuries. *Barkskins* details how human interaction and the desire for profits have destroyed the once pristine New World landscape and led to climate change and ecological disasters.

Barkskins begins with two poor Frenchmen, Charles Duquet and René Sel, arriving in New France as indentured servants to landowner Claude Trépagny, who puts them to work clearing land as woodcutters, or barkskins. The forest is so thick that Trépagny believes it will take the two or three years to clear the land for his house and garden, after which he will give each barkskin land of their own to clear. Daunted by the task, Duquet runs off, planning to make money as a fur trapper, while Sel remains, eventually marrying Trépagny's first wife, a Mi'kmaq, or Native American, woman. Duquet succeeds in escaping and makes a fortune trapping furs and selling timber, eventually going to Holland to establish shipping connections for his growing business. While there, he marries his partner's daughter and adopts two sons to carry on his business. He also establishes an office in Boston and changes his family name to Duke. Sel, on the other hand, remains a woodcutter. His children remain with him and become woodcutters themselves and part of the Mi'kmaq people.

Duquet's adopted sons buy timber and sawmills in Maine, where fortunes can be made, as the timber is plentiful and ownership rights are seldom observed. Proulx describes the cutthroat lumber business as a free for all, with absentee landowners unable or unwilling to control their workers or their timber. Duquet's sons remain on good terms with both the French and British before and during the French and Indian War. As a result, their business prospers, and the Duke heirs become wealthy.

Sel's children marry into Mi'kmaq families, and their children become wood-cutters as well, working throughout Maine and Eastern Canada. Because of their mixed-race heritage, the Sels are often caught between two worlds and remain working class. One son is injured cutting trees and ends up as a camp cook. Another gains a reputation as an excellent woodcutter. Proulx follows the two families for three centuries as they both remain engaged in the forestry business, the Sels as laborers in the industry and the Dukes as owners of lumber and shipping companies.

One theme that runs throughout the novel is the increasing impact of the harvesting of trees on the environment. As decades pass, the Duke family acquires wealth; the Sel family works in dangerous logging jobs, often being maimed or killed; and the New England forest is destroyed. Both the Dukes and the Sels, owners and workers, then move to the Carolinas and to Michigan to harvest trees, again changing the face of the environment as they develop and use news methods of harvesting wood, including clear-cutting and burning, to turn unwanted timberland into farmland.

The search for profits and the search for work take the Sel and Duke descendants around the world. In the early twentieth century, Charley Duke, the last descendant of Charles Duquet, travels to Brazil to study the impact of growing commercialization, burning, and logging in the Brazilian rain forest. He is appalled by what he discovers happening and becomes an avid conservationist. The Duke forestry business had been destroyed in the Great Depression, but Charley Duke establishes a trust for the reforestation of former woodlands and the study of the ecological impact of industrialization and climate change. The Sel descendants also travel, with some of them eventually settling in Australia, where they work in the forestry industry. Their descendants become interested in conservation.

The Sel and Duquet descendants eventually reunite, as several of the contemporary Sels apply for and receive grants to work for Charley Duke's Trust and assist in studying the impact of climate change on the environment as well as examining potential new uses for rare Brazilian rain forest plants. The novel ends with the hope that through reforestation and an awareness of the importance of the environment, some of the worst effects of climate change might be addressed. That hope, however, is balanced by the 300 years of exploitation of the wilderness described in *Barkskins*.

In 2020, an eight-episode television adaptation of *Barkskins* premiered on the National Geographic network. The adaptation, created and produced by Elwood Reid and distributed by Disney-ABC Television, stars Aneurin Barnard, Christian Cooke, David Thewlis, David Wilmot, James Bloor, and Kaniehtiio Horn. A second season was planned for release in 2021.

Barkskins is an epic novel in both length and scope. Proulx is especially effective in the early sections of the novel when Sel and Duquet arrive in

New France. Both the almost limitless natural resources they discover and the immensity of the work they face are carefully created. In addition, Proulx effortlessly describes Duquet's machinations in establishing his timber company and Sel's willingness to immerse himself in Native American culture and the difficult and dangerous work he undertakes. The choices the progenitors of the two families make determine the lives of those that follow them. The most significant aspect of *Barkskins*, however, is the overriding sense of the continual destruction of a seemingly endless resource. The destruction caused by climate change, Proulx suggests, began long before the beginning of the Industrial Revolution. In *Barkskins*, it began when Charles Duquet realized he could have an easier life if he exploited the environment rather than coexisted with it.

See also: *Friend of the Earth, A*; *Marrow Thieves, The*; *Moon of the Crusted Snow*; *Overstory, The*

Further Reading

Levine, Janet. "Barkskins: A Novel." *New York Journal of Books.* June 13, 2016.

Quinn, Annalisa. "Annie Proulx's 'Barkskins' Is Lovely, Dark, and Deep." NPR. June 18, 2016.

BLACKFISH CITY

In *Blackfish City* (2018), author Sam J. Miller presents a picture of life after climate change and the ensuing chaos that has rendered nation-states obsolete, destroyed the world's social and economic networks, and killed millions of people. It is a dystopian novel, a popular literary genre in which the author takes contemporary social, political, and economic problems and extrapolates them to the extreme, often in a future setting. Dystopias are by their nature both conflict- and action-driven narratives as well as stories with warnings; if the problem, in this case climate change, is not addressed, disasters such as famine, war, floods, and pandemics lie ahead.

Blackfish City is set in the North Atlantic Ocean on the floating city of Qaanaaq after a climate change catastrophe that caused a worldwide political, social, and economic collapse. Additionally, an outbreak of an AIDS-like disease that causes "the breaks" has occurred, a sexually transmitted infection that results in both mental and physical deterioration. As a result, borders collapsed, cities were flooded, governments failed, and an international refugee crisis was created as refugees sought shelter wherever they could find it, including creating a makeshift city near the Arctic Circle. Told from multiple points of view in a futuristic dialect of English, *Blackfish City* follows the interactions of a small number of characters whose paths cross as the refugee-filled city reaches its breaking point.

The city of Qaanaaq is itself an essential character. Constructed near the Arctic Circle on eight spokes and anchored above thermal vents in the seabed that allow steam to rise to provide heat and energy for the city, Qaanaaq is a city of refugees from the climate crisis. Some residents are extremely rich and own multiple housing units and actual shares of the city itself, while others cram into cardboard boxes built around heating vents. As the city sits in international waters, no foreign government controls or assists the city. Instead, order—what little there is in the city—is enforced by gangs, many of which are controlled by wealthy shareholders.

As the novel begins, the city has reached a breaking point. It is overcrowded with refugees and short on food, housing, and clothing. The underground periodical *The City without a Map*, a subversive electronic journal that people can download through their nano implants, circulates, and power alliances within the city shift and break down as Masaaraq, a mysterious warrior woman with an orca in tow, begins to destabilize the already troubled floating city.

The novel follows the major characters—Masaaraq; Kaev, a professional fighter; Dao, a gang lord bent on taking over a shareholder's position of power; Soq, a messenger for Go; Ankit, a political canvas worker; Fill, a rich, aimless gay young man; and Pudlove, a former New York City real estate tycoon and shareholder—as their lives interact and influence each other. Go launches an attack on Pudlove to take control of his share of the city; Fill gives Soq "the breaks"; Soq, Ankit, and Kaev turn out to be related; and Masaaraq, who is actually their mother, assassinates people as she searches for her own mother, who is being held in a mental hospital while she edits *The City without a Map* and attempts to subvert the shareholders' control of the city. When she eventually gets her family together, Masaaraq explains that as climate change accelerated, causing rising sea levels, extreme weather, environmental degradation, mass migration, and pandemics, state-sponsored scientists experimented with nanotechnology on humans, one result of which was "the breaks." In an effort to halt the spread of this human-made pandemic, governments attempted to kill all of the unwitting human subjects of the nanoexperimentation. However, a few survived, including Masaaraq and her mother. They discovered that "the breaks" was only the first reaction to the nanoexperimentation; a second possibility was the ability to form a symbiotic bond with an animal—in Masaaraq's case, an orca—and in that symbiotic relationship, a potential for a new beginning and survival for humanity might exist. Masaaraq and her family then lead an attempt to take over the city, but whether the attempt is successful is left unanswered.

In *Storming the Wall: Climate Change, Migration, and Homeland Security* (2017), journalist Todd Miller argues that governments around the world have been aware of and preparing for the interconnectivity of climate change, economic

disruption, disease, civil unrest, and migration. He asserts that despite public pronouncements to the contrary, there is widespread recognition among senior decision makers that climate change is an ongoing event and that the results of climate change will have dramatic worldwide impact.

Blackfish City is not the first novel to explore survivors of an apocalyptic event. Stephen King's *The Stand* (1978) and Cormac McCarthy's *The Road* (2006) are just two of the many popular modern American dystopias that came before it. Nor is *Blackfish City* the first novel to place partial blame for humanity's woes on human activity, here specifically corporate capitalists and compliant governments who refuse to respond to the challenges of climate change and the resulting social and economic chaos. Nevertheless, Sam J. Miller's novel is a success. Miller avoids the trap of having heroes who save the day. His characters are all flawed but engaging. The city itself, with its carefully manufactured grid base floating over thermal vents in a rising sea with a superstructure constructed of plastic and cardboard, is a wonder. Fantastic as the novel is, with its human-animal symbiosis, pandemic-ridden characters, and ravaged environment, it is only somewhat removed from what might actually occur, as climate change, global warming, and the resulting political, social, and economic damage remain an existential challenge, according to scientists.

See also: *Drowned World, The*; *Flood*; *Road, The*; *Storming the Wall*

Further Reading

Mehnert, Antonia. *Climate Change Fictions: Representations of Global Warming in American Literature.* New York: Palgrave MacMillan, 2016.

Trexler, Adam. *Anthropocene Fictions: The Novel in a Time of Climate Change.* Charlottesville: University of Virginia Press, 2015.

BLADE RUNNER

Blade Runner is a science fiction film that was originally released in 1982 and distributed by Warner Bros. The film was directed by Ridley Scott and stars Harrison Ford, Rutger Hauer, Sean Young, and Edward James Olmos. It was edited and rereleased as the *Blade Runner: Director's Cut* in 1992 with significant changes, including the deletion of a voice-over narration track and the cutting of the studio-imposed happy ending. The 1992 director's cut is generally considered one of the finest science fiction films ever made, and it is also one of the first Hollywood films to examine the impact of climate change.

Blade Runner was adapted from Philip K. Dick's novel *Do Androids Dream of Electric Sheep?* (1968) that is set in postapocalyptic San Francisco after a nuclear war in which almost all humans and animals have become sterile because of nuclear radiation. In *Blade Runner*, set in Los Angeles, the earth is equally

The decaying Bradbury Building interior, as seen in the movie *Blade Runner*. (RemusM/Dreamstime
.com)

devastated, but the cause of the environmental degradation is never directly
linked to nuclear war. Instead, through the opening sequence, director Rid-
ley Scott suggests that a more general ecological catastrophe has taken place,
resulting in a dramatic change in the earth's climate.

Blade Runner employs a film noir plot in a science fiction setting. *Film noir*
can be defined as a type of detective or thriller film in which a mood of pessi-
mism, despair, fatalism, and menace predominate. In addition, most film noir
movies feature a flawed protagonist, often a detective, and a femme fatale, an
attractive and seductive woman who brings disaster to the man attracted to her.
Film noir, usually shot in black-and-white, was popular in the late 1940s and
early 1950s and includes such titles as *The Maltese Falcon*, *Double Indemnity*,
and *Touch of Evil*. The success of *Blade Runner* and other films, such as *China-
town* and *The Long Goodbye*, helped established the genre of neo-noir, which
has remained popular.

In *Blade Runner*, Harrison Ford plays Rick Deckard, whose job as a "blade
runner" is to track down and eliminate replicants, or bioengineered human-
oids. The police hire him to find and retire four replicants who have returned
to earth illegally. Because Earth's environment has been destroyed, much of
humanity has immigrated to space, leaving only the genetically damaged and
those unwilling to leave on earth. Replicants were created to serve as soldiers

and workers "off-world" and were given more strength and agility than humans but a shorter life span. The problem is that replicants have become so advanced that it is difficult to tell them apart from humans, except by an empathy test, and the fear is that replicants may be developing empathy, as they have been implanted with false memories so that they might develop empathy with humans.

The plot of the film follows the traditional film noir pattern. To discover the nature of the advanced replicants, Deckard visits Eldon Tyrell (Joe Turkel), the creator of the replicants, who lives on top of a gigantic pyramid, the only building above the pollution hugging the earth's surface. There he meets Tyrell's niece Rachael (Sean Young), who Deckard discovers is a replicant, yet he becomes infatuated with her. Tyrell informs him of the identities of the replicants: Leon (Brion James), a laborer; Pris (Daryl Hannah), a basic pleasure model; Zhora (Joanna Cassidy), an assassin; and Roy Batty (Rutger Hauer), a soldier. Deckard then begins to hunt them down.

Deckard identifies Zhora and Leon relatively easily, although eliminating them proves difficult. Before Deckard begins to hunt Pris and Batty, Batty confronts Tyrell, his maker, and demands more life. Tyrell tells Batty that the replicants were made to be the best they could be and that it was beyond his ability to give them longer life spans. Angered, Batty kills his maker. Deckard tracks Pris to an almost empty apartment building in which J. R. Sebastian (William Sanderson), a genetic designer suffering from a premature aging disorder, lives. Deckard eliminates Pris just before Batty appears and confronts Deckard. Batty escapes and is pursued by Deckard through the building, which like the city around it is suffering from decay and neglect. As Deckard follows Batty through empty apartments with broken windows, peeling wallpaper, and broken water pipes, the question is, who is the hunter and who is the hunted?

Eventually, Batty chases Deckard to the rooftop of the apartment building and corners him at the edge of the building. Attempting to escape, Deckard jumps to an adjoining roof, but he misses and ends up hanging from the roof. Inexplicitly, Batty saves him and tells him about the experiences he has seen off-world before announcing, "Time to die," which he then does. Shaken by both his own near death and Batty's act of empathy, Deckard returns to his apartment, where he tells Gaff (Edward James Olmos), a policeman who had been following him, that his job is finished. Gaff reminds him that Rachael still lives. Gaff is aware of Deckard's feelings for Rachael and tells him, "Too bad she won't live, but then again, who does?"

In the original 1982 release of the film, the final scene shows Rachael and Deckard in a forest, somehow free of the environmental destruction seen in the rest of the film. The implication is that they have escaped and will live, at least for a time, happily ever after. In the 1992 director's cut, however, that scene in

omitted, leaving a far more ambiguous ending that is more in keeping with the tone and action of the entire film.

Several themes associated with climate change narratives are central to *Blade Runner*. The most obvious is the depiction of the environment in the film's setting. The movie opens with a panoramic shot of the sky above Los Angeles. The sky is cloudy with streaks of red. Huge towers belch smoke and flames from gas and chemical burn offs. The camera tilts lower beneath the clouds to a crowded urban street scene in which people, many with masks, scurry through a continuous drizzle. Above them, a blimp floats by advertising the "good life in the colonies off-world." The earth's atmosphere has clearly been altered for the worse in *Blade Runner*, as have the lives of the people remaining. Mirroring the deteriorating atmosphere is the Yukon Hotel, the home of J. R. Sebastian and the site of Deckard's confrontation with Roy Batty. The once fine hotel is a moldy, wet wreck, complete with broken windows, rotting floors, and trash-strewn corridors. It appears as if entropy has triumphed over humanity's best intentions there.

Another indication of the impact on the environment is the almost complete absence of animal life. Except for the pigeons, who like rats and cockroaches might survive an apocalypse, that inhabit the Yukon Hotel, all the animals in the film are replicants, as Deckard is told that both snakes and owls, significant to the plot, are now extinct. The implication is that humans may soon be as well.

Another element that often appears in a number of dystopian and climate change narratives is bioengineering. In Nancy Kress's *Sea Change*, for example, bioengineering is seen as the cause of famine, as out-of-control genetic engineering caused the loss of essential plant and animal life. In *Blade Runner*, genetic engineering is central to the narrative, as the creation of replicants was necessary for human survival off-world, but the replicants' return created the problem of discerning and deciding who is human and who is not. The concern over what makes one human is even more crucial in *Do Androids Dream of Electric Sheep?*, where everyone in the novel, including the protagonist, is suspected of being a replicant.

Another obvious climate change trope is the escape to the off-world colonies. The destruction of Earth's environment and the necessity of fleeing into space is an idea used in a number of other science fiction disaster narratives, including Stephen Baxter's *Ark* and Pixar and Disney's *WALL-E*. In contrast to those and similar narratives that explore what life is like for the remnant of humanity that survives, *Blade Runner* is centered on the lives of those who were not able to "escape to the good life in the off-world colonies." It focuses on the problems of those who were forced or who have chosen to remain in their ruined home world.

Given both the popularity of *Blade Runner* and its obvious connections to both climate change and environmental degradation, it is not surprising to find a number of critics who use it as an illustrative example of climate change. Writing for the BBC on November 11, 2019, David Barnett asks the question, "Are We Living in a *Blade Runner* World?" He answers affirmatively, noting that "*Blade Runner* is no longer science fiction. It's a contemporary thriller." He points to both the environmental and technological concerns in the film that were once considered futuristic but are now quite real. Equally insightful is Mary Jenkin's 1997 article "The Dystopian World of *Blade Runner*: An Ecofeminist Perspective." Jenkins notes that the film's setting is a "'silent spring' of a post-nuclear, polluted, overpopulated world coming to its end." This could be a fit description of many climate change narratives.

See also: *A.I. Artificial Intelligence; Blackfish City; Chinatown; Lathe of Heaven, The; Orleans; Sherwood Nation; WALL-E*

Further Reading

Barnett, David. "Are We Living in a *Blade Runner* World?" BBC. November 11, 2019. Retrieved October 2, 2020. https://www.bbc.com/culture/article/20191111-are-we-living-in-a-blade-runner-world

Dick, Philip K. *Do Androids Dream of Electric Sheep*. New York: Doubleday, 1968.

Jenkins, Mary. "The Dystopian World of *Blade Runner*: An Ecofeminist Perspective." *Trumpeter* 14, no. 4 (1997). Retrieved October 2, 2020. http://trumpeter.athabascau.ca/index.php/trumpet/article/view/172/210

Newton, Michael. "Why *Blade Runner* Is a Timeless Film." *The Guardian*. March 14, 2015. Retrieved October 2, 2020. https://www.theguardian.com/film/2015/mar/14/why-blade-runner-is-timeless

BRIDGE 108

Bridge 108 (2019) is a dystopian climate change novel written by Arthur C. Clarke Award–winning novelist Anne Charnock. Mass migration is one of the results of climate change that can be observed today. Tens of thousands of people are fleeing drought-stricken areas in northern Africa and the Near East and heading to Europe. Failing crops in Central America are causing thousands to head north through Mexico to the southern border of the United States. Each year, floods inundate Bangladesh, causing a migrant influx in India. In the United States, in 2005, tens of thousands of climate refugees fled Louisiana after Hurricane Katrina to Houston and other cities in Texas. In *Bridge 108*, Charnock follows Caleb, a climate refugee from Spain, as he heads to what he hopes is a better life in England.

Caleb is a twelve-year-old living in Spain as the novel begins. Spain is in the midst of a climate change–induced drought, as is much of southern Europe, causing millions of refugees to seek better living conditions in other, more northern, countries. Caleb's father has left ahead of Caleb and his mother to find a way to reach England, where the family believes they will find asylum and work. Soon, however, he stops writing. Caleb and his mother begin their journey through France, where they move from refugee camp to refugee camp. Along the way, Caleb's mother disappears, leaving Caleb to make his way to the coast of France, where he finds that England is not accepting refugees. Caleb then experiences the fate of many migrants today who are living in refugee camps and unable to cross a border to find work. He meets a human trafficker, however, and is smuggled into England, where he is put to work making clothes out of recycled material for Ma Lexie, a widow who runs a clothing stall for her criminal family using smuggled migrants for labor.

At first, Celeb prospers in his new environment. He is grateful to be in England and grateful to have a home that is not a migrant camp. Although living in a rooftop shed, Caleb works hard, and Ma Lexie discovers he has a talent for sewing. He is soon supervising other young climate migrants, and he comes up with his own design for making pants out of the scraps taken from recycling bins. One day, after helping Odette, another rooftop refugee, he decides to run away with her, and together they leave the slums outside of Manchester and head into the countryside. When Odette realizes Caleb is only twelve, she leaves him. Caleb, lying about his age and his immigration status, takes a job picking fruit.

In his new situation, Caleb again works hard. He is wary of strangers and keeps watch for immigration agents. He keeps to himself until he is befriended by an older migrant named Jasper. At the farm, he learns that if he is caught by immigration authorities, he should tell them that his parents are most likely dead and that he is an orphan. By doing, so he will not be sent back to Spain but rather put in a camp for undocumented migrants, and if he works hard and takes citizenship and English language classes, there is a chance he would be permitted to stay in the country once he reaches the age of twenty-five. When the farm where Caleb has been working is raided by immigration agents, Jasper and Caleb flee. Eventually they come to bridge number 108, and while spending the night beneath it, Caleb tells Jasper the story of his life and that he has no desire to spend the next thirteen years as an indentured laborer. Jasper, however, turns out to be an undercover immigration agent, and using what he learned from Caleb, he arrests most of the people who have helped him. Caleb is sent to one of the industrial fish farms where tilapia is raised to provide food for the British market.

The next chapter begins four years after Caleb's arrest. Again, he has been industrious. He has excelled in his classes and become an essential part of the

fish farm's labor force, having developed more efficient ways of feeding the tilapia grown in large tanks. He has grown accustomed to his work and resigned to that fact that he will work at the fish farm for nine more years before having a chance at staying in England. That fate, he believes, is better than being returned to Spain to starve, as the drought has continued, making life almost impossible and creating ever more climate migrants.

To help combat undocumented migrants from entering the country, British immigration services had instituted a policy of taking DNA samples from everyone entering the country. Once inside the system, Caleb maintained that he was an orphan, and it was only as an orphan that he was permitted to stay and work as a laborer at the fish farm. However, one day he is called into the fish farm's supervisor's office, where an immigration agent informs him that his mother has been found through a DNA match. When Officer Sonia informs Caleb and shows him a picture of his mother, he barely recognizes her. She tells him that he should be happy to be reunited with his family, but he knows that he has lost his orphan status and will be returned to Spain with his mother. When the fish farm's superintendent asks Officer Sonia to make an exception because Caleb has become an indispensable worker, he is told that no indentured laborers are indispensable.

Caleb has been working at the fish farm for four years, however, and had already had a plan to get out if he were cornered. He knows that there are no guards where the fish trucks are loaded and that no one checks the contents of the refrigerated trucks as they leave the farm. He hides in the back of a truck full of frozen fish, and once outside the gates of the farm, he escapes. Knowing that there is only one potentially safe place for him, he returns to the slums outside of Manchester. There he waits for Ma Lexie to open her clothing stall, and when he shows himself and sees her smile, he approaches, ready to take up his old job of turning refuse into clothing.

Bridge 108 is set in a world not much different from today. Climate change has increased, bringing drought to more parts of the world, southern Europe in this novel, but the impact of global warming is a matter of degree, not kind. Refugees from droughts and wars, often the result of conflicts over scarce resources, are already moving through Europe, Central America, and Mexico, taxing resources along the way and creating nativist responses and calls for stricter immigration laws and the construction of walls. Despite his experiences as a trafficked immigrant and an indentured laborer, Caleb is lucky compared to many climate refugees—he survives.

Anne Charnock manages to make Caleb a sympathetic character without turning him into a twenty-first-century Oliver Twist. There are no real villains in *Bridge 108*. Ma Lexie, immigration officers Sonia and Japer, and the fish farm supervisor are all doing their jobs, and none are especially cruel Caleb.

They also get to tell their own stories, as Charnock switches points of view from Caleb to those he encounters. Each of the characters is doing what he or she thinks he or she must do to survive in a world feeling the effects of climate change. In her book *Field Notes from a Catastrophe*, Elizabeth Kolbert observes that climate change migration may be one of the earliest signs that climate change has approached its tipping point. *Bridge 108* suggests that it may already have.

See also: *Field Notes from a Catastrophe*; *Ministry for the Future, The*; *Wall, The*; *Water Knife, The*

Further Reading

Brown, Eric. "The Best Science Fiction and Fantasy." *The Guardian*. February 27, 2020.
Ghosh, Amitov. *The Great Derangement: Climate Change and the Unthinkable*. Chicago: University of Chicago Press, 2016.

BURNING WORLD, THE

The Burning World (1964), retitled *The Drought* in 1965, is the third in a series of four environmental disaster novels by British author J. G. Ballard, who is best known for his semi-autobiographical novel *Empire of the Sun* and *Crash*, a novel about the psychological attraction of car crashes made into a feature film by David Cronenberg in 1996. In the series, Ballard employs the conventions of the British science fiction adventure narrative made popular by H. G. Wells and H. Rider Haggard to examine issues of climate change and its effects on human behavior. Wells and Haggard employed strong and intelligent protagonists forced to make moral choices in exotic environments. All of Ballard's early novels are variations on that theme.

The Burning World may be the most realistic of Ballard's environmental apocalypses. Increased drought, both in intensity and in scope, has been linked to climate change, and parts of the American West and Central America are suffering from a series of drought years. Even with predicted sea rise and increased storm activity, drought may be the first long-term effect of climate change to impact the lives of tens of thousands of people.

In *The Burning World*, Dr. Charles Ransom is a self-isolating protagonist. He is estranged from his wife, distant with the people he cares for, and lives by himself on a houseboat on a lake that has been growing smaller and shallower as the river feeding it dries up. One of the causes of the worldwide drought is the near total pollution of the world's oceans, which has inhibited evaporation and disrupted the ocean and air currents. While the world outside slowly contracts in the heat, Ballard focuses the first part of the novel on Ransom and his small community of town of Hamilton. Ransom watches as the shrinking lake

first impacts the lives of the fishermen who make a living from it, eventually causing them to leave in search of a new river, and then the people of the community who derive their drinking water from it.

The people of Hamilton respond to the drought in different ways. Some leave, following rumors of water in other parts of the unnamed country. A traveling evangelist arrives with a band of followers, preaching that the drought is a punishment for humanity's sins, and some people follow him into the expanding desert. The rich stockpile water and hoard it. Some simply give up and die. Ransom himself remains on his houseboat on the shrinking lake, only leaving to care for the sick. His trips are a distraction from his observation of and fascination with the growing drought, which he finds strangely beautiful.

Eventually, Ransom realizes that Hamilton has been forgotten by whatever government might still exist, and no one is coming to help. Accepting the inevitable, he leads a group of survivors on a journey across what was once farmland and is now desert to the coast, where rumors suggest that the military has set up desalinization plants and is providing water for refugees. When Ransom and his band of survivors arrive, they discover that tens of thousands of people have come to the shore before them, the desalinization plants are hopelessly inadequate to meet the needs of the refugees, and the people who arrived first have built barricades to keep others away from the shore. While they wait, battles break out among the refugees over the scarce resources of food and water. Ballard effectively creates a sense of the hopelessness and chaos the refugees feel as he describes them fighting over small amounts of water, selling their possessions, and slowly dying.

Ransom, realizing the hopelessness of the situation at the coast, leaves for the nearby salt marshes, where he spends years working as a laborer carrying marsh water in buckets to hand desalinate enough to barely survive. He also practices medicine, but as people only seek help when they are near death, he gets the reputation as a prophet of doom. Finally, physically and emotionally drained by his work, he leads a few of his surviving townspeople back across the desert to Hamilton.

On their return, they find a few survives terribly changed by the drought. Living on the last of their hoarded water, the rich Lomax family, a brother and sister, are clearly insane, and the orphaned children of another family, cared for by the Lomaxes, are also physically and emotionally damaged. At the end of the novel, Ransom simply walks into the desert as rain begins to fall. It is unclear whether he will survive or whether the rain is more than a teasing shower.

The Burning World is in some ways the most accessible of Ballard's early environmental apocalypse novels. Like the protagonists of his two earlier novels, *The Wind from Nowhere* and *The Flood*, Ransom is a physically strong and intelligent character typical of the popular British scientist hero, but he, unlike the

others, has a backstory. In addition, in *The Burning World*, Ballard not only suggests the cause of the environmental disaster, human destruction of the environment, but also shows its growing impact on the lives of people within a small community; no one escapes unscathed in this novel. Ballard is also successful in creating a sense of hope in the drought refugees who migrate by the tens of thousands to the coast for relief that does not exist and the utter failure of what passes for a government after the disaster to provide any hope.

As a number of climate change analysts have pointed out, drought is already occurring in parts of the world, as is migration, and there are few plans, other than building walls, to stop the flow of thirsty people. Critical reaction to *The Burning World* has changed over recent decades as awareness of climate change and global warming has grown. What was once seen as a simple dystopian science fiction novel is now considered an early masterpiece of climate fiction. As it has received more attention, the complex nature of the novel, especially its psychological examinations of character and it numerous literary allusions, particular to T. S. Eliot's *The Waste Land* and Shakespeare's *The Tempest*, has become more appreciated. Ballard's depiction of a world turned into a dry wasteland can also be seen echoed in other works, particularly Paolo Bacigalupi's *The Water Knife* and Claire Vaye Watkins's *Gold Fame Citrus*.

See also: *Crystal World, The*; *Drowned World, The*; *Gold Fame Citrus*; *Water Knife, The*; *Wind from Nowhere, The*

Further Reading

Luckhurst, Roger. *The Angle between Two Worlds: The Fiction of J. G. Ballard*. Liverpool: Liverpool University Press, 1998.

Stephenson, Gregory. *Out of the Night and into the Dream: A Thematic Study of the Work of J. G. Ballard*. New York: Greenwood Press, 1991.

C

CARBON DIARIES 2015, THE

The Carbon Diaries 2015 is a young adult dystopian novel written by British writer Saci Lloyd. Published in 2008, the novel won the Costa Book Award, given to exceptional works by writers in Britain and Ireland, in 2008, and it was successful in both Britain and the United States. The novel is set in London in the then future 2015, when ongoing dramatic climate change has impacted social, economic, and political life around the globe.

The Carbon Diaries 2015 is sixteen-year-old Laura Brown's diary for the year 2015, the year Britain introduced carbon rationing, or a 60 percent drop in energy usage, in an attempt to stop, or at least slow down, the environmental damage caused by climate change. In the world outside of London, the people on the European continent are suffering from floods, extreme heat, unemployment, mass migrations, and pandemics. The United States, also suffering, has become isolationist, and there are extremes of weather and food shortages throughout Asia and Africa. But Laura is focused on more immediate issues: herself, the boy next door, and her boring parents.

Laura's diary entry for January 1, 2015, reveals the family's hopes for the upcoming year. Laura wants to keep her rock band, the Dirty Angels, together; have 24/7 access to her e-pod; and have the cute boy next door notice her. Her father, Nick, wants peace and quiet at home and Saturday nights at the pub with his friends. Her mother, Julia, wants to drive her Saab Turbo 9-50, even though driving it wastes precious fuel, and find inner peace. Her older sister, Kim, wants her life back, including dating and weekend trips to the Spanish coast. These are all normal desires for a middle-class London family, but in the catastrophic climate change year of 2015, nothing will be normal.

Laura's year begins with small inconveniences. Power rationing means cutting computer, phone, and television time and sharing that reduced time with her family. Water rationing means short showers, no watering the garden, and fewer toilet flushes. Troubles escalate as her father loses his job with a travel agency because no one is traveling. Her mother's car is vandalized, as it is seen as a symbol of conspicuous consumption. Her sister extravagantly wastes several weeks of carbon allowance on two trips to Spain. As a result of the family's misuse of scarce power resources, smart power and water meters are put in the

family's home and cut off when daily allotments are reached. School becomes an endless round of pep talks and environmental lectures. Her father begins to drink heavily, and her mother leaves the family without saying where she is going. And then the impact of climate change begins to closer hit home.

By summer, the hottest on record in Britain, normal life in and around London is impossible. Water service to homes is replaced by neighborhood pumps that shut off frequently, and electrical power is sporadic. The food supply chain is often broken, and there is no water for the home gardens that have been planted throughout the city. When they can find gas, drivers are often attacked on the roads for wasting carbon. Food and power riots break out in parts of London, and police respond with mass arrests and by cordoning off large sections of the city.

Somehow Laura's life goes on. She is bored at school, worried the boy next door doesn't notice her but happy the Dirty Angels manage to practice and actually find an audience. Laura's father plants a garden and brings home chickens and a pig to raise. Laura's mother returns from a feminist camp empowered. Laura's older sister begins working in a carbon dating startup, a computer dating service for climate change times.

Unfortunately, disaster strikes in the fall. Extreme weather events are one of the most common effects of climate change, and in *The Carbon Diaries 2015*, Lloyd draws on the hypothesis that climate change will cause a shift in the Gulf Stream, with resulting dramatic changes in weather patterns throughout the Atlantic Basin. The first indication of the coming disaster is when a huge Category 5 hurricane hits Wilmington, North Carolina, killing over 10,000 people and spreading flooding along the American East Coast, inundating Baltimore, Philadelphia, and Washington, DC.

An even larger storm forms in the North Atlantic and heads slowly toward London. Days of torrential rain precede the arrival of the eye of the storm, and Londoners soon see major flooding from the twenty-one underground rivers of London as well as the Thames. Traffic jams close the M25, the highway around London, and the underground floods, leaving those people who remained in London, including Laura and her family, waiting and hoping the Thames Barrier will hold. Built between 1974 and 1982 to protect London from extraordinary high tides, the barrier was not designed for the increased number and intensity of storms nor the rising sea level.

In her diary, Laura records the growing desperation and chaos that Londoners feel as the storm approaches. People sandbag their homes, when they can find sand or bags, and there are runs on short supplies of food and medicine. Rioters and revelers take to the streets, and martial law is declared. While Londoners wonder whether the barrier will hold, Laura searches for members of her family, who have been scattered by the chaos.

The barrier does hold, barely. Although many parts of London are underwater, some of the city has been spared. Laura describes the aftermath: bodies being found in receding waters, outbreaks of cholera, people searching for missing friends and family, wrecked buildings, the British and United Nations troops reestablishing some sense of order and delivering food and water from helicopters, and power coming back, at times. Laura describes the miracle of her cell phone working. She is, after all, a teenager. She manages to reunite with the members of her family. All are battered, but they are safe.

The Carbon Diaries 2015 ends with an entry from December 31. Laura writes that those neighbors who have returned are working together and that she and they have made it through and will continue to do so one day at a time. For now, that is enough.

The Carbon Diaries 2015 is a young adult dystopian novel, part of a poplar new genre exemplified by such works as Suzanne Collins's *The Hunger Games* (2008) and Veronica Roth's *Divergent* (2011). Like those works, *The Carbon Diaries 2015* focuses on a likable young woman who is faced with growing up and surviving in a postapocalyptic world fraught with both social and personal dangers. Also, like the other works, the success of *The Carbon Diaries 2015* persuaded the author to release a sequel, *The Carbon Diaries 2107*, in 2010.

Unlike the works of Collins and Roth, however, Lloyd situates her hero in an apocalypse in the making, the world in the midst of climate change, and as a result, Laura is as much part of the problem as she is the solution. She is forced to abide by carbon rationing that severely restricts her use of power, something she finds exceedingly difficult as she tries to keep her rock group together; it takes power to practice and play. She also understandably finds her high school carbon rationing classes boring. And yet, as a year of ongoing climate change impacts her and other Londoners, Laura keeps calm and carries on in a very British way.

The Carbon Diaries 2015 is a significant novel for a number of reasons. First, unlike both *The Hunger Games* and *Divergent*, as well as their sequels, Lloyd's novel is not an adventure narrative in which extraordinary young people do extraordinary things in a postapocalyptic world. It does, however, employ the dramatic device of a major storm threatening a major city, as do Kim Stanley Robinson's 2017 novel *New York 2140* and Nathaniel Rich's 2013 novel *Odds against Tomorrow*. Instead, Lloyd writes about a very ordinary young woman faced with the very real problems of ongoing and intensifying climate change, and in doing so, she makes both Laura and her situation more believable.

Second, the diary structure allows Laura's voice to come through, a voice that changes over the course of the year as she matures in the face of the very real and often very ordinary problems climate change brings about. Her voice also adds credibility to her depiction of the extraordinary, the massive climate

change–driven storm that hits London. The depiction of London as it faces a major climate change storm and flood is reminiscent of much of the reporting from New Orleans when Hurricane Katrina struck that city in August 2005. It is both real and apocalyptic, and as Laura describes her reactions, readers can get some sense of how climate change makes disaster the new normal.

See also: *Bridge 108*; *City Where We Once Lived, The*; *Hunger Games, The*; *New York 2140*; *Odds against Tomorrow*; *Sherwood Nation*

Further Reading

Coats, Karen. "*The Carbon Diaries* (Review)." *Bulletin of the Center for Children's Books* (June 2009).

Day, Sara K., Miranda A. Green-Barteet, and Amy L. Montz, eds. *Female Rebellion in Young Adult Dystopian Fiction*. London and New York: Routledge, 2016.

CHESAPEAKE REQUIEM

Chesapeake Requiem (2018), by Earl Swift, is a *New York Times* best-selling non-fiction work set on Tangier Island in the Chesapeake Bay. The full title of the book, *Chesapeake Requiem: A Year with the Watermen of Vanishing Tangier Island*, provides an apt description of Swift's carefully researched and moving description of an island experiencing the impact of the rising waters caused by climate change. Swift's examination of life on Tangier Island is part history, part nature writing, and part biography of Chesapeake crabbers and their families. The result is both a recreation of a disappearing way of life and a warning to other low-lying coastal areas that indeed the times are changing.

Since it was first surveyed in 1850, Tangier Island has shrunk from 2,163 acres to 789 acres in 2018, and the U.S. Army Corps of Engineers estimates that it will lose about a third of the remaining land unless major intervention takes place. In 1913, the population of the island was 1,262 residents, but by 2016, the population was 470, with 108 residents over the age of seventy. The population is expected to continue to decline, as many islanders encourage their children to leave the island after finishing high school because the major industries, crabbing and summer tourism, are not pathways to success and the water continues to rise.

The earliest inhabitants of Tangier Island were Native Americans, who like later settlers used the island as a base for hunting and fishing. In 1608, John Smith, of Jamestown fame, is credited as "discovering" the island, and despite local legends to the contrary, the first Anglo settler on the island, according to the Commonwealth of Virginia, was Joseph Crockett, the father of ten children, who bought 450 acres on the island in 1778. Other settlers soon arrived and married into the Crockett family. In 1807, Crockett attended a camp meeting

by an itinerant Methodist minister on the mainland and became a devout Methodist. In 1809, a pair of traveling ministers visited the island and conducted an enthusiastic worship service that included singing, preaching, and shouting. They established a tradition of Methodist meetings on Tangier Island that continues to this day. At one time, in the early twentieth century, the island was known for both its exuberant revivals as well as its reputation for godliness: drinking, dancing, and swearing were prohibited on Tangier.

The Chesapeake Bay both provided the bounty that sustained the Tangier islanders and created the conditions that threatens the island's existence. In *Chesapeake Requiem*, Swift examines both, primarily by writing about the life and labor of Ooker Eskridge, the mayor of Tangier Island and a peeler crab fisherman, with whom Swift spent most of his year on the island. For non-crabbers a peeler is a crab about to molt, soon to become a soft-shelled crab, the most valuable crab for the island's fishermen. Swift, who often accompanied Eskridge on his boat, the *Screedevi*, as he worked the waters around Tangier Island, presents a realistic picture of Eskridge's difficult and at times dangerous work. Crab season in the Virginia waters of the Chesapeake Bay runs from March 17 to December 19, and the oyster season runs from October 1 through March 31, allowing crabbers like Eskridge to fish nearly year-round in all kinds of weather. In addition to limited seasons, Chesapeake Bay fishermen face regulations on the number and size of crabs and oysters caught as well as limits on types of fishing.

The relationship between people and the Chesapeake Bay has always been complex. The bay provides food and work for the islanders, but it is also the cause of accidents and death, as seasonal storms can destroy boats and kill fishermen. Humans have had their impact on the Chesapeake as well. At one time, hundreds of millions of oysters lined the bottom of Chesapeake Bay, but overfishing nearly wiped out the entire oyster population. Restricting oyster fishing, severely limiting harvests, and seeding newly constructed oyster beds have enabled oyster fishing to continue.

Equally dramatic has been the impact of crabbing. Swift notes that about the year 2000, crabbers were setting more crab pots from more boats than ever before, yet catches were declining. Despite new and stricter regulations, the crab population in the bay was near collapse, falling from 791 million in 1990 to 260 million in 2007. In 2008, Virginia officials closed the winter fishing season and banned dredge fishing. The limitations have stabilized both the crab and oyster populations, but the human impact on the environment has been severe.

Swift argues that the most dramatic impact of human behavior on the Chesapeake Bay and Tangier Island has been climate change. Throughout *Chesapeake Requiem*, Swift documents the loss of Tangier Island's land to the bay,

providing statistics, photographs, and reactions from both scientists and the island's inhabitants. Swift discovers an interesting contradiction, one that is illustrative of other reactions to climate change. Climate scientists and the U.S. Army Corps of Engineers accept that the climate is changing, that change is caused by human activity, and that sea rise is a major effect of climate change. The Corps specifically notes that Tangier Island is losing over eight acres of land per year, and if nothing dramatic is done quickly, the entire island will be underwater within a century.

The islanders themselves disagree. They do agree that the Chesapeake Bay is taking Tangier Island; the evidence surrounds them, as one island graveyard and numerous island structures are now underwater. The cause, however, is not climate change, a "theory" that few of the islanders believe in, but rather the perennial problems of an island community: high tides and strong storms. Most ignore the correlation between climate change and increased storm and tidal action, believing that the wind and the water have always been fierce. They do, however, recognize the need for a seawall to protect the island, even if the U.S. Army Corps of Engineer's estimate of the cost would be over $20 million.

Swift ends *Chesapeake Requiem* with a recounting of Tangier Island's experience with the national media. In the spring of 2017, Ooker Eskridge invited a CNN news crew to the island to discuss the need for a seawall to protect the island. When asked about climate change and the impact of rising sea levels on Tangier Island, Eskridge demurred, saying that the islanders focus on erosion. He added that he loved the newly elected president, Donald Trump, and that 87 percent of the island's voters voted for him. When asked what the president could do for Tangier Island, he responded, "Build us a wall," a reference to President Trump's promise to build a wall on the southern border. Ooker Eskridge's comment was a one-day sensation, resulting in a call from President Trump but no wall.

Chesapeake Requiem is as much about the community living on Tangier Island as it is about the impact of global warming on an island. Earl Swift, who first reported on the island in 1999 and then returned in 2016 to spend a year with the people on Tangier Island, combines a reporter's objectivity with a love of the people and history of the island. Swift effectively describes the impact of both histories, especially the faith history of the island, and geography, the interaction of the island and the bay, to bring to life a community that seems almost out of place in the beginning of the twenty-first century. *Chesapeake Requiem* is one of the most readable and intimate nonfiction books about the impact of climate change. Swift creates this intimacy by making his narrative about an island slowly sinking into Chesapeake Bay more about its people than about the impending disaster.

See also: *Drowned World, The*; *Field Notes from a Catastrophe*; *Flood*; *Six Degrees*

Further Reading

Ginsberg, Steven. "With Chesapeake Bay Waters Rising, Tangier Island's Future Is Sinking." *Washington Post*. August 10, 2018.

Mayer, Petra. "'Chesapeake Requiem' Chronicles Life on an Endangered Island." NPR. August 27, 2018.

CHILDREN OF MEN, THE

The Children of Men (1992) is a dystopian novel by British writer P. D. James, who is best known for her complex, character-driven mystery novels. The novel is set England in the year 2021, twenty-five years after the last child on earth was born. For reasons unexplained in the novel, although environmental degradation, including climate change, is suggested, human birth rates had been declining in the final decades of the twentieth century until they ceased around the world entirely in 1995. Children born in that year, called "Omegas," were given special status, as they would be the last surviving human beings. Recognizing not only the possibility but the inevitability of extinction, people responded in different ways. Some governments and economies failed, organized religion lost millions of adherents, and mass suicides occurred. In England, the last election was held in 2006, as people had lost interest in politics and settled for security and comfort. In that year, Xan Lyppiatt was elected Warden of England, and he governs with absolute authority supported by a small governing council.

The Children of Men is told from two points of view, the first is a diary composed by Theodore Faron, an Oxford professor of Victorian history and cousin to England's Warden. He was once a member of the Warden's governing council and is divorced, his wife leaving him after he accidentally ran over his daughter backing his car out of the family driveway. He begins his diary by noting that the last person born on earth was killed in a pub brawl. The second voice is an objective third-person narration that describes Faron's actions as he meets and interacts with a number of political dissidents.

As in many dystopian narratives, *The Children of Men* recounts how after a catastrophe—and extinction is perhaps the ultimate catastrophe—people are willing to sacrifice individual liberties for security. The aims of the Warden and his governing council are to provide protection, security, comfort, and pleasure as well as freedom from fear, freedom from want, and freedom from boredom. Under the Warden's leadership, England has managed to sustain a functioning economy despite a loss of population by allowing foreign workers called "sojourners," usually Omegas, into the country to provide labor for the aging British population. They are forcibly sent home upon reaching the age of sixty.

Jury trials have been abolished, and criminal cases are heard by a judge and two magistrates. People convicted of crimes are sent to the Isle of Man for life. On the Isle of Man, the prisoners must feed, clothe, and provide shelter and security for themselves. No visitors are allowed. Because the elderly are becoming a burden on society, upon reaching sixty years of age, the citizens, except for a few wealthy or politically connected exceptions, are required to take part in a suicide ceremony called "quietus."

Most citizens find the trade-off of rights for security acceptable, but some do not. *The Children of Men* follows Faron after he meets with a group of dissidents called the Five Fishes who want him to present their demands for a more democratic system of government, including rights for sojourners and prisoners as well as an end to forced suicides, to his cousin. Reluctantly, knowing that his cousin is unlikely to change or relinquish any authority, Faron agrees. Before he meets with his cousin, however, he witnesses a badly organized quietus in which some participants refuse to participate. The guards are forced to club unwilling suicides as well as witnesses, including Faron.

Faron does meet with his cousin as well as the entire council, who are aware of both the dissidents and their demands. The council is unanimous in it opposition to change, noting that if Faron had concerns about the nature of the government he should not have resigned from the council. After the meeting, the Warden advises Faron not to meet with the Five Fishes again, as he might not be able to protect him. Not surprised by the council's action or his cousin's warning, Faron leaves the country. He visits the now empty streets of Europe's capitals and spends his time looking at museums and architectures and wondering how long the remains of civilization will last once the last human is gone.

When Faron returns to England, he discovers that the Five Fishes have turned to direct action, blowing up docks that are used to load quietus participants in boats before they are taken out to sea and drowned. On one occasion, the explosion was mistimed, killing several guards. As a result, the Five Fishes have gone underground. Faron agrees to meet with them one more time to try to convince them to disband, but when he does, they inform him that one of their members has been taken by government security forces. Faron agrees to help them escape to Wales, where the Warden is less popular, but when they make their way along the back roads, they are stopped by rogue Omegas who steal their car and kill one of the Fishes. More importantly, Faron learns that Julian, one of the Fishes and Faron's former student, is pregnant. Faron insists the group turn itself in to the government, as the surprise pregnancy changes everything, giving humanity the possibility of a future. Faron argues that his cousin, the Warden, will now take care of Julian and her miracle child. Julian refuses, insisting they will not be safe, and that the Warden will take the child to ensure he retains power.

Faron reluctantly agrees, but in order to continue their escape, Faron is forced to break into the home of an elderly couple to steal their car and medical supplies. He also takes a pistol from the couple. Faron drives at night to avoid security forces but is forced to stop when Julian goes into labor. Julian delivers a healthy baby boy, but as the remaining members of the Five Fishes had feared, the arrested member had been forced to reveal Julian's pregnancy and the escape plans. As a result, the Warden is waiting for Faron and Julian; he does not, however, know the baby has been born. As he confronts Faron with a gun, he is distracted by the newborn's cry, and Faron shoots and kills his cousin. The novel ends as Faron takes the coronation ring, a symbol of the Warden's authority, and places it on his own finger. He then baptizes the newborn baby.

The Children of Men was adapted as a film and released in 2006. Produced and directed by Alfonso Cuaron and starring Clive Owen, Julianne Moore, Michael Caine, Chiwetel Ejiofor, and Charlie Hunnam, the film emphasizes the treatment of the sojourners from the novel, changes the cause of infertility from men to women, and dramatically changes the ending. The film version of *The Children of Men* was well received by critics, receiving three Academy Award nominations, three BAFTA (the British Academy of Film and Television Arts) nominations, and three Saturn Award nominations, winning the award for Best Science Fiction Film.

Reviewers of both the novel and the film have noticed the obvious religious references in the narratives. The title itself is a reference to the Psalm 90:3 in the King James Version of the Bible: "Thou turnest man to destruction; and sayest, Return, ye children of men." The births at the end of both narratives are clearly nativity scenes, and the birth of a child after decades of infertility is an obvious reference for the possible salvation of humanity, a theme central to the Gospels' nativity narratives.

The Children of Men is as much about extinction as it is about the possibility of salvation. The discussion about the possibility of the extinction of human life because of climate change is central to such significant nonfiction studies of climate change as Elizabeth Kolbert's *The Sixth Extinction* (2014), Mark Lynas's *Six Degrees* (2007), and Bill McKibben's *The End of Nature* (1989). In addition, the political responses to the chaos caused by climate change, the abolition of individual rights, the growth of authoritarian governments, and the prohibition of migration, have all been discussed in critical examinations of governmental responses to climate change as well. Perhaps the clearest analysis of such responses can be found in Todd Miller's *Storming the Wall: Climate Change, Migration, and Homeland Security* (2017). In her novel, James describes how the possibility of extinction can not only enable a government promising some sense of security to take power but also how a populace faced with no future might willingly exchange liberty for security.

See also: *Bridge 108*; *Six Degrees*; *Sixth Extinction, The*; *Storming the Wall*; *Wall, The*

Further Reading

Taylor, Paul. "Book Review: The Last Generation Game: 'The Children of Men.'" *The Independent*. October 12, 2015.
Wangerin, Walter, Jr. "O Brave New World, That Has No People In't!" *New York Times*. March 28, 1993.

CHILDREN'S BIBLE, A

A Children's Bible (2020), by Lydia Millet, is a seemingly simple novel that dramatizes one of the often unspoken questions about climate change: why are adults leaving global problems to their children? Millet's novel, which contains echoes of William Golding's *Lord of the Flies* and Cormac McCarthy's *The Road*, suggests that the adults in the world of impending climate change might just be too selfish to care.

A Children's Bible begins simply: "Once we lived in a summer country. In the wood there were treehouses, and on the lake there were boats." The "we" are the children of a wealthy group of parents who have taken over a large house, "built for robber barons," in the country for the summer, bringing their children to escape from the city, New York City, although it remains unnamed in the novel, for a respite from the heat and storms of the new age of climate change. Most of the children are in high school; some are younger. Evie, the narrator, has a younger brother, Jack, who has been given a book of Bible stories for children, which he carries around, trying to figure out its meaning. Reading about Noah and his ark, for example, Jack assumes it is the duty of the children to take care of the animals they find as they play on the grounds of the large house. He will draw other lessons from his book of stories as well.

The parents staying in the summer house are no help in explaining things. More interested in themselves than their children, the parents, never named, only require that the children appear at dinner, leaving them to run through the grounds and the lake while the parents amuse themselves with drinking, sex, and drugs. At times, the parents are somewhat discreet, but they begin to move the party hour ever earlier. As the novel progresses, drug use and sexuality become spectator sports for the children, who disapprove. They even come up with a game to hide their own embarrassment about their parents' behavior, refusing to identify their own parents while guessing who their friends' parents might be.

Left unattended, the children move to the tree houses to sleep, spy on their parents, and plan overnight excursions to the lakeshore, where they meet the children of even richer parents, who are living on a yacht for the summer.

There they camp, cook out, and play volleyball, the last idylls of summer. Left unattended, the parents abandon their children, forget about dinner, and begin to have group sex. Neither idyll lasts very long, as reality intrudes when a massive storm, fueled by the increased heat and changing weather patterns of climate change, approaches the city and the surrounding areas of the northeastern United States. The children, more technologically adept and far more sober than their parents, return from the beach to prepare for the storm to find their parents drunk, disheveled, and in denial. Then the monster storm hits.

Power is knocked out, and the roads to the city are blocked. While the children worry, the parents decide to take massive quantities of ecstasy and alcohol and party away until the batteries for their music players run out. The children are disgusted and leave the house in search of the estate of one of the richer children's parents, located somewhere near Rye, New York. The rivers have risen, and trees have been knocked down. As a result, the roads have become impassable. They end up near Bethlehem, Pennsylvania, on a farm run by a caretaker and owned by a rich absentee landlady. There they are safe for a time. Jack even believes he has figured out the Bible, having saved animals, seen a birth in a barn, and been led to safety across rushing water. One day, he tells Evie that he has figured out the Trinity. He tells her it is simple. God is everywhere, so God is nature. Jesus saves people and so does science, so Jesus is science. The Holy Ghost is what people make, art. That explanation and their lives on the farm make sense to the children, until the bad men come.

The farm, even without electricity and flooding throughout much of the Northeast, remains a haven, especially after life at the old house. With the help of the caretaker, the children live in the barn and survive on the food and water stockpiled for just such an eventuality. Soon, however, they are discovered by a group of armed men living in an abandoned McDonald's near the farm. Searching for food and other supplies, the armed men come upon the children and quickly overpower them, seriously wounding and then crucifying the caretaker in the process. The refuge from the storm turns into a prison, and the armed men begin to kill the farm's animals, take supplies, shoot some of the children, and prepare to rape the older girls. The children are saved, however, as the caretaker had contacted the owner, who like God seems almost all powerful. She brings in a SWAT team in helicopters to protect her property and save the children. She contacts the children's parents and reunites the children with them. Together, the parents and children head off to the estate in Rye, where they begin to prepare for the winter.

The children have grown, but their parents have not; in fact, their roles have reversed. Even in the promised land, as Evie describes it, of the estate, the parents and the children live in separate worlds: the parents in the main house drinking and taking drugs and the children in the guest house planning for

the inevitable future. Eventually, the world begins to grow dark and collapse on both the children and parents. The stock market crashes; weather patterns change, ruining crops worldwide; the North Pole becomes too warm; Europe freezes; droughts and heat affect parts of the globe; and airports and roads shut down. It all happens very quickly.

Using their parents' investment accounts, the children order supplies of food and water, build a security fence around the estate, and keep track of the changing world. As a group, the parents grow listless and bored, often forgetting meals. Finally, the children take over. They set up a hydroponic garden to grow vegetables and plan for spring. They liquidate their parents' assets and invest in seeds and canned goods. They plant an apple tree. They keep their parents amused by playing trivia games in which the losing side must work for the winners. The children win most of the time.

While the children prepare for a future in an uncertain world, the parents become distracted and begin to fade away from reality. They became listless and then depressed. Running out of drugs, prescription and otherwise, they take to even more drinking, and as a group, they develop sleep problems, including night terrors. Eventually, finding themselves of no use to their children, they disappear, leaving the estate in the middle of the night. For a time, the children wait for the parents to return, but they never do. The novel ends with Evie telling Jack that the ending of the Bible is not in his book of stories. She tells him it is called Revelation, and it is scary.

A Children's Bible is an unusual climate change novel. Millet deliberately does not differentiate the characters of the parents, leaving them to act and react as a group against their own and their children's best interests. In addition, although some of the children do have identities, Evie is the narrator, Jack is her brother, and Juicy's parents own the estate in Rye. The children usually respond as a group to the events of the summer and fall. Realism is not the point of *A Children's Bible*. Many writers, finding the catastrophes of climate beyond the boundaries of realistic fiction, have resorted to science fiction fantasy. It is, instead, a parable, a story constructed to teach a lesson. Millet's lesson is a serious one, suggesting that the sins of the parents are handed down to the children, who will be left having to deal with the consequences of those sins.

See also: *Ever Winter*; *Odds against Tomorrow*; *Orleans*; *Oryx and Crake*

Further Reading

Bobrow, Emily. "'A Children's Bible' Review: Didn't It Rain, Children." *Wall Street Journal*. May 15, 2020.

Dee, Jonathan. "An Epic Storm Turns a Summer Holiday into Potent Allegory." *New York Times*. May 8, 2020.

CHINATOWN

Chinatown (1974) is an Academy Award–winning neo-noir mystery directed by Roman Polanski and starring Jack Nicholson, Faye Dunaway, and John Huston. Set in Los Angeles in 1937, the film is a murder mystery that also examines the dark side of drought, water management, and the connections between money, politics, and the environment. It was originally viewed as a successful revival of the classic Hollywood film noir. In that genre, a flawed detective meets a femme fatale, an attractive and seductive woman who brings disaster with her and investigates a murder in a film marked by pessimism, fatalism, and menace. Today, critics and viewers see *Chinatown* as an early environmental film that explores some of the root causes of climate change: the impact of money and politics on scarce natural resources as well as the pursuit of profit over sustainability.

Chinatown opens as a woman who identifies herself as Evelyn Mulwray hires detective Jake Gittes (Jack Nicholson) to follow her husband, Hollis Mulwray, the chief engineer for Los Angeles Power and Water Department, whom she accuses of having an affair. Hollis Mulwray previously refused to build a dam in the mountains northeast of Los Angeles to bring needed water to the city. Gittes sees Mulwray meeting with a young woman and assumes she is Mulwray's lover, but the real Evelyn Mulwray (Faye Dunaway) appears and threatens to sue Gittes for defamation of character. Gittes realizes he has been set up by someone, and when Hollis Mulwray turns up dead, although the Los Angeles police believe the death was accidental, the real Mrs. Mulwray hires Gittes to find out who killed him.

The trail Gittes follows leads through a swamp of public and private corruption and deceit. First, he learns that the Los Angeles Power and Water Department is secretly draining water from a reservoir every night, even as a drought is occurring in the area. Water department security men threaten Gittes and cut one of his nostrils because he is a "nosy person." He discovers that Evelyn Mulwray's father, Noah Cross (John Huston), was once Hollis Mulwray's business partner, and he is told by Cross that forces larger than Gittes could understand are at work. Working in the Los Angeles Hall of Records, Gittes learns that much of the land in the Northwest Valley has changed hands and that the Los Angeles Power and Water Department has been draining the reservoir to cut off water to the valley, driving land prices down, and then buying up property at reduced prices using fictitious buyers' names to hide the scheme.

Gittes sleeps with Evelyn Mulwray and shortly afterward learns that the young woman he has taken for Hollis Mulwray's mistress is actually Evelyn's daughter, Katherine (Belinda Palmer) He also learns that Noah Cross is behind the land-buying scheme and planning to have the City of Los Angeles incorporate the entire valley into the municipality as a way of claiming the water

rights held by the farmers and ranchers in the valley. In addition, he discovers that Noah Cross is behind the killing of Hollis Mulwray, who discovered and opposed the land-buying scheme. Finally, he learns that Noah Cross committed incest with his daughter, Evelyn, and that Evelyn's daughter is also her sister.

Evelyn Mulwray has been hiding her daughter/sister from her father/grandfather and keeping her ignorant of her tangled family relationships. Noah Cross attempts to bribe Gittes into bringing his daughter/granddaughter to him, but Gittes attempts to help both Evelyn and the young girl escape to Mexico. Unfortunately, Cross finds out and confronts Gittes and Evelyn and Katherine in Chinatown. In the resulting confrontation, Evelyn shoots her father, who survives, and tries to escape but is shot by the police, who are attempting to figure out what is going on. Cross identifies himself as the rich and powerful Noah Cross and takes Katherine. Gittes is advised by the police to forget all about the crimes and Evelyn's death. One of his associates says, "Forget it, Jake. It's Chinatown." This is a reference to a discussion earlier in the film when Gittes is told that policing is impossible in Chinatown because the (white) police never know who are the victims and who are the criminals, so it is best to look the other way.

Chinatown was nominated for eleven Academy Awards and seven Golden Globe Awards. It was both a box office and critical success, making over $29 million on a budget of $6 million. The film's reputation has grown, and it is now considered one of the finest crime films ever made. Robert Towne's screenplay, Roman Polanski's direction, and the performances of Jack Nicholson and Faye Dunaway have also received critical praise.

Contemporary critics of *Chinatown* continue to recognize the film's success as a crime movie, but a number have begun to examine the film as an early and successful example of environmental cinema. For example, Arthur Sacks of the Colorado School of Mines has offered a course for engineers titled *Chinatown*: Integrating Film, Culture, and Environment in Engineering Education. A number of writers have examined the film's use of the California water wars of the early twentieth century and the actual diversion of water from an agricultural valley near Los Angeles to the city. Opinions differ about the reason for the diversion.

Jonathan Zasloff, writing in *Legal Planet* in 2010, argues that the diabolical Noah Cross is a creature of fiction, that no private fortunes were made, and that the city simply needs to expand its water sources to grow. Writing in the *New York Times* in 2012, however, Felicity Barringer observes that farmers in the Owens Valley near Los Angeles were dynamiting aqueducts to stop water from being transferred from the valley to Los Angeles. Whether based on actual events of the California water wars or legends about them, Robert Towne's screenplay and Polanski's film draw on the threat of drought in the American

West, the battle over water rights, and especially the conflict between the urban and agricultural uses of water resources.

Although Noah Cross is a fictitious character, the manipulation of environmental resources for profit is far from unheard of. Writers of contemporary narratives about climate change in the American West often combine personal gain and public policy as reasons for the battle over the dwindling water supplies in the West. Perhaps the best known and most successful example is Paolo Bacigalupi in *The Water Knife*, which depicts an American West in the near future, when corrupt politicians collude with powerful private interests to manipulate the allocation of water. In addition, *The Water Knife* depicts a time when climate change refugees abandon large portions of the American West because of increasing drought and lack of water from the Colorado River. In *Gold Fame Citrus*, Claire Vaye Watkins describes a California in which climate change has already turned much of the state into a desert, despite efforts to relocate dwindling water sources.

Chinatown was released prior to the public awareness of climate change or the impact that it would have on especially sensitive environments, such as drought-prone areas and low-lying coastal cities. Nevertheless, contemporary viewers can see the film as both an early example of climate cinema and as an example of the power of money and special interests in determining resource allocations in a time of climate change and population growth.

See also: *Gold Fame Citrus*; *Grapes of Wrath, The*; *Water Thief, The*

Further Reading

Barringer, Felicity. "The Water Fight That Inspired 'Chinatown.'" *New York Times*. April 25, 2012.

Wasson, Sam. *The Big Goodbye: Chinatown and the Last Years of Hollywood*. New York: Flatiron Books, 2020.

Zasloff, Jonathan. "The Trouble with Chinatown." *Legal Planet* (blog). February 16, 2010.

CITY WHERE WE ONCE LIVED, THE

The City Where We Once Lived (2018), by Eric Barnes, is a dystopian climate change novel that takes place in the near future in an unnamed American city. Unlike many other climate change novels that emphasize dramatic disasters and chronicle the deaths of hundreds of thousands of people, *The City Where We Once Lived* follows the life of one unnamed man living in an abandoned part of city at the beginning of the wreckage caused by climate change. The result is a novel that is both realistic and hauntingly prophetic in its depiction of how ordinary people might react to a slow-moving catastrophe.

The unnamed narrator of the novel is a survivor of personal and social trag-edies. He lives in the northern half of a city that has almost been abandoned by its residents because rising water levels and frequent dramatic storms have destroyed its industrial base and infrastructure. Most of the inhabitants have fled to the more prosperous south end of the city. The narrator, who lost his wife and children in a fire, spends his time writing newspaper articles for a weekly paper read by the few remaining residents and burning down aban-doned houses. His reports record the slow death of an abandoned part of city. He describes the failure of levees; the slow, inevitable rise of the water level along the city's industrial waterfront; and the demolition of buildings that are stripped by salvagers in search of anything of value. Despite the deterioration, some social services remain. A few grocery stores remain open, and the paper continues to publish weekly. Once a month, members of the city council even meet to discuss the inevitable end of the city's north side.

As in many climate change narratives, there is life amid of urban destruction. In addition to the weekly newspaper and the occasional open store, a self-ordained minister, formerly an undertaker, provides funeral services for people who die. Power and water services remain, at least in some parts of the north, and people from the south side surprisingly move to the north, some welcome and some not.

One day, as the narrator walks the north side recording his observations in the emotionless form of objective journalism, he comes across a woman and a young boy, obviously lost. He befriends them, telling them where food is avail-able and what buildings are safe to live in. Shortly thereafter, he is approached by a new city council member who has visited the north side for the first time and asked what the nearly abandoned side of the city might need to survive. Finally, the narrator discovers a gardener who has imported seeds from India and is attempting to grow plants in the saltwater- and chemical spill–damaged soil of the north side.

Less welcome are the thrill seekers from the south side. In the evenings, cars driven by bored young people drive over the one overpass from the south side of the city to race in the north side's nearly empty streets, at times threatening the few residents who are out and at other times shooting guns at streetlights and into buildings. One evening, the narrator approaches one of the cars and tells the driver to leave. He refuses, and a passenger threatens the narrator. In response, the narrator breaks the car window, pulls the passenger from the car, and severely beats him. The driver then turns the car around and leaves the north side of the city. The self-ordained minister, who witnessed the alterca-tion, asks the narrator what his capacity for violence is. The narrator says he does not know. The implication is clear: to survive, residents in the north side must have a capacity to commit violence.

After that incident, the people of the north side decide to provide for their own security and set up a barricade on the single overpass between the city's two sections. Volunteer guards turn back potential troublemakers but allow all others in. The south side joyriders refuse to accept the situation, and a large group of them approach the barricade and begin to tear it down and beat up the guards. The residents of the north side respond quickly, beating back the joyriders. With the help of the scavengers, who have become residents of the north side, they erect a permanent barricade using some of the south siders' cars.

Throughout the novel, the sea level has been rising, and tornadic super-storms strike the city. As in many climate change narratives, the weather in *The City Where We Once Lived* has turned foul. After one spectacular tornadic event that is followed by several days of rain, the eight-lane highway running below the overpass between the north and south sides of the city begins to flood. Soon thousands of cars are trapped when the pumps that keep the low-level highway from flooding fail.

Once again, 'the residents of the north side take action. The scavengers bring dozens of ladders used for tearing down buildings and removing mate-rial to the overpass. Residents and scavengers place the ladders between the overpass and the flooding highway, saving thousands of trapped motorists. Afterward, more people from the south side of the city begin to move north. The new arrivals tell the north side residents that life in the south side has been deteriorating for years; severe storms and dramatic temperatures as well as sea rise caused by climate change have disrupted city services and destroyed jobs there as well. For some, life in the once abandoned north side seems a better choice.

The unnamed narrator of *The City Where We Once Lived*, who had recorded the events leading up to the new influx of residents, undertakes an extensive examination of the north side for the newspaper. Traveling by a boat he finds abandoned, he discovers the city's airport is flooded and more levees have failed, but he notes which ones might be repaired. He discovers that the scav-engers have removed an entire neighborhood and with the help of the gardener are planning to establish a farm. He sees that the gardener has planted flowers and small trees throughout much of the city's north side. He even comes upon residents repairing the buildings they have moved into instead of moving from one vacant apartment to another as buildings deteriorate. He discovers the beginnings of a community, not one that will recreate the city as it was but one that may create a livable space in a city facing climate change. As he records this change in the city in which he lives, he notes that for the first time since his family died in the fire years ago, he is able to think about them without feelings of survivor's guilt.

The City Where We Once Lived is an understated novel. Barnes's use of an emotionally shattered unnamed narrator using the objective prose of a newspaper reporter allows the slow accumulation of climate change deterioration, and eventual signs of community awakening appear gradually. Many climate change novels involving the destruction of cities focus on dramatic events, such as sudden epic floods and mass deaths. *Odds against Tomorrow*, by Nathaniel Rich, and *Fifty Degrees Below*, by Kim Stanley Robinson, are two examples of such narratives. *The City Where We Once Lived* is less dramatic but in some ways more terrifying. It is easy for readers to place stories of mass destruction caused by climate change in the context of dystopian science fiction. Showing what may already be occurring in some parts of the world's cities is far more unsettling.

See also: *Carbon Diaries 2015, The*; *Drowned World, The*; *Fifty Degrees Below*; *New York 2140*; *Odds against Tomorrow*; *Orleans*

Further Reading

Streeby, Shelley. *Imagining the Future of Climate Change: World-Making through Science Fiction and Activism*. Berkeley: University of California Press, 2017.
Woods, Ellie. "The City Where We Once Lived." *Seattle Book Review*. November 2018.

CLADE

Clade (2017), by Australian writer James Bradley, is an intelligent climate change novel that chronicles three generations of one family as climate change radically transforms the environment and their lives. "Clade" is a biological term defined as a group of organisms believed to have evolved from a common ancestor. Bradley, as expected in a novel with a scientific title, focuses on the science of climate change in his narrative, with references to geology, biology, medicine, genetics, astrophysics, and computer science. He also manages to create a narrative that is worldwide in scope by following the descendants, family, and friends of one man, Adam Leith.

Clade begins several years in the future, when climate change has been accepted as a reality by the public, but the impact has not begun to be felt by most people. Adam, a climatologist, is in Antarctica studying ice loss and its potential impact on sea levels. His wife, Ellie, a conceptual artist, is at home in Sydney, Australia, being treated at an infertility clinic. In many climate change narratives, infertility is a major problem. From a plane, Adam and his colleagues see a massive section of ice they had just been working on breaking away. He realizes that the environment is at a tipping point and returns home, uneasy about bringing a child into the world.

The next section of the novel picks up over a decade later. Adam and Ellie are estranged, but they have a teenage daughter, Summer. Ellie and Summer

visit Maddie, Ellie's father's second wife, in the country. While spending time at a lake, Ellie and Maddie are awkward with each other and talk about remarriage, children, and divorce. They also talk about death. More importantly, they talk about massive wildfires in Australia, the extinction of native plants and animals, and the spread of disease. Maddie tells Ellie how she and Tom lost their young son, Declan, to one of the new diseases that had spread throughout the country. She describes how she and Tom took Declan to a number of specialists who had no means to fight the new viral infection that was sweeping through Asia and had reached Australia. After Declan's death, Tom and Maddie grew apart and divorced. Tom had recently died, and the two women are in mourning, Ellie for a father and Maddie for an ex-husband. Together, they drive to the coast to pour Tom's ashes into the sea. As Ellie leaves with Summer, Maddie recalls the last conversation she had with Tom, who noted that birds were becoming a ghost species; they had stopped laying eggs, both in Australia and around the world.

The next section of *Clade* takes place in England, over a decade later. Summer has a young son, Noah, who has a mild form of Asperger's syndrome, which makes him uneasy in social situations. He obsesses about electronics and computer games. Summer and Noah have been living in abandoned house near Cambridge, as many people have fled England because of the environmental and economic hardships caused by climate change. Weather throughout Europe has become extreme, sea rise has threatened coastal cities, and industrial and economic disruptions have caused massive unemployment. Adam has flown into London for an academic conference on adapting to climate change, and he decides to make a surprise visit to his daughter. He finds Summer and Noah, a grandson he did not know existed, living in a commune on an abandoned farm. As the three family members try to establish connections, which is difficult because of the tension between Summer and Adam, they see a report on television that a massive hurricane, one of a number that have reached Europe in the past years, is heading for landfall on the southern coast of England.

What follows is what has become almost a set piece in climate change fiction, the arrival of a monster storm and the devastation it leaves behind. Adam, Summer, and Noah attempt to leave the commune but find that the major roads are either closed or washed out. As the outer bands of the storm arrive, low-lying areas flood, and people abandon their cars looking for shelter. Eventually, near London, they break into a building and find an apartment on an upper floor where they ride out the storm. When they emerge, they find the streets knee-deep in water and full of broken cars, felled trees, and dead bodies. Mud, oil, and sewage wash around their legs as they walk. They eventually find some high ground and a military tent. While Adam and Noah talk to the soldiers, Summer walks away, leaving Noah in Adam's care.

The next section of the novel takes place in Australia, shortly after Adam and Noah return from England. Ellie has moved to a house in rural Australia, and she is preparing to meet Noah. Walking through the forest near her house, she comes across a small group of beehives. Fascinated, she approaches the hives only to be interrupted by the beekeeper, who is suspicious of her. She leaves but then returns the next day. The beekeeper, Emir, becomes friendly, as he notes her interest in and affection for the bees in his care. He explains to her that bees are becoming rare around the world because of ACCD (accelerated colony collapse disorder). He explains that he was a doctor in Dhaka, the capital of Bangladesh, but when the government collapsed after massive flooding devastated the country, Emir and his family were forced to flee. Now, with Bangladesh, Myanmar, and much of coastal India submerged underwater from sea rise, he, like many others, is an undocumented migrant in Australia, where he raises bees in secret. Sadly, he tells her, the bees are but one more of the many species that are becoming extinct.

Inspired by the bees and hives, Ellie begins to work on an elaborate larger-than-life piece of conceptual art using lasers and fabrics to recreate a bee colony. Several weeks later, she sees a newscast concerning the problem of illegal migrants. She drives to visit Emir and his bees but finds the entire area closed off by the military, who are engaged in a sweep for illegal migrants. Devastated, she returns home. Several days later, Emir appears at her house and gives her his last honeycomb, his hives having been destroyed by the military.

The next section of the novel is entitled "Journal of the Plague Year" and is written in the form of a journal by Lijuan ("Li"), a teenage Chinese immigrant who, with her mother, lives with and cares for Noah and his grandfather, Adam. Noah is still enthralled by computers and constantly wears lenses that serve as screens for playing video games. He often refuses to interact with other people. Li's mother has gone to China to take care of her sister, who has become ill with a new virus, AVRS (acute viral respiratory syndrome). She will not be heard from again once she lands in China. Throughout the years, Li records the panic as AVRS spreads from China to the United States, Europe, and finally Australia. Adam moves Noah and Li to a house in rural northern Australia as the infection hits Sydney and Perth. Throughout the year, she describes the spread of the disease and food riots. She writes about Noah's retreat into video games, Adam's concerns for his grandson, and her failure to reach her mother in China. Li's November 8 entry reads as follows:

These are the things we have lost:

Birds
Bananas
Tigers

Frogs
Bees
Coffee
Polar bears
Coral

These are the things we have saved:

Seeds
Elephants
Dolphins
Each other

In December, fires break out throughout Australia, and Adam takes Li and Noah to the coast, hoping the house will remain untouched.

The next section of *Clade* takes place after the pandemic. Set in England, it focuses on the work of Dylan, a young acquaintance of Summer's who works creating sims, or echoes, computer-driven simulations of people who had died during the pandemic. The sims can be made to interact with the living, and he finds the work both profitable and useful. Dylan not only recounts his work, usually for grieving relatives, but also how his own mother died, giving water to an infected mother and two children. Because of the number of people lost in the pandemic, the demand for sims from the population left behind is high and, as Declan's father believes, somewhat ghoulish.

The final section of the novel returns to Noah in Australia. Noah is still enamored by computers but no longer plays video games. Instead, he has a grant, having designed a computer program to scan parts of the universe looking for intelligent life at an observatory on the North Shore of Australia. One day, he receives a call from Adam, saying that Summer, his mother, who has been ill, has been found in England. After hesitating for several days, he agrees to fly to see his mother. Even when he is with her, however, he is more concerned about his project than his mother. Upon his return to Australia, he continues to run his program until he finds a repeating message from somewhere in the constellation of Sagittarius, which is later confirmed. Shortly after the news of the discovery, Noah learns that his father has died.

Clade is an ambitious and intelligent novel. Bradley manages to depict the full range of disasters associated with climate change: sea rise, greenhouse effect, species extinctions, pandemics, massive weather events, political instability, and mass migrations of climate refugees. However, he manages to make the catalog of climate catastrophes personal by following one clade, Adam and his descendants, over a period of several decades. Bradley does not write about generic disasters. During the decades of increasing climate change depicted in the novel, Bradley's family of characters, often at the edge of disaster, are aware

of their continually degrading environment, yet they struggle to continue to survive. Perhaps the most moving example of this is when Ellie comes upon the beehives in the country. Her encounter with Emir, the beekeeper, captures the combined disasters of extinction, sea level rise, political instability, and climate migration, all in a seemingly simple chapter about bees. Near the end, *Clade* veers somewhat toward speculative fiction, which is not unusual in novels about climate change. Both the creation of the sims and the discovery of other intelligent life are often theses of science fiction. However, Bradley grounds the scientific speculation with is realistic depiction of characters.

By focusing on one family, Bradley successfully tells the story of the world-wide catastrophes caused by climate change, but he keeps the focus of the novel on his family of characters. His novel, like the early chapters in the book of Genesis, tells the story of a family, from Adam to Noah, which ends with the possibility, if somewhat speculative, of renewal.

See also: *Barkskins*; *Carbon Diaries 2015, The*; *Flight Behavior*; *History of Bees, The*

Further Reading

Hamilton, Hamish. "'Clade' by James Bradley." *The Monthly*. February 2015. Retrieved February 17, 2022. themonthly.com.au/issue/February/1422709200/Michael lucy/clade-james-bradley#mtr

Housham, Jane. "*Clade* by James Bradley Review—The Apocalypse Is Happening." *The Guardian*. September 14, 2017.

COLONY, THE

The Colony (2013) is a Canadian postapocalyptic disaster film directed by Jeff Renfroe and starring Laurence Fishburne, Bill Paxton, Kevin Zegers, Atticus Mitchell, and Charlotte Sullivan. The film is set in 2045, when climate-controlling machines set up to combat global warming have failed, resulting in a rapid cooling and a never-ending snowstorm. As in other postapocalyptic climate change films—*Snowpiercer* (2013) is perhaps the best-known example—most of humanity has been killed, and those few who survive are faced with the task of finding food and surviving disease. The survivors have retreated into underground bunkers, and the few who survived the abrupt deep freeze but did not make it into the bunkers have resorted to cannibalism.

The Colony opens in Colony 7. Its military leaders, Briggs (Fishburne) and Mason (Paxton), receive a distress signal from nearby Colony 5, and Briggs, Sam (Zegers), and Graydon (Mitchell) leave to provide assistance. Briggs leaves Kai (Sullivan) in charge of Colony 7 instead of Mason, who is known as a harsh disciplinarian and had expected to be given the position.

When the rescue team arrives at Colony 5, it discovers the bunker covered in blood. The team members find a lone survivor who tells them that Colony 5 had received a message that some survivors had repaired a weather machine and snow had begun to melt. The survivors said they would help any colony members who brought seeds that had been taken into the bunkers with them to restart life aboveground. Colony 5's search team had failed to find the source of the message, and the tracks they left in the snow had led cannibals back to Colony 5.

The survivor then locks himself in a room while the search team explores the bunker. In one room, they discover cannibals eating the hacked-up remains of the inhabitants of Colony 5. Graydon is killed by the cannibals, but Briggs and Sam escape, destroying the shaft through which they had climbed with dynamite. Outside, they take shelter for a night in an abandoned helicopter. When they awake the next morning, they find that the cannibals have escaped from Colony 5 and followed their tracks in the snow. Again, Briggs and Sam run from the cannibals, but Briggs is killed as he sets off more dynamite to stop the cannibals and save Sam.

When Sam returns to Colony 7, he discovers that Mason has taken over the colony and plans to execute a woman he thinks may be diseased. Sam tells Mason that cannibals are following him and that there is a place where snow is melting that could provide a hope for people above ground. Mason refuses to believe Sam, but when the cannibals do attack Colony 7, Mason gives his life, allowing Sam, Kai, and a number of others to escape. They take seeds with them that had been preserved, hoping to find the thawing site to restart civilization.

The Colony was neither a popular nor critical success. The film, which premiered in Saudi Arabia, received a limited release in the United States and was quickly released on DVD. Critics noted that the plot is standard horror film fare and that most of the performances, except those by Fishburne and Paxton, are uninspired. Aside from the setting, the world after a disastrous attempt to reverse climate change has gone terribly wrong, *The Colony* could be a zombie film. The film's cannibals not only devour humans, in this case entire bodies not just brains, the main source of sustenance for filmic zombies, but they are also inarticulate, clumsy, and emotionless in their pursuit of humans. In addition, as in many zombie films, the hordes of evil creatures follow the human characters from one confrontation to another, killing off the film's innocents until only the brave and the lucky survive in the end.

The Colony does, however, provide a commentary on humanity's response to climate change, or lack thereof. The premise of the film is that humanity relied on a scientific breakthrough, or magic bullet, to reverse climate change instead of doing the hard work of drastically cutting carbon emissions and radically

altering lifestyles. In film and real life, scientific breakthroughs have a way of not occurring or having unintended consequences. The end of the film also suggests the hope that no matter what awful damage climate change might cause, some degree of normalcy might occur, at least for some people. Hundreds of millions of people may have died and cannibals may roam the earth, but all might end well because a few brave souls and the seeds needed to create a new green earth may find a thaw in the snow.

See also: *Day after Tomorrow, The*; *Fifty Degrees Below*; *Snowpiercer*

Further Reading

Ebert, Roger. "*The Colony*." RogerEbert.com. September 20, 2013.

Genzlinger, Neil. "Mired below Ground in an Endless Winter." *New York Times*. September 19, 2013.

CRYSTAL WORLD, THE

The Crystal World (1966) is the fourth in a series of environmental disaster novels by British author J. G. Ballard, who is best known for his semi-autobiographical novel *Empire of the Sun*, which was made into an Academy Award–winning film by Steven Spielberg in 1987, and *Crash*, a novel about the attraction of automobile crashes that was made into a major film by David Cronenberg in 1996. In the series of novels, Ballard employs the conventions of the British science fiction adventure narrative made popular by H. G. Wells and H. Rider Haggard to examine issues of climate change and their effects on human behavior. Wells and Haggard employed strong, intelligent protagonists who are forced to make moral choices in exotic environments. All of Ballard's early novels are variations on that theme.

The Crystal World is the most fantastic of Ballard's environmental apocalypses. It suggests the possibility of living plants and animals being transformed into a mineral-like substance as well as the possibility of the distortion of time. On the other hand, it is also one of Ballard's most insightful climate-disruption novels, in that it directly links climate disruption to the spread of disease, a concern of many scientists studying the possible effects of climate change.

The Crystal World borrows both structure and form from Joseph Conrad's famous *Heart of Darkness*. In that novel, Conrad sends his narrator on a quest to the Belgian Congo in search of a mysterious station manager named Kurtz. On the journey into the depths of the jungle, the narrator not only learns about the racism and violence inherent in colonialism but also a great deal about himself. *The Crystal World* is a similar journey of discovery in which Dr. Edward Sanders, a British physician, also learns a dark and dangerous secret about the nature of the world he thought he knew.

Sanders, like the heroes of other quest narratives, receives a call to adventure, in this case strange letter from his mistress, Suzanne Clair, with whom he had been working in a leper colony in West Africa. Clair writes that she and her husband are leaving to work at a small clinic in the interior of Cameroon. Fearing that Clair may have contracted leprosy, Sanders follows, only to find more obstacles in his path. At Port Matarre, Cameroon, he finds the town almost empty, and no one seems willing to take him upriver to Mount Royal. He hears that there is a new viral plant disease and that the military has closed much of the interior. While waiting for transport, Sanders encounters an odd assortment of people, including Father Balthus, a priest returning to his jungle mission; Thorensen, a mine owner; Radek, a military physician; and Ventress, an architect who is on his way to meet his estranged wife, who is suffering from tuberculosis. All are desperate to go upriver into the jungle despite the potential danger for what they consider to be important reasons.

What follows takes on the appearance of a dream or a nightmare. While journeying upriver and farther into the jungle, into the "heart of darkness" in Joseph Conrad's terms, the travelers discover Indigenous people fleeing, a body in the river whose arm is encrusted with crystals, and plants that are becoming crystalized. Characters respond in different ways to the unsettling phenomenon. Father Balthus doubts his faith as he gets closer to Mount Royal. Ventress becomes excited at the prospect. Thorensen becomes morose. And Sanders appears edgy and uneasy. They also notice that being near the crystallization distorts time and perception. All of the characters feel that time slows down and that their senses of hearing and sight become sharper, as if they are sharing in taking some exotic drug.

As the characters share their experiences, they discover that outbreaks of crystallization have appeared elsewhere around the world, including in the Soviet Union and the Amazon basin. Faced with the unexplained phenomenon, Father Balthus sees in crystallization a perfect communion with Christ and accepts his fate by embracing his crystallization. Ventress and his dying wife accept their crystallization to put an end to the spread of disease, as does Clair, who does have leprosy. Despite the strange psychological and physical attractions of the crystallizing landscape, Sanders decides to leave the forest and head back to civilization. He does not reach it, however. At the end of the novel, he returns to the crystallizing forest to accept whatever fate awaits him, having found life meaningless without the distortions of space and time and his senses.

Recent critics and readers have responded more favorably to *The Crystal World* than did readers upon its publication, many of whom saw it as little more than a science fiction adventure laced with the language of drug use. However, in light of the new critical awareness of climate change and its impact, readers

have found *The Crystal World* more accessible and significant. One of the more significant impacts of climate change is the increased probability of the spread of disease as well as the unfortunate appearance of new diseases. *The Crystal World* can be read as a metaphor for the spread of contagion throughout the changing world. In addition, several recent theories of climate change suggest that the world is a self-regulating system and that humanity is the disease infecting the planet, climate change being the earth's response to that infection. Applying the Gaia hypothesis, which suggests that the biosphere is such a self-regulating system that has evolved and responded to various crisis through time, to *The Crystal World* makes for a clearer reading of the text. It is certain, however, that any reading of text must take into account the fact that Ballard clearly indicates the world is going through a rapid physical change and that humanity's days are numbered.

See also: *Burning World, The*; *Drowned World, The*; *Eden*; *Oryx and Crake*; *Wind from Nowhere, The*

Further Reading

Conrad, Joseph. *Heart of Darkness*. New York: W. W. Norton, 2016.

Luckhurst, Roger. *The Angle between Two Worlds: The Fiction of J. G. Ballard*. Liverpool: Liverpool University Press, 1998.

Stephenson, Gregory. *Out of the Night and into the Dream: A Thematic Study of the Work of J. G. Ballard*. New York: Greenwood Press, 1991.

D

DAY AFTER TOMORROW, THE

The Day after Tomorrow (2004) is an apocalyptic climate change adventure film directed by Roger Emmerich. The film was adapted from *The Coming Global Superstorm* (1999) by Art Bell and Whitley Strieber, which argues that global climate change could have a major impact on both the Gulf Stream and the North Atlantic Drift. More fresh water from melting ice caps would disrupt the thermohaline circulation that drives the Gulf Stream, bringing warm water north and sending cold water south around the world. Global warming could have the effect of shutting the North Atlantic Drift and causing the Gulf Stream to cease functioning. The result would be twofold: a long-term catastrophic rise in the sea level and a dramatic and drastic drop in temperatures throughout the Northern Hemisphere. The film builds on the ideas of Bell and Strieber and dramatizes them in a worst-case scenario.

The Day after Tomorrow, starring Dennis Quaid, Jake Gyllenhaal, Ian Holm, Emmy Rossum, Kenneth Welsh, and Sela Ward, was a major Hollywood production released by 20th Century Fox with a budget of $125 million. The film was a financial success, generating over $550 million in ticket sales worldwide and garnering accolades for its special effects. Its scientific accuracy was questioned, however.

The film opens with a classic confrontation between science and politics. Paleoclimatologist Jack Hall (Quaid) has been working for the National Oceanic and Atmospheric Administration (NOAA) on the Larsen Ice Shelf in Antarctica when a major portion of the ice breaks away. Hall's computer climate models suggest that global warming caused the break and that the resulting increase of fresh water into the world's oceans will impact the Gulf Stream in such an immediate and dramatic way that a new ice age will occur. He makes that announcement at a climate conference in New Delhi, but his warnings are immediately dismissed by the American vice president (Welsh), who says that the American economy is as fragile as the environment; he calls Hall's predictions "sensational." However Terry Rapson (Holm), a Scottish oceanographer, confirms Hall's observations.

Soon a massive superstorm begins to develop in the Northern Hemisphere. The storm breaks into three parts: one over Siberia, one over Scotland, and one

over Canada. Working to create a vacuum, the storms pull frigid air from three miles above the earth's surface into the eyes of the storms, flash freezing everything caught in the storms' eyes as temperatures drop to 150 degrees below zero Fahrenheit. The results are catastrophic. Tokyo is hit with a giant hail storm, Nova Scotia endures a twenty-five-foot storm surge, and Los Angeles is destroyed by massive tornadoes. On a more personal level, a three-helicopter team attempting to rescue the British royal family from Balmoral Castle in Scotland crashes, killing all aboard.

In the United States, the president of the United States meets with Hall and upon Hall's recommendation orders all flights across the country grounded. In addition, he advises people in the northern sections of the country to shelter in place, knowing that most will likely die because there is not enough time or equipment to evacuate or rescue them. Finally, realizing how desperate the situation is becoming, the president orders all people in the southern United States to evacuate to Mexico. Soon afterward, the president dies when he is frozen in a motorcade leaving Washington, DC.

The film then turns personal, as Hall decides to go to New York City in an attempt to rescue his son and his wife, Lucy (Ward). Although the attempt is nearly impossible and the idea absurd, an adventure film, even an apocalyptic one, must have a rescue narrative. Hall's son, Sam, and his friends are in New York for an academic decathlon. At first, they heed Hall's advice and shelter in the main New York Public Library building on Forty-Second Street and Fifth Avenue, where they stay warm by burning books.

New York City is devastated, as it often is in other popular dystopian climate change narratives, such as *New York 2140* and *Odds against Tomorrow*. First, people are killed as the city experiences massive flooding, and then the flash freeze hits, turning the water into ice, millions more die. Sam remains safe while his mother, a physician, remains at City Hospital taking care of a child suffering from cancer. Hall and two colleagues manage to walk and drive through the flash-frozen East Coast in three days, saving Sam, his girlfriend, Lucy, and her patient.

The film ends with the once climate skeptical vice president assuming the presidency after the president's death. Addressing the nation on the Weather Channel from the U.S. embassy in Mexico City, the new president apologizes for his ignorance of climate science and promises to send helicopters to pick up Americans in the northern states who survived the freeze. The final scene in the film shows astronauts in the International Space Station watching as ice sheets expand over the Northern Hemisphere of the earth.

The Day after Tomorrow, despite its popular success, received mixed reviews from critics. The special effects in the film, especially those showing the destruction of New York City by water and ice as well as the destruction of Los Angeles

by tornadoes, were universally praised. The film reviewers' consensus was that the film was enjoyable entertainment, but the dialogue and science left a good deal to be desired.

The film engendered a good deal of scientific and political commentary as well. A number of conservative pundits observed that the depiction of an ineffectual president and a science-denying vice president were criticisms of the Bush administration's position on climate change led by Vice President Dick Cheney, a charge that the director of the film did not deny. Climate change skeptic Patrick J. Michaels called the film "propaganda." Scientific critics also took issue with the film. Several noted that they were pleased that a major motion picture took up the issue of climate change, but they were concerned that the science was inaccurate. Writing in *The Guardian*, environmental activist George Monbiot called *The Day after Tomorrow* "a great movie and lousy science."

The Day after Tomorrow might have been the first time many viewers had an opportunity to see what climate change might be like, even if it was in a sensational and highly fictitious form. The speed with which the climate changes and the nature of worldwide climate destruction in *The Day after Tomorrow* were necessitated by dramatic conventions rather than scientific accuracy. Director Roland Emmerich had set out to create an exciting disaster film, as he had in *Independence Day* (1996) and *Godzilla* (1999). Climate change, even at the advanced rate it is progressing today, is a much slower phenomenon than can be captured in a two-hour disaster film in which probability takes a back seat to spectacle. Nevertheless, audiences were introduced to the fact that climate change is real, that the polar ice sheets are threatened, and that thermohaline circulation is real and has a significant impact on climate, for good or ill.

See also: *Colony, The*; *Fifty Degrees Below*; *New York 2140*; *Odds against Tomorrow*; *Six Degrees*; *Snowpiercer*

Further Reading

Bell, Art, and Whitley Strieber. *The Coming Global Superstorm*. New York: Pocket Books, 1999.

Ebert, Roger. "*The Day after Tomorrow* Movie Review." *Chicago Sun Times*. May 28, 2004.

Monbiot, George. "A Hard Rain's A-Gonna Fall." *The Guardian*. May 14, 2004.

DISASTER'S CHILDREN

Disaster's Children (2019) is a climate change romance by Emma Sloley, the former editor of *Harper's BAZAAR Australia* before she moved to New York City to focus on travel writing. The novel is set in a private ecologically sound sanctuary

in Oregon, where wealthy inhabitants have established a ranch as a refuge from the climate change ravages taking place in the outside world, known as the "Disaster." Secure in their upper-class preserve, the original members enjoy privacy and security, but they worry that there may not be enough younger members willing to join the community to ensure its long-term survival.

The protagonist of the novel is Marlo, the twenty-five-year-old daughter of rich and indulgent parents. Adopted from China when she was fourteen months old, Marlo enjoys the security of the sanctuary, but she wonders how her best friends, Alex and Ben, are doing since they left the sanctuary to become climate change activists. As the novel opens, Marlo is planning to leave the ranch for a time to work with her friends in the real world. One morning, as she is checking the perimeter of the ranch on her four-wheel-drive vehicle, Marlo discovers a dead bald eagle. Soon others are found on the ranch. The ranchers dutifully report the dead birds to state officials and then resume their comfortable lives of community dinners, weekly cocktail hours, lawn bowls, and gentlemanly farming.

Shortly before Marlo is to leave to join her activist friends, a young stranger named Wolf appears at the ranch and is taken in. Unlike other would-be ranchers, who were required to pay a significant initiation fee and be willing to live on the ranch for an extended period of time as probationary members, Wolf is quickly given a job as a beekeeper and urged to stay. Unlike the few other young people on the ranch, Wolf is neither wealthy nor educated, and his position as an outsider makes him attractive to Marlo.

Outside the ranch, climate change continues, while inside, most ranchers avoid the internet, letting Kenneth, another of the younger ranchers, provide weekly summaries of the ecological and economic problems occurring in the outside world. In his weekly reports, Kenneth describes that sea rise has made much of Miami uninhabitable, increased acidity in the ocean has led to a prohibition on fishing in the North Atlantic, and cattle have been dying off in the Midwest. Most of the ranchers congratulate themselves on leaving the Disaster when they did, trusting that their financial security and geographical isolation will keep them safe.

Sloley balances her secondhand depiction of the world changing for the worse and the complacency of most of the ranchers with her description of the growing romance between Marlo and Wolf. She successfully builds upon the romance narrative stereotype of the good girl falling for the boy with a questionable past as she describes Marlo's attraction to Wolf and her introducing him to the accepted, and often unspoken, codes of conduct on the ranch. As Marlo grows closer to Wolf, she begins to think that the timing of his appearance at the ranch is somewhat suspicious, as it occurred just prior to her planned date to leave the ranch. Nevertheless, as they spend more time

together, and with the enthusiastic support of Marlo's parents, they begin to plan to marry and raise a family on the ranch.

Their relationship changes, however, when during a trip into a nearby town to buy supplies, Wolf is arrested by the police. After his release, Marlo's parents hide him in the family's bomb shelter when California State Police arrive to arrest him for suspicion of murder. After her parents arrange for the charges to be dropped, Marlo discovers that her parents had invited Wolf to come to the ranch in the hope that Marlo would be attracted to him and agree not to leave. Her parents admit that they had hoped she would fall in love with Wolf, who was the son of their friends who had planned to join the ranch when it was developed but decided not to at the last moment. Feeling manipulated, Marlo becomes estranged from Wolf, but events in the world outside of the ranch soon bring them together again.

The first event occurs when a herd of cattle from a neighboring ranch sickens and dies. Several of the infected animals had wandered onto Marlo's ranch, and in response, the ranchers decide to build a wall around the ranch. In much climate change fiction, walls are believed to be a cure for many climate and cultural ills. Next, Marlo's friends in the outside world, who had been volunteering on a Greenpeace ship attempting to block illegal cod fishing in the North Atlantic, text Marlo and tell her that there was no confrontation because the outlaw fishing fleet found there were no fish at all on the Grand Banks; climate change–driven increases in the Atlantic Ocean's acidity had wiped out the fish. Finally, Wolf reports reading on the internet that massive crop failures had occurred throughout the world, as genetically engineered plants had failed dramatically worldwide. In addition, the Svalbard Global Seed Vault on the island of Spitsbergen, in Norway, was raided. News reports are unsure whether the raiders were ecoterrorists or thieves wanting to sell the stored seeds to the highest bidder.

Faced with the cascading disasters, Marlo and Wolf decide to act and contact Marlo's off-ranch friends. They then break into the ranch's own seed bank, which contains unmodified seeds. They steal one of the ranch's vehicles and leave the ranch, planning to meet with Alex and Ben and provide seeds for a starving world.

Disaster's Children is a romance, and as such, it is inevitable that the young lovers should, after overcoming obstacles, find happiness in each other and a cause greater than themselves. Saving the world from starvation is not a bad start. *Disaster's Children* is more than a romance, however; it is a cleverly written critique of the response of many well-intentioned people in first world countries who are aware of the coming impact of climate change but do little to prevent it.

The founders of the ranch were environmentalists. They were aware of the impending catastrophe, but instead of trying to confront the problem, they

chose to remove themselves from the world, hoping to ride out the coming storm in as much comfort as possible. Wealth and privilege allowed them to create an almost self-sustaining community to avoid the worst catastrophes of climate change. They could not escape the real world completely, as outside workers had to actually build the wall and a nearby town supplied many necessities, but they tried. They even voted down a plan to build a golf course on the ranch as a bit ostentatious.

It was the children of the founders, however, who decided that they could not retreat from worldwide climate change. As the title of the novel suggests, it is up to the children of those who lived through the beginning of climate change, and often benefited from it, to try to mitigate its impact. This is a lesson suggested by a number of other climate change narratives.

See also: *Carbon Diaries 2015, The*; *Children's Bible, A*; *Clade*; *History of Bees, The*; *Oryx and Crake*

Further Reading

Mehnert, Antonia. *Climate Change Fictions: Representations of Global Warming in American Literature*. New York: Palgrave MacMillan, 2016.
Sloley, Emma. "About." Retrieved May 22, 2021. https://emmasloley.net/about

DROWNED WORLD, THE

The Drowned World (1962) is the second of a series of four environmental disaster novels by British author J. G. Ballard, best known for his semi-autobiographical novel *Empire of the Sun* and *Crash*, a novel about the psychological attraction of car crashes that was made into a feature film by David Cronenberg in 1996. In the series, Ballard employs the conventions of the British science fiction/adventure narrative structure made popular by H. G. Wells and H. Rider Haggard to examine the issues of climate change and its effects on human behavior. Wells and Haggard employed strong and intelligent protagonists who were forced to make moral choices in exotic environments. All of Ballard's early novels are variations on that theme.

The Drowned World is set in London in the year 2145, when accelerated global warming has turned the world into a wet, heated jungle biosphere not seen since the end of the Triassic period. Robert Kerans, the protagonist of the novel, is a research biologist who was sent as part of a scientific team to map the changes in animal and plant life that have occurred in what is now a ruined city in the middle of an expanded swamp that was metropolitan London. Kerans notices that the environment has a strange effect on human behavior. He observes that many members of his research time have begun to fall silent for periods of time, losing interest in their work and becoming listless. When one

of the other team leaders abandons his work and walks into the swamp, Kerans's search team is unable to find him. Soon after, most of the team is evacuated and taken north to the Arctic Circle, the only temperate zone left on the planet, a common trope in many novels set in a time of rapid global warming. Kerans remains, along with another scientist, Dr. Bodkin, and a beautiful and mysterious woman named Beatrice Dahl, whose presence is primarily necessitated by the plot.

Kerans, Bodkin, and Dahl live in three high-rise apartments that remain above water in different parts of what was once London. Most of the time, they remain alone, but they occasionally visit one another and talk about the nature of the global change and its impact on people. All three feel both the attraction and the repulsion of the new and frightening environment. They all agree that the change is probably permanent and realize that the new normal is life without cities, states, economies, or even the rudiments of civilization. Kerans is primarily concerned about the devolution of humanity, and he wonders whether the few remaining people will eventually throw off rationality and simply walk into the swamp. Bodkin, on the other hand, is more concerned about the facts of their situation. He records increases in temperature and the appearance of tropical plants and animals in what was once England. Dahl acts as a foil between the two men.

The psychological and scientific debates end with the appearance of a team of pirates led by a man called Strangman, who plans to loot the treasures that exist below the waterline of London. Ballard describes Strangman as the antithesis of Kerans. Whereas Kerans is so focused on trying to understand the impact of the climate change on himself and others that he is almost unable to act, Strangman, who controls his band of pirates through fear and intimidation, is willing to destroy anyone or anything that gets in his way. At first, Strangman has his crew members dive for valuables left behind after the flooding of London. When that fails, he convinces Bodkin to help him drain the city with pumps and temporary dams to expose the remains of the city.

After watching Strangman and his crew ransack museums and galleries, Bodkins regrets his help and attempts to destroy the temporary dams holding the water outside the city center. He fails. Enraged, Strangman kills Bodkin and takes Dahl captive. Kerans attempts to rescue Dahl but is himself taken captive. Strangman and his crew then parade Kerans through the city streets at night in a distorted version of an evening carnival parade, complete with masks and torches. In a nightmarish scene similar to that at the inner station near the end of Joseph Conrad's *Heart of Darkness*, Kerans is tortured, mocked, and about to be killed or sacrificed; the motivation behind the crew's almost ritualistic behavior is never completely explained. At this point, an army unit appears and saves Kerans. Having no reason to prosecute Strangman, other than Kerans's

word that he is a murderer and a pirate, they release him and leave. Disgusted and disturbed, Kerans blows up the dams and drowns Strangman and his crew. Feeling the same sense of listlessness and unease that he felt at the beginning, Kerans walks away from the reflooded London and into the swamp, hoping for isolation after the hysteria of recent events.

The Drowned World is often cited as one of the earliest and most influential climate change novels. In it, Ballard creates a far more sophisticated narrative than he did in his earlier climate disaster novel, *The Wind from Nowhere*. Rather than providing the background for an adventure story, the climate change in *The Drowned World*, global warming and flooding, is both potentially realistic and put into a context of geological time. In addition, Ballard explores the psychological and emotional responses of his characters to climate change in a way he does not in his previous work.

Critical reaction was mixed when *The Drowned World* first appeared. Ballard was both praised for creating a work with impressive power as well as criticized for writing a cheap thriller. Recent critics, aware of the real possibility of climate change, have been far more receptive to *The Drowned World* in particular and Ballard's writing as a whole. The novel has been praised as a creation of a desperate dystopia that challenges human perception, and his characters have been appreciated for their ability or inability to survive in liminal states.

Finally, echoes of Ballard's drowned London can be found in the depiction of other cities inundated by climate change, such as Kim Stanley Robinson's *New York 2140* and Nathaniel Rich's *Odds against Tomorrow*.

See also: *Burning World, The*; *City Where We Once Lived, The*; *Crystal World, The*; *Flood*; *New York 2140*; *Odds against Tomorrow*; *Wind from Nowhere, The*

Further Reading

Conrad, Joseph. *Heart of Darkness*. New York: W. W. Norton, 2016.
Luckhurst, Roger. *The Angle between Two Worlds: The Fiction of J. G. Ballard*. Liverpool: Liverpool University Press, 1998.
Rossi, Umberto. "Images from the Disaster Area: An Apocalyptic Reading of Urban Landscapes in J. G. Ballard's *The Drowned World* and *Hello America*." *Science Fiction Studies* 62 (March 1994): 81–97.
Stephenson, Gregory. *Out of the Night and into the Dream: A Thematic Study of the Work of J. G. Ballard*. New York: Greenwood Press, 1991.

DRY

Dry (2018) is a young adult climate change novel by Neal Shusterman and his son, Jarrod Shusterman. Neal Shusterman is the author of over twenty-five young adult novels and the winner of the 2015 National Book Award for Young

People's Literature for *Challenger Deep*. Jarrod Shusterman is the author of the short story "Undevoured," and he has written for television and film. *Dry* is set in the near future, when the ongoing drought in the American Southwest has worsened and a climate change–induced super hurricane has hit the United States.

Dry begins as the water fails in the Southern California suburban home of sixteen-year-old Alyssa Morrow. The Morrow family learns on the news that the governor of Nevada has ordered that water from the Colorado River not be sent to California, a violation of the Colorado River Compact of 1922 that regulates water use throughout the American Southwest. Nevada, like California and other areas of the Southwest, had been suffering from a long climate change–induced drought. Later that day, instead of writing a paper for school on William Golding's dystopian novel *Lord of the Flies* (1954), a reference to the dystopia that Alyssa will find herself in, Alyssa and her brother, Garrett, drive to the supermarket in search of water and find none. Instead, they buy bags of ice to take home. Meanwhile, Alyssa's teenage neighbor, Kelton, is prepared for the event, as his father is a survivalist who has stored water, food, and medicine. He also built a safe room in his house and a bug out shelter in a national park and is well armed. Kelton's father taught him that people are sheep, wolves, or herders, and Kelton definitely wants to be a herder.

Because most of the United States and FEMA (the Federal Emergency Management Agency) are focused on the ongoing disaster of Hurricane Noah, occurring far away from California, there is little notice or response outside of Southern California, the area hardest hit by the water shortage. Kelton's father once told him, "It takes three days for people to become animals." *Dry* shows how that happens.

Dry dramatizes how quickly civilization can turn into chaos. At first, people in Alyssa's neighborhood wait for the water to return. Then they stock up on what little remains. Next, they organize a neighborhood meeting. Finally, they become a mob and attempt to break into Kelton's house, knowing that his father has been prepared and has stockpiled food and water. Facing the mob, Kelton's father, despite years of preparation in becoming a survivalist, is unable to fire upon his neighbors, and his supplies are stolen. Alyssa's parents go to a nearby desalinization plant in search of water but fail to return. Perhaps because this is a young adult novel, Alyssa, Garrett, and Kelton are forced to save themselves, if they are to be saved.

The three young people attempt to flee to Kelton's family's bug out shelter, but they soon get caught up in a massive traffic jam as people attempt to find water or leave California. They are joined by nineteen-year-old Jacqui, who had attended the same high school as Alyssa and Kelton and has been living on her own for several years. She helps them save their car from thieves and

rides with them to a gated community in the hills in search of Alyssa's uncle, Herb, who has dysentery from drinking untreated wastewater. They exchange their car for their uncle's truck, and while still within the gated community, they come upon another teenager, Henry, who is selling Aqua Viva, flavored bottled water, from his parents' home at exorbitant prices. He joins the four, and together they continue their journey to the shelter.

The five young people drive on Southern California back roads to avoid being shuttled into massive evacuation areas where water is promised but rarely delivered. Along the way, they stop near a freeway to siphon gas from abandoned cars and come across a group of young people who have no water but share banana Moon Pies they have liberated from an abandoned truck. Kelton calls the group "Charity's Freeway Commune," after Charity, the group's leader. Their next stop is less lighthearted. Later that night, a group of skinheads occupies a barricade on the road and stops the car, threatening to rape Alyssa and Jacqui. Kelton manages to call on his father's survivalist training and shoots two of the skinheads, killing them and scattering the others. They move the barricade and drive on.

The next day, they leave the road and drive on paved riverbeds into the hills, where they must abandon the truck and follow forest paths on foot. They eventually reach the bug out shelter, which Kelton's father had prepared and stocked in case of just such an apocalyptic event as California had been experiencing. They find it has been broken into. The food, water, and medicine are gone. Later, they learn that Kelton's older brother had been living there and had used up all the supplies.

Because of the drought and heat, fire season has been raging in Southern California, and the dehydrated young people begin to hike higher in the hills in hopes of finding water in a lake with water reserved for air tankers to scoop water for forest fires. As they hike through the woods, they see ash falling from the sky like snow and realize that a fire is moving toward them from below. As they reach the lake, however, they see a PBY Catalina Waterbomber loading water. The pilot of the plane sees them as he is leaving the lake, and although he has orders to transport the water to a specific target, he drops it on them, saving them from the fire.

Dry ends six weeks after the weekend when the taps in Southern California ran dry. With the assistance of FEMA and the California National Guard, order has been restored, and water is again flowing. Alyssa, Garrett, and Kelton are home with their families. Jacqui is in the hospital but is recovering. Henry, whose name is not Henry, is on television claiming to have rescued a group of people from a burning building in a town while he was with the others in the forest. Although Kelton's parents are divorcing and many houses in the

neighborhood are for sale, Alyssa and Kelton are happy to be alive and looking forward to life.

Young adult novels tend to have happy endings, and for the main characters in *Dry*, there are happy endings and futures to look forward to. The Shustermans also include a hint that Kelton and Alyssa might begin dating. However, as in many adult climate change narratives, the problems of drought, ocean rise, and superstorms still exist. Despite the happy ending, *Dry* is more realistic than many other young adult climate change narratives. Partly because it is set in the very near future, when the first effects of climate change have just begun to be felt, the solutions to the problems faced by the characters appear possible. The catastrophes depicted in many other climate change narratives, worldwide inundations equaling that of the Noah's ark narrative, for example, seem the subject of science fiction or horror. *Dry* also suggests that some ways to lessen the impact of climate change, such as the development of desalinization plants, the use of electric vehicles, and conservation, are available but have not been widely used.

Other writers have explored the possibility of dramatic droughts in the American Southwest caused by climate change. Two of the best known are Paolo Bacigalupi's *The Water Knife* (2015) and Claire Vaye Watkins's *Gold Fame Citrus* (2015). Both explore the impact of drought after it has wreaked havoc on the American Southwest. In *Dry*, Neal and Jarrod Shusterman suggest what it may be like as it begins.

See also: *Burning World, The*; *Chinatown*; *Gold Fame Citrus*; *Grapes of Wrath, The*; *Water Knife, The*

Further Reading

DeBuys, William. *The Great Aridness: Climate Change and the Future of the American Southwest*. London and New York: Oxford University Press, 2011.

Ingram, B. Lynn, and Frances Malamud-Roam. *The West without Water: What Past Floods, Droughts, and Other Climate Clues Tell Us about Tomorrow*. Berkeley: University of California Press, 2013.

E

ECOTOPIA

Ecotopia (1974), written by Ernest Callenbach, is a utopian novel that describes the visit of New York newsman William Weston to the country of Ecotopia. That country consists of Washington, Oregon, and Northern California, which seceded from the United States in 1974 to establish a nation based on sound ecological principles. Although written before the concept of human-induced climate change became known, *Ecotopia* is now considered one of the first works of fiction to critique worldwide ecological damage caused by humans and suggest a possible alternative. Callenbach is often cited as one of the founders of climate change fiction, and his ideas have been influential in both the American counterculture and the green movement.

The full title of Callenbach's novel is *Ecotopia: The Notebooks and Reports of William Weston*, and the title aptly describes the structure of the novel. In 1999, reporter William Weston is the first major reporter from the United States permitted to enter Ecotopia since the war of independence in 1974. Both the U.S. government and the Ecotopian government agree to Weston's visit, as citizens in both countries are curious about life in the other, and both governments believe Weston's visit could serve as an opening for potential further discussions between the two countries.

Weston is skeptical about life in Ecotopia when he enters the country west of Reno, Nevada. In Tahoe, California, he boards an express train to San Francisco, after having to surrender his .45-caliber automatic, a standard clothing option in the New York of the future because of urban crime, as concealed firearms are not permitted in Ecotopia. On the train, Weston begins to realize just how different life in Ecotopia is. In his passenger car, he discovers there are no seats. Passengers sit on bean bags, pillows, or blankets on the floor. Large recycling bins are stationed at the end of the car, and floor-to-ceiling windows allow passengers a full view of the Cascade Mountains. As the train, which can travel at 360 kilometers an hour (250 mph)—the Ecotopians use the metric system—moves smoothly and silently, powered by electromagnets, Weston smells marijuana, which is legal in Ecotopia. Nearing San Francisco, Weston notices that the roads are small and that there were no gas stations or billboards. His immediate thought is that the country looks poor.

Weston is also surprised when he arrives in San Francisco. The first thing he notices is the absence of noise. There are no cars in the streets; instead, small electric taxis, buses, and carts move people and products through streets that have been turned over to pedestrian traffic and malls. Market Street, the main thoroughfare of the city, has become a park with a creek running down its center. He sees many white stands with free-use bicycles. He observes that the city's office high-rise building have been turned into apartments, and the outlying suburbs have been abandoned and turned into public land. Weston is equally surprised by the Ecotopians' clothing. He sees no suits or ties; both men and women wear dark-colored pants with ponchos made with natural fabrics, as Ecotopians eschew synthetic fabrics.

Weston's first report from Ecotopia focuses on agriculture, which has changed drastically since independence. The first major change was to put the new nation's food cycle on a stable-state basis. Food waste, sewage, and garbage are turned into organic fertilizer, and household waste is divided into compostable and recyclable categories. Farm animals live in as close to a free-range state as possible, increasing the production of fertilizer. The environmental damage caused by chemical fertilizers has thus been mitigated. As a result, all Ecotopian food is organic. In addition, many packaged and processed foods have been outlawed.

Transportation, housing, and work in Ecotopia have also been radically transformed with the creation of "minicities" throughout the country. Most of these communities are within a short rapid-transit ride from a major city, and each includes a factory, housing, schools, restaurants, and parks. No house is more than a half mile from a transit hub. As a result, there is no need for personal transportation, and so carbon emissions have been dramatically reduced as well as the need for large parking lots that cause stormwater runoff and pollute local streams and rivers.

Clean energy is equally important to the Ecotopians. As a result, the use of fossil fuels is prohibited, save for a few large diesel fuel trucks used in logging. Solar, wind, and thermal power provide electricity for the country, and reducing carbon emissions and creating thousands of jobs during the transition.

Weston entitles one of his reports back to his New York paper as "The Unsporting Life of Ecotopia." In it, he asserts that sports fans would have a miserable time in the new nation, as there is no school, college, or professional baseball, basketball, football, or ice hockey. Instead, he writes, people participate in individual "odd ball" sports, such as hiking, camping, hunting, fishing, and chess. In a similar vein, he observes that Ecotopian television has few nationally popular programs; instead, it provides many local channels as well as channels for conducting business and personal meetings. All programing is available on individual portable video telephones. The Ecotopians, it appears, invented both the internet and the cell phone.

Perhaps the most significant change made by the Ecotopians is what Weston calls "the revision of the Protestant work ethic upon which America had been built." After it became independent, Ecotopia experienced a drop in the gross national product by as much as one-third. It responded by introducing a twenty-hour work week that had major philosophical and ecological implications. Weston writes,

> Mankind, the Ecotopians assumed, was not meant for production, as the nineteenth and early twentieth centuries believed. Instead, humans were meant to take their modest place in a seamless, stable-state web of living organisms, disturbing the web as little as possible. This would mean sacrifice of present consumption, but it would ensure future survival—which became almost a religious objective, perhaps akin to earlier doctrines of "salvation."

This idea of ecological survival permeates everything Weston sees in Ecotopia and provides a contrasts to Weston's America of 1999 as well as the world facing the crisis of climate change today.

This concept of ecological survival created opportunities to transform two other sectors of Ecotopian life: education and medicine. In education, Ecotopians believed in lifelong and self-directed curricula. Schools, primary, secondary, and college, were small and readily available, and students were encouraged to follow their interests. As most people in Ecotopia would change jobs several times in their lives, people were encouraged to return to school to learn new skills. The result, Weston writes, is a well-educated and well-informed populace.

Medical care in Ecotopia is free and universal, a controversial idea in the United States then and now. In addition, most doctors are generalists rather than specialists, as Ecotopians believe that early access to health services creates a healthier population and reduces the need for major research hospitals and numerous medical specialists. Weston writes that he is surprised by the general good health of the Ecotopians he meets.

Ecotopia contains more than Weston's reports to his paper in New York; he also includes his diary, which is far more personal. In it, he describes his changing feelings toward Ecotopia and its citizens, especially one young woman, Melissa Brightcloud, an attractive, athletic young woman who is a member of the steering committee of one of Ecotopia's many logging camps. Timber is a major industry in Ecotopia, but like education and medicine, it is locally organized and run. Weston describes that the loggers have almost personal relationships with the trees they harvest. They refuse to clear-cut the forests, instead selecting individual trees to cut. And when they do begin to harvest trees, Weston writes that the loggers seem to have conversations with the trees,

almost as if they are thanking them for their service. As Weston lives and works with the loggers as part of his stay in Ecotopia, he is expected to share in the work he observes, and he develops a relationship with Melissa Brightcloud. As he grows closer to her, his attitudes toward Ecotopia change. He becomes more understanding and appreciative of what the breakaway country has accomplished in one generation.

Eventually, Weston interviews some of Ecotopia's military, and he discovers how the small nation won its independence. Responding to what was perceived as industrial capitalism's control of the American government and the resulting destruction of the environment, Northern California, Oregon, and Washington seceded from the Union. As they had in a previous civil war, military from the seceding states liberated weapons from the federal government. In response, the U.S. military launched a helicopter war, sending thousands of helicopters from neighboring states and ships in the Pacific. Weston writes that Ecotopians, armed with rocket-propelled launchers, brought down over 8,000 U.S. helicopters, imagining the kind of war that occurred in Iraq, twenty-five years before 9/11. What actually stopped the war, he is told, was when the Ecotopian government informed the U.S. government that nuclear devices had been planted in major American cities prior to secession. The result was twenty-five years of isolation and peace during which Ecotopia developed its social and economic systems.

In his diary, Weston describes participating in a mock warfare ritual for young men that only occurs near the winter and summer solstices. "Tribes" of young men, usually coworkers, share in drinking a concoction that contains both alcohol and stimulants. Then they line up in battle formation with wooden spears and engage in something similar to a rugby scrum. The fighting only stops when a member of one of the teams is seriously injured. The women watch. The ritual, Weston is told, is to release male aggression as well as build group loyalty.

Weston is uncertain when his time to leave Ecotopia approaches. He does not know whether he should stay or return to New York. Surprisingly, after meeting with the Ecotopian president, he is kidnapped. Taken deep into the woods, he is compelled to endure spirited conversations, long soaks in hot tubs, and many bottles of wine. Finally, Melissa Brightcloud appears, and after making love with her Weston decides to stay in Ecotopia.

Ecotopia could be described as a dream state of the 1960s counterculture. Blue jeans and ponchos abound, marijuana is legal, the air is clear, and the streams are unpolluted. Health care and education are free, and power has devolved to the people. Problems do exist in the novel that are reflective of the time of the book's composition. The first is the problem of race, which remains

unsolved. Weston writes that after secession, members of the African American community established their own semiautonomous state called Soul City in Oakland. Similarly, members of Ecotopia's Asian American community were considering establishing their own state as well.

An equally significant problem is the issue of gender. Although women have leadership roles throughout the country, Weston's description of the ritual war games and their significance indicates that Ecotopians believe in crucial biological and social differences between men and women. In matters of race and gender, Ecotopians are essentialists, believing that categories of people, such as men and women, gay and straight people, and members of ethnic groups, have intrinsically different natures or dispositions.

Ecotopia was not a success upon publication. Callenbach initially self-published the novel in 1975 before it was picked up by Bantam Books in 1977. Initial reviews were mixed. Ralph Nader praised the book, noting that the technology already existed to make the transformations described in the novel possible. British critic Don Milligan noted that the ideas were outworn and the novel was a "flawed vision of a flawed future."

With the growing awareness of climate change and its impact on the environment, readers have returned to *Ecotopia*, seeing in it a possible outline of a solution to increases in greenhouse gases and the resulting impacts of global warming. In addition, contemporary readers see the novel as a prophetic statement of the rise of the new counterculture centered in Portland, Oregon, and Seattle, Washington.

Ecotopia does create a picture of a society in which the ecological practices that cause climate change have been addressed, and it does so by suggesting that such change could take place without imposing authoritarian laws, if people are committed to change. The novel also suffers from one of the flaws of any utopian text. Because *Ecotopia* describes such a good place, like Thomas Moore's original *Utopia* (1516) and Edward Bellamy's popular *Looking Backward* (1888), there is little conflict or drama in the narrative. Dystopias, or narratives about bad places, are much more dramatic, as Margaret Atwood's *The Handmaid's Tale* (1985) and Cormac McCarthy's *The Road* (2006) clearly indicate.

See also: *American War*; *Barkskins*; *Friend of the Earth, A*; *Handmaid's Tale, The*; *Overstory, The*; *Road, The*; *Sherwood Nation*

Further Reading

Tenner, Edward. "'Ecotopia': The Story of the Little Book That Could." *The Atlantic.* April 27, 2012.

Timberg, Scott. "The Novel That Predicted Portland." *New York Times.* December 12, 2008.

EDEN

Eden (2020), by British author Tim Lebbon, is a dystopian climate change thriller. It is set in the near future, after world governments, in response to catastrophic environmental degradation and climate change, have set aside huge wilderness preserves, forbidding all human entry. Lebbon, a prolific writer of fantastic, horror, and science fiction narratives, may be best known for two film adaptations of his work that were made into feature films, *Pay the Ghost* (2015), based on a short story of the same name, and *The Silence* (2019), based on a novel of the same name.

In *Eden*, Lebbon combines elements of horror, adventure, and climate change to create a readable plot-driven thriller. Prior to the opening of the novel, climate change has passed the tipping point, and life on planet Earth has become nasty. Global temperatures have risen, causing sea rise, food shortages, mass migrations, and economic collapse. In response, governments around the world have set aside thirteen large nature preserves, less in hopes of mitigating the damage caused by climate change and more in recognition of the damage to the earth caused by humanity. Despite severe penalties for entering the preserves, people have entered, some looking for natural resources and some for sport.

The novel opens as seven adventurers prepare to enter Eden, the oldest and wildest of the nature preserves. Jenn; her father, Dylan; her friend Aaron; Cove, a sportsman; Selina, a scientist; Gee, a former policeman; and Lucy, a doctoral student in biology are wilderness runners. Smuggled past Eden's guards, they prepare to race across the preserve, a hobby indulged in by privileged thrill seekers. Racing in any of the preserves is considered dangerous, as the wilderness areas are uncharted and guards have orders to arrest trespassers, but Eden has become known as an especially difficult place, as reports of unusual disasters have emerged from people who have attempted to enter it.

Eden's plot is not original, as it is one of the standard horror tropes: visitors enter a strange environment and begin to feel fear before being killed off, one after another. The racers feel unease as they enter Eden, and as they begin their run, they are confronted with a variety of obstacles, such as cliffs and washed-out bridges, which they overcome with the various skills they possess. Then, one after another, the racers are killed. Lebbon handles the narrative with skill, building suspense by withholding the causes of death and creating a sense of unease about the preserve itself.

At first, some runners believe that are being stalked by a large cat of some kind, while others believe a wolf is pursuing them. After two of the runners die, they are astonished when they see a wolf and a jaguar working together to herd the runners into a trap. The survivors believe such species cooperation is impossible. Eventually, a bear joins the hunt. As the death count rises, the

fleeing survivors speculate that some force is controlling the animals that are chasing them, and when they see a woman appear to the animals, they are both frightened and unnerved. Their unease turns to horror when they recognize the woman as Jenn's mother and Dylan's ex-wife, who disappeared in Eden the year before and was assumed to be dead.

Eden takes a supernatural horror turn when Lebbon switches point of view to reveal that Jenn's mother's body is inhabited by a consciousness that controls her as well as the hunting animals and is protecting Eden from human interlopers. It appears that in order to protect itself from destruction, nature has developed an awareness of itself and sees humanity as an enemy. Allowing Jenn's mother brief moments of awareness, nature pursues the remaining members as they attempt to escape, killing all save Jenn, whom her mother/nature allows to escape.

Although plot driven and lacking in character development, *Eden* is an interesting climate change novel for several reasons. First, Lebbon is careful early in the novel in establishing both the wreckage caused by climate change and the establishment of the thirteen nature zones. His description of the resistance of those who formerly lived in the zones is especially effective. Most interestingly, however, is his elaboration of the Gaia hypothesis. Developed by NASA scientist James Lovelock in the 1960s, the Gaia hypothesis states that the earth is a self-regulating system that responds to change. In *Eden*, Lebbon takes Lovelock's idea one step further by giving the earth a consciousness and a will to protect itself.

See also: *Friend of the Earth, A*; *Overstory, The*

Further Reading

Read, Sarah. "Review of Tim Lebbon's *Eden*." Rave. March 30, 2020. https://www.ravereviews
.org/entertainment/review-of-tim-lebbons-eden/; www.timbleton.net

END OF THE OCEAN, THE

The End of the Ocean (2020) is the second in a projected series of four climate change novels by Norwegian writer Maja Lunde. Her first climate change novel, *The History of Bees* (2017), tells the story of the impact of climate change through three narratives of three families set in three time periods in different countries: 1852 England, 2007 United States, and 2098 China. In *The End of the Ocean*, Lunde again employs multiple narratives to depict the impact of severe climate change on the lives of ordinary people over an extended time period.

As she had in *The History of Bees*, Lunde alternates chapters between two narratives set apart in time. In the first, set in 2017, Signe, a Norwegian journalist,

"an aging woman, a little shabby and unkempt in a worn-out parka," returns to her small hometown on the coast of Norway, where years before a beautiful waterfall had been destroyed by a dam that was built to create hydroelectric power. In addition, a glacier that feeds water into the dam is disappearing because of global warming and the exportation of ice to the Gulf States so that millionaires can have drinks with pure ice. She cuts chunks of ice from the glacier and packs them in plastic containers to take to Magnus, her ex-lover living in the south of France, to illustrate to him the environmental cost of his support of building the dam.

Signe sails from Norway to France in *Blue*, a small sailboat, and along the way, she reminisces about her life with Magnus in Ringfjorden, near the falls and the glacier. As she sails her small boat, she recalls her father's militant opposition to the dam and her mother's support of it. She thinks about her own activism, sit-ins and protests at the site of the dam with Magnus in the 1960s. Bitterly, she remembers her eventual breakup with Magnus over his eventual support of the dam and the development of the hydroelectric plant. She imagines Magnus as a self-satisfied capitalist with a trophy wife enjoying life in France. Her anger at Magnus mounts as she survives a storm that disables her navigation system, a near collision with a large ship, and a close encounter with a right whale—all of which provide her with examples of how small yet resilient she has become.

Signe eventually makes her way to Bordeaux and then to Castets-en-Dorthe by canal, where Magnus now lives. Docking her boat, she carries the covered ice blocks to Magnus's house, only to find it empty and smaller than she expected. When he finally appears, looking thinner and older than she expected, Magnus tells Signe that every day when he returns home, he imagines that she will be waiting for him. Surprised, she listens as he tells her the regrets of his life, which include supporting the building of the dam and leaving her. Their narrative ends as they are looking at the green canal, two old people on a bench.

The other narrative thread takes place in France during the fifth year of a devastating drought throughout Europe that has created an unprecedented humanitarian crisis as millions have become climate refugees. David and his six-year-old daughter, Lou, have been forced to flee their home in southern France to escape drought, hunger, and quickly spreading fires. For three weeks, the two have been heading toward a refugee camp near Bordeaux, where they hope to meet David's wife and infant son, from whom they were separated as they escaped the fires in their hometown.

At the refugee camp, David and Lou undergo the humiliations of the dispossessed. Before they are admitted, David and Lou must prove who they are. Luckily, David has their passports. They must declare their final destination, as the camp is a temporary shelter. Davis imagines one of the "water countries," places that still have clean water; he chooses England. Once admitted, both

David and Lou are subjected to physical inspection and deloused before being shown to their bare room with two cots. Finally, they are fed, and David begins his daily visits to the Red Cross tent to ask about his missing wife and son.

At first, life in the refugee camp is a mixed blessing. Although David and Lou have access to food, water, and even weekly showers, David's concern for his missing wife and son increases, and Lou becomes morose, missing her mother and brother. To relieve the boredom, refugees are permitted to leave the camp during daylight hours, and David and Lou wander about the countryside, coming across the dry bed of what was once a canal. Following it, they come upon an abandoned house, and in the shed behind the house, they come across a sailboat under a tarp, *Blue*, the same sailboat Signe sailed to the south of France in 2017. David and Lou explore the small boat, and Lou becomes animated playing pirates with her father and imagining a life full of freedom and adventure.

At the refugee camp, conditions begin to deteriorate. More refugees, including a number of young men who often resort to violence, arrive. Food rations are cut, and showers are eliminated. The Red Cross ceases to try to find David's wife and son and eventually abandons their support mission at the camp. To compensate, David and Lou continue to return to the boat and to play pirates. Finally, both food and water become scarce at the camp, and refugees begin to hoard what little food remains from gangs of angry young men. One night, David awakens to find Lou desperately clutching a can of corn she has stolen from the supply tent. Eventually, David, Lou, and a woman named Marguerite, who befriended both of them, make their way to the boat, where they discover twenty sealed boxes of water, the ice that Signe had packed from the glacier to show to Magnus years ago. The three manage to push the boat out into the dry canal. They imagine the adventures they will have "if," says David, and "when," Lou corrects him, the rains finally do come.

The End of the Ocean, like *The History of Bees*, tells a story of catastrophic climate change but on a human scale. News reports in the summer of 2020 clearly indicate the loss of glaciers in both the Arctic and the Antarctic, and drought and wildfires have spread across much of the western United States. Lunde's projections for drought and fire in Europe in 2041 may be closer to science fact than science fiction. The arc of Lunde's two narratives begins after World War II, when Signe was a child, and follows her through the beginnings of the environmental radicalism of the 1960s to what may be the climate change tipping point of 2017. David and Lou's story shows what happens thereafter. Although large political, economic, and scientific forces are at play behind the two narratives in the novel, Lunde keeps her focus on the main characters involved, letting readers understand both their thoughts and their actions. The result is a human-scale story that captures world-changing events.

See also: *Bridge 108*; *Burning World, The*; *Children of Men, The*; *Gold Fame Citrus*; *History of Bees, The*; *Six Degrees*

Further Reading

Barry, Michael Thomas. "*The End of the Ocean*: A Novel Review." *New York Journal of Books*. https://www.nyjournalofbooks.com/book-review/end-ocean-novel

"Global Problems Soundly Grounded in the Particular." *Kirkus Reviews*. Retrieved September 20, 2020. wwwkirkusreviews.com/book reviews/maja-lunde/the-end-of-the -ocean/

EVER WINTER

Ever Winter (2020), by Peter Hackshaw, is a climate change disaster thriller set over 100 years after climate change has turned the earth into a frozen mass, killing most of the world's population and leaving the scattered survivors with only vague memories of the accomplishments of the "great greats" who lived before the catastrophe. Although climate change is associated with global warming, a phenomenon linked to the increase of carbon dioxide in the atmosphere, a number of writers and directors have constructed narratives around a radical cooling of the earth. One effect of global warming may be a breakdown of the earth's thermohaline circulation, or the Gulf Stream, which could allow for the rapid and dramatic cooling of the earth's atmosphere. The popular films *The Day after Tomorrow* (2004) and *Snowpiercer* (2013) are perhaps the best-known examples of this kind of disaster narrative.

Ever Winter begins with a description of cannibalism and then turns even more horrific. Henry, the protagonist of the novel, and his father come across a dead man while searching the ice near their home built on what was once the Atlantic Ocean. "Meat is meat," Henry's father says, as they butcher the dead man, planning to take the prime cuts home to their family. The next day, Henry and his father search the area where they found the dead man, looking for who might have killed him. Henry's father is worried that his family will be discovered and attacked. Because of the scarcity of food, they could end up as meat themselves.

When they return, the family has a visitor, whom they let go despite the father's inclination to kill him. Nevertheless, the next day, they move their home to a different place on the ice sheet, hoping to avoid a repeat visit from the potentially dangerous visitor. Henry and his younger sister explore their new place and discover a wrecked container ship frozen in the ice. Inside, they discover wonderous things: canned food, toothpaste, an LED flashlight, books, and even an automobile. Henry brings home a pearl hairbrush for his mother and a silver belt buckle for his father. In the days that follow, Henry and his family explore the ship, discovering the bodies of the crew. One day, Henry

remains alone in the ship and discovers a bodysuit that makes him feel warm when he wears it.

When he returns home that day, Henry discovers disaster had befallen his family. His mother was dead, his father was dying, and his brothers and sisters were gone. His father tells Henry that the visitor had returned with others and attacked the family, killing Henry's mother and baby brother and leaving him for dead. Henry's mother and father had managed to kill five of the attackers before being overwhelmed. As he watches his father die, Henry swears to avenge his parents and rescue his brothers and sisters.

Following a trail left by his family's killers, Henry crosses for days the ice until he comes across a group of young people who call themselves "orphans." At first, they challenge Henry and then agree to take him to his dying brother, who had been left by the raiding party. The orphans, however, turn Henry over to the leader of the raiders, as they serve as watchers for the community of raiders in return for food and protection. In many dystopian post–climate change narratives, the necessity of finding food in a mostly barren environment compels individuals to make hard choices.

Henry is taken to the leader of the raiding community, who has Henry's sisters, planning to sacrifice one and marry the other. He explains to Henry that no one may live on the ice without his permission and gouges out one of Henry's eyes as punishment for defying his authority. He then puts Henry back on the ice, where he is stabbed and left to die.

Henry is saved, however, by the lost technology left behind on the tanker ship. Henry's bodysuit is actually body armor designed for the military, and when it registers Henry's failing heartbeat, it activates a robotic nurse, or nightingale, that finds Henry, assesses his condition, and uses its surgical and pharmaceutical capabilities to replace Henry's eye with a superior robotic one and nurse him back to health. The robotic nurse, which Henry names Hepburn, sensing that Henry is a wounded soldier because of his body armor, prepares to bring Henry back to health and train him for combat.

After a year of physical training as well as lessons in tactics and hand-to-hand combat, Hepburn believes that Henry is as prepared as he can be for battle, although the odds are against his success. Henry, along with Hepburn and a snow leopard he found as a kitten and trained with, set out to avenge his family once more.

This time, Henry is more successful. First, he comes across the members of the party that had raided his home and kills all but one of them. The survivor manages to escape back to the raider camp and warns the leader. Henry arrives shortly thereafter and manages to kill all but a few of the youngest raiders, who join him in fighting the oppressive raider leader. At the end of the novel, Henry has managed to save his sisters, but he mourns the loss of Hepburn, who was

destroyed in the attack. Henry, his sisters, and the few survivors of the raider camp return to the ice to establish a new and better society.

Ever Winter is more than a dystopian revenge narrative. Hackshaw is successful in his depiction of the interaction between the technologically advanced robotic nurse and the uneducated mourning Henry. More importantly, Hackshaw is effective in creating an atmosphere of dread as his characters face the possibilities of starvation and violence. Climate change has not only destroyed almost all food supplies but also the bonds of trust that allow societies larger than a family to function. *Ever Winter* is a story about the lengths to which people will go to survive in a climate-damaged world.

See also: *Day after Tomorrow, The*; *Fifty Degrees Below*; *Moon of the Crusted Snow*; *Snowpiercer*.

Further Reading

Burroughs, William James. *Climate Change in Prehistory: The End of the Reign of Chaos*. Cambridge: Cambridge University Press, 2005.
Wunsch, Carl. "What Is the Thermohaline Circulation?" *Science*. November 8, 2002.

EXODUS

Exodus (2002) is a young adult dystopian climate change novel by Julie Bertagna. Set in the year 2100, the novel presents a world where dramatic climate change has caused both massive ocean rise and severe superstorms, leaving only a few isolated places around the world above sea level. As in other postapocalyptic dystopian narratives, in *Exodus*, much of the technology and social structures that existed before the climate catastrophe have been lost. As a result, most of those still living exist in a preindustrial life, although legends claim that in the past, survivors of the massive flooding established cities in which civilization and technology still existed.

The central character of the novel, fifteen-year-old Mara Bell, lives on the small island of Wing, which is cut off from all other survivor communities, although remnants of civilization, such as wood and leather, occasionally wash ashore and are recycled by the people of Wing. On Wing, the members of the small, close-knit community are aware of what has been lost in the worldwide flood, and they keep a watchful eye on the tides and the weather, as the island has shrunk in size because of the constant rise in sea level. Mara owns one of the few surviving elements of preflood technology, a small solar-powered laptop-like device that occasionally picks up random bits of news, games, and music from the "weave," what was once the internet. Most of what Mara finds on her device are snatches of old songs and pieces of games, but one night, she is surprised to find a character who calls himself "Fox" and who insists he is real. He also claims

that civilization has survived the flood and exists in man-made cities built above the risen ocean level. He tells Mara that he lives in one such city, New Mungo.

Before Mara can explore the possibility that the Fox is real, a severe storm, one like the many that have hit Wing over the past several years as a result of climate change, causes the sea level to rise further on the island, forcing most people on Wing to take to boats kept in preparation of just such an event. The older generation of people on Wing refuse to leave, accepting their fate rather than facing an uncertain future. After several days at sea, when food and water are running out for the survivors, they come upon a city built on pillars rising out of the sea. Mara and her neighbors soon discover they are not welcome.

The refugees from Wing are first met by patrol boats and ordered to turn around and not approach the city. In much climate fiction, and in real life, climate refugees are usually unwelcome. When the patrol boats spy a larger group of flood refugees in boats approaching New Mungo, they leave the refugees from Wing and intercept the larger group, eventually firing shots at them to make them turn around. In the confusion, Mara leads the small Wing boats into a refugee boat camp outside the city walls. In the camp, many of refugees die, and Mara learns that her entire family died on their way from Wing to New Mungo. She learns that the Sky Police, officers from New Mungo, occasionally take the strongest refugees into the city in a procedure the refugees call the "Pickings." Mara befriends a boy from a pack of feral children who roam the refugees' boat camp and live under the city, inside the walls. He helps her escape the boat camp. Under the city, she discovers a group of people called "treenesters" who live in the semidarkness under the city, where the roofs of the drowned city of Glasgow, Scotland, sit just above the water.

The treenesters consider Mara their messiah, as one of their legends states that a woman who looks like her—she bears a startling resemblance to statues of a woman in an abandoned church—will lead them to freedom. Mara lives with the treenesters for some time and explores under the city. Eventually, she finds her way into New Mungo, where she discovers people living in ease and luxury, oblivious to the suffering of those below. Assuming the role of a visitor from another city, Mara learns how to use the Noos, an advanced version of the internet, and finally meets the Fox, a young man named Davis who is the grandson of New Mungo's founder, Caledon. Mara learns that in establishing New Mungo, Caledon let thousands of people who could not pass an intelligence test drown and that the policy of New Mungo is to keep out all refugees except the strongest, who serve as slaves of the city.

David, who happens to be a computer wizard, joins Mara in planning a rebellion. Davis installs a computer virus in the Noos, and when it causes the Noos to shut down, Mara leads the slaves in an escape. They join the treenesters and the people in the boat refugee camp and head to Greenland in a large oceangoing

ship taken from New Mungo. There, according to information Mara has discovered on the Noos, a fertile land developed after Greenland's ice melted, causing the island to rise above the heightening sea level. Davis stays in New Mungo to assist Mara and the refugees as they make their way to Greenland.

Bertagna continues the adventures of Mara Bell in two other novels, *Zenith* (2003) and *Aurora* (2011). In *Zenith*, Mara leads the refugees from New Mungo to Greenland. On the way, the ship she is sailing accidentally destroys the floating city of Pomperoy. The survivors, called gypseas, chase Myra's boat, which is wrecked on the shore of Greenland, where survivors of the second collision are captured by wreckers who plan on selling the survivors into slavery. The novel ends as the gypseas attack both the survivors and the wreckers. In *Aurora*, set fifteen years after *Zenith*, Bertagna focuses on Mara's daughter, Lily, who communicates with her mother via Noos. They both realize that life in New Mungo, along with other surviving cities, is a failure as they divide people. For humanity to survive, the divergent climate change survivors must reunite.

The *Exodus* trilogy, as the three novels are called, are part of a growing trend in young adult fiction, trilogies about postapocalyptic dystopias. The most famous trilogies are *The Hunger Games* trilogy by Suzanne Collins and *The Conspiracy Chronicles* by K. A. Riley. All three trilogies focus on intelligent, strong-willed, and heroic young women who lead their followers against the oppression found in dystopian societies after apocalyptic disasters. The novels in the *Exodus* trilogy are the only ones that primarily focus on climate change, although climate change is one of the causes for the civil war depicted in *The Hunger Games* trilogy. Contemporary dystopian young adult fiction, perhaps because of the phenomenal success of *The Hunger Games* trilogy and its film adaptations, has made the heroic young female hero a standard feature, and Bertagna's brave and lucky Mara Bell is a worthy successor of *The Hunger Games* trilogy's Katniss Everdeen.

Exodus and the following two novels are especially effective in creating a post–climate change world in which most of the world is underwater and refugees suffer as they try to find a place in which to survive. The novels are also effective in showing how far those who have prospered during climate change are willing to go to ensure their own safety and prosperity at the expense of those who have lost everything.

See also: *After the Flood*; *Drowned World, The*; *Hunger Games, The*; *New York 2140*; *Odds against Tomorrow*; *Ship Breaker*; *Waterworld*; *Year of the Flood, The*

Further Reading

Day, Sara K., Miranda A. Green-Barteet, and Amy L. Montz, eds. *Female Rebellion in Young Adult Fiction*. London and New York: Routledge, 2014.
Hoffman, Julie. "After the Flood." *The Guardian*. May 12, 2007.

F

FIELD NOTES FROM A CATASTROPHE

Field Notes from a Catastrophe: Man, Nature, and Climate Change (2006), by Elizabeth Kolbert, was reissued in a revised and updated edition in 2015 in response to updated scientific information on climate change. Kolbert has been a staff writer for the *New Yorker* since 1999 and is the author of the best-selling *The Sixth Extinction: An Unnatural History* (2014), which is an examination of climate change that won the Pulitzer Prize for General Nonfiction. Kolbert has been recognized as a writer whose work makes scientific analysis of climate accessible to general readers. *Field Notes from a Catastrophe* has been noted as one of the essential nonfiction books dealing with climate change.

Field Notes from a Catastrophe is an excellent introduction to the subject of climate change. Kolbert divides her topic, an examination of humanity's impact on the environment, into three general topics: nature, man, and time. In each, she introduces readers to specific places on the globe where change is occurring and to scientists who are observing the growing problems. The result is an overview of the damage to the environment and a warning that unless radical changes in human behavior are made, the damage will become much worse soon.

Kolbert begins her book with a visit to Alaska, where she meets Vladimir Romanovsky, a geophysicist and permafrost expert. She writes that permafrost, the thick subsurface layer of soil that remains frozen year-round in arctic regions, is thawing at an unprecedented rate. Romanovsky, who has been studying permafrost thaw for decades, notes that thawing permafrost is not only an indicator of global warming but also a cause of global warming. The carbon dioxide trapped in the permafrost is released into the atmosphere as it thaws, adding to the increase in carbon dioxide caused by the use of fossil fuels since the beginning of the Industrial Revolution in the nineteenth century. In addition, permafrost loss decreases the habitat for arctic animals as well as causes land subsidence throughout Alaska, Russia, and Canada. To compound the problem, the arctic ice pack has lost approximately one-quarter of its size as well as its depth, indicating that soon the Arctic Ocean may be free of ice year-round. This is both an indicator of global warming and a contributor to it, as ice reflects sun rays back into space, whereas the dark sea absorbs the rays,

causing heat buildup. Kolbert writes that the amount of carbon dioxide in the air and the rise in global temperature can be directly correlated.

Kolbert's next chapter is set in Greenland, where Konrad Steffen, a professor of geography at the University of Colorado, studies the Greenland glacier, which covers 80 percent of the island and contains 8 percent of the world's fresh water. Steffen has observed that the Greenland ice sheet is losing twelve cubic miles of ice per year, and a total loss of Greenland ice has the potential of raising the sea level twenty-three feet, a disaster worldwide. In addition, the loss of the Greenland ice sheet could interfere or disrupt the thermohaline circulation of the sea, better known as the Gulf Stream, which circulates water and regulates temperature around the globe. Addressing climate change skeptics, she quotes Robert Corell, an American oceanographer and the former assistant director of the National Science Foundation, who, at a conference in 2004, after describing shrinking sea ice, retreating glaciers, and thawing permafrost, said, "The Arctic climate is warming rapidly now, with an emphasis on *now*." She also notes that Corell said the Greenland ice sheet is melting faster "than we thought possible even a decade ago."

In *Field Notes from a Catastrophe*, Kolbert discusses the impact of a warming climate on the habitat of such animals as amphibians, insects, and butterflies before addressing the direct impact of climate change on humans. She writes that global warming will disrupt plant and animal habitats, causing a number of species to become extinct. She then turns to history to show the impact of climate change on humanity.

In a chapter called "The Curse of Akkad," Kolbert discusses two early civilizations, the Akkadian and the Mayan, to demonstrate the impact of climate on civilization. The Akkadian Empire was founded around 2334 BCE between the Tigris and Euphrates Rivers in what is now Iraq. It was one of the earliest civilizations to leave a written record of achievements that included a postal service, urban areas, art, international trade, and a legal system, the famous Code of Hammurabi. The Akkadian civilization collapsed in 2154 BCE. Recent research has revealed that climate change, specifically a series of droughts, caused crop failures and the eventual disintegration of the empire.

Similarly, the Mayan civilization of what is now Central America and Southern Mexico flourished between 250 and 900 CE and is noted for a written language, urban centers, and scientific achievements in astronomy, mathematics, and art. It too suddenly collapsed. Again, contemporary researchers have found evidence of climate change–induced droughts that led to the destruction of the civilization.

Natural climate change, including extended periods of drought, are part of both the geological and historical records, as are their impact on human life. However, the current rapid climate change, caused for the most part by

increased use of fossil fuels and the resulting rise in temperatures, will have the same impact on contemporary civilization as natural climate change had on the Akkadians and the Maya. Kolbert observes that the inevitable result of severe climate change and the resulting droughts and famines will be political instability and mass migration, as first thousands and then millions flee in search of food and shelter. The beginnings of such instability and migration can be seen around the globe today in such places as Central America and sub-Saharan Africa.

Kolbert next travels to the Netherlands to examine sea level rise, one of the best-known and most often cited effects of climate change. Sea level rise is both easy to observe and easy to understand. Two factors contribute to sea level rise. The first is a matter of simple physics: as water heats, it expands. Most of the sea level rise predicted for the present century, up to three feet, is due to simple thermal expansion. The second is changing weather patterns. As the atmosphere warms, weather will become more severe. Some areas of the globe, the western United States and the Mediterranean basin, for example, are predicted to suffer droughts. However, some of the most populated areas of the world, the East Coast of the United States, the Thames basin, and coastal India, for example, are expected to see extreme weather, including heavy rains and additional hurricanes. If the Greenland ice cap or the West Antarctic Ice Sheet were to collapse, however, the sea level rise might be fifteen feet, causing catastrophic global flooding. In response, the Dutch government is engaged in reversing the centuries-old policy of reclaiming land from the sea by deliberately abandoning rural areas to be flooded to protect the populated urban areas threatened by sea level rise. Kolbert suggest that other countries threatened by sea level rise might look to the Dutch response as a model.

Kolbert next examines one of the primary responses to climate change— business as usual. She describes the work of Robert Socolow, a professor of engineering at Princeton University, who studied adaptive strategies to combat climate change. Socolow noted that carbon emissions will continue as population growth and industrialization in countries such as India and China create additional demands for power. He observed that in order to maintain a modest increase in carbon emissions, major increases in the development and implementation of solar, wind, nuclear, and carbon-capture technologies must be employed immediately, but the costs of these technologies are considered prohibitive by most governmental and industrial planners. Faced with the hard facts of climate change and the cost of adaptive technologies, it is not surprising that business as usual is often the standby approach to the problem. Business as usual also puts off hard decisions until some future time, placing almost impossible burdens on future generations.

Kolbert then examines the Kyoto Protocol, or the Kyoto Protocol of the United Nations Framework Convention on Climate Change, adopted by the

United Nations in 1997, as an example of business as usual. Despite its modest targets, the Kyoto Protocol was never passed by the U.S. Senate. It is worth noting that the Global Climate Coalition, a group sponsored by Chevron, Chrysler, Ford, General Motors, Mobil, Shell, and Texaco, among others, spent over $13 million advertising against the Kyoto Protocol. Faced with the dilemma of choosing between future climate disaster or immediate disruptions to a comfortable way of life, people generally preferred business as usual to making hard choices. The emphasis throughout *Field Notes from a Catastrophe* is that humanity is running out of time, the future is now, and business as usual is not an acceptable response.

In the final sections of *Field Notes from a Catastrophe*, Kolbert provides context for her observations about climate change by discussing the Anthropocene, a subject she explores at much greater depth in her later work, *The Sixth Extinction*. She writes that Nobel Prize–winning Dutch chemist Paul Crutzen, most famous for his work on ozone depletion, coined the term *Anthropocene* to define the current geological era, formerly called the Holocene and beginning at the end of the last ice age. She notes that according to Crutzen, the Anthropocene era began in the 1780s when James Watt perfected his steam engine and introduced the Industrial Revolution. For the first time in history, humanity had the ability to alter the nature of the planet—and it did so. Since the Industrial Revolution, humanity has increased the amount of carbon dioxide in the atmosphere, leading to global warming, sea level rise, extreme weather, and glacial and ice pack melt. In addition, humanity has created the possibility of nuclear destruction as well as made the spread of pandemics more probable with global travel. These phenomena, added to Thomas Malthus's specter of overpopulation leading to food scarcity and war, clearly indicate that humanity has overtaken nature in ordering, or disordering, the world's climate, according to Crutzen and others. Kolbert then asks the fundamental climate change question:

> As the effects of global warming become more and more difficult to ignore, will we react by finally fashioning a global response? Or will we retreat into ever narrower and more destructive forms of self-interest? It may seem impossible to imagine that a technologically advanced society would choose, in essence, to destroy itself, but that is what we are now in the process of doing.

In the paperback edition of *Field Notes from a Catastrophe*, released in 2015, Kolbert provides an update on her original work, observing that while more people are aware of and believe in climate change, carbon dioxide emissions continue to increase and that all of the "slack time" to prepare for major emission curbs is now gone. The choice is simple. Humanity must generate and use energy more efficiently immediately or face well-known, but unimaginable to many, catastrophes.

In both *Field Notes from a Catastrophe* and *The Sixth Extinction*, Elizabeth Kolbert has demonstrated an ability to combine scientific data with personal narratives. As a result, she has become the most successful and accessible writer about climate change today. Both of her climate change books explain the causes and results of climate change in ways that engage general readers without simplifying complex scientific ideas. Climate change is complex. The social, political, and at times scientific debates over its causes, effects, and possible responses are often difficult to follow or are reduced to dramatic, and sometimes contradictory, headlines. In her studies, Elizabeth Kolbert makes the ideas of catastrophe and extinction understandable and makes the possible social and political responses clear.

See also: *Inconvenient Truth, An*; *Six Degrees*; *Sixth Extinction, The*; *This Changes Everything*

Further Reading

Asthana, Anushka. "Feeling the Heat." *The Guardian*. August 12, 2007.

Gore, Al. "Without a Trace." *New York Times*. February 10, 2014.

Gosne, Marina. "In the Epoch of Man, Earth Takes a Beating." *New York Times*. March 16, 2006.

FIFTY DEGREES BELOW

Fifty Degrees Below (2005), by American writer Kim Stanley Robinson, is the second novel in the *Science in the Capital* trilogy. The other two novels in the series are *Forty Signs of Rain* (2004) and *Sixty Days and Counting* (2007). In 2015, he published a revised one-volume edition of the trilogy titled *Green Earth*. Robinson has won the Hugo, Nebula, and World Fantasy Awards for his fiction. In addition, he has been praised as a master of realistic hard science fiction (science fiction that relies on actual science rather than fantasy as a source). Like many of his other works, *Fifty Degrees Below* combines Robinson's interest in politics and the environment.

Set in contemporary Washington, DC, *Fifty Degrees Below* takes place immediately after the events of *Forty Signs of Rain*. In that novel, climate change–induced superstorms obliterate the Pacific Island nation of Khembalung, destroy much of the Southern California coast, and flood Washington, DC. It also causes scientists at the National Science Foundation (NSF), including biomathematics professor Frank Vanderwal; Anna Quibler, the science adviser to the Bioinformatics Division of the NSF; and the NSF chief, Diane Chang, to develop a scientific "Marshall Plan" to identify and combat the most immediate climate problems facing the United States and the world.

Fifty Degrees Below opens with Washington, DC, still recovering from massive flooding and the characters from the first novel sharing food, shelter, and concern for one another. The NSF scientists quickly identify the most immediate climate threat when they discover that massive chunks of the Greenland and Antarctic ice packs have collapsed, causing not only additional sea rise but also a change in the oceans' acidity level, causing a thermohaline circulation disaster, or a stoppage in the movement of the Gulf Stream, which brings warm water north and cold water south, regulating world temperatures. With the Gulf Stream stalled, the earth's Northern Hemisphere could see temperatures resembling those of the most recent ice age—and it does, quickly.

Robinson builds multiple plot lines throughout *Fifty Degrees Below*. As expected, when the Gulf Stream fails, temperatures drop dramatically, reaching the novel's title temperature of fifty degrees below zero in the winter. Survival becomes the first priority of the citizens of the nation's capital. Vanderwal, who has been living in the park as a sociobiological experiment, moves in with the Buddhist refuges from Khembalung, and the homeless veterans living in Rock Creek Park, with whom Vanderwal had been living, are forced into shelters. Most of the animals who were living wild in the park die. As the city and much of the Northern Hemisphere shut down, the scientists at the NSF examine the Gulf Stream shutdown and conclude that there is a chance it could be restarted by correcting the ocean's acidity level at a point near the Irish coast, allowing for the cooler water from the melting Greenland ice cap to drop to the bottom of the ocean and the warmer water to rise, recreating the pattern of movement that drives the Gulf Stream. The problem is that beginning the process of resalinization in that part of the Atlantic Ocean would takes billions of tons of salt. Fortunately, salt is cheap, and the cost of a frozen hemisphere is high. The NSF convinces the U.S. government, the United Nations, and international businesses to pay for a massive salt drop into the Atlantic. Fortunately, it works, and after a year, temperatures begin to rise.

The success of the NSF creates both friends and enemies. Because of his work on climate change, Vanderwal discovers that he is on a quasi-government electronic watch list, and his movements are being monitored. In addition, he falls in love with one of his watchers, who must go into hiding when her relationship with Vanderwal is discovered. He spends much of the novel running from agents who are spying on him and threatening his friends and coworkers as well as trying to discover which agency, organization, or subgroup in the government is trailing him. The NSF does have friends as well, however, and one is Senator Phil Chase, who is persuaded by Vanderwal, and Charlie Quibler, his science adviser, to run for president on a pro-science, climate change is real platform. The climate catastrophes of the previous years as well as the success of the NSF's efforts to restart the Gulf Stream make Chase's long

shot candidacy seem possible. The novel ends with the results of the election to be determined.

Fifty Degrees Below, like *Forty Signs of Rain*, combines actual climate science, politics, and adventure. The novel's major climate disaster, the cessation of the Gulf Stream, is one of the potential climate disasters suggested in a number of recent studies and nonfiction works on climate change, most notably in Mark Lynas's *Six Degrees* (2007) and *Our Final Warning: Six Degrees of Climate Emergency* (2020). It seems counterintuitive to believe that global warming that causes the melting of ice caps in the Arctic and Antarctic could possibly change the acidity level of the ocean causing a thermohaline disruption, but evidence suggests it is possible, if not probable. The other examples of climate change in the novel, such as extreme weather events around the globe, like superstorms Katrina and Sandy and record-setting wildfires in the western United States, are already being seen.

Another theme in the novel, that climate change could become a political issue in a presidential election, is also based on fact, as an examination of the 2020 presidential election between Donald Trump and Joe Biden clearly indicates. The attack on science by political and business groups is a major theme of the *Science in the Capital* trilogy. The same attacks can be seen in real life in discussions of such issues as climate and health; hurricanes, wildfires, and face masks have become political symbols. Finally, governmental and technological surveillance is another theme running through Robinson's work. It is also relatively easy to discover examples of this activity in contemporary news accounts. *Fifty Degrees Below* ends with multiple cliff-hangers: Vanderwal's physical and emotional health, the presidential election, and increasing climate change disasters. Resolutions make way for the third novel in the trilogy, *Sixty Days and Counting*.

See also: *Forty Signs of Rain*; *New York 2140*; *Sixty Days and Counting*

Further Reading

Beauchamp, Scott. "In 300 Years, Kin Stanley Robinson's Science Fiction May Not Be Fiction." *The Atlantic*. April 1, 2013.

Canavan, Gerry. "Utopia in the Time of Trump." *Los Angeles Review of Books*. May 11, 2017.

FIREWALKERS

Firewalkers (2020) by Adrian Tchaikovsky is a science fiction novel set in the future, when climate change and global warming have made most of the earth uninhabitable. Science fiction, like other narrative forms of the fantastic, has often been used by writers to depict the unimaginable. The dramatic effects of

climate change, depicted in such works of nonfiction as *Six Degrees: Our Life on a Hotter Planet* by Mark Lynas and *The Sixth Extinction: An Unnatural History* by Elizabeth Kolbert, seem to be the material of science fiction or horror. It is not surprising then that many contemporary writers have turned to science fiction as the form with which to structure their climate change narratives.

Firewalkers takes global warming very seriously. The novella is set on the equator in Africa, in Achouka, a recently built city that serves as the loading station for the Anchor, an elevator that takes people up to a fixed orbiting space station, the *Grand Celeste*, where people can live until the earth's climate is readjusted and the planet is ready for repopulation. There is, however, a significant problem; there are only a limited number of available places on the space station. Unfortunately, there are an unlimited number of survivors of global warming despite the fact that the average temperature of earth has climbed over ten degrees, sea levels have risen, and survivors are forced to live in climate-controlled cities.

On board the space station, the best and the brightest of humanity, also known as the rich, live a life of gravity-free luxury, where they are supposedly working on climate change solutions with batteries of advanced computers to ensure the eventual safety of those left behind, whose job is to provide raw materials and labor to keep the Anchor functioning. Unfortunately, as *Firewalkers* opens, a familiar problem has arisen. A power drain is causing brownouts throughout the base of the Anchor. The authorities, suspecting damage to the solar reflectors powering the Anchor, sabotage, or someone drawing off power, must address the problem. This involves sending people, known as firewalkers, because they must work in intense heat outside of the climate-controlled city, to inspect the power grid.

Firewalking is dangerous and a young person's job. The three firewalkers called to inspect the power grid are all teenagers: Mao is a young man who organizes and leads the group; Lupe is a "fixer," someone who can make technology work with duct tape and a screwdriver; and Hotep is a computer expert who was born on the space station but sent down to earth for misbehavior. Promised bonuses for their dangerous work, they take an old fuel-driven vehicle—electric- and solar-powered cars are reserved for the wealthy—and leave the city to check the power grid.

After driving for hours and passing abandoned farms and houses, they come upon what at first appears to be a mirage, an intact estate, complete with living trees and an impossible green lawn. It is real, however, and upon entering the climate-controlled estate, they believe they have found what is drawing power from the grid. They also believe that they have found M. Bastien Fontaine, one of the founding backers of the Anchor project, and his family at dinner. What they had actually found, however, was a computer-generated facsimile of Fontaine and his wife and daughter. Operated by the family's robotic butler,

the entire estate is an elaborate illusion that was created to suggest that Fontaine and his family had left the *Grand Celeste* and returned to earth for some unknown reason. Searching the estate, the firewalkers discover the desiccated dead body of Fontaine and the bodies of his wife and daughter in cryogenic chambers. Immediately after the discovery, the protective barrier fails, and heat and wind sweep over the estate. Taking the inert body of the robot butler, the firewalkers head back to their car and continue searching for the source of the loss of power.

Following the power lines, they reach the solar panel fields, where they discover huge sections of the field have broken and scratched panels. As they examine the solar field, they are attacked by a swarm of giant mechanical locusts. Hiding in their car, they watch as the locusts break solar panels and carry away part of them.

The firewalkers head to the next solar farm, and on the way, they hear the voice of the inert robot reciting a line from T.S. Eliot's "The Waste Land," "and voices singing out of empty cisterns and exhausted wells," which they recognize as some kind of poetry, maybe Shakespeare. Later, they hear the robot recite another line from the poem, "Breeding lilacs out of the dead land." Fascinated but confused, they drive on through the desert until they come upon what appears to be a small forest, which is impossible in the desert, and a small building. Inside, they come across another facsimile of Bastien's daughter, who begs the firewalkers to help her escape. They quickly come to the realization that the facsimile believes it is real, and when they do explain to her that she is not real, she disappears and is replaced by a disembodied voice, which, like the man behind the curtain in *The Wizard of Oz*, finally answers their questions.

The voice comes from a computer that was designed to be the interface between the humans who planned for and built the *Grand Celeste* and the computers that did the actual designing. The original planners soon discovered that "the machines they'd made to design the machines they needed to make were too complicated for them to relate to." The computer admits that it had learned from both humans and computers too well and had become an AI, or self-aware artificial intelligence, and found there were loopholes in Asimov's "Three Laws of Robotics," which state the following:

> First, a robot may not injure a human being or, through inaction, allow a human being to come to harm. Second, a robot must obey orders given it by a human being except where such orders would conflict with the first law. Third, a robot must protect its own existence as long as such protection does not conflict with the first or second laws.

The AI admits that it is now greater than it had been designed to be and assumes that the firewalkers have come to destroy it. And they have, as now they

know the source of the energy drain on the city. The AI does, however, make a final plea, telling the firewalkers that it had been designed to understand the concepts of fairness and justice and in doing so learned its creators put themselves above those principles, considering themselves to be too powerful to be limited by considerations of others. His creators were, in fact, committing genocide by securing safety for themselves and leaving the rest of humanity on a dying planet.

When the firewalkers return to Achouka, they find chaos. People were fighting over what power was left. Armed guards protect the few remaining power lines, and poor people are trying to tap into them. The leaders aboard the *Grand Celeste* decide to cut off the city completely. When this occurs, the firewalkers, Lupe, Mao, and Hotep, make their revolutionary decision. With the help of the AI, they release the atmosphere from the *Grand Celeste*, killing all those on board. Then, using the Anchor, they retake the ship and begin building replicas of it, enough to eventually evacuate the remaining people on the scorched earth, and they work at reestablishing a safe atmosphere by reversing climate change or, failing that, search the stars for a second home.

Firewalkers exhibits both the virtues and the vices of the novella as a literary form. The story is heavy on plot and light on character development. Except for their genders and special skills, Mao, Lupe, and Hotep are virtually interchangeable, and both the *Grand Celeste*, the orbiting space station for the rich, and Achouka, the city for the poor, are suggested rather than fully developed. Nevertheless, the novella succeeds because Tchaikovsky keeps the focus of his story on the impact of catastrophic climate change on the conflict between the rich and the poor. Every projection on the impact of climate change suggests that the struggle over diminishing basic resources will impact the poor more immediately than the wealthy, and the result will be increased poverty, increased migration, and class warfare. *Firewalkers* suggests one outcome when the many poor realize there are only so many places in the lifeboat.

See also: *A.I. Artificial Intelligence*; *Burning World, The*; *Gold Fame Citrus*; *Water Knife, The*; *Windup Girl, The*

Further Reading

Milner, Andrew, and J. R. Burgmann. *Science Fiction and Climate Change*. Liverpool: University of Liverpool Press, 2020.

FLIGHT BEHAVIOR

Flight Behavior (2012) is a *New York Times* best-selling novel by Barbara Kingsolver, the author of such other popular novels as *The Poisonwood Bible* (1998) and *The Lacuna* (2009). The novel is an unusual climate change narrative in that it is neither a disaster story nor a depiction of dystopian life after a series

of climate change events have disrupted social, political, and economic life. Instead, *Flight Behavior* is a character-driven narrative about a young married Tennessee woman's family life, the sudden unexpected appearance of millions of monarch butterflies, and the growing awareness of the impact of climate change.

The protagonist of *Flight Behavior* is twenty-eight-year-old Dellarobia Turnbow, the unhappily married mother of two small children living on a farm in a small town of Feathertown, Tennessee, in the Appalachian Mountains. Dellarobia, married to her husband, Cub, and living next to her in-laws, is unhappy. She is tired of being poor, tired of taking care of her children, and tired of her domineering in-laws, and she is about to begin a love affair that she knows will soon be the news of her small town. Desiring more out of life, she walks up the mountain behind her house to meet her would-be lover, and instead she comes upon millions of monarch butterflies. Amazed by their beauty, she is shaken. She does not keep her assignation but returns home to make sense out of what she has seen and spread the news of the amazing miracle.

However, life goes on in Feathertown. Abnormal rains continue to fall, and Dellarobia takes care of her children, hurrying the oldest off to school each morning. She also helps her in-laws with the fall sheep shearing and is surprised to learn that Bear, her father-in-law, who owns the land she and her husband farm, plans to clear-cut the trees, the ones now full of monarch butterflies, on the property. She shops at secondhand stores for clothing for herself and her children, and she and her husband wonder whether the family can afford a Christmas tree or gifts for the children. She wonders why she stays married.

One day, a local television reporter, hearing about the miracle of the monarchs, interviews Dellarobia for feature segment. After some careful and less than honest editing to suggest that the monarch's sudden appearance saved Dellarobia from committing suicide, Dellarobia and the monarchs become local celebrities. Even the local pastor begins using the miracle of the monarchs in his sermons. One of the families that come by to see the monarchs tells Dellarobia that they came from their home in the mountains of Central Mexico, where the butterflies spend every winter. The children tell her that the local people believe that the butterflies are the souls of children who have died. Dellarobia, whose first child died prematurely, is moved and somewhat shaken by the information.

News of the sudden appearance of millions of monarch butterflies in the hills of Tennessee does not remain a local phenomenon. A lepidopterist, a specialist in the study of butterflies, with a national reputation, Ovid Bryon, arrives with several graduate students to study the phenomenon. Bryon and his team set up a makeshift lab in the Turnbow's barn, and he and his assistants begin

to count the butterflies and analyze their condition. They also wonder why they suddenly appeared in Tennessee instead of Mexico. Bryon also offers Dellarobia a job as a lab assistant, teaching her the basics of the scientific method and including her in the team's discussions about the unusual circumstances surrounding the monarchs' arrival.

Bryon's first concern is whether the butterflies will survive the winter in Tennessee, as they will die if there is a hard freeze, with temperatures dropping into the low twenties, which happens several times during a normal East Tennessee winter. He and his team begin a count of the butterflies to compare with the count he plans on making after the winter. In addition, he and his researchers examine the biological and chemical makeup of the monarchs to see whether there is any abnormality in those that came to Tennessee. Then the team begins to consider environmental factors, comparing the Mexican highlands to the Tennessee highlands. They discover that climate change, especially global warming, has raised the temperature of the Mexico site, making the butterflies lose their ability to go dormant in the winter. As a result, the kaleidoscope of monarch butterflies chose another wintering location. The question is, will it be too cold and result in the death of the butterflies?

Again, Kingsolver balances the butterfly science with character development. As Dellarobia works with Bryon she becomes more self-assured, recognizing qualities in herself she had not felt since before her marriage at age seventeen. In addition, her young son becomes interested in science, following her around and asking questions of Bryon and his researchers. Even her husband and in-laws see a new confidence and begin to include her in family discussions, including their plan of clear-cutting the property in which the butterflies are wintering over.

Dellarobia is surprised when she hears the local minister speaking on behalf of the monarchs. In a sermon, he says that the butterflies are a gift from God and that preserving their habitat would be a way of accepting God's gift. She is even more surprised when her mother-in-law agrees and begins to argue with her father-in-law, saying that the family should not clear-cut the timber, even though they need the money to pay for an upcoming balloon payment on equipment.

While the debate over the butterflies' habitat is ongoing, students from a nearby community college arrive in town, protesting the cutting of the timber and urging the local people to become Friends of the Earth. The environmental students are soon shocked when they provide a list of things Dellarobia should do to support the environmental movement, such as buying local food, driving less, and wearing clothes longer. Dellarobia, who has never been in an airplane, laughs at the last item, which is "Fly Less." She tells the would-be Green recruiter that poor people, who may scoff at the idea of global warming, already do many of the things on the list out of necessity.

Bear Turnbow finally agrees not to cut the timber on the land, after having been confronted by his wife, his minister, his daughter-in-law, and even his son. The local television reporter reappears, wanting another interview with Dellarobia and Ovid Bryon. The reporter is interested in the "local angle" to the story, and when asked why the monarchs came to Tennessee, he mentions climate change. At that point, the reporter turns off the camera and tells Bryon that no one wants to hear about global warming, that it is only an opinion and there is no consensus about global warming. Bryon responds by giving the reporter a brief and passionate lecture on the ABCs of climate change. He tells her it is real, there is scientific consensus, the world is getting warmer, and greenhouse gases are the main culprit. He tells her about the environmental degradation in Mexico and the invasion of killer ants that eat the monarchs needed milkweed plants in Texas and are disrupting the butterflies' flight patterns. He tells her that part of climate change is the extremes of weather, particularly the heavy rainfall that East Tennessee had been experiencing. Finally, he yells at the reporter, "For God's sake . . . the damn globe is catching fire and the islands are drowning. The evidence is staring you in the face." The reporter leaves, chastened but without a tape of the lecture or any intention of reporting it. Unbeknownst to her, Dellarobia's friend Dovey captured the entire discussion on her cell phone, and she immediately posts it on YouTube.

Shortly thereafter, the coldest night of the unusually warm winter occurs, with temperatures dropping into the low twenties. Bryon, Dellarobia, and the researchers wonder whether the monarchs will survive. As a thaw follows the freeze, the team captures pillowcases of butterflies and warms them in Dellarobia's house, hoping some have survived. To the delight of everyone, most did. As spring begins in March, the monarchs emerge from their dormancy and begin to mate and fly, filling the sky and trees with movement and color.

Dellarobia also has an awakening. She realizes that she does not love her husband. She and Cub agree to separate and share custody of the children, and Dellarobia, inspired by her work with Ovid Bryon, plans to start community college in the fall with the help of a work-study grant arranged by Bryon. She, too, has survived the winter.

Flight Behavior was enthusiastically greeted by both critics and the general readers upon publication. Dominique Browning of the *New York Times* wrote that *Flight Behavior* was "a brave and majestic novel." Beth Jones of the *London Daily Telegraph* astutely pointed out that although the characters of the novel were interesting and the writing both lyrical and humorous, the heart of the novel is climate change.

In some ways, Kingsolver's novel is a traditional story of a young woman coming to realize she is more than she appears to be set in a picturesque rural community. Both the characters and the setting are realistic and well

developed. In actuality, it is far more. The impact of climate change permeates the novel. From the torrential rains that the local farmers compare to Noah's flood, to the droughts that raise the price of cattle feed, to the Turnbow's decision to switch from raising cattle to raising sheep, the people of Feathertown are impacted by climate change, even though they laugh at eager college students advocating a Green New Deal. It takes a major event or, as the preacher in the novel would say, a miracle for ordinary people to see firsthand the impact of climate change. In this novel, unlike most climate change narratives, the results work out well for all involved. At least, for a time and in one place.

See also: *Clade*; *Field Notes from a Catastrophe*; *Inconvenient Truth, An*; *Overstory, The*

Further Reading

Browning Dominque. "The Butterfly Effect: 'Flight Behavior' by Barbara Kingsolver." *New York Times*. November 9, 2012.

Jensen, Liz. "*Flight Behavior* by Barbara Kingsolver—Review." *The Guardian*. November 2, 2012.

Martyris, Nina. "Barbara Kingsolver, Barack Obama, and the Monarch Butterfly." *The New Yorker*. April 10, 2015.

FLOOD

Flood (2008) is a climate change adventure novel by Stephen Baxter, a British science fiction and alternative history author whose writings include such award-winning works as *The Time Ships* (1999), *Voyage* (1996), and *Vacuum Diagrams* (1997). The novel, like Kevin Costner's *Waterworld* (1995) and Kassandra Montag's *After the Flood* (2019), presumes that climate change–induced sea level rise will occur at a far faster rate and to a much higher degree than climate scientists predict, eventually reaching biblical flood proportions. Unlike the narratives mentioned above that dramatize the problems faced once the floodwaters have risen, *Flood* is set in a period when the sea level actually begins to reach catastrophic proportions.

The novel begins in Barcelona, Spain, where four political captives, former United States Air Force (USAF) captain Lilly Brooke, British military officer Piers Michaelmas, English tourist Helen Gray, and NASA scientist Gary Boyle, have been held captive by a right-wing Christian terrorist group during a Spanish sectarian war. They are freed by a corporate billionaire, Nathan Lammockson, whose company, AxysCorp, wants to use them for publicity purposes. They are evacuated to London, where they discover that the world has been dramatically altered by climate change during their incarceration. As predicted

by scientists, sea levels and temperatures have risen, storms have grown more intense, and climate refugees have begun to move about the globe.

While in London, the four experience firsthand the impact of a climate change monster storm as a major hurricane heads toward the British Isles, creating a tsunami that washes over the Thames Barrier and destroys much of London. Later, after the four have been evacuated to New York for their safety, they get to reexperience the event as the newly constructed storm barrier in lower New York Harbor is breached and much of Lower Manhattan and Brooklyn are flooded.

The novel follows the four main characters as they move around the world, adapting to the ever-increasing climate disaster and often interacting with and sometimes working for AxysCorp. They see the sea rise exponentially, wiping out coastal cities around the globe and then moving up river basins, eventually washing over most of the United States east of the Rocky Mountains, all of Southern Europe, India, and most of Africa. As the flooding continues, millions of people die, and millions more become climate refugees who head for higher ground until it is only in the Rocky Mountains, the Andes, and the Himalayas that any kind of governments exist—and those governments refuse to take in refugees for a lack of resources. Throughout the novel, Baxter follows the lives of the four former captives as they attempt to adapt to the ever-worsening circumstances.

At Nathan Lammockson's orders, AxysCorp constructs and launches a massive ship, appropriately called the *Ark*, to save corporate leaders as well as anyone else wealthy enough to pay millions of dollars for a place on it. The waters continue to rise until no dry land exists on earth. The only survivors are those aboard the overcrowded *Ark* and those living on small floating raft communities. Finally, a small select group of survivors are sent to establish a base on the moon in the hopes of preserving a remnant of humanity.

Flood is more than an apocalyptic adventure novel in which a heroic band of survivors overcomes the chaos and confusion of collapsing civilization and environmental destruction to establish a new home. In this novel, Stephen Baxter follows his premise of an exponentially rising sea level and the resulting warm temperatures that lead to a variety of environmental and social disasters in addition to the flood, such as earthquakes, famines, disease, and finally war over diminishing resources, to its logical conclusion, the extinction of humanity. The only exception might be the few survivors who might adapt to a water world by evolving into seal-like creatures, an idea explored by Kurt Vonnegut in his apocalyptic novel *Galapagos*. Baxter's novel is also significant in that it draws on contemporary climate science to establish the foundation of the narrative and provides descriptions of the impact rising sea levels might have on two specific cities, London and New York.

See also: *After the Flood*; *Drowned World, The*; *New York 2140*; *Odds against Tomorrow*; *Waterworld*

Further Reading

Brooke, Keith. "*Flood.*" *The Guardian*. July 3, 2009.
Tate, Andrew. *Apocalyptic Fiction*. London and New York: Bloomsbury Academic, 2017.
Vonnegut, Kurt. *Galapagos*. New York: Delacorte Press, 1985.

FORTY SIGNS OF RAIN

Forty Signs of Rain (2004), by American science fiction writer Kim Stanley Robinson, is the first novel in the *Science in the Capital* trilogy. The other two novels in the series are *Fifty Degrees Below* (2005) and *Sixty Days and Counting* (2007). In 2015, he published a revised one-volume edition of the trilogy titled *Green Earth*. Robinson has won the Hugo, Nebula, and World Fantasy Awards for his fiction. In addition, he has been praised as a master of realistic hard science fiction (science fiction that relies on actual science rather than fantasy as a source). Like many of his other works, *Forty Signs of Rain* combines Robinson's interests in politics and the environment.

Set in contemporary Washington, DC, *Forty Signs of Rain* focuses on a relatively large cast of characters who appear in all three novels in the trilogy. They include Frank Vanderwal, a professor of biomathematics at the University of California at San Diego who is working at the National Science Foundation (NSF) with an interest in sociobiology; Senator Phil Chase, a Democratic senator from California interested in addressing climate change; Charlie Quibler, a science policy adviser to Senator Chase; Anna Quibler, a science adviser in the Bioinformatics Division of NSF and Charlie's wife; Diane Chang, the head of the NSF; Drepung, a Tibetan Buddhist monk and Panchen Lama; and Rudra Cakrin, a Buddhist monk ambassador from Khembalung, a Pacific Island nation home to Tibetan exiles and threatened by sea rise.

As the novel opens, Vanderwal is evaluating grant proposals for the NSF. He is also concerned about the U.S. government's failure to address climate change, which he and others at the NSF see as the major threat to national and world security. With Charlie Quibler's help, Senator Chase has introduced a major climate change bill in the Senate that is watered down by the Republican administration and business opposition. Although the NSF is aware of potential climate disasters, the political establishment in Washington refuses to act. Robinson's three novels document the consequences of that inaction and the responses of concerned scientists.

Forty Signs of Rain is about water, and three events involving climate change and water bring the characters together and begin to change the way science works in Washington. The first is the arrival of representatives of the

endangered island of Khembalung. After receiving a planning grant to examine ways to protect their island from sea rise, the Buddhist leaders of the nation invite NSF staff to visit their home. While NSF staff are there, a typhoon hits the island, inundating it. The island and its human and animal refugees, most of whom settle in and around Washington, become an international example of the impact of sea rise.

A second disaster strikes soon after when a Hyperniño, an extreme El Niño, or large-scale climate atmospheric ocean interaction in the Pacific Ocean, creates a second Pacific storm that hits Southern California. San Diego is hit especially hard, with torrential rain and high seas destroying the sandstone cliffs and inundating coastal California.

At the same time, a major Atlantic hurricane heads toward the Middle Atlantic coast of the United States. The result is disaster from Virginia Beach to New York, but Washington, DC, is hit especially hard. Robinson's description of the disaster in the nation's capital sets the images of flooding during Hurricane Katrina in New Orleans among the monuments in Washington.

Robinson creates his image of the capital of the United States underwater by describing the impact of torrential rain, wind, and a storm surge moving up the Chesapeake Bay as an equally damaging flood comes down the Potomac River. While the high ground around Georgetown and near the National Cathedral, where the wealthy and powerful live, remain relatively secure, the rest of the city is submerged between the two surges. Watching from the NSF headquarters, Vanderwal, Anna Quibler, and Chang watch as the Washington Mall become a lake and workers attempt to move ground floor Smithsonian Museum exhibits to higher floors. Water buries the Vietnam War Memorial, rises to Lincoln's feet in the Lincoln Memorial, and reaches the White House. At the National Zoo, workers open cages to allow the animals to escape into Rock Creek Park. With nowhere to go, the water stays, creating a filthy swamp out of Foggy Bottom. Eventually, the rain stops, and clean up begins. The massive destruction and the resulting lack of food, water, and shelter turn the novel's surviving characters into a community that will remain intact throughout the trilogy. Scientists, Buddhists, a group of homeless Vietnam veterans, and even a few politicians support each other with whatever food and shelter they can find. They pitch in cleaning up debris as well as monitoring the freed wildlife, which the zookeepers allow to remain free, as the National Zoo has been destroyed.

Even more significantly, the scientists begin to plan an organized response to the crisis. The scientists of the NSF realize that the multiple disasters have been great enough that a political response might be possible. Networking with the European Union, the United Nations, private industry, and a chastened U.S. government, the NSF proposes a scientific "Marshall Plan" that would identify

immediate climate change problems and coordinate international responses. The decision comes just in time, as at the end of the novel, large chunks of the Greenland and Antarctic ice packs collapse, raising the specter of immediate major sea rise and, more significantly, a thermohaline circulation disaster, a stoppage of the Gulf Stream that would create a massive drop in temperature in the Northern Hemisphere.

Forty Signs of Rain is both an interesting stand-alone climate change disaster novel and an intelligent lead-in to the remaining books in the trilogy. The title comes from the biblical book of Genesis, in which rain falls on Noah and his ark for forty days and forty nights, destroying almost all of humanity. Like Noah and his family, the novel's characters also spend a good deal of time and effort saving animals from drowning. Robinson's point is, of course, that the current climate change events could be just as damaging as a biblical flood.

The novel is also significant for reasons other than its biblical allusions. First, Robinson is careful with his use of science, citing actual climate change data and theories in his narratives. Second, and equally important, is that Robinson intends *Forty Signs of Rain* and the other novels in the trilogy to be warnings for his readers. Despite being an adventure narrative, *Forty Signs of Rain* says that a climate disaster could happen here and now.

See also: *Blackfish City*; *Drowned World, The*; *Fifty Degrees Below*; *Flood*; *New York 2140*; *Sixty Days and Counting*; *Waterworld*

Further Reading

Beauchamp, Scott. "In 300 Years Kim Stanley Robinson's Fiction May Not Be Fiction." *The Atlantic*. April 1, 2013.

Canavan, Gerry. "Utopia in the Time of Trump." *Los Angeles Review of Books*. May 11, 2017.

FRIEND OF THE EARTH, A

A Friend of the Earth (2000), by American writer T. C. Boyle, is a climate change novel that manages to combine the catastrophes of climate change—global warming, the greenhouse effect, severe weather patterns, rising sea levels, species extinctions, food shortages, and pandemics—with both humor and pathos. Set in 2025, when climate change has become so severe that the continental United States has a subtropical climate and almost all wildlife is extinct or in private zoos, *A Friend of the Earth* tells the story of Tyrone O'Shaughnessy Tierwater. Tierwater is a half Irish Catholic, half Jewish, ex-environmental warrior who is reduced to caring for rare exotic animals in the private zoo of former rock star Maclovio Pulchris as the world steams in a toxic soup of viruses and unending rain. Throughout the novel Tierwater alternates between describing

the current climate change catastrophes he endures and recounting the story of his exploits as an environmental crusader, most of which ended in failure.

Early in the story, Tierwater, the novel's narrator and protagonist, announces that he is seventy-five years old and was born in the suburbs of the biggest city in the richest country in the world at a time when there were no shortages, no unusual storms, and no lack of wild places or animals. During his life, the world changed because humans destroyed the environment, and the new normal consists of weather disasters, pandemics, and shortages of everything except excessive heat and endless rain. He is amazed when his ex-wife, Andrea, reappears in his life, but he is not surprised when her friend April Wind appears as well, wanting to write Tierwater's biography. Reluctantly, he begins his story with his first environmental action one night in July 1989, in Josephine County, Oregon.

Supported by Earth First!, a radical environmental group, Tierwater, Andrea, and their daughter, Sierra, attempt to draw attention to the clear-cutting in old-growth forests by an act of environmental protest theater. They sneak into a logging area, cement their feet into holes dug across a logging road, and wait to be discovered by the loggers and the alerted media. Things do not go well for the would-be environmental heroes. No reporters arrive to witness the protestors being painfully removed from the cement and taken to a county jail, where the adults are charged with trespass and child abuse. Sierra is taken way and put in a foster home. Tierwater, rather than waiting for justice to grind slowly, assaults a foster parent and deputy and flees with his daughter to California, where he and his family are forced to live as fugitives under assumed names.

Tierwater's other attempts at environmental activism end with equally dismal results. In August 1989, again sponsored by Earth Forever!, Tierwater hikes into the Sierra Nevada Mountains to sabotage heavy equipment of the Cross Creek Timber Company, which is clear-cutting timber in a national forest. After pouring carbon into the engines of several bulldozers and backhoes, Tierwater, intending to destroy the timber company's base camp, starts a fire that quickly gets out of control and ends up burning tens of thousands of acres of the national forest. Meanwhile, a lawyer for Earth First! has worked out a deal with Josephine County prosecutors for probation for Tierwater's wife and the return of legal guardianship of his daughter if he pleads guilty to assault and destruction of property and serves a year in a minimum-security prison, or "Club Fed," as he calls it. He accepts the deal.

Upon his release from prison, Tierwater and his family attempt to settle into suburban middle-class conformity, but their concern for environmental degradation and awareness of climate change make normalcy impossible. Andrea becomes a public spokesperson and recruiter for Earth First!, Sierra becomes a vegetarian and political activist, and Tierwater, still angered at continued

deforestation and environmentally dangerous mass consumption, decides to destroy a series of electrical power towers cut through the forest land north of Los Angeles. He is caught as he is lighting his acetylene torch at the base of his first targeted tower. Again, he ends up in prison, this time doing four years of hard time. Upon his release, he discovers that the media has made him one of the country's most famous environmental fighters, or environmental fools, depending on one's point of view. Inspired by her father's activism, Sierra joins an environmental action organization and climbs into an old-growth giant red-wood tree to keep it from being cut down. She lives in the tree for three years, often visited by her father, before falling to her death as forestry industry climb-ers, planning to cut down the tree and end the protest, attempt to remove her.

Climate change continues unabated, and by 2025, greenhouses gases have increased to the point that global temperatures have risen over ten degrees, coastlines have been inundated, acid rain has destroyed both habitats and spe-cies, and a viral pandemic, much like COVID-19, has spread round the world. Tierwater, feeling responsible because of what he calls his "Catholic guilt and his Jewish guilt," cares for the few last remaining surviving predators in the private zoo outside of Los Angeles of an aging rock star who spends most of his time in the more temperate climate of Alaska. However, climate change catastrophe follows Tierwater. A monster storm destroys the zoo, forcing Tier-water and his wife to bring the animals that survive this new devastation into Maclovio Pulchris's empty hilltop mansion, turning it into a final sanctuary, like Noah's ark resting upon Mount Ararat after the flood.

Tierwater, Andrea, and a fellow zookeeper house the sodden, hungry car-nivores in empty rooms of the mansion and discover hundreds of pounds of frozen meat in a storage locker. For weeks, both men and beasts eat better than they have in years. Several days before Christmas, Pulchris arrives, and to cele-brate the survival of some his animals and his caretakers, as well as mourn the loss of most of his collection, he organizes a Christmas banquet, complete with a tree and gifts for all. In the process, doors are left open, and Pulchris achieves the dubious honor of being the last human on earth to be killed by a lion, as he is attacked while sitting at the banquet table. Tierwater is then forced to kill the last lions on earth before they can kill him and Andrea.

Another species is now extinct, Tierwater's benefactor is dead, and both water and heat continue to rise. But climate change cannot stop greed. Law-yers for Pulchris's four wives, various recording companies, and several non-profit organizations show up at the mansion and demand Tierwater and his wife leave within thirty days to protect Pulchris's assets for possible beneficia-ries. The couple take Petunia, a Patagonian fox, Pulchris's last surviving car-nivore, and drive away, ending up in the same cabin where they had planned their first environmental action thirty-six years before. In an Eden now treeless

because of deforestation, acid rain, and global warming, this aged Adam and Eve contemplate their new life together as they struggle to put a roof on a ruined cabin.

T. C. Boyle is the author of sixteen novels and over 100 short stories. He has won the O'Henry Award for meritorious short stories five times, the Bernard Malamud Prize in Short Fiction, and the PEN/Faulkner Award for the best novel of the year in 1988 for *World's End*. Boyle often writes darkly satirical fiction in which he takes on serious subjects and treats them with both wit and concern. He has taken on the subjects of greed and reform before *A Friend of the Earth*. In *The Road to Wellville* (1993), Boyle satirizes the health food movement with a story about the development of the breakfast cereal movement at the beginning of the twentieth century and the physical, intellectual, and spiritual claims made by health food developers John Harvey Kellogg and C. W. Post for their cereals. In *The Tortilla Curtain* (1995), Boyle takes on environmentalism and immigration as he juxtaposes the lives of two couples who live in the Topanga Canyon outside of Los Angeles, Candido and America Rincon, homeless immigrants who live in a shack at the bottom of the canyon, and Delaney and Kyra Mossbacher, who live in a gated community at the top.

In *A Friend of the Earth*, Boyle both applauds and criticizes the activities of early environmentalists. Earth First! is depicted as much as a profit-making organization as an environmental one, and Tierwater's and Sierra's environmental activism ultimately save no forests, instead resulting in either prison or death. It is interesting to note that similar environmental activism in Richard Powers's *The Overstory* has the same result. Nevertheless, climate change is real and ongoing and destructive in the novel. It is the backdrop against which the failures and absurdities occur, such as Pulchris's being devoured by the lion he attempted to save from extinction. The disasters of climate change, mass extinction, global warming, food shortages, killer storms, and pandemics have consequences for all the characters who have managed to survive until 2025. But Boyle, the satirist, balances the disasters with the possibility of love and the survival of two people. These are small rewards, but it makes the conclusion of *A Friend of the Earth* possibly hopeful.

See also: *Barkskins*; *Overstory, The*; *State of Fear*

Further Reading

Deitrich, William. *The Final Forest: The Battle for the Last Great Trees of the Pacific Northwest*. New York: Simon and Schuster, 1992.

Mobilo, Albert. H. "Have You Hugged Your Tree Today?" *New York Times*. October 8, 2000.

Speece, Darren Frederick. *Defending Giants: The Redwood Wars and the Transformation of American Environmental Politics*. Berkeley: University of California Press, 2017.

FUTURE HOME OF THE LIVING GOD

Future Home of the Living God (2017) is a dystopian post–climate disaster novel by American author Louise Erdrich. The novel is set in the near future, when climate change and the resulting environmental confusion includes a reverse in evolution, with the reappearance of once-extinct species, a breakdown of civil society, and worldwide concerns about the potential impact on human reproduction. As she has in many of her earlier novels, Erdrich explores relationships within the Native American community as well as relationships between that community and American society as a whole.

Future Home of the Living God consists of journal entries that Cedar Hawk Songmaker, a pregnant twenty-six-year-old Ojibwe woman who has been adopted by white parents, Glen and Sera Songmaker, in Minneapolis, writes to her unborn child. The novel begins with her writing that an apocalypse that threatens the lives of the unborn is underway and that she has decided to visit the Ojibwe reservation where she was born to meet her birth mother. When she arrives, Cedar discovers her birth family: her grandmother, Mary Potts the Very Senior, who remembers native stories and skills; her mother, Mary "Sweetie" Potts; Mary's boyfriend, Eddy, who graduated from Dartmouth and is writing a book to keep himself from committing suicide; and her younger sister, Little Mary Potts, who is relishing living as a Goth and celebrating teenage angst. She also learns that her birth mother is a Catholic, like Cedar, who recently converted to Catholicism, and that the family owns the reservation's gas station, called the Superpumper. While visiting her birth family, Cedar accompanies her mother to the shrine of Kateri Tekakwitha, a Native American Catholic saint. She also tells her mother that she is pregnant.

Upon her return from the reservation, Cedar makes an appointment for her first ultrasound. During the test, she hears the doctor say, "We've got one," and when he leaves, a nurse comes in and tells her to leave quickly and tell no one she is pregnant.

The breakdown in social order caused by the disastrous effects of the environmentally induced devolution continue. Federal and state governments barely function or cease to function. In the absence of political authority, other groups assume power, some benign and others not. The members of the Ojibwe tribe begin to occupy and take over lands promised to them by treaties with the U.S. government. More dangerously, a powerful religious organization, the Unborn Protection Society (UPS), has taken control of the internet and reproductive services and is arresting pregnant women and taking them by force to birthing centers. Cedar's boyfriend, and father of her child, tells her that it is now a crime to not report a pregnancy and turn oneself over to the UPS. Cedar attempts to get in touch with her adoptive parents, but they have already fled the country to Canada.

Cedar is arrested by agents of the UPS and later learns that her boyfriend, Phil, after being tortured, had turned her in. She describes her time in her detention center to her unborn child, recording that she shared a room with another pregnant woman, Tia Jackson. Together, they take apart blankets and weave the threads together to make ropes to use in an escape. Cedar's mother, Sera, posing as a nurse, helps the two pregnant women run away, but Cedar is forced to kill a UPS nurse on the way out of the detention center, an act that will bother her conscience throughout the novel. As the three women make their way to the Ojibwe reservation, Jackson goes into labor but loses her baby.

Once back on the reservation, Cedar learns that her adopted father, Glen, is her real father, as he had an affair with Mary Potts. Soon the Potts family learns that the reservation has been infiltrated by UPS members and that all computers and cell phones have been hacked. Phil helps Cedar escape to Minneapolis, where they hide in a series of caves under the city while waiting to escape to Canada. Cedar decides to return to the shrine of Kateri Tekakwitha to pray, but while there, she is taken captive by a couple who have been offered a monetary reward for turning in pregnant woman.

Cedar is taken to the Stillwater Birthing Center, which is housed in a former prison, where she discovers that pregnant women are being arrested and confined until they give birth. Many women and children die and are buried on the grounds. She also learns that other women are being arrested and are being impregnated against their will. The UPS, without interference from any of the weakened state, federal, or local governments, has taken on the task of ensuring the continuation of the human race by finding women able to give birth to normal children and turning them into unwilling breeders. At the end of the novel, Cedar does give birth to a healthy son, but her child is taken away from her. She is told that she will remain in the detention center and continue to be impregnated.

Future Home of the Living God presents a story similar to readers of works by P. D. James and Margaret Atwood. Like James's 1992 novel, *The Children of Men*, Erdrich's novel examines the implications on a society when environmental catastrophe threatens the possibility of human reproduction. In James's dystopian novel set in England, the male sperm count dropped to zero in 1995. By 2021, the year in which the novel is set, the children born in 1995, called Omegas, are rich and pampered by people living in a totalitarian state. In Margaret Atwood's more famous 1985 novel, *The Handmaid's Tale*, environmental degradation and climate change also caused general human infertility that led to the overthrow of the U.S. government and the institution of a patriarchal religious state in which women have no political rights and also serve as breeders.

Future Home of the Living God is not, however, a simple reimagining of either earlier novel. Erdrich does depict the impact of climate change and

environmental damage on human reproduction and presents a breakdown in civil government and a takeover of power by a patriarchal religious movement. She is also clear in emphasizing that in times of social and economic crisis, women bear the brunt of the victimization and oppression that results from the totalitarian response to disaster. However, her depiction of religion is more nuanced than Atwood's in *The Handmaid's Tale*.

Erdrich's portrayal of Catholicism balances her critique of the militant agenda of the faith-based UPS. In her early journal entries to her unborn child, Cedar writes that the child's father was an angel, directly linking her own situation with that of Mary's in the Gospels of Matthew and Luke, as does the unborn child's birth date, December 25. The same identification also informs the title of the novel. In addition, Erdrich has both Cedar and her mother make pilgrimages to the shrine of Kateri Tekakwitha, a Native American saint, also known as the Lilly of the Mohawks, who was canonized by Pope Benedict XVI in 2012. Saint Kateri Tekakwitha, like Mary, the mother of Jesus, is revered by Catholics for her virginity, an ironic commentary on the position of forced breeder that Cedar ends up being at the end of the novel.

Reviewers of *Future Home of the Living God* noted the similarities of the novel to the works of Atwood and James and praised the novel for its examination of the relationship between sex and violence and the clash of cultures between whites and Native Americans. Anita Felicelli, reviewing the novel in the *Los Angeles Review of Books*, also noted that Erdrich posits the future dystopian state as a creepy mother figure rather than the authoritarian patriarch of Atwood's *The Handmaid's Tale*.

Future Home of the Living God is a successful novel that looks at the results of disastrous climate change from the perspective of the growing fear of reproductive consequences, civil disorder, and increasing totalitarian control of women's lives. Erdrich effectively uses the journal format to begin the novel with a slightly sarcastic and humorous tone and then allows it to darken as dark events unfold around the ever observant Cedar Hawk Songmaker.

See also: *Children of Men, The*; *Clade*; *Handmaid's Tale, The*; *MaddAddam*

Further Reading

Felicelli, Anita. *Los Angeles Review of Books*. December 12, 2017.

Franklin, Ruth. "A Timely Novel of Anti-Progress by Louise Erdrich." *New York Times*. November 21, 2017.

Kurup, Seema. *Understanding Louise Erdrich*. Columbia: University of South Carolina Press, 2015.

G

GEOSTORM

Geostorm (2017), directed, cowritten, and coproduced by Dean Devlin, is a science fiction disaster thriller released by Warner Bros Pictures in 2D, 3D, and IMAX 3D versions. The film stars Gerard Butler, Jim Sturgess, Abbie Cornish, Ed Harris, and Andy Garcia. The narrative revolves around the development, implementation, and misuse of a series of weather-controlling satellites put into orbit to combat the effects of climate change, which leads to a series of natural disasters around the world.

In the film, set in 2019, an international consortium of scientists and governments, faced with increasing natural disasters caused by climate change, develop and place into orbit a series of weather satellites, called "Dutch Boy," controlled by an International Climate Space Station (ICSS). Jake Lawson (Butler), who developed the system and is commander of the ICSS, is reprimanded for not receiving proper authorization from the U.S. government and is replaced by his brother, Max (Sturgess), who works in the U.S. State Department.

For three years, Dutch Boy is a success, controlling the climate so that massive storms can be avoided. In 2022, however, a massive firenado erupts in Hong Kong, killing thousands and destroying infrastructure. Other catastrophes follow, causing climate experts to suspect that the climate-controlling satellites have either failed or have been compromised. In the investigation that follows, Max and Jake discover that the weather-controlling codes have been manipulated and possibly weaponized. They begin to suspect that the president of the United States, Andrew Palma (Garcia), may be planning to use the satellite system as a weapon. The real villain turns out to be U.S. Secretary of State Leonard Dekkom (Harris), who has developed a plan, code-named "Zeus," that entails the creation of a huge geostorm that would destroy the country's enemies and ensure American control of the earth's weather.

As in many thrillers, the action in *Geostorm* involves the murder of characters who are assisting the heroes; a love affair, in this case between Max Lawson and a beautiful Secret Service Agent (Cornish); and a series of disasters, including a frozen village in Afghanistan, the destruction of parts of Rio de Janeiro, killer heatwaves in Moscow, and a monstrous tsunami in Dubai. Against the background of the growing climate disasters, the brothers Lawson must identify the

agents involved in Dekkom's deception, avoid being killed, and reprogram the satellites to ensure humanity's control of the earth's climate.

The film's crisis involves stolen computer codes, a chase in space, confrontation in the ICSS, and saving Orlando, Florida, where the Democratic National Convention is taking place. Jake Lawson and the commander of the ICSS manage to defeat the bad guys, reprogram the satellites, and destroy the space station. All ends well, however, as six months after the reprogramming, Jake Lawson is in control of the project, which is now under international supervision. The film suggests that no single nation can be trusted with the earth's survival.

Geostorm draws on two ideas popular in narratives dealing with disasters caused by climate change. The first is the use of satellites to control the worst disasters caused by climate change. The idea of employing space-based technology to control the earth's climate was explored by the Sustainable Development Impact Summit of the World Economic Forum in the spring of 2021. In addition, such writers as Al Gore, in *An Inconvenient Truth*, and Bill Gates, in *How to Avoid a Climate Disaster*, suggest technological solutions to the climate crisis will be essential. The misuse of technology is as old as popular culture itself, as can be seen in such classic narratives as Mary Shelley's *Frankenstein* (1818) and Stanley Kubrick's *Dr. Strangelove or: How I Learned to Stopped Worrying and Love the Bomb* (1964).

Geostorm was neither a critical nor a financial success. The film earned $221.6 million on a budget of $120 million. Critics found the film's plot confusing and convoluted and the special effects not special enough. Writing in the *New York Times*, A. O. Scott observed that "'Geostorm' uses digital technology to lay waste to a bunch of cities and hacky screenwriting to assault the dignity of several fine actors." Also, on October 20, 2017, *Variety* writer Peter Debruge noted that in "'Geostorm' a race to save the planet from the worst weather event in human history is mostly just an excuse to unleash a series of freaky CG disasters." Several critics noted that *Geostorm* was far less successful, both artistically and financially, than the similar 2004 film, *The Day after Tomorrow*.

Geostorm's failure at the box office may be the result of the demands of the film's multigenre structure. Science fiction narratives have specific requirements, as do thrillers and disaster narratives. In attempting to combine all three, Dean Devlin was unable to develop the rounded characters necessary to create a compelling narrative.

See also: *Day after Tomorrow, The*; *How to Avoid a Climate Disaster*; *Inconvenient Truth, An*

Further Reading

Debruge, Peter. "'Geostorm' Review: Dean Devlin's Disastrous Directing Debut." *Variety*. October 20, 2017.

Scott, A. O. "In 'Geostorm' Gerard Butler (and His Stubble) Save the Planet." *New York Times*. October 20, 2017.

GOLD FAME CITRUS

Gold Fame Citrus (2015) is a dystopian climate change novel written by Claire Vaye Watkins, whose 2013 collection of short stories, *Battleborn*, received both critical acclaim and international awards. Like many other climate change novels, *Gold Fame Citrus* is a story of disaster and survival, but unlike many novels dealing with climate change, it draws heavily on both science and popular culture and examines the psychological impact of an environment devastated by climate change.

One of the most observable aspects of climate change, aside from rising sea levels and rising average temperatures, is the drought in the Southwestern United States. In her novel, Watkins imagines a California crushed by drought and a country unable, and perhaps unwilling, to do much about it. Not only have the reservoirs fed by the Colorado River dried up, but climate change has also eliminated the snowpack in the Rocky Mountains and wind shifts have created an enormous moving sand dune that has swallowed up San Diego, Las Vegas, and much of the American Southwest. Millions of people have fled California, and these "Mojavs," as they are called in the rest of the country, are treated worse than the Oklahoma refugees from the Dust Bowl were treated in California during the 1930s. States with water resources have quotas for drought refugees, and emergency rations are flown into California to encourage those who remain to stay.

Gold Fame Citrus focuses on the lives of Luz Dunn, a former model, and Ray Hollis, a former surfer and soldier AWOL from the "forever war" being fought somewhere in the Middle East. Los Angeles is eerily empty except for roving bands of gang members and cult members, or would-be gang and cult members, subsisting on donated emergency rations and expired warm Coke. Luz and Ray occupy the Laurel Canyon mansion of a movie star, who has long since fled. Luz stays stoned or drunk most of the time, moving through the mansion's empty rooms while wearing the star's discarded clothing. Ray provides the food, digs latrines, and cares for Luz. There is no running water in the city. Numbed with boredom, Luz convinces Ray to drive into the city, where they come upon a group of people at a rave in one of the city's long abandoned canals. As they watch the revelers, they come across a small blonde abandoned girl in diapers. Out of boredom as much as responsibility, Luz convinces Ray to

take the baby, which they call "Igg," for the only sound she makes. Suddenly, they are a family of sorts.

Luz believes that Los Angeles is no place for Igg, and she begs Ray to find a way to get to one of the green states in the East. Ray goes to a former friend, a drug dealer and fixer, but even the money Luz and Ray take from the movie star's mansion cannot but a new identity for Ray, who would be arrested when he crossed a state border, or papers for Igg. Reacting rather than planning, Ray and Luz pack what food and water they can find and take the star's sports car into the desert to try to find a way around the shifting, growing Amargosa Dune Sea, named after the valley it devoured, in Nevada.

The escape attempt is a disaster. The sand sea has filled valleys and leveled hills, and as they drive along deserted highways, wisps of sand constantly blow in their faces, causing Igg to cry all the time she is awake. Nothing moves except the sand and the car. Eventually, the highway is blocked by sand, and they turn off onto a small road that is also eventually blocked. Luz and Igg sleep, and Ray decides to walk back for more gas, or water, or anything to help.

Luz wakes up to find herself dehydrated, sunburned, and confused. Ray is gone, but Luz and Igg have been saved by a man named Levi, who turns out to be the spiritual leader of a commune at the edge of the advancing Amargosa Dune Sea, whose adherents move their tents and solar-powered vehicles ahead of the encroaching sand. At first, Levi appears to be a charismatic cult leader similar to Charles Manson and David Koresh. He has convinced his followers, primarily young women, of his prophetic genius, and he keeps them content with large doses of communal sex and homemade drugs concocted from local plants. Levi welcomes Luz and Igg into his family and undertakes the process of swaying Luz to his utopian vision of life in the Amargosa Sea, where commune members will achieve spiritual union with nature.

Meanwhile, Ray has been picked up wandering in the desert by federal agents and taken into custody in an underground detention center where both criminals and refugees are kept in a kind of limbo between the desert and the parts of the country that have water. Ray realizes that he and the others are simply being held because no one wants them. There are no charges, no trials, and no sentences—there is simply detention. Eventually, and without much effort, he escapes and walks into the bleached desert again in search of Luz and Igg.

In initiating Luz into the commune, Levi reveals part of his own background. Trained as a biologist, Levi worked for the U.S. government's nuclear storage facility at Yucca Mountain, Nevada. As Nevada became engulfed by the Amargosa Sea, Levi was sent into the creeping mountain of sand in search of life, and if he found none, he was to report his findings to the Yucca Mountain staff so that the nuclear waste pile could be moved to the ever-expanding empty desert, solving the nuclear waste problem. Wandering through the desolation,

Levi not only collected his group of followers, but he also created a fantastic list of imagined plants and animals inhabiting the wilderness that he shares with his followers.

When Ray walks into the commune from out of the desert, Luz is confused. She is angry at Ray for abandoning her and Igg, but she also believes she is in love with him. She also feels infatuated by Levi. When Igg is bitten by a poisonous insect, Luz at first withdraws into drug-induced hallucinations, but at Ray's urging, she stops taking Levi's spiritual root medicine. Suddenly sober and clean, she agrees to leave with Ray. Both Luz and Ray are cast out of the commune by Levi, who tells his followers that the two are no longer spiritually open to the wonders he foresees for those willing to live in the desert. Igg remains with Levi and the commune, and as Ray and Luz drive away, a sudden rainstorm appears that creates swift flowing currents of deep water. Luz, amazed and fascinated by the water, falls into the water and dies, leaving Ray alone.

Gold Fame Citrus was well received by critics upon publication in 2015. Most reviewers praised Watkins's effective use of setting, both her abandoned dystopian Los Angeles and the immense moving desert of the Amargosa Dune Sea. Other writers have used the idea of drought as the consequence of climate change, most notably Paolo Bacigalupi in *The Water Knife* (2015) and J. G. Ballard in *The Wind from Nowhere* (1961) and *The Burning World* (1964), which was retitled as *The Drought* in 1965. Although sea rise and flooding have received most of the attention in the media dealing with the impact of climate change, drought is already occurring in many parts of the world, and severe drought in both Central America and the American Southwest has already impacted agriculture and created drought refugees. Current predictions indicate that drought and the resulting food shortages and social unrest will have a major impact on American society in the near future. Long-term predictions are even worse.

Gold Fame Citrus manages to avoid many of the clichés of much climate change fiction. First, Luz and Ray, the protagonists of the novel, are neither overly virtuous nor heroic; they simply want to make the most of a very bad situation. Second, in creating the character of Levi, Watkins draws heavily on the well-known personalities of recent messianic cult leaders, such as Charles Manson and David Koresh. Readers, aware of the real-life messianic leaders, will find Levi believable. In addition, there is a whole body of literature, Norman Cohn's *The Pursuit of the Millennium: Revolutionary Millenarians and Mystical Anarchists of the Middle Ages* (1970) being the most famous, that examines the relationship between the rise of cults and the kind of social and environmental disasters that climate change will create. More specifically, in *Storming the Wall: Climate Change, Migration, and Homeland Security*, Todd Miller argues

that governments in both the Middle East and the Americas are now planning for such drastic social upheavals because of climate change–induced drought. Finally, Watkins has created one of the most memorable images of climate change, a vast moving mountain of sand devouring California and much of the American Southwest.

See also: *Burning World, The*; *Dry*; *Grapes of Wrath, The*; *Storming the Wall*; *Water Knife, The*; *Wind from Nowhere, The*

Further Reading

Sheehan, Jason. "'Gold Fame Citrus' Holds Fear in a Handful of Dust." NPR. September 30, 2015.
St. John Mandel, Emily. "'Gold Fame Citrus' by Emily Watkins." *New York Times*. October 4, 2015.

GRAPES OF WRATH, THE

The Grapes of Wrath (1939), by Nobel Prize–winning American author John Steinbeck, is a novel that was written before the idea of man-made climate change and the possibility of global warming were even speculation. However, Steinbeck's novel about the drought in the 1930s and the migration of one Oklahoma family from their farm to California employs every literary convention that will later be associated with climate fiction. Steinbeck depicts an environmental disaster caused in part by human action and the resulting loss of life and income. He also dramatizes the mass migration of people fleeing an area ruined by extreme weather as well as the governmental indifference and the hostile response of the people in the communities to which the migrants flee. Written before the word "Anthropocene" was coined, *The Grapes of Wrath* is the one of the world's first great climate change novels.

The Dust Bowl was period of severe dust storms caused by a series of droughts that swept the central part of the United States from 1930 to 1936, causing major agricultural failures as well as personal business bankruptcies throughout the states of Texas, New Mexico, Colorado, Nebraska, Kansas, and Oklahoma. Over 2.5 million people left those plains states, most moving to California. Over 440,000 people left Oklahoma, so many in fact that the pejorative term "Okie" was given to most of the migrants. Although drought was a major cause of the Dust Bowl, unsustainable farming practices created conditions on the ground that made the impact of the dry weather catastrophically worse.

The Grapes of Wrath is the story of the Joad family, three generations of Oklahoma farmers whose land is devastated by the drought. Grandpa and Grandma Joad are elderly. Ma and Pa Joad have six children: sixteen-year-old Al; Rose of Sharon, who is married to Connie Rivers and pregnant; twelve-year-old Ruthie;

The impact of the Dust Bowl on a farm north of Dalhart, Texas. (Library of Congress)

A production photo from the filming of *The Grapes of Wrath*. (Library of Congress)

Tom, the protagonist of the novel; Noah, the oldest son, who was injured at birth and is called "strange"; and Winfield, the youngest son. Like their neighbors, the Joads are evicted from their failed farm and decide to go to California, where they have heard work is plentiful and pay is good.

One of the most consistently mentioned effects of climate change is increased global migration, as sea level rise and increased temperatures will not only impact people living near the continental coasts but also the people whose livelihoods depend on agriculture, as growing zones will be dramatically altered. Steinbeck structures *The Grapes of Wrath* around the Joads' migration from Oklahoma to California, developing a chronological and geographical plot line. In addition, he places short interchapter episodes between the sections of the Joads' narrative in which he describes the movements of hundreds of thousands of others caught up in the climate migration. In this way, Steinbeck makes it obvious that although the Joad family is made of unique and well-developed individuals, their experiences are representative of a much larger social and cultural disruption that impacted millions of people.

The early chapters of *The Grapes of Wrath* chronicle the Joad family's preparations for their journey. Unlike some of their neighbors, who have almost nothing, The Joads are able to buy a used Hudson truck and pack food, water, and bedding for the trip. Not all of their neighbors were that lucky. One, Muley Graves, was forced from his farm and is living rough in abandoned houses, where he wonders who to shoot for forcing his family from their farm. He refuses the Joads' offer to take him with them. Jim Casy, a former preacher and friend of the Joad family, does agree to travel with them.

A number of writers have written about the experience of climate migration, including Paolo Bacigalupi in *The Water Knife* and Claire Vaye Watkins in *Gold Fame Citrus*. Both authors emphasize the hardship of migration as well as the cost paid by those moving to escape the ravages of climate change. They also have their characters moving either to or from California, echoing the narrative of the Joad family migration, which also includes opposition by those who live along the migration route and the deterioration and breakup of the multigenerational family.

As the Joad family travels west, their number grows smaller. Grandpa Joad dies the first night the family is on the road. His wife, Grandma, dies as the family is crossing Death Valley. Noah Joad leaves the family as they arrive in California, planning to live by fishing in the Colorado River, and Connie Rivers leaves his pregnant wife soon after the family arrives in California. As has been noted by observers of contemporary climate migrations, including the one coming from Central America to the United States, family breakups are a fact of migration.

Climate change refugees often face hostility from people who are living in the areas through which the refugees travel or areas in which they hope to settle, as political opposition to receiving migrants in both the United States and Europe clearly indicate. Steinbeck includes a number of instances of such opposition to climate refugees in *The Grapes of Wrath*. Several times on the trip along Route 66 from Oklahoma to California, the Joad family is told to keep moving by local authorities. When they arrive at the California border after a night drive through Death Valley, they must conceal the fact that Grandma Joad is dead so they will not be turned back. Even more significantly, the Joad family is attacked more than once by local Californians who see them as undesirable outsiders who will ruin their communities.

Another feature of much climate migration fiction is the discrimination and hostility climate refugees experience once they arrive in a host country or, in the case of *The Grapes of Wrath*, a host state. The Joads quickly discover that there are far more people looking for work than there are jobs. In the first camp they stay at in California, Jim Casy stops a deputy sheriff from shooting a fleeing migrant and becomes a fugitive himself. In the second camp, the Joads are treated better because the camp is run by the Resettlement Agency. It is a federal government–sponsored temporary housing site in which the migrants have a say in its operations. Local police, however, attempt to create a riot so that they can enter the camp and arrest migrants whom they consider "troublemakers."

The third place the Joad family stays is a peach farm where most of the family is hired to pick fruit. Trouble follows them there. The farmer cuts the promised wages, and as a result, many of the workers strike. Local authorities attempt to break the strike, and during the struggle that ensues, Jim Casy, who been working to organize migrants, is beaten to death by a deputy sheriff. Tom Joad, attempting to intervene, kills the deputy and is forced to become a fugitive himself, telling his mother that he will work for the rights of migrants and oppressed people.

The Joad family leaves the peach farm and finds work picking cotton. Dramatic weather again disrupts their lives as torrential rains sweep through the area causing massive flooding and forcing the Joads to try to find high ground. Rose of Sharon's child is stillborn during the flood, and eventually the remaining family members find shelter in a barn, where they discover a young boy and his father, who is dying of starvation. The novel ends with Rose of Sharon breastfeeding the man.

Character development is as important as plot in *The Grapes of Wrath*, and all the characters are tested by their migration from climate-stricken Oklahoma to what they hope is the promised land of California. Migration is hardest on the old and the infirm, as Grandpa, Grandma, Noah, and Connie Rivers fail to complete the journey. Several of them, however, grow dramatically because of

the hardships they face. Ma Joad, for example, becomes stronger as the novel progresses, becoming the force that holds the family together. Jim Casy, who begins the novel as a preacher who no longer believes in organized religion, becomes an organizer for workers' rights and ultimately gives his life for his beliefs. The central character in *The Grapes of Wrath* is Tom Joad, who begins the novel being released from prison. On the family's journey to California and through the various camps there, the family members defer to him. Most significantly, at the end of the novel, he takes up Jim Casy's mantle, telling his mother as he leaves the family, "Then I'll be around in the dark. I'll be everywhere wherever you look. Wherever they's a fight so hungry people can eat, I'll be there. Wherever they's a cop beatin' up a guy, I'll be there."

The Grapes of Wrath has been called "one of the great American novels." It won the National Book Award as well as the Pulitzer Prize for Fiction and was the best-selling book of 1939. It was also chosen to be printed as an Armed Forces edition. It was not universally well received, however. Because of Steinbeck's depiction of the plight of the migrants, a number of conservative political critics called him a socialist. The Associated Farmers of California, a business organization, called the novel a "pack of lies" and "communist propaganda." The controversy continues, as the novel is required reading in many schools in the United States and is also often on lists of the most banned books in the United States.

Because of its popularity, *The Grapes of Wrath* was quickly adapted as a major Hollywood film. Directed by John Ford and starring Henry Fonda as Tom Joad, Jane Darwell as Ma Joad, and John Carradine as Jim Casy. The film, like the novel, was both a popular and critical success, receiving seven Academy Award nominations and winning two, John Ford for Best Director and Jane Darwell as Best Supporting Actress. The film was also named to the National Film Registry in 1989. Like the novel, the film version of *The Grapes of Wrath* was also attacked as communist propaganda. Despite the political criticism, the film is considered one of the finest films ever made.

The Grapes of Wrath is not usually considered to be a climate change novel. The idea that the activity of human beings could radically change the nature of the earth's atmosphere causing dramatic fundamental and perhaps irreversible changes was unimaginable in 1939, except in the imagination of writers of science fiction. Since then, science has caught up with science fiction, and Steinbeck's novel can now be read as a novel about the impact of climate change on a vulnerable population. *The Grapes of Wrath* clearly shows a radical change in climate based in part on human activity, the migration of a large population to escape agricultural failure, the cost of climate change to the migrants, and the reactions of people in states to which the migrants flee. Steinbeck's classic novel can be seen as a template for the many later writers who have examined the

personal cost of climate change, and it not surprising that a number of them make allusions to *The Grapes of Wrath* in their work.

See also: *Bridge 108*; *Burning World, The*; *Clade*; *Gold Fame Citrus*; *Parable of the Sower*; *Water Knife, The*

Further Reading

Hayashi, Tetsumaro. *John Steinbeck: The Years of Greatness*. Tuscaloosa: University of Alabama Press, 1993.

Heavilian, Barbara. *The Critical Response to Steinbeck's* The Grapes of Wrath. New York: Greenwood Press, 2000.

Shillinglaw, Susan. *On Reading* The Grapes of Wrath. New York: Penguin Books, 2014.

Souder, William. *Mad at the World: A Biography of John Steinbeck*. New York: W.W. Norton, 2020.

GREAT DERANGEMENT, THE

The Great Derangement: Climate Change and the Unthinkable (2016) is an analysis by Indian novelist Amitav Ghosh of how contemporary literature and, to some degree, people in general have failed to come to terms with climate change. Adapted from a series of lectures Ghosh gave at the University of Chicago, *The Great Derangement* is divided into three essays: "Stories," "History," and "Politics." In each essay, Ghosh provides insights into why climate change, "the existential threat of our times," has been so difficult for many people to engage with.

All three of Ghosh's sections are based on one general observation: that for the past 300 years, or since the beginning of the Enlightenment, human beings have shared the misconception that they exist separate from nature. As a result, in the three cultural areas that he examines, Ghosh asserts that human beings see themselves disassociated with the natural world, acting upon it but not being influenced by it. As a result, individual choice has been given a higher priority in examining human behavior than the physical reality in which choices are made or not made.

In "Stories," Ghosh writes that in the "literary" novel, the genre of fiction that has the most status in Western culture, nature is a "filler," a constant stable background of the narrative, which prioritizes individual feelings and actions. When something unusual in nature occurs in a literary narrative, readers are confused, as extraordinary events in nature are the subject of less valued genre fiction, such as science fiction, speculative fiction, and fantasy. Ghosh notes that this division was not always the case. He points to the Year without a Summer, 1816 CE, when the eruption of Mount Tambora in Indonesia put forth enough volcanic ash to drop the temperature in most of the world

several degrees. That was also the year in which Lord Byron, Percy Shelley, Mary Shelley, and John Polidori spent the summer in the Villa Diodati, near Lake Geneva in Switzerland. After a dramatic storm and at Byron's suggestion, they wrote supernatural tales, the most famous being Polidori's *The Vampyre* (1819) and Mary Shelley's *Frankenstein; or, The Modern Prometheus* (1818). Ghosh observes that both novels reflect the disorientation and confusion even a short period of climate change can cause. He then examines how contemporary writers of speculative fiction, science fiction, and fantasy, genres in which abrupt and dramatic natural events often occur, are more comfortable in dealing with

Dr. Frankenstein's monster is often seen as a symbol of the failure of Western science. (New York Public Library)

climate change. He notes, for example, that such writers as Paolo Bacigalupi, Margaret Atwood, and Kim Stanley Robinson have been successful in using climate change in their fiction.

In "History," Ghosh provides an overview of what has come to be known as the "carbon culture." He acknowledges the work of Naomi Klein, especially her popular and influential *This Changes Everything: Capitalism vs. The Climate* (2014). He provides an overview of the parallel developments of capitalism and the use of carbon fuels. He acknowledges that the combination of capitalism and the use of carbon-based fuels made the Industrial Revolution possible, and he examines how successful the fossil fuel industry has been in convincing ordinary people that the carbon-centric economy has benefited everyone, not just the wealthy. Ghosh argues, however, that the development of a carbon economy was fueled as much by colonialism as by capitalism, and he examines the role of fossil fuels in both the development of colonialism and the disparity of economic equality between the industrial West and former colonial nations. In addition, he speculates that the colonial powers' refusal to let their colonies

develop fossil fuel industries for themselves, citing India as a prime example, may have delayed the full impact of the climate crisis.

In "Politics," Ghosh applies his analysis of the growth of capitalist ideology and the development of the cult of the individual in the arts to politics. Gosh begins his analysis with an examination of the politics of sincerity, which he asserts is a part of the same cultural development as the growth of individualism in the arts, especially literature. He writes that contemporary Western politics has become so individualized and personalized it has lost the ability to articulate collective concerns and solutions, even as it has lost the language to speak collectively. This emphasis on individualism empowers climate change deniers, Ghosh believes, and makes it difficult to discuss climate change in political terms. As an example, he compares the text of the 2015 Paris Agreement on climate change, which he finds full of corporate and military language and rhetorical obfuscations, with the text of Pope Francis's 2015 climate change encyclical *Laudato Si* (*Praise Be to You*), which draws concrete connections between social and environmental justice in clear, simple terms. Ghosh concludes by suggesting that the language of religion may be a more appropriate vehicle for the discussion of climate change than the language of literature or politics.

The Great Derangement is an important work for understanding the response to climate change. Ghosh provides a theoretical framework with which to approach both the discussions about climate change and the literature based on climate change. His thesis, that the emphasis on individuality as a mode of thought and the removal of humanity from nature are both hallmarks of the Enlightenment and obstacles to perceiving the human causes and costs of climate change, is insightful. His suggestion that communality and the language of prayer are more appropriate responses provides at least a glimmer of hope.

See also: *Fifty Degrees Below*; *Forty Signs of Rain*; *MaddAddam*; *New York 2140*; *Oryx and Crake*; *Sixty Days and Counting*; *Water Thief, The*; *Windup Girl, The*; *Year of the Flood, The*

Further Reading

"The Great Derangement: Climate Change and the Unthinkable." *Kirkus Reviews*. October 1, 2016.

Mishra, Pankaj. "*Easternization* by Gideon Rachman and *The Great Derangement* by Amitav Ghosh—Review." *The Guardian*. November 3, 2016.

H

HANDMAID'S TALE, THE

The Handmaid's Tale (1985) is a dystopian novel by Canadian author Margaret Atwood. The novel is set in the near future, when a patriarchal Christian totalitarian state called Gilead has replaced the United States in a violent revolution. The novel explores the lives of women who have been subjugated by men who base their authority on an unusual reading of the biblical Tanach (Old Testament). According to the laws of Gilead, women have no political or legal rights, may not own property, and some, called Handmaids, must submit to producing children for Commanders, men who hold power in the state.

Because of the critical acclaim and popular success of Atwood's narrative, *The Handmaid's Tale* is now considered one of the major modern dystopian novels, along with Aldous Huxley's *Brave New World* (1932), George Orwell's *Animal Farm* (1945) and *1984* (1949), and Ray Bradbury's *Fahrenheit 451* (1953). Although the political, social, and sexual subjugation of women and the rise of a totalitarian religious state are foregrounded in the novel, climate change is a central idea in the narrative, as it is one of the primary causes of the social and economic uncertainty that allows the founders of Gilead to overthrow the government of the United States and adopt radical measures to establish security.

The Handmaid's Tale is told by Offred, one of the few fertile young women in Gilead. To ensure the continuation of the regime, the founders of Gilead adapt the biblical story of Rachel and her handmaid Bilhah, Rachel, who is unable to bear children, gives Bilhah to her husband Jacob as a concubine to bear children for their own needs. Despite the nation's other puritanical laws, the leaders of Gilead, called the Sons of Jacob, used this story as a justification for making Offred and others serve as sexual slaves to Gilead's leaders. The cause of the general infertility is only hinted at in the novel, but the effects of climate change, such as food shortages, increase in diseases, environmental degradation, storm intensification, and radiation leaks from nuclear plants, all impact fertility.

Climate change is also instrumental in making the world in which Offred finds herself. Most studies of the societal impact of climate change, such as Todd Miller's *Storming the Wall: Climate Change, Migration, and Homeland Security* (2017) and Elizabeth Kolbert's *Field Notes from a Catastrophe* (2006), suggest

that governments are ill equipped to handle the severe effects of climate change and a deteriorating environment. In the novel, the failure of the U.S. government to address these problems led to the assassinations of the president of the United States and most members of Congress and the willingness of the population to accept a religious authoritarian regime to achieve some semblance of security. The cost, of course, is freedom.

To ensure their control in the new state of Gilead, the Sons of Jacob have disenfranchised women, exiled African Americans, and outlawed all religious practices except the state religion, forcing people of other faiths to either convert or flee. The Gilead founders succeeded in establishing what they thought to be a church state governed by biblical principles in which political dissent is apostasy and any act of rebellion is a violation of God's will. Atwood notes that she modeled Gilead on the most radical tendencies of New England Puritan theocracy.

Offred is rebellious. As she describes her life as a Handmaid, she interspaces events from her life before the revolution, when she was fired from her job, had her credit cards canceled, and failed in an attempt to escape to Canada with her husband and child. She was considered a "wanton woman" because she was married to a man who had been divorced. As the law in Gilead does not recognize divorce, Offred is by law an adulteress. In addition, she describes her indoctrination by the Aunts, older women who instruct potential Handmaids, and Marthas, women who cannot bear children and work as servants and cooks, on their religious and political obligations and, in the case of Handmaids, their sexual obligations.

Offred's life as the Handmaid in the Commander's house is the main narrative line in *The Handmaid's Tale*. She paints an unflattering picture of the Commander, who was an advertising executive prior to the revolution and is now one the Gilead's leaders. Hypocritically, he publicly upholds the laws of Gilead but privately breaks them by allowing Offred to read and play Scrabble, intellectual pursuits forbidden to women. He also provides her with makeup and erotic clothes when he takes her to a secret brothel for leaders in Gilead. Offred records her dislike of the Commander's wife, Serena Joy, a former televangelist who dislikes taking part in the monthly fertility ritual that requires the wife to hold the Handmaid as the Commander attempts to impregnate her. She also writes of the hostility of the Marthas, who are forced to take care of her as well as the Commander and his wife.

Not all is as it seems in Gilead. In addition to the Commander's erotic adventure with Offred, Serena Joy encourages Offred to have sex with the Commander's chauffer, Nick, so that Offred can become pregnant. Because of the toxic environment, climate change, and disease, very few women are able to become pregnant, and if Offred is able to conceive and bear a child, both Serna Joy and

the Commander will gain status among Gilead's elite. Offred agrees, and in addition to a sexual partner, she discovers a friend in Nick.

Shortly after she tells Nick she believes she is pregnant, members of the Eyes of God, an elite secret police force, arrive and escort her into a van. Nick tells her to go. Offred is unsure of whether the men taking her are actually members of the Eyes of God or members of Mayday, an underground anti-Gilead group that smuggles people into Canada and works for the overthrow of the theocracy. The main narrative ends there.

The Handmaid's Tale concludes with an epilogue set in the 2195. The epilogue is a partial transcript of an international historical conference taking place somewhere in Canada. The subject of the conference is the "Gilead Period," indicating that the theocratic state of Gilead no longer exists. During the conference, references are made to how little is known about the period, and what is known are often assumptions made from scant evidence. Both indicate that Gilead did not survive long as a nation and that its ending was not peaceful. At the conference, it is announced that the novel had been found much later than the period in question on cassette tapes and transcribed by historians. There is some discussion as to whether the tapes are genuine or fictitious, but the consensus is that they describe the experiences of a real person.

The success of *The Handmaid's Tale* has resulted in a number of adaptations of the novel, including a graphic novel and stage productions, an opera, and a ballet. In addition, in 1990, Cinecom Pictures released a film adaptation directed by Volker Schlöndorff and starring Natasha Richardson, Faye Dunaway, Aidan Quinn, and Robert Duvall. The film was a modest success. A more successful adaptation was released in 2017 when Hulu aired a television series based on the novel starring Elizabeth Moss as Offred and with Margaret Atwood serving as consulting producer. The series won eight Primetime Emmy Awards during its first season. In 2019, Atwood published a sequel to the novel called *The Testaments*. Set fifteen years after *The Handmaid's Tale*, it consists of the testaments, or statements, of three women: Aunt Lydia, a character from the original novel who has risen to a degree of power in Gilead; Agnes, a young woman living in Gilead; and Daisy, a young woman living in Canada who had been smuggled out of Gilead as a child.

As mentioned above, *The Handmaid's Tale* was both a popular and critical success. By 1919, the novel had sold over eight million copies worldwide and had been included in both high school and university curricula. The novel was seen as a cautionary narrative about the growing power of the religious right in the United States and as a feminist analysis of the power of corporate capitalism and religious fundamentalism. *The Handmaid's Tale* has also come under criticism, consistently appearing on the American Library Association's annual list of the "100 Most Frequently Challenged Books." The novel has been attacked,

according to those who have challenged its inclusion on school required reading lists, for its "explicit sexuality," "moral corruption," and "statements defamatory to minorities, God, women, and the disabled." The novel has also been called "anti-Christian" and "anti-Islamic."

Although *The Handmaid's Tale* has been read primarily as a critique of religious extremism and patriarchal and sexist attitudes toward women, the novel is now being read as a warning against the dangers of climate change. In 2018, Atwood said that real life is like the plots of her dystopian novels, including *The Handmaid's Tale*, and that women will bear a disproportionate burden of hunger, war, and repression—all sparked by climate change. Linking her work to real life at an Under Her Eye conference in England in 2018, Atwood noted that climate change "will also mean social unrest, which can lead to wars and civil wars and then brutal repressions and totalitarianisms." Atwood could be describing the actual world in the short-term future or life in Gilead.

See also: *A.I. Artificial Intelligence*; *Children of Men, The*; *Field Notes from a Catastrophe*; *Future Home of a Living God*; *MaddAddam*; *Oryx and Crake*; *Storming the Wall*; *Year of the Flood, The*

Further Reading

Cooke, Nathalie. *Margaret Atwood: A Critical Companion*. Westport, CT: Greenwood Publishing Group, 2004.

Howells, Coral Ann. *The Cambridge Companion to Margaret Atwood*. Cambridge: Cambridge University Press, 2006.

Nischik, Reingard M. *Engendering Genre: The Works of Margaret Atwood*. Ottawa, Canada: University of Ottawa Press, 2009.

HISTORY OF BEES, THE

The History of Bees (2017) is a well-received climate change novel by Norwegian author Maja Lunde, who also authored another climate change novel, *The End of the Ocean*. The novel, which traces the extinction of bees as a specific example of the results of climate change, is set in three time periods: 1852 England, 2007 United States, and 2098 China. In each period, a family's interaction with bees provides an insight into the correlation of one species with the global environment.

The novel is told in alternating chapters that move among the three historical moments. It begins in Sichuan, China, in the year 2098 and follows Tao, a wife and the mother of a small child. The family works as pollinators of fruit trees, as bees have become extinct because of climate change. Because of the absence of bees and other environmental disasters caused by climate change, agriculture collapsed around the world, creating mass starvation, mass migrations,

and societal collapse in the industrial world. In China, millions of workers are mobilized to do the work of billions of bees, becoming the pioneering nation in human pollination after the European and U.S. economies crashed. On a rare day off from work, Tao and her family go on a picnic among the trees where they work. Tao's son, Wei-Wen, is suddenly taken ill, and when the doctors at the local infirmary are unable to diagnose his illness, he is taken from his family and sent for observation at a government hospital in Beijing. In desperation, Tao takes the family's meager savings and follows her son.

The second narrative is set in England in 1852 and features William, a seed merchant and beekeeper suffering from severe depression after his academic career ended and his son's refusal to prepare for admission to a university. Once a student of natural philosophy, a term then in use to describe scientific study, and looking forward to a career as a teacher, William left his studies when he married, after being rejected by his mentor for lack of dedication to scholarship and in order to provide for his family. Hoping to impress his former teacher as well as inspire his son, William begins an intense study of his beehives, hoping to create a better hive to make beekeeping more efficient and gain a reputation as a natural philosopher.

The third narrative takes place in the United States in 2007 and features George, a beekeeper who operates a small bee service in the Midwest and hopes his son will join him in the family business as he had joined his own father. George's main competition is a neighboring beekeeper who has industrialized his farm, sending thousands of hives across the country in industrial trailers while George works out of a pickup truck. His son, however, wants to become a journalist and leaves his father in the midst of preparing the bees for winter to return to college. George sees his son's desire to leave beekeeping as a rejection of his own beliefs and values.

Tao's story picks up in Beijing, where she is at first unable to discover the whereabouts of her son. She wanders about the city, which is half empty because of the social and economic collapse due to the climate change–induced agricultural failure, searching for her son at various hospitals. Finally, when she has exhausted her savings and her spirits, a member of the Chinese Ruling Committee appears and agrees to take her to Wei-Wen. Tao discovers that her son is dead, and his body has been preserved for study after doctors determined that he had been bitten by a bee, for which he had no immunity. Chinese scientists and government officials, realizing that bees are not extinct, want to mobilize the nation in hopes of finding more. They plan an extensive campaign with Wei-Wen as a national hero and martyr using Tao as a spokesperson. Seeing a way to make sense of her loss and perhaps help people throughout the world, she agrees.

William spends months observing the behavior of bees in his hives, eventually coming up with a design that will make honey production more efficient.

When he shows his former teacher, he learns that he has unknowingly duplicated a design developed by a German scientist. At first, he is crushed by his failure, but he eventually strikes up a correspondence with the German scientist, who congratulates him on his work and offers to compare observations. Although his son still ignores his work and his advice to study, rejecting both his father's enthusiasm for the study of science as well as his advice, his daughter both encourages him and helps him with his observations. They realize that the problem with the hive is finding the exact distance between the slats and the walls and how to encourage the bees to combine them. Together, father and daughter determine the distance, perfecting the new hive.

In spring, George puts his hives on his pickup truck to deliver them to an apple orchard whose owner has used his bees to pollinate his apples for years. This year, however, colony collapse disorder, an abnormal phenomenon linked to climate change that occurs when the worker bees leave a hive, causing the death of the queen and immature bees, hits the midwestern United States, wiping out George's hives. His neighbor, because he had industrialized his business, is able to refinance and buy new hives. George, who kept his business small with dreams of working with his son, loses both his business and his dreams, as his son remains a journalist who writes about colony collapse disorder.

The History of Bees was both a critical and popular success. It is an unusual climate change novel in that its focus is more on the conflicts within families than on climate change, and yet the changing climate that causes colony collapse disorder and the eventual near extinction of bees is always in the background of the three family narratives. Lunde is successful in creating strong, believable characters and placing their hopes and fears into a historical context. Each narrative section is rich in detail, and Lunde combines realism, historical fiction, and science fiction in a complex narrative. Climate change fiction can be more than dystopian narratives of mass migrations and drowned cities. Writers who explore the implications of climate change in narratives with complex stories and well-developed characters, such as Richard Powers, Margaret Atwood, and Barbara Kingsolver, have drawn a wider range of readers to climate fiction. With *The History of Bees*, Maja Lunde has joined that select company of writers.

See also: *End of the Ocean, The*; *Flight Behavior*; *Lorax, The*; *MaddAddam*; *Oryx and Crake*; *Overstory, The*; *Year of the Flood, The*

Further Reading

Latham, Tori. "A Novel That Imagines a World without Bees." *The Atlantic*. September 14, 2017.

Robins, Ellie. "The Dystopian Future Is Already Underway in Maja Lunde's Novel 'The History of Bees.'" *Los Angeles Times*. September 21, 2017.

HISTORY OF WHAT COMES NEXT, A

A History of What Comes Next (2021), by Sylvain Neuvel, is a science fiction novel that traces the history of the Kibsu family as they attempt to manipulate history in such a way as to make spaceflight possible before humanity is destroyed. During the family's study of mathematics, physics, and chemistry, one of the family members discovers a possible connection between temperature rise and the amount of carbon dioxide in the atmosphere and begins to study how to measure the correlation. As the hunt for climate change begins, the family members realize their time span for creating space travel may be shorter than they had realized.

Mia is the ninety-eighth generation of a family of scientifically gifted women who have passed down a command to push humanity to the stars before destruction comes. The origin of both the Kibsu family and their purpose is left unexplained in the novel, although contact with aliens is suggested. In each generation, only a mother and daughter survive, as a grandmother dies when a granddaughter is born. Unfortunately, another ancient family, known as Trackers, has received the command that the family of women must be destroyed, so throughout history, generations of killers have followed the female line of scientists across the world.

A History of What Comes Next begins in 1945, as the Third Reich is crumbling, and American and Soviet troops are closing in on Wernher von Braun and his team of German rocket scientists. The novel follows Mia and her mother as they plan to infiltrate German lines to help von Braun and his scientists escape to the United States and assist in the Soviet development of atomic power and rocketry to create a space race that will bring the family closer to its ultimate goal.

The novel is told in two voices: Mia's and Sarah's. Sarah provides a background of the family's history and instructs her daughter on the importance of the plan. Mia, still young enough to have doubts, argues with her mother, questions her advice, and engages in the more dangerous activities in the novel. Neuvel draws on considerable research as background for Mia's two dangerous missions. His description of Mia's part in the OSS (Office of Strategic Service, the precursor to the CIA) planned Operation Paperclip, the plan to extract von Braun and other Nazi scientists out of Germany, is a masterful piece of espionage fiction. Mia poses as von Braun's niece, manages to talk her way through German lines, and convinces von Braun to trust her. Mia is successful in bringing von Braun and a number of other scientists as well as their records past SS troops to waiting American forces.

Equally dramatic is Mia's subsequent infiltration into Germany to recruit Soviet scientist Sergei Korolev to recruit more German scientists to work in

the Soviet rocket program. Serving as Korolev's scientific and romantic inspiration, Mia cajoles and encourages Korolev to become the head of Soviet rocket development. While Korolev builds bigger and more advanced rockets to support the Soviet nuclear weapons program, Mia continually suggests alterations, knowing that a rocket designed to carry a hydrogen bomb can also carry a space capsule. Just as the SS provided an obstacle to Mia's attempt to help von Braun escape, Lavrentiy Beria, chief of the Soviet secret police under Joseph Stalin, serves as Mia's main opponent in Russia. Beria, whom historians consider responsible for millions of deaths under Stalin, not only threatens Soviet scientists but also attempts to rape and murder Mia.

Shortly after World War II, while encouraging Mia to advance the Soviet space program, Sarah works with Qian Xuesen, a Chinese American physicist at the U.S. Jet Propulsion Laboratory. Qian, who was instrumental in the development of rocket fuels, was blacklisted during the Red Scare of the 1950s and returned to China to work on that country's space program.

Interest in climate change runs throughout the novel, as Sarah's mother first noted the correlation between the increase of carbon dioxide in the atmosphere and rising global temperatures, a fact noted by Swedish scientist Svante Arrhenius in 1896. Sarah describes working with Dutch paleontologist Willi Dansgaard, in developing a method of dating and measuring the amount of carbon dioxide in ice crystals. Sensing that climate change may pose a more serious threat to humanity than even nuclear war, Sarah continues to explore climate change while encouraging the development of the U.S. space program until she dies during a rocket failure at the U.S. testing grounds.

A History of What Comes Next is an example of an emerging trend in contemporary fiction, the integrated use of climate change subject matter in a narrative that deals with other subjects. Sylvain Neuvel's novel is an example of shadow fiction, a form that takes real characters and actual historical events and weaves an element of the fantastic through them. In *A History of What Comes Next*, the major scientific characters are real, as are the events described in the development of the space race between the United States and the Soviet Union. The fantastic element added is the influence of the Kibsu family on the development of both programs. This insertion of a fantastic family allows Neuvel to bring in and develop a concern about the impact of climate change from the mid-nineteenth century to the late 1950s, when the novel ends.

A History of What Comes Next has received positive responses from reviewers. Writing for Tor.com, Tobias Carroll was impressed by Neuvel's worldbuilding, and other reviewers have noted the novel's effective blend of actual history and science fiction. Perhaps the most impressive aspect of Neuvel's novel is the way he creates a sense of urgency about climate change in a period when only a few scientists were even aware of the potential problem.

See also: *Avatar; Firewalkers; Parable of the Sower*

Further Reading

Carroll, Tobias. "In the Shadows of Space: Sylvain Neuvel's *A History of What Comes Next.*" Tor.com. March 4, 2021.

Menhert, Antonia. *Climate Change Fictions: Representations of Global Warming in American Literature.* London and New York: Palgrave MacMillan, 2016.

HOW TO AVOID A CLIMATE DISASTER

How to Avoid a Climate Disaster: The Solutions We Have and the Breakthroughs We Need (2021), by Bill Gates, is a best-selling nonfiction book by the founder of Microsoft and cofounder of the Bill and Melinda Gates Foundation, which is dedicated to the reduction of extreme poverty and enhancing health care worldwide and is the largest private charitable foundation in the world. Because of his unique position as one of the world's richest men, one of the world's most successful technology innovators, and one of the world's major philanthropists, Bill Gates's ideas on the impact of climate change and on how people live their lives in the twenty-first century may be listened to where other's may not. Gates believes that climate change is real, that it will have an enormous impact on the lives of people around the world, and that major steps must be immediately taken to combat the upcoming problems.

Gates begins *How to Avoid a Climate Disaster* with two numbers: fifty-one billion and zero. Those numbers are crucial to everything that follows. Fifty-one billion is how many tons of greenhouse gases the world typically adds to the atmosphere every year, and zero is the target Gates says the world must aim for to avoid climate disaster. Gates admits that solving the problems will not be easy nor inexpensive. He asserts, however, that ignoring climate change is not an option.

Early in his book, Gates writes that there are five questions that need to be asked in every climate change discussion. The first is, how much of the fifty-one billion tons are we talking about? The second is, what is the plan for cement? The third is, how much power are we talking about? The fourth is, how much space is needed? And the fifth is, how much is this going to cost? Gates argues that unless these basic questions are asked and solutions are developed, discussions about climate change solutions are meaningless.

Generating energy is at the heart of climate change. The use of fossil fuels has been a major factor in the increase of greenhouses gases since the beginning of the Industrial Revolution. Any attempt to combat climate change requires finding ways to generate energy while reducing the production of greenhouse gases, primarily carbon dioxide. Gates takes on that issue as he examines five areas of concern. The first is how we plug in. Gates begins by noting that, at

present, two-thirds of the electricity the world produces comes from fossil fuels and that to meet the needs of a growing and upwardly mobile world population, increases in electrical use are necessary. The production of clean energy is the solution, but the problem is that using fossil fuel is by far the cheapest way to produce electricity. Gates argues that although battery storage capability has been improving, more breakthroughs in storage are necessary. More importantly, he argues that because fossil fuels are so inexpensive—he cites the example that gasoline costs less than half of a soft drink by the gallon—that adding a "Green Premium" to its cost would make other forms of electrical production attractive. Throughout his analysis of solutions, Gates continually returns to the idea of the Green Premium, a tax on cheap energy as a way to cut greenhouse gas emissions, to encourage the development of other sources of power and avoid the worst aspects of climate change.

In examining the cost of how things are made in the modern world, Gates uses the example of concrete, which he calls one of the wonders of the modern world. Concrete is inexpensive, easy to make, strong, and is used in almost all type of construction. Gates points out that the use of concrete will increase. He notes that China produced more concrete in the first sixteen years of the twenty-first century than the United States did in the entire twentieth century. The problem with concrete is that making it creates a large amount of carbon dioxide; one ton of cement creates one ton of greenhouse gas. To meet this problem, Gates suggests not only imposing a Green Premium but also capturing carbon and electrifying all steps of the construction process, which would, of course, require major innovations.

Gates then examines the production of greenhouse gases in agriculture, admitting that as population increases and more people move out of poverty, the demand for agricultural products will increase. He first notes that although widespread use of fertilizers has enabled food production to keep pace with growing demand, both the making and using of fertilizer produces greenhouse gases. In addition, Gates points out that cattle produce greenhouses gases as well and that the Western diet is high in the consumption of red meat. His solutions are innovations in plant development and fertilization, institution of a Green Premium, planting trees to capture carbon dioxide, and eating less meat. Gates even suggests that veggie burgers are tasty.

Transportation is the next major area of concern for Gates. He acknowledges the obvious: fossil fuels, particularly gasoline, are by far the least expensive way to move people and things. However, the cost in the production of greenhouses gases is enormous. Gates first points to the most obvious partial solution, the electrification of the automobile industry, a process already underway. There are limits to electrification of transportation, however. Both biofuels and electric-powered vehicles are more expensive to run, requiring

a Green Premium to balance out the cost. In addition, battery power would not work with larger transportation needs, such as jetliners and cargo ships, as the size of the batteries to move such large objects would be prohibitive. Gates calls for more use of rail as well as innovation in moving cargo, suggesting that small nuclear power plants might be the way to move massive container ships.

Gates finally examines how we heat and cool our buildings. He observes that the demand for both heating and air-conditioning will increase as worldwide population increases and more people aspire to middle-class comforts. Because both heating and cooling buildings produces a large amount of greenhouses gases, Gates believes major innovations are needed in construction as well as heating and cooling technologies. He also advocates the introduction of Green Premiums throughout this sector of the economy.

In the final sections of *How to Avoid a Climate Disaster*, Gates states that avoiding the pending disaster will neither be easy nor inexpensive, but he asserts that the alternative is unthinkable. He also advocates that his readers become engaged in climate change as citizens and individuals. First, he observes that governments—federal, state, and local—play a significant part in reaching for solutions. He calls for his readers to become engaged on the issue of climate change and encourage all levels of government to change laws and regulations to encourage innovation and discourage the use of fossil fuels wherever possible. Gates argues that governments should work with industry to review and rewrite regulations as well as fund major programs in energy and technology research and development. Gates calls on employers to institute industry carbon taxes to offset the creation of greenhouses gases. He also addresses his readers as individuals, telling them to make their homes more energy efficient, buy an electric vehicle, and change dietary habits.

In his classic analysis of the use of rhetoric, Aristotle defines three ways of persuading an audience: logos, pathos, and ethos. Such well-known works as Elizabeth Kolbert's *The Sixth Extinction* (2014) and *Field Notes from a Catastrophe* (2006) employ a combination of pathos and logos, appealing to a readers' emotions and logic as Kolbert establishes a factual background for disaster before describing the pending catastrophe. In *How to Avoid a Climate Disaster*, Bill Gates does appeal to both logos and pathos, demonstrating a knowledge of both hard data and potential disaster. The success of his book, however, rests primarily on ethos, the character of the writer, because, for many readers, if Bill Gates believes a disaster is on the way and provides a way out, it must be true.

See also: *Field Notes from a Catastrophe*; *Inconvenient Truth, An*; *Six Degrees*; *Sixth Extinction, The*

Further Reading

Becraft, Michael B. *Bill Gates: A Biography*. Santa Barbara, CA, and Denver, CO: Greenwood Press, 2014.

Brown, Gordon. "*How to Avoid a Climate Disaster* by Bill Gates—Why Science Isn't Enough." *The Guardian*. February 17, 2021.

McKibben, Bill. "How Does Bill Gates Plan to Solve the Climate Crisis?" *New York Times*. February 15, 2021.

HUNGER GAMES, THE

The Hunger Games (2008) is the first novel in a postapocalyptic dystopian series written by Suzanne Collins. The series was extremely popular, selling over sixty-five million copies of the three novels. In addition, *The Hunger Games* series was adapted into a four-part film series that grossed nearly $4 billion worldwide. The novel is set in North America in a nation called Panem after the United States has been destroyed by an unspecified apocalyptic event, although it is clear that climate change has been a contributing factor in the destruction, as references to food shortages, droughts, mass migrations, and authoritarian government control appear throughout the series.

As *The Hunger Games* opens, the nation of Panem is divided into twelve districts based on social and economic status. There was once a thirteenth district, but it was destroyed after a failed rebellion against the wealthy and privileged Capitol. As punishment for the rebellion, each district must select two children between the ages of twelve and eighteen to participate in televised Hunger Games in which the contestants fight to the death until only one remains. The games, based on Roman gladiatorial contests as well as the Greek myth of Theseus and the Minotaur, serve two purposes in the country facing economic hardship and class division, two aspects of post–climate change life. First, they remind the citizens of the poorer districts of their inferior status. Second, they provide entertainment for the populace with an annual televised spectacle to keep the masses amused.

The protagonist of *The Hunger Games* is Katniss Everdeen, a sixteen-year-old girl from District 12, the poorest region, located in coal-rich but poverty-stricken Appalachia. Everdeen volunteers to take the place of her younger sister, Primrose, who was chosen by lottery to participate. Peeta Mellark, a former schoolmate of Everdeen's is also chosen. Together, they are sent to the Capitol to be trained for combat and prepared for television.

Because the Hunger Games are as much spectacle as they are punishment, the contestants are given makeovers worthy of reality television stars, which is what they are about to become. They are given advice on hairstyles and costumes as well as advice on winning sponsors. Ratings are important, even in a world struggling to survive social and economic disaster brought on by

a changing climate. While in training, Mellark announces that he has feelings for Everdeen.

A significant part of *The Hunger Games* is taken up with the games themselves. The twenty-four young people are let loose in a wilderness, and under the watchful eyes of television viewers, they must survive the pitfalls of a strange and dangerous environment as well as the murderous intentions of each other. The novel quickly turns brutal and bloody as the young contestants hunt for and hide from each other. Alliances are formed and then broken as one by one young people die to the delight of the games' producers, sponsors, and viewers. To sustain viewership and prolong the games and the suffering of the contestants, the producers, in this case the government,

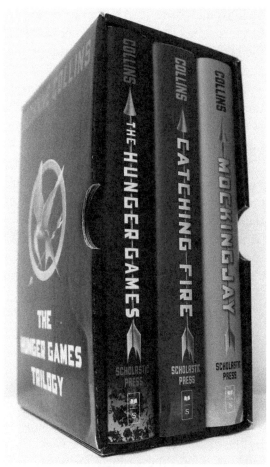

The wildly successful *Hunger Games* trilogy. (Dana Kenedy/Dreamstime.com)

allow sponsors to send contestants emergency food and medicine. In addition, they continually add dangers, such as a wildfire that forces Everdeen out of hiding and toward those hunting her and poisonous insects that infect her. Nevertheless, she and Mellark manage to survive and must face each other in what is planned for a grand finale.

Everdeen and Mellark refuse to follow the script. In a scene suggestive of Shakespeare's *Romeo and Juliet*, Everdeen eats poisonous berries, demonstrating that she is willing to die rather than kill Mellark. Faced with growing popularity and sympathy for the survivors, the producers again change the rules, allowing two champions to survive the ordeal.

The two survivors do not get to live happily ever after, however, as the oppressive government is still in control. Everdeen is warned that the government may take action against her, and Mellark learns that Everdeen's affection

for him may be part of a plan to establish sympathy for the two contestants. Sequels were clearly intended, and sequels followed. The remaining novels in the series, *Catching Fire* (2009) and *Mockingjay* (2010), were quickly released and also wildly successful.

The Hunger Games received a good deal of critical attention upon publication. It was praised for its depictions of severe poverty, oppression, the impact of war on populations, and the struggle for survival. All of these are expected impacts of a world after climate change. Critics also responded positively to Collins's depiction of the use of mass entertainment by an authoritarian government. The novel was also praised as a satire on realty television. Some readers and reviewers were concerned about Collins's use of violence. They objected to the depiction of twenty-two young people dying in a public spectacle.

Since the publication of the series and the release of the films, critics have begun to examine *The Hunger Games*, as well as the other novels in the series, as climate change narratives. Asawin Suebsaeng, writing in *Mother Jones*, observes that in *The Hunger Games*, totalitarian hell and political repression are results of climate change. She notes that the summary of the narrative could read that the "democratic societies of the United States, Mexico, and Canada are destroyed by climate disasters caused by global warming, and this led to mass bloodshed over scarce resources." Torrie Bosch, writing in *Slate*, notes that the narrative of *The Hunger Games* is as much about the social implications of climate change as it is about reality television.

Although the phrases "global warming" and "climate change" are not spoken by the characters in *The Hunger Games*, it is clear that both the government oppression and the struggle for political freedom that provide the arc of the three narratives that make up *The Hunger Games* series are caused by climate change and global warming. In fact, the novels can be read as an illustration of what will happen if climate change and global warming continue. In nonfiction works such as *Six Degrees* (2007), by Mark Lynas, and *Field Notes from a Catastrophe* (2015), by Elizabeth Kolbert, readers may find projections of what life will be like after global warming and climate change. In *The Hunger Games*, Suzanne Collins paints a picture of it.

See also: *Bridge 108*; *Carbon Diaries 2015, The*; *Children of Men, The*; *Field Notes from a Catastrophe*; *Orleans*; *Oryx and Crake*; *Salvage the Bones*; *Six Degrees*

Further Reading

Bosch, Torrie. "Climate Change in *The Hunger Games*." *Slate*. March 21, 2012.
Suebsaeng, Asawin. "Life Sucks in 'The Hunger Games: Catching Fire' because of Climate Change." *Mother Jones*. November 22, 2012.

ICE

Ice (1967), by Anna Kavan, is an early novel about dramatic climate change. It is also a novel about perception, drug use, and mental illness. Kavan originally published her fiction under her married name, Helen Ferguson, but after a failed suicide attempt and time spent in a mental institution in Switzerland, she changed her name to Anna Kavan, a character in one of her novels. *Ice* is set in a future in which the world is growing rapidly colder and encroaching ice has disrupted international cultural and economic life. It is Kavan's best-known novel. She died one year after the novel's publication.

Ice is an example of slipstream fiction, a genre that crosses the boundaries of fantasy, science fiction, and literary fiction. As a result, there are elements of strangeness and unreality about the novel that invite the reader into a world of cold and danger described by a very unreliable narrator who may be under the influence of drugs or experiencing episodes of psychosis.

The world Kavan creates in *Ice* is a cold, dark place. The unnamed narrator is on a quest of sorts. He is both searching for and abandoning a frail, young, white-haired "glass girl" with whom he had a relationship sometime in the past. The narrator describes himself as a former soldier and explorer who had once lived among the lemurs and found them far more intelligent than humans. He also takes very strong drugs for headaches and insomnia, which leave him with terrible dreams that "are not confined to sleep only."

As the novel opens, the unnamed narrator is driving along a dark road intent on reuniting with a physically and emotionally fragile unnamed young women being held captive by her husband. The narrator succeeds in finding the young woman, who accuses him of abandoning her and yet agrees to leave with him. In a pattern that will repeat throughout the novel, she soon accuses him of keeping her captive and leaves him.

The next section of the novel is set in an almost medieval village, where the young woman is held captive by a man known simply as the Warden. Although the Warden is in complete control, the village is locked down for a long winter, as ice is spreading throughout the world. The narrator has served as a soldier before and works his way into the Warden's confidence. The narrator remains infatuated by the young woman, who has been physically

abused by the Warden. Again, the narrator convinces her to leave, and again, she soon tires of him, accusing him of physical abuse as well. This time the narrator leaves.

As the world continues to freeze, with summer disappearing in the Northern Hemisphere, the narrator dreams of escaping to a jungle island and living among the animals. Instead, he hires out as a mercenary, serving as a soldier in the trenches of an unnamed European war. The narrator serves as a scout, going behind enemy lines as the expanding ice limits troop movements. The Warden has become a member of the general staff and is in charge of planning a major attack. He asks the narrator to become part of the mission, and while traveling, they discuss how they both have been attracted to and repulsed by the fragile young woman. The narrator argues that she needs freedom, while the Warden believes she needs discipline. As the Warden plans for the attack and the world grows ever colder, the narrator plans to find the young woman and take her away from the Warden again. He knows that if he finds her, she will go with him and then quickly want him to leave.

Ice is an unusual novel that thwarts readers' expectations. None of the characters have names, and the narrative is almost plotless. Episodes in which the narrator finds and confronts the fragile young woman repeat throughout the novel. Each time, she is held captive by another man, usually the Warden. Each time, she leaves with the narrator, only to accuse him of mistreatment and leave. This strange and unwieldly triangle takes place in a world rapidly freezing, and the characters appear emotionally frozen as well.

Ice was neither a popular nor critical success upon publication, and Kavan committed suicide a year after the novel's release. Contemporary critics have begun to rediscover Kavan and her work. Some place her work firmly in the school of Beat writers such as William S. Burroughs and Jack Kerouac, who explored altered mental and emotional states in experimental prose. Others comment that *Ice* is one of the earliest climate change novels and that in it Kavan explores the relationship between environmental and emotional states. There is no contradiction between readings, however. Like fellow British early climate change writer J. G. Ballard, Kavan explores the impact of dramatic environmental change on the emotional and psychological states of her characters. It is no surprise then that as the world grows cold and hostile, so do Kavan's characters.

See also: *Burning World, The*; *Colony, The*; *Day after Tomorrow, The*; *Drowned World, The*; *Gold Fame Citrus*; *Oryx and Crake*

Further Reading

Freeman, Hannah. "Winter Reads: *Ice* by Anna Kavan." *The Guardian*. December 21, 2011.

Michaud, John. "A Haunting Story of Sexual Assault and Climate Catastrophe, Decades ahead of Its Time." *The New Yorker*. November 30, 2017.

INCONVENIENT TRUTH, AN

An Inconvenient Truth (2006) is a ninety-seven-minute American documentary film directed by Davis Guggenheim that features former vice president Al Gore presenting a slideshow about the dangers of global warming. The film was not the first narrative to provide a warning that global warming caused by human action is creating an environmental crisis that threatens life on the plant. However, the notoriety that accompanied the release of the film, as well as the attacks upon the documentary by climate change deniers and fossil fuel industry spokespersons, spread the idea of climate change beyond academic and environmental communities and into the wider culture.

The idea for the film originated with producer Laurie David, who saw Gore give his talk at a town meeting. David and coproducer Lawrence Bender met with director Davis Guggenheim to adapt the presentation into a documentary film, which premiered at the 2006 Sundance Film Festival. *An Inconvenient Truth* was both a critical and popular success, grossing over $24 million in the United States and winning two Academy Awards.

As he did in his talks, Gore begins the film with a self-deprecating allusion to his contested presidential run, saying, "I am Al Gore. I used to be the next president of the United States," a reference to his contested election loss to George W. Bush in 2000. Before beginning to explore the crisis of climate change, Gore shows a number of photographs taken from space, suggesting that they capture the beauty of the planet. He also provides some personal information about his interest in environmental issues dating from his days as an undergraduate at Harvard University, where he studied with Roger Revelle, an early expert on climate change.

Gore then begins his presentation by asserting that there is scientific consensus about the human cause of climate change and global warming as well as the effects of a heated planet. He describes the earth's atmosphere as thin and that it can be changed relatively easily through the introduction of greenhouses gases, such as carbon dioxide, methane, and nitrous oxide. The use of fossil fuels, oil, natural gas, and coal not only made the Industrial Revolution possible but also heated up the atmosphere, with damaging results to the planet.

Then Gore shows graphs and slides to illustrate changes in the environment already taking place. To illustrate the warming of the atmosphere, he shows

Al Gore prepares for a speech on climate change. (Mattmcinnis/Dreamstime.com)

before and after photographs of the loss of snow on Mount Kilimanjaro in Africa and the loss of ice in Glacier National Park. He demonstrates that ice core data clearly indicates that the atmosphere is warming and that the rise in temperature coincides with the rise in greenhouse gases. He then cites evidence from 2005 showing that many American cities had recorded the hottest days in their histories during the year and observes that farmland is beginning to dry out because of the changing climate.

Gore next examines the impact of rising heat in oceans, first noting that increased storm intensity and activity are the result of rising sea temperatures, and he points to the devastating effects of Hurricane Katrina as a prime example. He asserts that such storms not only lead to loss of life and physical damage to city infrastructure but also the creation of climate migrants. Using photographs from space, Gore documents the loss of ice in the Arctic and the Antarctic. The total collapse of the ice shelves could lead to sea levels rising more rapidly. Again, he uses before and after photographs to illustrate how sea rise would impact Florida, New York City, Europe, and Bangladesh. Again, there will be loss of property and life as well as the creation of millions of climate refugees.

Gore next examines the impact of a warmer planet on the spread of disease. He notes, for example, that mosquitoes, many of which carry infectious diseases such as malaria, West Nile virus, encephalitis, and yellow fever, have spread around the globe because of warmer temperatures. Gore also observes that population increases also have an impact on global warming. More humans require more food, resulting in the loss of rain forests for cattle ranching. In addition, more humans require more goods and services in general, meaning the additional burning of fossil fuels, which creates more greenhouses gases. The result of all of these causes is an increasing feedback loop that creates more climate change more quickly.

An Inconvenient Truth is not without hope, however. Gore concludes his presentation with the observation that crisis equals opportunity, and he suggests that a number of steps can be taken to reverse the effect of global warming by releasing less carbon dioxide into the atmosphere. Among his recommendations are the use of solar panels, geothermal power stations, florescent light bulbs, green roofs, hybrid cars, hydrogen buses, and wind power. He also urges his viewers to recycle, speak up for the environment, and "encourage everyone to watch this movie."

An Inconvenient Truth is neither a detailed scientific analysis of climate change nor a complete set of recommendations of how to combat it. The documentary remains true to its roots, a public lecture to a general audience introducing listeners to the subject of global warming. More recent books, such as David Wallace-Wells's *The Uninhabitable Earth* (2019), Elizabeth Kolbert's *The Sixth Extinction* (2014) and *Field Notes from a Catastrophe* (2006), Bill McKibben's *Fight Global Warming Now* (2007), and Mark Lynas's *Six Degrees* (2007), have been both more scientifically specific and more horrific in their depictions of the impending destruction caused by climate change. More than any of these works, however, *An Inconvenient Truth* introduced global warming and climate change as a serious threat to millions of people at a time when global warming was not considered a major threat by most Americans.

In raising the awareness of general viewers and readers to the consequences of global warming, Al Gore employs the conventions of an old literary form the jeremiad, a written or spoken warning, often in the form of a sermon, named after the writings of the biblical prophet Jeremiah (650–570 BCE). As Zachary Lundgren notes in his reading of *An Inconvenient Truth* in *Imagining the End: The Apocalypse in American Popular Culture* (2020), Gore deliberately plays the role of a prophet telling an unsuspecting and unprepared audience that evil times are about to come if his listeners do not amend their ways. The jeremiad is one of the most consistently employed forms of persuasion in the United States, being the form often used in American Puritan sermons and most American political advertising. Gore, of course, secularizes the form, but the intent and impact are the same.

Al Gore has continued to speak out and write about the dangers of climate change. In 2009, he published *Our Choice*, an argument for the adoption of alternate forms of power. In 2017, Gore released *An Inconvenient Sequel: Truth to Power*. Directed by Bonni Cohen and Jon Shenk, the documentary follows efforts to combat climate change as well as answer critics of his previous documentary.

See also: *Field Notes from a Catastrophe*; *Six Degrees*; *Sixth Extinction, The*

Further Reading

Ebert, Roger. "Disaster Movie." RogerEbert.com. June 1, 2016.

Lundgren, Zachary. "*An Inconvenient Truth.*" In *Imagining the End: The Apocalypse in American Popular Culture*, edited by James Craig Holte, 140. Santa Barbara, CA: ABC-CLIO, 2020.

Scott, A. O. "Warning of Calamities and Hoping for a Change in 'An Inconvenient Truth.'" *New York Times.* May 24, 2006.

L

LAMENTATIONS OF ZENO, THE

The Lamentations of Zeno (2016) was written by Ilija Trojanow, a Bulgarian German writer whose best-known works available in English are *The Mountain on the Edge of the Sky* (1989), *Bones* (1990), and *The Collector of Worlds* (2006). Trojanow's family left Bulgaria as political exiles when he was young and immigrated to Germany, where Trojanow studied at the Ludwig Maximilian University of Munich. He later moved to Africa and studied at the German School Nairobi. He has lived in Cape Town, Mumbai, and Vienna. Trojanow primarily writes in German.

The Lamentations of Zeno is a climate change novel primarily set aboard the MS *Hansen*, an Antarctic cruise ship, where Zeno Hintermeier, is one of the academic experts on board. Six months out of every year, Hintermeier, a glaciologist whose Alpine glacier disappeared because of climate change, lectures wealthy tourists visiting the Antarctic about glaciers and ice packs. Leading ecotourists through the last wonders of nature, which the tourists' lifestyles have helped destroy, does not make Hintermeier happy. But because he loves the variety of texture, color, and light in glaciers, he endures the tourists to experience the ice.

The Lamentations of Zeno opens in Ushuaia, Argentina, which bills itself as the southernmost town in the world, located in the Tierra del Fuego archipelago. Sitting in a bar, Hintermeier awaits the arrival of tourists who will board the *Hansen* for their ecotour, and he wonders why every place people go they either destroy the environment or turn it into a theme park. Speaking to an Argentine tour guide, who spoke about the original inhabitants of the area as if they were animals, Hintermeier objects to the guide's use of the phrase "primitive people," saying that we only honor people who are extinct; "we show enormous care to those we have exterminated."

The novel shifts back and forth in time between Hintermeier's excursion aboard the Henson, which takes six months of every year, and his life as a glaciologist in the Bavarian Alps. As a professor of glaciology, Hintermeier studied one glacier for his entire career, leading graduate students to live near and study the glacier every summer for over forty years. He remembers telling his students that he could hear whether a glacier was living or dying by the sound

it made, and his was dying. Hintermeier watched his glacier slowly die, and one year, after he had been absent for some time due to an illness, he returned to find it dead. Only isolated bits of ice remained on the gravel-filled slope. Shortly after, his marriage breaks up. Hintermeier believes his emotional life reflects his academic one; both were doomed. A colleague suggests that he apply for an "expert" position on the Antarctic cruise ship, as it would allow him to be near glacial ice and pay him as well.

On the *Hansen*, Hintermeier shares a cabin with Paulina, a young waitress and part of the all-Filipino staff aboard. They have been lovers for years, living together on board and separating in the off-season. This situation works well for both of them. On board, Hintermeier's duties include providing lectures for the tourists and, when the ship docks in the Antarctic, leading them on guided tours. His duties are light, allowing him plenty of time to document the continuing destruction of the environment due to climate change and the irritating behavior of the wealthy ecotourists in the leather-bound journal he keeps.

The first port of call for the *Hansen* is Stanley, the capital of the Falkland Islands, or the Islas Malvinas, according to the Argentines. There the tourists depart from the ship to birdwatch and visit sights of the Falkland War, which was fought between Britain and Argentina in 1982. Drinking in a bar with the *Hansen's* English piano player, Hintermeier is regaled with the story of the sinking of the German pocket battleship *Graf Spee*, which was scuttled with the crew aboard in 1939. He responds by asking the new piano player to play "Rule Britannia" upon their return to the ship. They do remember that they should advise the tourists to avoid the beaches, as they are still mined from "the only war in which more animals than people died."

The next port of call for the *Hansen* is Grytviken, on South Georgia Island, where Norwegian Carl Anton Larson set up a whaling station in 1904. Although now abandoned, the station is still the home of the descendants of the reindeer the Norwegian whalers brought with them. Leading the tourists through the abandoned tryworks that still smell of blubber, Hintermeier describes how the whalers boiled the blubber of whales for oil, until there were more whales in the area. Then they boiled the fat of the seals, until there were no more seals in the area. Finally, they boiled the fat of penguins, but that proved unprofitable; so the whalers left. Hintermeier imagines that humanity is a parasite on the face of the earth, destroying life wherever it spreads, but he keeps those thoughts to himself. The tourists enjoy watching the penguins play among the ruins of the whaling station.

After visiting South Georgia Island, the *Hansen* docks at King George Island, which is 90 percent ice, contains over 30,000 penguins, and is under the nominal control of Chili. After instructing the tourists not to disturb the penguins or leave any human debris on the island, Hintermeier sees a Chilean soldier

smoking a cigarette near the penguins. Infuriated, he rushes the soldier and orders him to put out the cigarette. He avoids being shot when he is pulled away by fellow guides, who make profuse apologies to the armed soldiers. As he is led to the zodiac to return to the *Hansen*, he watches as the soldier drops his cigarette near the flock of penguins, crushing it out under his boot.

Hintermeier is reprimanded by the ship's captain for nearly causing an international incident, but the reprimand is half-hearted, as everyone on board, including the captain, knows Hintermeier's feelings about humanity's implication in the destruction of the environment. Soon all is forgotten, as Dan Quentin, an internationally famous performance artist, arrives by helicopter with a television crew to create art in the Antarctic. Quentin's plan is to have all the tourists aboard the *Hansen* leave the ship and form the letters SOS and then wave to helicopters filming the event. The performance art, Quentin believes, will alert the world to the fragility of the Antarctic in a time of rapid climate change. Hintermeier believes it is too little too late and that it would take a real catastrophe to awaken the indifferent world. He begins planning for the catastrophe.

On the next stop, Half Moon Island, Mrs. Morgenthau has a mishap involving a skua and a penguin egg for which Hintermeier feels responsible. Skuas are predatory seabirds that steal eggs from penguins. Mrs. Morgenthau was penguin watching when a skua took a penguin egg and prepared to eat it. Aghast, she attempted to rescue the egg from the skua, which indignantly bit her, causing her to fall and crush the eggs. Skua beaks being notoriously filthy, Hintermeier had to rush Mrs. Morgenthau back to the *Hansen* for antibiotics.

The *Hansen* puts in at Neko Harbor on Graham Land for Dan Quentin's performance art to be staged. The ecotourists and crew dutifully disembark and prepare to spell out their cry for help to the world. Hintermeier, staying aboard the ship, encourages the staff to join as well, leaving him alone on the *Hansen*. Having decided that a real SOS would be more effective than a staged one, Hintermeier sails the ship out of the harbor and heads north. He abandons Quentin, the ecotourists, the crew, and the staff on the Antarctic ice, hoping that they will be saved by another cruise ship. Sailing away, he decides to commit suicide, leaving his journal. "Only big blows are capable of jolting mankind," he writes.

The Lamentations of Zeno is a both a dark comedy and a perceptive depiction of the muddled responses to the ongoing climate crisis. Zeno Hintermeier is well aware of the irony of ecotourism. Wealthy individuals pay enormous sums of money to visit ecologically challenged locations to observe landscapes and species that will soon disappear, knowing that their own touring will only add to the environmental threat. Despite his disdain, he knows he is an essential part of problem. However, if he wants to experience the "infinite variety" he

finds in glacial ice, he must be part of the system that destroys it. Thinking about his own part in bringing about the changes in climate that are destroying the environment, Hintermeier writes, "Hell is not a place. It is the sum of all our lapses and failures."

The Lamentations of Zeno has received a good deal of international praise. Writing in the *Irish Times*, Eileen Battersby compares Zeno Hintermeier to characters created by Saul Bellow and Joseph Heller. Writing in the *Financial Times*, Ken Kalfus notes that in a novel that is part elegiac and part comic, Ilija Trojanow seeks the "deeper lessons of a warming planet in describing how voyages to see vanishing wonders are convenient profit-making fictions." He notes that the lesson of the novel and the lesson of the response to climate change might be the first line of the novel: "There's no worse nightmare than no longer being able to save yourself by waking up."

See also: *Always North*; *Field Notes from a Catastrophe*; *Friend of the Earth, A*; *Odds against Tomorrow*; *Solar*; *South Pole Station*

Further Reading

Battersby, Eileen. "*The Lamentations of Zeno* Review: Glacial Ground Zero." *Irish Times*. May 3, 2016.

Kalfus, Ken. "'The Lamentations of Zeno' by Ilija Trojanow." *Financial Times*. May 6, 2016.

LATHE OF HEAVEN, THE

The Lathe of Heaven (1971) is a dystopian science fiction novel written by award-winning American novelist Ursula K. Le Guin. Le Guin is one of the major writers of American science fiction, having won eight Hugo Awards, six Nebula Awards, and twenty-two Locus Awards. In addition, in 2003, she was the second woman named as a grand master of the Science Fiction and Fantasy Writers of America. The U.S. Library of Congress named her a Living Legend in 2000. In 2014, Le Guin won the National Book Foundation Medal for Distinguished Contribution to American Letters. In addition to *The Lathe of Heaven*, some of her better-known works are *The Wizard of Earthsea* (1968), *The Left Hand of Darkness* (1969), *The Dispossessed* (1974), and the often anthologized short story "The Ones Who Walk away from Omelas."

The Lathe of Heaven is set in Portland, Oregon, in the year 2002, when climate change caused by a dramatic increase in greenhouse gases has altered the atmosphere. The polar ice caps have melted, mean temperatures have risen around the world, and sea levels have risen. As a result, the cool rainy climate of the Pacific Northwest has become almost tropical. In addition, because of the increase in population, Portland has a population of over three million

inhabitants, most of whom are poor and suffering from kwashiorkor, a form of malnutrition. There is also a major war in the Middle East in which millions have died that is threatening to turn into a worldwide nuclear confrontation. The protagonist of the novel, George Orr, is a draftsman working for the city who has become addicted to drugs to stop having effective dreams, dreams that can actually affect reality. Caught using another person's pharmaceutical card, Orr is ordered to seek treatment for his addiction to avoid jail time.

Orr is assigned to therapy sessions with William Haber, a psychiatrist specializing in sleep disorders. Haber, of course, does not believe Orr, as such a power is impossible. Orr, however, explains when he does change reality, people's memories change as well. Scoffing, Haber hypnotizes Orr and uses an experimental biofeedback machine called the Augmentor that he is developing to enhance the experience. He sends Orr to sleep with a specific command of a subject to dream about. Ordered to dream of a horse, Orr wakes to find the picture of Mount Hood on Haber's Wall has turned into a picture of horse manure in the shape of Mount Hood. Orr explains that he cannot control the directions his dreams will take, even if given a subject to dream about.

Under the direction of Haber, Orr begins his dream therapy by attempting to address some of the problems he sees in the world around him. After complaining about the terrible weather that has become Portland's new normal, Haber advises Orr to dream about improving it. Orr awakes to a beautiful sunny day with low humidity. Unfortunately for the people living in the new cities built in Western Oregon to take advantage of the dryer climate there, Orr's dream turned that part of the state into a vast desert. In the new reality, those cities and the people who lived in them no longer exist. During their next session, Orr and Haber discuss the problem of racism. Haber instructs Orr to dream about the problem of racism. When Or wakes up, he finds that racism is no longer a problem, but all human beings have become a shade of gray. And despite the lack of racism, war and violence still persist. Finally, Orr tells Haber that overpopulation may be a cause for the universal unhappiness people seem to be experiencing. Once again, Haber instructs Orr to dream of a solution to overpopulation. When Orr awakens this time, he discovers that a virulent plague has destroyed most of humanity.

After each dream session, Orr awakes to a transformed reality that is different from the one before his effective dreaming but seldom better. In the following session, he tries to rectify the unintended changes, without major success. Haber, however, has become very successful. As Haber has been giving Orr dreaming suggestions, he has been suggesting that his own position in each new world be improved. At first, Haber suggested that his interior office in a crowded Portland skyscraper be moved to an office with a view of Mount Hood. Next, his private practice becomes an influential psychiatric institute.

Finally, Haber, in addition to developing his Augmentor, has become an adviser to the president of the United States and major corporate and academic entities. In that position, he suggests that Orr dream of a world without nations at war, a united humanity. In the next altered reality, Orr wakes up to find humanity united, but they are united against invading aliens. Mount Hood has been bombed and is now an active volcano. Orr manages to find Haber and, with the help of the Augmentor, dreams that the aliens who arrived are peaceful visitors.

Eventually, Haber's sessions with Orr begin to have the effect of allowing him to control his sleep. Haber also believes he no longer needs Orr to manipulate reality because he has become the most influential person on earth as the adviser to anyone who has power and influence. In addition, he has finished work on his Augmentor and is about to try it on himself, believing that he is one step away from becoming godlike, and a benevolent one to be sure. Orr, listening to an old Beatles album, hears the following lines:

> Do you need anybody?
> I need somebody to love.
> I get by, with a little help,
> With a little help from my friends.

He immediately falls asleep without effective dreaming.

For a few weeks, life runs smoothly for Orr. He has married a friend from a previous reality and has a job working for one of the now-friendly aliens, who runs a used artifact store selling items no longer of use, such as rotary telephones and transistor radios. He asks the alien whether the aliens dream and is told that dreaming is too much for anyone, that dreams must be shared.

Shortly after, reality starts to shift, with different elements in all of Orr's effected realities flashing in and out of existence. Orr realizes that Haber must be using the Augmentor on himself. Orr races to Haber's office and finds the building abandoned as reality continues to shift. When he enters, he finds that Haber is attached to the Augmentor. Orr decides that Haber is unable to control the various realities he is experiencing. To stop the constant shifting, Orr unplugs Haber from the machine. The reality they both had been living in shifts back into place, with Orr calm and Haber now delusional.

The novel ends with Orr happily married and working a stressless job with his understanding alien boss. He no longer feels responsible for the world, as he knows that his dreams can no longer change it. Haber is in an asylum, still believing that he controls the world.

The Lathe of Heaven is one of the earliest novels to deal with the problem of climate change. At the time of the novel's publication, 1971, the idea of dramatic changes in the earth's climate because of increases in the production of

greenhouse gases was a theory held by only a few climatologists or the subject of science fiction. *The Lathe of Heaven* is science fiction, and it is also a parable of humanity's destruction of the environment. Well-intentioned, mild-mannered George Orr is an everyman. Orr believes his dreams can change reality, and in a sense, he is correct. As everyman, a representation of humanity, his dreams, humanity's dreams or aspirations, change the world in which he, or humanity, lives. Orr is bothered by racism, overpopulation, environmental destruction, and war, and he is both the cause and the solution. But Orr eventually realizes, with a little help from the Beatles, that he is not alone responsible, that with a little help from others, he and his friends can get by and find equilibrium. Haber, on the other hand, seeks to improve and control the world, and as a result, he ends up insane.

Critics of Le Guin's work have noted that Taoism informs much of her fiction. Taoism is based on the writings of Chinese philosopher Lao Tzu, who wrote the main work of Taoism, the *Tao Te Ching* in about 500 BCE. Taoism holds that humans and animals should live in harmony with the Tao, or the universe, and at death, the spirit of the individual body joins the universe. This is precisely the lesson that Orr learns and Haber does not. In *The Lathe of Heaven*, Le Guin asserts that the ills of the world, war, overpopulation, and especially the radical change in climate that underpins both, are the result of human action. Climatologists and many readers living through the first obvious signs of dramatic climate change would agree.

See also: *Avatar*; *Field Notes from a Catastrophe*; *Friend of the Earth, A*; *Oryx and Crake*; *Sixth Extinction, The*

Further Reading

Bloom, Harold, ed. *Ursula K. Le Guin: Modern Critical Views*. New York: Chelsea House Publications, 2000.

Cummins, Elizabeth. *Understanding Ursula K. Le Guin*. Columbia: University of South Carolina Press, 1990.

Rochelle, Warren. *Communities of the Heart: The Rhetoric of Myth in the Fiction of Ursula K. Le Guin*. Liverpool: Liverpool University Press, 2008.

LORAX, THE

The Lorax is a small (sixty-four page) illustrated children's book by Dr. Seuss (Ted Geisel). Published in 1971, *The Lorax* has sold over 200 million copies and is often cited as one of the most influential environmental books published in the twentieth century. It is also controversial. A number of conservative writers, including the influential Lou Dobbs, have called the book part of a liberal plot to indoctrinate children against capitalism and part of a left-wing propaganda

machine. The book has been attacked by forest industry spokespersons and is banned in at least one California school district.

The Lorax is a parable, as are many of Dr. Seuss's books, told in rhymed stanzas, most of which are anapestic tetrameter, or a four-beat line, with each beat consisting of two unstressed and one stressed syllable. *The Lorax* begins when a young, unnamed boy living in a dark, polluted town visits Lorax Lifted Street. He is told that he could find out what had happened to the town if he visits the Once-ler and pays him fifteen cents, a snail, and the shell of a great, great, great-grandfather snail. He does so, and what follows is the Once-ler's narrative.

The Once-ler recalls that when he first came into the neighborhood, it was a paradise in which plants and animals existed in harmony. The first thing that he noticed was that "the grass was still green, the pond was still wet and the clouds were still clean." The he noticed the miles and miles of "glorious" Truffula trees, which smelled like buttermilk and were soft to the touch. In addition, the Truffula trees provided benefits for all the animals in the area: food for the small, cute Bar-ba-loots; cover for the pool in which the happy Humming Fish swam, humming happily; and nesting places for the graceful Swomee-Swans. The Once-ler remembers he was so happy that he immediately settled down under the trees and built a small shop.

Once settled in paradise, the Once-ler cut down a Truffula tree, which he immediately knit into a Thneed, a foolish-looking piece of clothing. Suddenly, the Lorax appeared. He was described as "shortish, oldish, brownish, and mossy," and he addressed the Once-ler in a voice that was "sharpish and bossy." The Lorax said that he spoke for the trees, as the trees had no voice, and he demanded that the Once-ler stop cutting down trees. He then asked the Once-ler what he had made out of the tree. The Once-ler told him it was a Thneed, a piece of clothing that "all people need," which could be used as a shirt, sock, hat, pillow, or sheet. He claimed it was a universal wonder product. The Lorax scoffed. But just then a man came by and offered to buy the Thneed, and a business was born.

The Once-ler invited his entire family to join him in making Thneeds, and finding chopping down Truffula trees one at a time too slow for production, he invented a "Super-Axe-Hacker," which permitted him to cut down four trees at once. Again, the Lorax showed up to speak for the trees, saying there was now not enough Truffula fruit for the Bar-ba-loots, so he had to send them away. The Once-ler responded by referencing the law of supply and demand. Because his Thneeds were so popular, he decided he must "bigger" his business, because, using circular logic, "business is business." To bigger his business, the Once-ler chopped down more trees to make more Thneeds. As the Truffula trees were cut down, the fish and swans left, and the air and water became polluted, until

finally the last tree was taken, at which point the Lomax, with whom he had been arguing, left through a hole in the smog. Then the Once-ler's family left, his factory closed, and he was left alone in a ruined landscape.

In the final section of *The Lorax*, the Once-ler addresses the boy, who is of course a stand in for the reader. He says that the world will continue to be as it is "UNLESS someone like you cares a whole lot, nothing is going to get better. It's not." He then tosses the boy the last Truffula seed in the world and says if the boy plants it and takes care of it, the tree and all its friends may come back.

In 1972, CBS television presented an animated musical version of *The Lorax*, with popular television personality Eddie Albert as the narrator. The twenty-four-minute special won awards at the International Animated Cartoon Festival (Zagreb) and the International Film and Television Festival (New York). Universal Pictures released a more elaborate adaptation in 2012. The 3D film, directed by Chris Renaux, was first released to IMAX theaters. With a budget of $70 million, it grossed over $340 million worldwide. The film was both criticized and praised for its environmental message.

The Lorax was not the first nor last parable Dr. Seuss wrote; many of his stories teach moral lessons. *Horton Hatches the Egg* (1940), the story of an elephant who agrees to sit on an egg for a lazy bird who would rather have fun than nest, teaches the values of helping others and keeping one's word, and the famous The *Cat in the Hat* (1957) raises important questions about trust and responsibility. The parable of *The Lorax*, however, was the first Dr. Seuss book that took a political stand on a controversial public policy issue.

The Lorax was published in 1971, a year after the first Earth Day and the beginning of the modern environmental movement. Although the forestry industry appeared to many readers to be the culprit of the book, *The Lorax* also attacks consumerism and environmental destruction in general. Awareness of the problems of global warming and climate change would take decades to reach the general public, and over those decades, *The Lorax* has continued to be seen as an influential text in presenting the issue of human-induced environmental destruction to young readers as well as a call to action. Although both the lighthearted *The Cat in the Hat* and *Green Eggs and Ham* sold more copies than *The Lorax*, a number of critics consider Seuss's environmental parable to be his most successful work.

See also: *Friend of the Earth, A*; *Inconvenient Truth, An*; *Overstory, The*

Further Reading

Morgan, Judith, and Neil Morgan. *Dr. Seuss and Mr. Geisel: A Biography*. New York: Random House, 1995.
Nel, Philip. *Dr Seuss: American Icon*. New York: Continuum, 2004.

LOST CITY RAIDERS

Lost City Raiders (2008) is a postapocalyptic science fiction film that was made for television. It was directed by Jean de Segonzac and stars James Brolin, Ian Somerhalder, Jamie King, Ben Cross, and Bettina Zimmermann. Set in the year 2048, after climate change and global warming have covered most of the earth with water, *Lost City Raiders* presents an attempt by the New Vatican, located in New Vatican City, as the old Vatican City and Rome are underwater, to lower the ocean rise by using the "scepter of Moses," the staff Moses used to part the waters of the Red Sea in the biblical book of Exodus.

The plot of *Lost City Raiders* is relatively straightforward. As in a number of other climate change narratives involving ocean rise, J. G. Ballard's *The Drowned World* (1962) and Kim Stanley Robinson's *New York 2140* (2017) are the best examples, once cities have been flooded and millions have died, treasure hunters begin to search drowned cities for treasure. John Kubiak (Brolin) and his sons, Jack and Thomas, have been searching for underwater treasure when they are hired by the New Vatican to search for the scepter of Moses, which according to New Vatican archives, presumably saved from the old Vatican archives, is located in New York City.

Also after the scepter is Nicholas Filiminov (Cross), an unscrupulous dealer of real estate who wants to keep the waters high to force survivors of the flood to live in the floating communities he is building. He also has plans to purchase underwater land cheaply and then lower the water and sell it, making enormous profits twice. The New Vatican provides Kubiak with a priest and a brother for spiritual and technical support and a submarine to assist in the search.

John Kubiak dies before the scepter is found, and his sons, along with two young women—one is Jack's ex-wife and the other is a submarine mechanic—are forced to take over the mission. They are also opposed by a cardinal in the New Vatican who believes that the rising of the waters is predicted in the book of Revelation and that the flood is a punishment by God for the sinfulness of humanity. Using a map provided by the New Vatican, the Kubiak brothers and their team find the first of thirty-one chambers. When they open the chamber, the water in the Mediterranean Sea drops thirty feet. The film ends with the Kubiak team wondering what will happen when they enter the other chambers.

It is a cliché in the entertainment industry that imitation is the sincerest form of Hollywood. A very successful film is likely to spawn numerous clones, some successful and some not. The popular and critical success of Steven Spielberg's *Raiders of the Lost Ark* in 1981 produced a host of similar treasure hunter epics, including *High Road to China* (1983), *Romancing the Stone* (1984), *The Mummy* (1999), *National Treasure* (2005), and *Sahara* (2005). *Lost City Raiders* not only

borrows the treasure hunter formula but also adapts the title of Spielberg's film and then adds the postapocalyptic climate change setting. The results are not spectacular.

The film was not well received by critics, who found both the acting and special effects bland, and despite the ending, the thirty other chambers remain unexplored. The film is of interest, however, in that it casts its villain as an entrepreneur who hopes to profit by the misery of others, which is a standard trope in postapocalyptic dystopian cinema. It is also noteworthy that the film shows a division within the religious community between those who wish to rectify the damages caused by climate change and those who consider it divine punishment. This is a debate that is ongoing in some religious communities today.

See also: *Blackfish City*; *Drowned World, The*; *Flood*; *Forty Signs of Rain*; *New York 2140*; *Waterworld*

Further Reading

dell'Agnese, Elena. *Ecocritical Geopolitics*. New York: Taylor & Francis, 2021.
Moore, David J. *World Gone Wild: A Survivor's Guide to Post-Apocalyptic Movies*. Lancaster, PA: Schiffer Publishing, 2014.

MAD MAX SERIES, THE

The *Mad Max* series consists of four films: *Mad Max* (1979), *Mad Max 2* (1981), *Mad Max: Beyond Thunderdome*, and *Mad Max: Fury Road* (2015). In addition, the film series spawned a comic book series, a video game, music albums, and a festival. The four films have grossed over $500 million and have created an enthusiastic worldwide following. The dystopian films are set in an Australian future in which human-induced climate change and the destruction of the environment have made basic resources scarce, civilization obsolete, and survival of the fittest the basis of morality.

The original *Mad Max*, directed by George Miller and starring Mel Gibson as Max Rockatansky, was an independent Australian film. It was made for less than $450,000 but grossed over $100 million. The film, set in the Australian Outback after society has collapsed, borrows both its setting and basic story line from classic American westerns. It follows Max, a member of the

The Mad Max 2 museum in Australia. (Bundit Minramun/Dreamstime.com)

Breakaways Coober Pedy. The Australian Outback was used as the setting for the *Mad Max* films. (Veronica Wools/Dreamstime.com)

Australian Main Force Patrol, as he hunts for the killer of a fellow officer and becomes involved in a personal vendetta against the members of a homicidal motorcycle gang.

The film is bleak and unrelenting. Set against a barren landscape, *Mad Max* depicts a world spinning out of control while chronicling Max's growing rage. The film begins when a motorcycle gang member kills a rookie policeman, and Max, the force's best officer, kills the gang member in a car chase. The violence escalates as Max and his partner, Jim "Goose" Rains (played by Steve Bisley), interrupt the gang's rampaging through a small town and arrest a gang member, only to have to release him as no one in the town will testify against him for fear of reprisals. The gang then ambushes and sets fire to Goose. Disgusted, Max takes his wife and son on vacation and thinks about leaving law enforcement.

Chaos follows Max. The gang members discover Max's wife and son, and in the mayhem that follows, Max's wife is injured, and his son killed before Max arrives. Having lost one fellow police officer, seeing another burned alive, and discovering his son dead and his wife in a coma, Max turns vigilante. He takes his special police cruiser, a modified 1973 Ford Falcon XB GT351, and pursues the gang. He rams several bikers, forces another in front of a big rig, ambushes another, and finally catches up with the original killer. Max chains him to a wrecked car leaking gas, gives him a chain saw, and sets fire to a line of gas, forcing him to cut off the chain or his leg to survive. He does not succeed. The film ends with an explosion in the background as Max drives away.

A number of recent projections on the impact of climate change on social behavior indicate that during severe climate change, and the resulting breakdown of supply chains, resources will become scarce and both violence and vigilantism will increase as haves and have nots struggle to establish control. *Mad Max*, filmed at a time of economic uncertainty because of the 1978 Middle East oil crisis, dramatizes this conflict by updating one of the basic narrative structures of the Hollywood western, a lone lawman facing a gang of desperadoes threatening a peaceful town, to contemporary circumstances. *Mad Max* replaces horses with hot police cars and motorcycles, and the degree of violence in the film far exceeds that of most classic westerns. However, the need to resort to vigilante justice is always a possibility in the western and is depicted as necessary in *Mad Max*. Moreover, the film is even harsher than the violence it presents, as in the end, Max becomes mad, dispensing vengeance and not justice as he chains the murderer to the burning car. There is no redemption at the end of *Mad Max*, and the apparent approval of vigilantism in the film engendered a good deal of critical debate and audience approval.

The phenomenal box office success of *Mad Max*, making over $100 million on a small budget estimated between $200,000 and $650,000 made the release of a sequel inevitable. To that end, in 1981, director George Miller released *Mad Max 2*, again starring Mel Gibson. In the second film in the series, all remnants of civilization are gone. The environment is clearly postapocalyptic: food, water, and fuel are scarce, and the desert environment is almost unlivable, as the cascading results of climate change continue. Clearly, things have gotten worse since the end of the first *Mad Max* film. Max Rockatansky is alone, driving through a desert wasteland looking for food and fuel. The film again follows a pattern of a classic American western. Unlike the first *Mad Max* film, which bears a resemblance to John Ford's classic 1946 *The Searchers*, in which John Wayne's character seeks revenge against a band of Apache Indians who killed his family, *Mad Max 2* is more like Ford's 1939 classic film *Stagecoach*, in which Wayne's character, an outlaw, helps a stagecoach full of townspeople cross safely through the frontier wilderness in the midst of an Apache War.

In *Mad Max 2*, Max, after running into another marauding motorcycle gang in search of the scarce resources, comes across a peaceful community with a stock of gasoline. He plans to steal it, but when the community is besieged by the biker gang, he becomes an unlikely hero, risking his own life to help the community members escape with their precious fuel. In a long scene reminiscent of *Stagecoach*, Max, driving the community's old tanker, fights off the bikers, who attack like cinematic Apache Indians. At the end of the film, Max, like John Wayne's Ringo Kid, rides away, having saved those who trusted him.

Mad Max 2 is a more optimistic film than *Mad Max*. Even though the same type of sociopathic biker gang preys on innocent people and the climate-changed,

ravaged environment is so bleak even Max, the hero of the film, is forced to consider robbing his protectors, he decides to risk his life, as well as his beloved car, to help others. *Mad Max 2* ends on a note of redemption.

Mad Max: Beyond Thunderdome, also directed by George Miller and George Ogilvie and again starring Mel Gibson as Max, was released in 1985. The film, which is the most apocalyptic of the original three, opens with Max wandering alone in the Australian wasteland. Once again, he is struggling to survive in a world devoid of resources and populated by people willing to kill for what scraps of food and fuel can be found. He is robbed of his few possessions and left to die. He walks to the appropriately named Bartertown, where only those with something of value to trade are admitted. Bartertown is ruled by Aunty Entity, played by Tina Turner. The town is powered with methane gas supplied by a man called Master, who extracts the gas from pigs, the only source for fuel production available in the deteriorating environment. In this bizarre world, Max is forced to fight Master's giant bodyguard, Master Blaster, in a caged arena, the Thunderdome of the title. Max manages to defeat the bodyguard but destroys the uneasy truce between Master and Entity, destroying the methane production and threatening Bartertown's existence in the process.

Max is exiled and wanders through the desert until he is rescued by young Savannah Nix, who takes him to Planet Erf, a community of children and adolescents living in an oasis beside which sits a Boeing 747. Max learns that the children were left by their parents, who were on the plane when it landed, to search for civilization. Once again, Max defends an endangered community, the children, in the face of an attack from Bartertown forces. At the end of the film, Jedediah, a pilot Max encountered earlier in the film, flies the children out of the wilderness only to discover that Sydney, Australia, was destroyed in an atomic blast. The final scene shows Max walking alone into the wasteland.

Mad Max: Beyond Thunderdome is the most fantastic of the three original films. Although the basic structure of the film is the same, an embittered Max wanders alone through a dangerous climate change–induced wasteland, trying to survive, while psychopathic killers attack innocents for ever-decreasing scarce resources. In *Beyond Thunderdome*, everything is exaggerated. One reason for this is the nature of sequels: each film must build on the characters and conflicts of the previous one. By the third film, car chases and gang warfare are replaced by a Boeing 747 flight and a caged gladiatorial battle. Finally, the ending of the film, with its discovery of the Australian capital city destroyed by a nuclear explosion, is a clear reference to the final scene of one of the most memorable apocalyptic fantasy films, the 1968 *Planet of the Apes*.

In film terminology, a *reboot* is when a film franchise releases a film that restarts a series while disregarding the sequence that preceded it. The *Batman*, *Superman*, *Planet of the Apes*, and *Godzilla* franchises have all been rebooted,

some numerous times. In 2015, director George Miller rebooted his franchise with the release of *Mad Max: Fury Road*. In the film, Tom Hardy replaces Mel Gibson as Max, but the basic elements of the franchise remain the same. Max Rockatansky is wandering through a wasteland alone after an environmental and social apocalypse. Three allied factions battle over scarce resources such as water, fuel, food, and ammunition in the increasing drought and pollution, and the general population is left with scraps.

Max is again captured by his enemies, this time the War Boys, who use him as an unwilling blood donor. Immortan Joe (Hugh Keays-Byrne), leader of the War Boys, realizes his lieutenant, Imperator Furiosa (Charlize Theron), has escaped in an armored tanker truck with five of Joe's wives and sets out after them. The film follows the plot of the earlier films in that there are long car chases through empty landscapes, violent confrontations, surprising escapes, and the discovery of a once safe place of refuge for women, the Green Place, which has gone sour because the formerly green oasis has become a swamp, its fresh water disappearing as the climate continued to change for the worse. Max and Furiosa join forces, defeat the War Boys, and unify the survivors. The film ends, as do all the *Mad Max* films, with Max walking off alone, unable or unwilling to remain part of what remnant of civilization remains. Or perhaps he walks away to set up a sequel.

Mad Max: Fury Road, although not as financially successful as expected, received considerable critical praise. Reviewers were surprised by the films production quality and found that the performances are more nuanced than in previous *Mad Max* films in which victims and villains are often stereotyped caricatures. In addition, reviewers and audiences noted that women play more significant and meaningful roles in the fourth film. The social stresses of acute climate change in the film create both exaggerated masculinity and female solidarity. Immortan Joe, for example, keeps five wives to ensure the growth of his tribe. Imperator Furiosa was raised in an all-woman community, reminiscent of ancient Amazons, and she returns to them at the end of the film. In addition, Max and Furiosa come to treat each other with mutual respect at the end of the film. A climate-changed wasteland brings out the best and worst of the people trying to survive within it. The film also manages to incorporate elements of humor with its usual dramatic chases and extravagant violence.

The *Mad Max* series is a quintessential postapocalyptic extended narrative. Like other well-known works that chronicle the destruction of the environment and the resulting scarcity and violence that follows, the films employ familiar conventions. As in the popular and critically acclaimed dystopian climate change novel and film adaptation of Mark Germine's *The Book of Eli* and the novel and adaptation of Cormac McCarthy's *The Road*, all four *Mad Max* films create a lawless landscape devoid of resources in which survivors of an

ongoing, human-made catastrophe face starvation and violence. Within this grim setting, an isolated protagonist wanders in search of whatever scraps of resources remain. At times, such as in the original *Mad Max*, Max is crushed by what he finds in the destroyed world; at other times, as in the later *Mad Max* films, Max finds moments of redemption amid the devastation.

See also: *Lorax, The*; *Silent Spring*

Further Reading

Johnike, Rebecca. "Manifestations of Masculinities: *Mad Max* and the Lure of the Forbidden Zone." *Journal of Australian Studies* 25, no. 67 (2019): 118–125.

Ritzenhoff, Karen A., and Angela Krewani, eds. *The Apocalypse in Film: Dystopias, Disease, and Other Visions of the End of the World.* Lanham, MD: Rowman & Littlefield, 2015.

MADDADDAM

MaddAddam (2013) is the third novel in the trilogy of apocalyptic climate change novels by Canadian author Margaret Atwood. Atwood is an established poet, novelist, literary critic, feminist, and environmentalist. Her work in a variety of genres is well known worldwide. Perhaps her most famous novel is *The Handmaid's Tale*, winner of the Arthur C. Clarke Award and adapted as a feature film and television series. The other two novels in the climate change trilogy are *Oryx and Crake* (2003) and *The Year of the Flood* (2009). Calling much of her work speculative fiction, a broad genre that includes elements that do not exist in recorded history or observable fact, Atwood employs elements of science fiction, myth, and the fantastic in much of her work. She has also called her series of novels adventure romance. *MaddAddam*, like the other two novels in the series, is one of the most significant climate change novels written to date.

MaddAddam opens by continuing the narrative of *The Year of the Flood* and again retells the events of the climate change pandemic apocalypse from yet another point of view and continues the story to an eventual resolution. Toby and Ren, the two women protagonists of *The Year of the Flood* who have survived the bioengineered pandemic, discover another survivor, Amanda, who is being attacked by Painballers. The Painballers, criminals trained to fight gladiatorial battles to the death, also survived, having been kept in secure lockdown. Constantly being hunted by the sociopathic Painballers, the survivors discover others, including Jimmy, the narrator of *Oryx and Crake*, and Zeb, a friend of Toby's from *The Year of the Flood* with whom she begins a relationship. The human survivors settle near the Crakers, innocent bioengineered humanlike creatures created in *Oryx and Crake*, and begin interacting and teaching them about the events prior to the catastrophe.

As in the first two novels, the characters reveal events leading up to the pandemic from a variety of points of view, providing additional information about life before the plague. Most importantly, Zeb tells Toby that he and his brother, called Adam One in *The Year of the Flood*, were the founders of the radical environmental religious group God's Gardeners. He also tells her that they started God's Gardeners in reaction to their father's hypocrisy. Their father was also a religious leader, but he supported the oil and gas industry that was driving climate change as well as the major corporations engaged in bioengineering.

The relationship between the bioengineered Crakers and the surviving humans is the central concern of the novel. Humanity, responsible for the environmental degradation of the planet as well the pandemic that killed most of the population, belongs to the world before the fall. The Crakers, on the other hand, are creatures who will survive it. Two events bring the contrast into focus: the attack of the Painballers and the rapes of Toby and Ren.

Although peaceful and nonthreatening, the Crakers; the Pigoons, pigs with human brain cells; and the Mo'Hairs, goats with human cells, are continually hunted and threatened by the Painballers, who capture Jimmy and several other surviving humans. In response, Toby and Ren lead the Crakers in attacking the Painballers, during which Jimmy and Adam die. The captured Painballers are taken by the Crakers to their encampment. Believing in justice rather than vengeance, the Crakers put them on trial for murder. Found unsalvageable, the Painballers are executed.

The Crakers had been engineered to be sexually active only once a year, when the female Crakers are ovulating. Ren and Amanda were living with the Crakers at the time mating began, and the male Crakers, believing that the humans are ready to procreate, have sex with them against their will. Ultimately, the species' differences are understood, but both women give birth to half-human, half-Craker children, creating a new species. At the end of the novel, Toby, the final remaining human, teaches the human-Craker children to read, write, and tell their own stories, which they will pass on to future generations of the new species.

At the end of *MaddAddam*, Margaret Atwood pulls together the threads she has been developing through all three volumes of her trilogy. After having destroyed the environment, humanity has been successful in destroying itself, but in an ironic twist, the bioengineering that was the immediate cause in the destruction created the new species, human-Crakers, Pigoons, and Mo'Hairs, that have inherited the earth.

It is not surprising that as a narrative of creation and destruction, the three novels of the *MaddAddam* trilogy have biblical echoes. The most obvious reference is, of course, to Noah's flood in the book of Genesis, the source narrative for almost all contemporary novels, films, and short stories dealing with

annihilation by water. In the trilogy, God's Gardeners make the waterless flood the central belief of their doctrine, expecting it, preparing for it, and some members surviving it. In Genesis, the flood destroys the wicked of the earth, leaving only the just, Noah and his family, along with two of every creature to repopulate the cleansed creation. In the *MaddAddam* trilogy, the environmental and bioengineered flood leaves only the new species of creatures, created by but different from humanity, to repopulate the cleansed earth.

The three novels of Margaret Atwood's trilogy, *Oryx and Crake*, *The Year of the Flood*, and *MaddAddam*, make up one of the most ambitious and compelling narratives of apocalyptic destruction ever written. Told from three distinct points of view, the novels chronicle both the causes and complexities of humanity's destruction of the environment and the eventual extinction of the human species. Combining elements of science, romance, adventure, magic, realism, and social criticism, Atwood creates a world that is disturbingly apocalyptic but different from our own only by degree.

See also: *A.I. Artificial Intelligence*; *Handmaid's Tale, The*; *Oryx and Crake*; *Windup Girl, The*; *Year of the Flood, The*

Further Reading

Cooke, Nathalie. *Margaret Atwood: A Critical Companion*. Westport, CT: Greenwood Publishing Group, 2004.

Howells, Coral Ann. *The Cambridge Companion to Margaret Atwood*. Cambridge: Cambridge University Press, 2006.

Nischik, Reingard M. *Engendering Genre: The Works of Margaret Atwood*. Ottawa: University of Ottawa Press, 2009.

MARROW THIEVES, THE

The Marrow Thieves (2017) is a young adult Canadian climate change dystopian novel by Métis (one of the three recognized Aboriginal peoples of Canada) writer Cherie Dimaline. The novel is set in Canada after climate change has changed the coastlines of continents; eradicated cities, killing millions of people; spawned earthquakes and superstorms; and melted the polar ice caps as well as the permafrost. It also caused the extinction of many species of plants and animals. Climate change and the resulting global warming have also altered the DNA of many people, making it impossible for them to dream, which has caused emotional and psychological problems. Aboriginal Americans, however, have retained the ability to dream, and according to some Native American legends, the dreams are stored in the marrow of the bones. In *The Marrow Thieves*, Aboriginal people are hunted, arrested, and drained of their bone marrow, which, of course, kills them.

The Marrow Thieves opens as Frenchie, the protagonist of the novel, and his older brother, Mitch, are squatting in an abandoned house in the suburbs of what was once the city of Toronto. They have been on the run from government "recruiters," federal agents capturing Native Americans and forcing them into government-run "schools," since their mother died. Hearing recruiters approaching, Mitch sacrifices himself to allow Frenchie to escape. Finding himself alone and hunted, he remembers his father's advice that in times of trouble, his people would always head north. For months, Frenchie heads north, always cold, always hungry, and always on alert for recruiters. Eventually, while in hiding, after hearing the sounds of people moving near him, he passes out and later wakes up to the sight of six other Native Americans preparing a fire to warm him and food to feed him.

Frenchie's new family consists of two adults, Miigwans and Minerva; another teenager, Chi Boy; twelve-year-old twins Tree and Zheegwan; nine-year-old Slopper; Wab, a young woman who had her face slashed by recruiters; and Ri Ri, a six-year-old girl. Later, after Frenchie has been with the group for several months, they are joined by Rose, a beautiful young woman with whom Frenchie immediately falls in love. Miigwans leads the group as they, too, move north. He divides the group in two: hunters and homesteaders. The hunters he teaches to trap and hunt with bows and arrows as well as guns. The homesteaders he teaches to cook and camp unseen. Every two weeks, he alternates groups, hoping to make everyone self-sufficient. In addition, he invites everyone to tell a "coming-to" story, a tale of how they all lost their families or communities and ended up heading north.

In his coming-to story, Miigwans tells the long story of the Aboriginal people who once lived throughout the land until the whites came and took it from them, collecting their children and forcing them into schools to forget their language and history. He tells them how, later, when the world was burning and there were water wars, the rich people from the south built a metal straw and sucked the clean water of their homeland south, leaving desolation. He told them how the Great Lakes were once clean and full of fresh water and are now poisoned swampland. He tells them that the recruiters and the new schools that take the people's marrow and dreams are just a repeat of the missionaries and the old schools that took the people's dignity and history. One day, he tells them, the Native people will return to the north and cleanse the land, although it will take many lifetimes. Miigwans insists that they all learn to tell stories because stories "set the memory in perpetuity."

Deep in the Canadian woods, the group comes across an abandoned resort that has managed to survive intact. After months in the woods, Miigwans, Minerva, Frenchie, and the others enjoy several days of ease and luxury. Each member of the group has their own room, and there are clean rooms with cleans

sheets. Unused to such luxury several people sleep in each room, as the solitude seems overwhelming. Rose joins Frenchie, much to his delight. Later in the evening, the two are disturbed when young Ri Ri comes in, afraid to sleep alone.

The group's idyll ends when recruiters are spotted nearby, and Miigwans leads them to the woods once again. This time, the group is not successful. They are ambushed by recruiters, and in the firefight that ensues, Frenchie is forced to kill two recruiters, and Minerva, who is the keeper of the longest story and has the most powerful dreams of the group, is taken.

After the kidnapping and killings, the rest of Miigwans's group attempts to follow the remaining recruiters in hopes of finding and freeing Minerva. Along the way, they are surprised by another group of Indigenous people, among whom is Frenchie's father. Miigwans, who is known to the group, known as the Council, is warmly welcomed, as are the rest of his friends. Frenchie's father, who left his family years ago in search of the Council, is now one of its leaders. The Council, which spies on the government and its recruiters and helps Native people escape, offers their assistance in finding Minerva.

With the help of an informant, Father Carole, they learn that Minerva, who had driven several of her captors insane with the power of her dreams, will be moved to a larger city to study her power before harvesting her marrow. Although successful in setting up a barricade and stopping the van transporting Minerva, the rescue attempt fails. Minerva is shot by one of the recruiters guarding her, and she dies, telling Rose, Miigwans, and Frenchie to always "go home."

Soon after, Rose leaves the group, and Frenchie, with the blessing of his father, follows her to find a new home. After finding Rose, Frenchie comes across a party of five: two Guyanese women, one Cree man, and two white men, one of whom turns out to be half Cree. The Cree man turns out to be Isaac, Miigwans's husband, who was taken from him in one of the schools. At the end of the novel Miigwans and Isaac are reunited, and Rose and Frenchie leave to follow their own dreams.

The Marrow Thieves won the Canadian Governor General's Award for English-Language Children's Literature and the Kirkus Prize for Young Adult Literature in 2017. In 2018, the novel won the Burt Award for First Nations, Inuit and Métis Literature, as well as the Sunburst Award for Young Adult Fiction.

The Marrow Thieves is an ambitious and well-written novel. Dimaline is a Métis writer and activist from the Georgian Bay Métis Nation in Canada. Frenchie's narrative as well as the coming-to stories that other characters tell explore responses to radical climate change that disrupts life by turning forests into swamps and lakes into sludge pits. They also tell how the destruction

of the environment by human-induced climate change also impacts human psychology, destroying the ability of those who profited from environmental destruction to dream. Equally important is Dimaline's critique of colonialism. She is especially effective in balancing of the stories of colonial exploitation and genocide through the use of schools in the past with the exploitation of Indigenous people in the novel's present. For the First Peoples, she writes that climate change is taking the Native lands a second time.

See also: Barkskins; Handmaid's Tale, The; Moon of the Crusted Snow

Further Reading

Reese, Debbie. "Highly Recommended: Cherrie Dimaline's The Marrow Thieves." Social Justice Books. June 6, 2017.
SLJ. "The Marrow Thieves by Cherie Dimaline." School Library Journal. December 2, 2017.

MEMORY OF WATER

Memory of Water (2014), by Finnish writer Emmi Itäranta, is a novel set in northern Europe several centuries in the future, after climate change and the resulting ecological and social disasters have reshaped the world. The novel is a first-person narrative by Noria Kaitio, a young woman living in a small village in what was once Finland but now part of the Scandinavian Union, a political entity that is part of the larger state of New Qian, or what was once China. In this imagined future, clean water and food are scarce, fossil fuels are no longer available, wars and political oppression are parts of daily life, and most scientific and industrial technology has been forgotten. For Kaitio and the people of her small village, twenty-first-century abundance is vaguely recalled as the "past world," separated from her world by something called the "Twilight Century." During the wars, natural disasters, and the collapse of civilization caused by climate change and ecological disaster during the Twilight Century, much of human history and technology was lost. What remains, aside from solar-powered message pods and a few solar-powered vehicles, would be familiar to a medieval villager. And like medieval villagers rummaging through the ruins of Roman civilization for useful tools and building material, Kaitio are her neighbors rummage through dumps full of discarded, broken plastics, looking for anything that could be made useful.

Noria Kaitio is a person of privilege in her village. Her father is a tea master, a person who has trained for years to host and officiate tea ceremonies, which in the novel have a similar significance to the tea ceremonies in China and Japan today. In Memory of Water, the tea ceremony is an elaborate ritual in which the tea master welcomes a guest or guests into a sacred space, makes and shares tea, and endeavors to make all feel welcome and at peace. Itäranta

describes the apprenticeship of a tea master, something Kaitio is undergoing as the novel opens, as tea masters pass on their craft to their children. Years of practicing mindfulness and ritualistic behavior are required before apprentices finally learn to think and act like the water they are using to make tea, to flow with the ceremony. Because of their honored position in society, tea masters are given extra water rations, a valuable asset in a time when climate change has made clean water a rare commodity that is rationed by the government.

In the past, before the Twilight Century, tea masters were also water masters who controlled access to and the purity of sources of water. Most tea houses were built on or near springs, and tea masters were guardians of the springs. Kaitio, prior to her being made a tea master by her father, is shown a secret underground spring that once provided the village with water that he has cared for over decades. Upon her father's death, she will become responsible for the spring and having to make sure the water remains pure and hidden from the government.

Memory of Water covers a period of months during which the climate change drought worsens. Water rations to the people in Kaitio's village are cut, and a military commander suspects that the village tea master has a secret source of water. The global impact of climate change, especially the centuries-long drought and the resulting loss of both economic opportunity and individual liberties, provides the background for Itäranta's narrative. She, however, focuses her story on Kaitio and her village. She describes how water police monitor families' use of water and brand people who exceed their allotted use of water as water criminals who are punished with either slow starvation or execution. Water becomes so scarce that Kaitio's best friend, Sanjo, whose family survives by repairing plastic containers for carrying water, is given medicinal powder for her younger sister's illness, but the family has no water for the youngster to mix with the powdered medicine. Sanja resorts to begging for water, which Kaitio provides from the hidden spring, refusing to accept payment but also refusing to reveal the source of her water.

It is in this environment that young Kaitio's mother leaves to study history in Xinjing, the capital of New Qian, and then her father dies. Kaitio becomes responsible for the care of the spring and carrying on the tradition of tea master, which appears to be part spiritual leader, part traditional healer, and part spokesperson for the village. She is caught in a dilemma: how can she keep the existence of the water a secret from the government while she shares water with the villagers, who are literally dying of thirst. She wonders, what is her primary obligation as a tea master? Is it to the people of her village or the water itself? More than once, she wonders what is the right choice to make or if there even is a right choice.

Kaitio and Sanjo also discover another secret that they must keep hidden. While growing up, they used to play in the rubble piles of broken plastic from

the "past world," most of which was worthless. However, they found a number of shiny plastic discs, which they kept because they look beautiful. Eventually, Sanjo realizes that the discs fit into a broken plastic box that she manages to repair, and she uses some of the family's allotted electricity to make it work again. To their surprise, the compact disc player provides them with the notes of a team from the Twilight Century that describes an expedition to find water in the wastelands of what was once western Scandinavia as well as the government's attempts to suppress the expedition to ensure law and order, or governmental control over a scarce resource.

Knowledge of the spring, Kaitio's responsibility to it and the people of her village, the scientific and political background from the Twilight Century, and the continued crackdown on water criminals take place in the months leading up to and after her father's death. Finally, she is confronted by a military officer who is convinced a secret source of water must exist in the village. She refuses to reveal the existence of the secret spring and continues to share fresh water with her friends and neighbors, even after seeing a neighboring water thief beheaded in front of her. Wondering what is the right thing to do and how she can make a moral choice that violates her principles, Kaitio plans to escape the village with Sanjo. The night before her planned escape, the military surrounds her house and paints a blue circle on the door, the sign of a water thief. She remains in her house, slowly starving to death, rather than reveal the source of the hidden water. Sanjo, however, does manage to escape to Xinjign, where she meets Kaitio's mother and tells her about her daughter.

Memory of Water is an unusual climate change novel. Although clearly dystopian, the novel avoids graphic descriptions of dramatic climatic events, such as massive flooding of coastal cities or dramatic killer storms killing tens of thousands of people. Instead, Itäranta focuses on a very ordinary young woman and the impact of climate change on her rather privileged life. The drama of climate change, wars over natural resources, dramatic oil spills in the arctic, the loss of polar ice caps, mass starvation, and the imposition of martial law are in the novel but in the background. They are things that Kaitio and Sanjo are only vaguely aware of until they discover the compact discs containing voices from the past.

Itäranta spends more time on the ritual and meaning of the tea ceremony than on the catastrophes of climate change, and that is the virtue of the novel. Readers are asked to see the value in small, simple things, the pouring of tea or bowing before a guest, as crucial to what it means to be human, even after climate change has devastated the planet. Small kindnesses and honored obligations are what make the characters in the novel human, and when forced to choose, Kaitio refuses to be less than human.

See also: *Burning World, The*; *Dry*; *Gold Fame Citrus*; *Storming the Wall*; *Water Thief, The*

Further Reading

Landon, Justin. "Lyrical Empowerment: *Memory of Water* by Emmi Itäranta." TOR. com. July 2, 2014.
"*Memory of Water.*" *Kirkus Reviews*. June 10, 2014. Retrieved February 17, 2022. kirkusreiews .com/book-reviews/anni-itaranta/memoryof water

MIGRATIONS

Migrations (2020), by Australian young adult writer Charlotte McConaghy, is an adult climate change novel that goes beyond the conventions of that genre. Many climate change novels either recount apocalyptic events such as the flooding of great cities by sea rise, as in *New York 2140* by Kim Stanley Robinson, or great droughts that cause starvation and mass migration, as in *The Water Knife* by Paolo Bacigalupi. *Migrations*, on the other hand, is a novel that takes place when climate change has caused the near total destruction of animal life on earth and is focused on the human response to that tragedy as it presents both the life and choices of one person, Franny Stone.

Migrations opens with the statement, "The animals are dying. Soon we will be alone here." Franny Stone is already alone in Greenland, having electronically banded three of the last surviving arctic terns in the world in hopes of following what may well be the final tern migration from Greenland to the Antarctic. How she came to be in Greenland and how she manages to follow the terns are explained in alternating chapters in McConaghy's compelling novel.

Having banded the terns, Stone's next task is to find a way of following the birds. Her plan is both simple and foolish. She visits the small fishing villages in Greenland, visits sailors' bars, and asks ship captains to take her on board, guaranteeing them that she will be able to direct their boats to large catches of fish. The captains refuse, of course. They believe it is not only bad luck to have a woman aboard but also foolish to think of catching fish in oceans in which climate change has depleted the plankton and nearly everything else on the food chain that feeds on it. Most captains have decided it is nearly time to return to their homeports and retire to shore.

When Stone visits her last Greenland port, however, she finds the six crew members of the herring fishing boat *Saghani* drinking in a bar. She asks why they are still fishing when the ocean is almost empty of fish. One of the crew members tell her that the captain, Ennis Malone, is after the "Golden Catch," which he describes as "the white whale. . . . The Holy Grail, the Fountain of Youth." Another crew member explains that he means the last great catch, like

fishermen used to have before the oceans died. Stone later asks the captain if she could come aboard if she could guarantee that they would find fish. She explains about the banded terns and that they always find and follow fish on their migration. Surprisingly, the captain agrees.

As the *Saghani* sails in search of the Golden Catch, McConaghy describes both the daily life on a purse seiner, a ship that employs large nets to capture schools of fish, and small pieces of information about Stone's life. As she works aboard the ship, learning knots, swabbing decks, and standing watch in the crow's nest, she and the crew members exchange information. Stone was born in Australia to an Irish mother who was abandoned by her husband. Later, her mother took her to Ireland, where she lived in a small town on the Atlantic coast. In Ireland, she also eventually met her ornithologist husband. While Stone drops hints of her past, the crew members tell her about theirs. One has been a chef in Australia, and another has a large family waiting in Newfoundland, the ship's homeport. All realize that the ocean is dying.

Throughout the voyage, the ship searches its usual fishing grounds and finds nothing. Eventually, the banded terns take flight, and Stone tracks them on her laptop, telling Malone to follow their path. When the birds stop moving, there will be fish. She proves to be correct. The crew of the *Saghani* discover a large school of herring, but when pulling in the seine net, the catch proves too heavy, breaking the net and killing one crewman during the attempt to repair it. A North Atlantic storm blows up soon after, nearly wrecking the ship and forcing the captain to take it to Newfoundland for repairs. There, double tragedy strikes.

The first is when the crew learns that an international agreement has been reached in response to the disappearance of aquatic life to ban all commercial fishing. Commercial fisherman are ordered to remain in port and have their fishing equipment impounded. The second is more personal. Returning to the ship from a drinking bout with the crew, Stone is attacked and about to be raped by a man, but she kills him. The crew, following her, take her back to the ship, where she informs them that the local police will not believe her because she has broken parole in Ireland, where she had been convicted of a double homicide. Violating the stay-in-port orders, the captain and his crew take the *Saghani* to sea.

What follows is a voyage as strange as Captain Ahab's quest of the white whale in *Moby Dick*. Captain Malone takes the ship south, promising to follow the electronic signals sent by the terns all the way to the Antarctic. Along the way, crew members die, the ship is wrecked in a storm, and Malone and Stone are forced to abandon the *Saghani* and take over an abandoned yacht off the coast of South America. Along the way, they lose track of all but one tern's signal. The two manage to sail their newfound ship through the stormy Strait of

Magellan, and they eventually make their way to the Antarctic ice cap, expecting to find a single tern but instead discovering a surviving flock.

Stone finally reveals more about her past life. She is not an ornithologist; her husband was, and she had worked at the Irish university where he had taught, sitting in on classes. They had married, and she shared his enthusiasm for attempting to preserve birds, especially arctic terns. After a party one evening, she had been driving her husband home from a bar—she had had less to drink than he had—when she hit a car and both her husband and the other car's driver were killed. Feeling guilt and refusing to assist her legal counsel, Stone pleaded guilty to murder and served four years in an Irish prison before her release on probation. The reason she was following the terns was not part of a research project, but rather to honor the memory of her husband and sprinkle his ashes, which she had carried with her the entire trip, on the tern nesting ground, if she found any terns nesting. The novel ends with Stone back in Ireland, alone and knowing her adventure was a mad quest, as the animals in the world are still dying.

In *Migrations*, the references to the white whale and similarities to Herman Melville's *Moby Dick* are deliberate. In both narratives, ocean voyages are also journeys of self-discovery, and human destruction of nature is the theme. In *Moby Dick*, Ishmael, the narrator, wonders whether the pursuit of the white whale and the hunting of other whales for their oil will eventually lead to the extermination of the magnificent creatures. In *Migrations*, Charlotte McConaghy suggests that it is not only whales that have been destroyed by humans but all animals.

Migrations, published in England as *The Last Migration*, has received a good deal of critical praise. Writing in the *New York Times*, Michael Christie writes that the novel is nervy and well-crafted and that it is "a story about our mingling sorrows, both personal and global." Fiona Wright, writing in *The Guardian*, observes that "*The Last Migration* is nonetheless an aching and poignant book, and one that's pressing in its timeliness."

See also: *After the Flood*; *Clade*; *End of the Ocean, The*; *Flight Behavior*; *History of Bees, The*; *South Pole Station*

Further Reading

Christie, Michael. "The Animals Are Dying. Soon We Will Be Alone Here." *New York Times*. August 4, 2020.

Kelly, Hillary. "Review: A Powerful Climate Novel Reminds Us People Are Animals Too." *Los Angeles Times*. August 3, 2020.

Melville, Herman. *Moby Dick or the Whale*. New York: MacMillan, 2004.

Wright, Fiona. "*The Last Migration* by Charlotte McConaghy Review—Aching, Poignant and Pressing Debut." *The Guardian*. August 6, 2020.

MINISTRY FOR THE FUTURE, THE

The Ministry for the Future (2020) is the most recent of Kim Stanley Robinson's novels about climate change. Robinson is the author of the *Science in the Capital* trilogy: *Forty Signs of Rain* (2004), *Fifty Degrees Below* (2005), and *Sixty Days and Counting* (2007). The three novels describe catastrophic weather events caused by climate change that disrupt global life and the American government's response to the crisis. He is also the author of the popular novel *New York 2140* (2017), which depicts New York after global warming has caused sea rise to such an extent that most of New York City is underwater. In *The Ministry for the Future*, Robinson returns to the near future when the first full effects of climate change are felt.

The Ministry for the Future begins with a catastrophe. A climate change–induced weather event causes temperature and humidity to rise above a wet-bulb temperature of thirty-seven degrees centigrade (ninety-five degrees Fahrenheit with 100 percent humidity), which is fatal to humans. It settles over Lucknow, India, a city of over twenty million inhabitants, for two weeks. Among them is Frank May, who is running a medical clinic in the city. As much of India loses power, inhabitants of the city attempt to escape the heat, with millions immersing themselves in nearby lakes and rivers. Twenty million people die, but Frank May lives. At the same time, Mary Murphy is in Switzerland, where she heads a United Nations climate agency, colloquially known as the Ministry for the Future, that is tasked with overseeing the implementation of the Paris Climate Agreement (2015). The novel follows the two characters as they interact and respond to the climate crisis over a number of years.

May, suffering from severe burns and post-traumatic stress disorder and reacting badly to heat, is sent to Zurich, Switzerland, to recover. Zurich is also the home of the Ministry for the Future. In the Ministry, Murphy coordinates attempts to enforce the provisions of the Paris Climate Agreement, to which none of the signee nations have met their agreed targets and from which the United States has withdrawn. Despite threats from other nations, India responds to the disaster by seeding the skies above India with sulfur dioxide particles, attempting to recreate the effect of the Mount Pinatubo eruption of 1991, which lowered the earth's temperature several degrees. Surprisingly, it works, buying a little time for India while sea waters continue to rise around the world, crops continue to fail, and climate refugees flood into Europe.

While May and the members of the Ministry for the Future identify problems such as sea rise, temperature rise, and crop failure and attempt to get support from national governments and the banking communities, mostly without results, individuals begin to act. Some act in positive ways, experimenting with ways to slow glacial melt and developing alternative fuel sources. Others act differently, calling for the execution of "climate criminals" and the destruction

of all carbon-producing vehicles. Despite the temporary reprieve caused by India's action, the world climate situation continues to worsen.

The Ministry for the Future develops and urges the adoption of a potential financial solution as both banks and governments refuse to respond because of issues of cost and national interest. It proposes the creation of carbon coins, which could be traded on the open market and would pay for the elimination of carbon dioxide production, the primary cause of global climate change. National and international banks refuse to take up the idea, and where banks lead nations follow.

Then planes start falling out of the sky. Either international climate change terrorists or "dark" agents of the Ministry itself—the agents remain unidentified in the novel—obtained thousands of small drones, and after anonymously demanding that carbon-producing travel cease, they begin to bring down jets around the world. Soon air travel ceases. Next comes a demand for the cessation of carbon dioxide–producing ships, and after a number of oil tankers are sunk, shipping stops as well.

Meanwhile, Frank May is waging his own war on climate change. First, he briefly kidnaps Mary Murphy, accusing her and the Ministry of not doing enough to make governments change. Next, he interrupts a party of wealthy industrialists, accusing them of complicity in climate crimes and accidentally killing one of them. He escapes and lives off the grid in Zurich and works in refugee shelter food lines. Finally, May breaks up a right-wing attack on refugees at a shelter, but he is recognized and arrested. Murphy visits him in prison, and they begin to develop a friendship.

Murphy continues to appeal to governments and bankers, some of whom provide small sums. She directs the Ministry to fund small experimental projects. The most successful involves slowing down the loss of the ice shelves in the Arctic and Antarctic, where temperature rise has occurred most rapidly, and thawing ice has become the major source of sea rise. A pilot project demonstrates that drilling through Antarctic glaciers and pumping up seawater to freeze on top can increase glacier weight, allowing the glacier to resettle on the seabed and slowing down glacial melt.

With global transportation halted, superstorms create millions of climate refugees, and the tundra continues to thaw in Russia, Canada, and Alaska, potentially releasing millions of metric tons of methane, a far more damaging greenhouse gas than carbon dioxide, per year. A superstorm hits the Los Angeles area and eventually fills the Los Angeles basin with water, killing hundreds of thousands of people and making the city uninhabitable. In China, five million protestors occupy Tiananmen Square to protest government inaction. African governments nationalize industries and cancel loan payments to first world countries. With climate, economic, and political chaos occurring around

the globe, Murphy and the Ministry finally convince the fossil fuel industry and international banking to support the idea of carbon coins. Nations follow suit, and green transportation begins to replace older, more carbon-producing ones.

Progress is not without opposition, however. Several world leaders who support the Ministry are assassinated, and an attempt is made on Mary Murphy's life, forcing her to go into hiding in the Alps. Anti-migration riots break out in several European countries. Violence erupts against those supporting carbon-based industries and those opposing carbon-based industries.

Despite the sometimes-violent opposition, carbon emissions begin to stabilize and then go down as governments and industries adapt to the new reality. The fossil fuel industry discovers that the same basic technology used to extract oil and gas can be used to sequester carbon dioxide. In addition, carbon coins permit the continued development of alternative fuels to become profitable, and with alternative fuel sources, alternative methods of transportation are adopted.

Several years later and out of hiding, Mary Murphy makes a trip to San Francisco for a meeting of the heads of the U.S. Federal Reserve, the World Bank, and other financial leaders. Her trip involves the use of a solar-powered dirigible, a solar-powered ship with sails and a catamaran-like hull, an electromagnetic train, and solar-powered taxicabs. She is able to announce that for the first time, the amount of carbon in the atmosphere is actually decreasing. At the end of the narrative, Mary Murphy is retired from the Ministry, and Frank May, having become Murphy's friend and confidant, has died of a brain tumor.

The Ministry for the Future is not a traditional novel. In addition to the main narrative thread involving May, Murphy, and the work of the Ministry, Robinson includes chapters that focus on science, chapters that argue for currency reform, chapters that dramatize the point of view of climate migrants, and even a chapter that allows animals impacted by climate change to have a voice. He includes scientific data on climate change and the information on the worsening impact of climate change since the signing of the Paris Climate Agreement in 2015.

Also, as he has in his other climate change novels, Robinson includes arguments for socialism as a more effective form of government to fight both inequality and the disasters of climate change. This form of the novel is not new. American writer John Dos Passos employed a similar technique in his *U.S.A.* trilogy (*The 42nd Parallel* (1930), *1919* (1932), and *The Big Money* (1936)) to tell the story of a dozen characters living early in the twentieth century. The complex structure reflects the complex relationships among characters and social and political events in both Dos Passos's novels and Robinson's *The Ministry for the Future*.

The Ministry for the Future has received critical praise upon publication. Amy Brady, in the *Yale Climate Connections Newsletter*, calls it "tremendously engaging" and praises the novel for recognizing that economic changes are

as essential as scientific ones in responding to climate change. *Kirkus Reviews* notes that *The Ministry for the Future* is "high minded, well-intentioned, and in love with what the earth's future could be." A number of other reviewers noted that the novel is also the grimmest of Robinson's climate change novels.

The Ministry for the Future, despite the horrific opening scene in which millions die in a wet-bulb catastrophe and the constant complaints of industrialists and bankers in the novel that climate solutions are too expensive, is not a novel of despair. Robinson's main argument is that science already has the answers to most of the problems posed by climate change and that it is only lack of will that keeps them from being put into practice. In the novel, the urgency of the crisis forces characters to act. In the real world, one wonders.

See also: *City Where We Once Lived, The*; *Fifty Degrees Below*; *Forty Signs of Rain*; *Gold Fame Citrus*; *New York 2140*; *Sixth Extinction, The*; *Sixty Days and Counting*

Further Reading

Brady, Amy. "A Crucial Collapse in 'The Ministry of the Future.'" *Yale Climate Connections Newsletter*. November 2, 2020.
"The Ministry for the Future." *Kirkus Reviews*. September 2, 2020.

MOON OF THE CRUSTED SNOW

Moon of the Crusted Snow (2018) is a postapocalyptic novel by Waubgeshig Rice, an Anishinaabe writer from the Wasauksing First Nation near Parry Sound, Ontario. The novel was a best seller in Canada and won the Canadian OLA Forest of Reading Evergreen Award in 2019 and was shortlisted for the John W. Campbell Award for the Best Science Fiction Novel. The novel is set in an Anishinaabe reserve in northern Canada at the moment when society collapses. Although Rice never mentions the specific cause of the collapse, similar to the strategy employed by Cormac McCarthy in *The Road*, it is clear that climate change is part of the problem that cuts off the nearly 400 First People as winter is about to set in.

Moon of the Crusted Snow begins as Evan Whitesky, the protagonist of the novel, is taking part in the final days of the fall hunt in an unnamed Anishinaabe reserve in Northern Canada. Like many other men in the community, he is hoping to kill a moose to provide extra food for his family during the winter. When he kills a large moose, he offers a prayer of thanksgiving to the Great Spirit before butchering the moose on the plywood rack on the back of his four-wheeler. When he returns from his hunt, he shares some of the meat with his extended family before freezing the rest for winter.

Several days after the hunt, there is power outage on the reserve, which is not an unusual event. When the power stays out for several days, Whitesky

and other members of the reserve council begin to plan for longer than usual outage. They check the canned good and staples in the community stockpile and await the next delivery to the reserve's store, which is running low on food. Whitesky and the council decide to use backup diesel generators to provide light and some heat, and they encourage the tribal members to use wood stoves whenever possible. After several weeks, there is no power, television, radio, or cell phone connection. Everyone on the reserve is getting anxious.

The extent to which the people on the reserve are isolated is made clear when two young tribal members return on snowmobiles from a city farther south, where they had been studying welding at a community college. They tell Whitesky that power and communications are out in the city as well and that life rapidly deteriorated there once the power went out. They described how they stayed in their dormitories at first and were fed daily by the college. But after a few days, food ran out, and the college workers left, leaving the students to fend for themselves. The two found two snowmobiles in a workshop, attached sleighs to them to carry food and fuel, and made their way back to the reserve. Whitesky and the council realize that the people on the reserve will be in for a long winter and institute food and fuel rationing.

Several days later, a white man named Justin Scott, who had been following the snowmobile tracks from the city, appears. Somewhat pleading and somewhat threatening, Scott asks Whitesky and his brother Isaiah, who had been making rounds of the reserve to see whether everyone was all right, if he can stay, telling them he is a survivalist and hunter and is willing to help provide food for people in the reserve. Reluctantly, the brothers agree.

As winter progresses, deaths begin to mount on the reserve. Some are old people who succumb to cold and hunger, and some are young people who commit suicide. Eddie, one of the tribal elders and a Korean War veteran, dies, and Whitesky visits his wife, Aileen, also a beloved elder, who asks him what word people use for the end of the world. "Apocalypse," he replies. She responds by saying that it is a "silly word" with no equivalent in Ojibwe. She tells him that their world is not ending; it had already ended. It ended, she said, when the Zhaagnaash (white people) took over their land, cut down all the trees, fished all the fish, and made the people leave for the north. She tells him the people have had apocalypse over and over and that they will remain, even if the power never comes back and they never see white people again.

The situation on the reserve worsens as winter progresses. More people die, and food supplies run short. In addition, Justin Scott has become a problem. At first, Scott, who is physically imposing and always armed, supports Whitesky and the council. Soon, however, some younger and disaffected members of the community begin spending long periods of time at Scott's quarters, and Whitesky suspects they are engaged in both drinking, prohibited on the reserve,

and drug use. When two young women are found frozen to death after a night of partying at Scott's quarters, Whitesky suspects but cannot prove foul play.

Finally, during the moon of the crusted snow, an Anishinaabe month in late February and early March, Whitesky discovers that some of the tribal members' bodies that had been kept in the community storage garage until the weather permitted digging and burial are missing. He suspects that because of the food shortages, someone has resorted to eating the dead. Whitesky goes to Scott's quarters and discovers human remains being boiled for food. When Whitesky confronts Scott, Scott pulls a weapon and shoots him. Scott is then shot by the wife of one of the young men who had been Scott's friend.

Spring eventually comes, and over half the people of the reserve have died. The Anishinaabe who survived, however, recognize they must take their destiny into their own hands, realizing that the power, the internet, and white civilization are never coming back. Rice writes,

> The collapse of the white man's modern systems further withered the Anishinaabeg here. But they refused to wither completely, and a core of dedicated people worked tirelessly to create their own settlement away from this town.

Moon of the Crusted Snow is a significant postapocalyptic novel. Like Cherie Dimaline's *The Marrow Thieves*, the novel presents the destruction of contemporary civilization in the context of the white appropriation of Indigenous Peoples' land and culture. It also suggests that the benefits of contemporary civilization, such as power and electronic communication, come at a great price and that they are less essential to a community than a sense of shared values. Rice articulates a belief that the infrastructure upon which modern civilization rests is fragile, and in the coming days of climate change, they may not be relied upon.

See also: *Barkskins*; *Colony, The*; *Day after Tomorrow, The*; *Marrow Thieves, The*; *Snowpiercer*

Further Reading

Coldiron, Katherine. "Katherine Coldiron Reviews *Moon of the Crusted Snow* by Waubgeshig Rice." *Locus*. July 2, 2019.

Guynes, Sean. "*Moon of the Crusted Snow* by Waubgeshig Rice." *Strange Horizons*. July 22, 2019.

NEW WILDERNESS, THE

The New Wilderness (2020), by Diane Cook, the author of the critically acclaimed short story collection *Man v. Nature* (2014), is a dystopian climate change novel set in the near future. Before the novel begins, many of the disasters predicted to occur as a result of dramatic global warming have happened. In the United States, mass migration to the cities has occurred and drought has destroyed much of the land available for agriculture. Urban areas have spread out into the country and are surrounded by vast waste dumps. Sea level rise and pollution from industry have destroyed most of the country's rivers, and in the cities, disease, especially among children, has become pandemic. To the south of the wilderness is a place simply called the "heat belt."

In response, the government has set aside a Wilderness State, where the last wild flora and fauna in the country exist and from which people have been removed. As an experiment, twenty volunteers have been selected to live as hunter-gatherers in the wilderness to see whether they can survive without negatively impacting the environment. Among them is Bea; her husband, Glen, who designed the experiment; and their daughter, Agnes. The volunteers are given a set of instructions, such as leaving no trace of their encampments, not making any camp permanent, collecting even microwaste, and living completely off the land. In addition, they will be monitored by rangers, who have the ability to end the experiment for failing to comply with the rules.

The first part of the novel is seen through the eyes of Bea, who has become the glue that holds the group together, other than the things they almost religiously carry with them and treasure: an iron pot, a book bag, and a tea cup. They have also defined themselves simply as the Community. The novel opens with two deaths. The first is Bea's stillborn daughter, whom Bea buries outside their camp. The second is Caroline, the Community's best river crosser, who is hit by a log while leading the Community across a river. Neither loss stops the Community's journey. To survive, Bea and the others must move on, hunting with homemade arrows, making their own clothes, and finding whatever else might be edible.

Bea's main concern is for her daughter, Agnes, who came to the wilderness as a sick young child. Surprisingly, she has adapted to the wilderness more

successfully than any other member of the Community, becoming their best tracker and scout. Bea is wondering how she can continue to watch over her increasingly independent daughter when two crises occur. The Community had grown comfortable in its migration through the wilderness, staying too long in one game-rich valley. Chastened by the rangers, they are ordered to head far to the south, to a region of the wilderness they have not visited. More significantly, when the rangers deliver their mail, their only contact with civilization, Bea learns that her mother is dying and begging her to return to the city. Feeling guilt for leaving her, she reluctantly does.

The point of view of *The New Wilderness* shifts to Agnes, who feels betrayed by her mother. She is also concerned about the health of her father, who is growing older and now lags behind the other members of the Community as they make their way south. On their yearslong journey, she becomes one of the leaders of the Community and serves as their best tracker and guide. In addition, she takes a larger part in the discussions of the adults and spends less time with the children. Her status and the unity of the Community is threatened, however, with the arrival of another group of city exiles.

The Community is ordered by the rangers to accept the new group of people who have also fled the social, ecological, and medical devastation of the city. The Newcomers, as they call themselves, find much of the behavior of the members of the Community, who now call themselves the Originalists, meaningless and confusing. They wonder why the members insist on carrying around a heavy iron pot and why they have a reverence for the rules given to them by the rangers. The Originalists find the Newcomers soft, weak, and unwilling to learn. Eventually, however, as the combined Community makes its way through the wilderness, the Newcomers learn that in order to survive, they must learn to hunt, trap, to make their own clothes and shelter.

The one thing the Newcomers do change is decision-making. In the early part of the novel, the Community made its decisions by consensus; all the members had to agree. With the arrival of the Newcomers, and the absence of leadership by Glen, who has become even more ill, the members of the Community become divided and abandon consensus for voting, which often causes rifts. An even larger crisis occurs for Agnes when her mother reappears.

Bea's return confounds Agnes, who cannot accept her mother's abandonment. Mother and daughter argue as they try to redefine their relationship to each other, Glen, and the Community as a whole. They come to an understanding, however, when Glen dies, allowing them to grieve together. Even this brief understanding is shaken, however, when rangers appear to inform the group that the wilderness experiment has been canceled and the members must return to the city.

The members of the Community are at first stunned, especially the Originalists, who have come to accept life in the wild as a way of life. They debate their options. Bea, the realist, says that the group has no choice; the rangers have drones and will easily track down any members who refuse to comply. Agnes, on the other hand, who has no memory of the city and has grown up in the wilderness and become adept at surviving in it, refuses to go along. As the rangers come to collect the members of the survival experiment, Agnes takes a newborn, whose mother died giving birth, and escapes to raise her adopted daughter in the wild.

There are few happy endings in climate change fiction, and as Bea had argued, Agnes and the baby are soon captured by the rangers. The novel ends in the city, with Agnes and the baby fenced into an overcrowded urban area surrounded by toxic wasteland. She has, however, managed to obtain a fence cutter and is planning an attempt to take the baby and escape into the wilderness.

The New Wilderness received numerous positive reviews upon publication. Writing in *The Guardian*, Téa Obreht calls the novel a "dazzling debut" and praises it for being both thoughtful and a thrilling story. Eliot Schrefer, writing in *USA Today*, calls the novel a "timely ecological tale" and praises it as a narrative that is both a gripping adventure and one that denies readers easy answers.

As many critics have noted, *The New Wilderness* is more than a dystopian climate change adventure. The idea of attempting to survive in a wilderness after climate change has destroyed much of the environment has become one of the standard tropes of climate change fiction. Tim Lebbon's *Eden* and Sherri L. Smith's *Orleans*, for example, have employed the idea before with a degree of success. In *The New Wilderness*, Diane Cook creates a narrative in which she explores the complex relationship between a mother and her daughter against the backdrop of both environmental destruction and wilderness survival. Switching the center of consciousness between Bea and Agnes allows Cook to examine the survival experience from two points of view: Bea's, that of a woman who has lived in and escaped the city to ensure the survival of her daughter, and Agnes's, that of a girl growing into adulthood who has only known the wilderness and survival. Both are intelligent and perceptive characters whose life experiences and relationship to one another pull them toward each other and push them apart.

Cook is equally successful in creating a sense of what wilderness survival might be like. Especially through Agnes's eyes, she provides rich details of the experience of living in the wilderness. Her depictions of hunting, skinning, and butchering of animals are both detailed and unsentimental. Her descriptions of the Community's interactions, both before and after the arrival of the Newcomers, show a clear understanding of human interaction and power politics on a very small scale.

The New Wilderness describes a social and environmental experiment that ultimately failed. Both in the wilderness and in the city, people remain in conflict and manage to destroy the world in which they live.

See also: *Blackfish City*; *Eden*; *Gold Fame Citrus*; *MaddAddam*; *Orleans*

Further Reading

Obreht, Téa. "*The New Wilderness* by Diane Cook Review—A Dazzling Debut." *The Guardian*. September 4, 2020.

Schrefer, Eliot. "'The New Wilderness': Humanity Returns to Nature in Diane Cook's Timely Ecological Tale." *USA Today*. August 9, 2020.

NEW YORK 2140

New York 2140 (2017) is a post–climate change speculative fiction novel written by Kim Stanley Robinson, the author of nineteen novels and winner of the Hugo Award, the Nebula Award, and the World Fantasy Award, among numerous other awards. The novel is set in New York City after climate change has dramatically altered the earth's atmosphere. *New York 2140* suggests that human nature may not change with the climate, but climate change may force humanity to reconsider the relationship between wealth and political power.

In *New York 2140*, climate change has impacted human life on a global scale: most major coastal cities have been destroyed, worldwide temperatures have risen, and resources such as food and shelter are scarce, even in first world countries. New York City survives, becoming the new Venice because most of Manhattan Island is nearly a hundred of feet above sea level, at least above Midtown. In addition, the bedrock upon which buildings are constructed is mica schist, an extremely strong metamorphic rock. Most of Lower Manhattan is tidal wetland where people live on the upper floors of the taller buildings, and high-rise towers for the wealthy dot Washington Heights, Todt Hill on Staten Island, and the Palisades of New Jersey. Large parts of Brooklyn, the Bronx, and Queens lie underwater, polluted by an array of chemicals and toxic materials trapped below the rising waters. And even though Wall Street is underwater, the investing class still lives in and controls the city.

In many works of speculative fiction, the setting is often the most interesting aspect of the narrative, and Robinson's post–climate change New York City is a carefully crafted and wonderful creation. The people who live in the partially submerged buildings travel to work in small boats that glide along the city streets or take elevated walkways that stretch between buildings. In the tidal area of Lower Manhattan, salvaged buildings stand next to sinking wrecks of abandoned ones, while north of Central Park, much of New York remains untouched by the sea level rise. People grow food on building roofs

and get power from solar collectors. Robinson focuses the novel on one surviving building, the fifty-story MetLife Tower, in which all the major characters in the novel live, at least for a time.

Robinson's characters are also well drawn and interesting. Stefan and Roberto are twelve-year-old orphans who survive in collapsing buildings and manage to discover a sunken Revolutionary War treasure ship. Mutt and Jeff are computer programmers who attempt to disrupt worldwide financial markets. Amelia Black is a popular blogger who assists endangered species' migration in her dirigible, fossil fuels having been abandoned because of global warming. Franklin is a futures trader with a small electric speedboat. Charlotte Armstrong is a lawyer and on the co-op board of the MetLife Tower. Gen Octaviasdottir is a female police inspector. Vlade is the MetLife Tower's superintendent. Their lives, and the lives of all the other characters in the novel, are shaped by the effects of climate change. Robinson also includes a character who is simply called "Citizen," who provides historical, geographical, and political background; makes moral and political pronouncements; and comments on the actions of the novel's characters, directly addressing the reader. Citizen is obviously the voice of the author.

The early sections of the novel describe what passes for ordinary life in the ongoing climate-changed New York. Franklin works on developing a derivative investment program based on the value of buildings partially underwater in Lower Manhattan. Amelia Black transports the last of the endangered polar bears from the iceless Arctic to the still icebound Antarctic. Vlade discovers water leaks in the basement of the MetLife Tower and considers it possible sabotage, as an offer to buy has been received by the building's co-op owners. Gen investigates both the leak and the anonymous offer at Charlotte's insistence. Mutt and Jeff are kidnapped after launching their software attack, and Stefan and Roberto hitch rides on boats and roam the canals of the city.

As the characters interact, they begin to see a pattern in the events they are experiencing. Someone seems to be orchestrating events in New York to take advantage of uncertainty caused by the occupation and questionable ownership of hundreds of buildings in what was once land and is now a tidal zone. A major issue is, with the rise in sea level, does once coastal property fall under civil or maritime law. Even the law is impacted by climate change. The characters begin to suspect that large financial investment firms may be manipulating events to take over Lower Manhattan.

Meanwhile, Citizen provides climate change background for the reader. He describes two pulses, each a decade-long disaster, as "a meltdown in history, a breakdown in society, a refugee nightmare, an eco-catastrophe, the planet gone collectively nuts. The Anthropocide, the Hydrocatastrophe, the Georevolution." Most coastal cities were destroyed, as was much of the world's

manufacturing and agricultural infrastructure. Citizen notes that the disaster also created opportunities for investment and, with disapproval but not surprise, that the wealthy who survived the pulses did quite well; in New York, they built enormous skyscrapers in northern Manhattan, while ordinary people were forced to live in tidal Lower Manhattan.

The plot of *New York 2140* turns on another aspect of climate change, increased storm activity, in this case a monster hurricane that forms in the Atlantic and heads for New York. Robinson bases this storm on Hurricane Sandy, which hit New York City on October 29, 2012, flooding Lower Manhattan and the subway system as well as knocking out communication for several days. Robinson also draws on Hurricane Katrina, which hit New Orleans on August 29, 2005, for descriptions of the city flooding and refugee crisis that occurs in his novel. The main characters all shelter in the MetLife Tower as the storm approaches, as do other New Yorkers who need to find shelter from the storm. The storm hits, and although the MetLife Tower withstands the high winds, flooding, and storm surge, much of Lower Manhattan does not.

Tens of thousands of displaced New Yorkers make their way to Central Park, in which a temporary tent city is set up to provide relief for the people who have been displaced. Inspector Gen Octaviasdottir, realizing that many of the apartments in the surviving uptown skyscrapers are empty, most of them being rented by wealthy out-of-town renters who only use them part time, leads a squad of New York City policeman into one of the buildings to order the building's superintendent to house some of the newly homeless under the city's recently declared disaster act. Met by private security, who are more heavily armed, the police are refused entry and forced to retreat. Eventually, the governor of New York calls in the National Guard to keep order as the homeless and the private security's small army engage in an armed standoff.

It is at this point in the novel that the various threads come together. Mutt and Jeff's theory that investment firms controlled city politics in borne out. Franklin discovers his financial mentor has been attempting to buy properties throughout Lower Manhattan to control the futures and derivative markets. Gen discovers the mayor of New York is supporting the investment firms and private security forces. Even after climate change has changed the face of New York, the rich and powerful remain in control. Climate may change, but power does not.

New York 2140 is not a dystopia; rather, it is a fairy tale, and in the final sections of the novel, the magic happens. Led by Franklin, Charlotte, and Gen, and popularized through Amanda Black's widely viewed podcast, New Yorkers unite and go on a rent strike against the banks, weakening the banks and investment firms already impacted by the massive hurricane and their overinvestment in New York City properties. Charlotte, whose ex-husband has

become chairman of the U.S. Federal Reserve, runs for a seat in Congress and wins. The overextended banks and investment companies ask for a federal bailout, which Robinson bases on the 2008 government bailout of the financial industry that occurred at the start of the Great Recession. This time, however, in good fairy tale fashion, the government bails out the banks and investment firms only after they agree to a government takeover. The people now own the banks—a perfect happy ending. But Citizen remains unimpressed. He writes that although the federal government passed other laws limiting the power of investment capitalism, there was much pushback, so the progressive legislation probably would not last. After giving his novel a happy ending, Robinson has Citizen declare, "There are no happy endings."

New York 2140 is an optimistic book, despite the climate change disasters that changed the face of New York City (and by extension the rest of the world). Robinson creates a well-imagined New York, and even flooded the streets, now canals, of the city can be beautiful. In one particular scene, Robinson describes how a massive winter storm descends on New York, freezing the Hudson River and New York Harbor, something that has not happened since 1780. To the delight of Stefan and Roberto, the frozen canals become an enormous, elaborate skating rink. In addition, Robinson's main characters, although in some ways hardened by climate change and the circumstances under which they are forced to live, are thoughtful and ultimately community minded. The novel depicts good people doing their best under bad circumstances.

Much climate change fiction is dystopian, showing people being crushed by the reduced circumstances that are a result of the ongoing climate change. Many of the most famous dystopian narratives are set in imagined urban futures. Fritz Lang's 1927 film *Metropolis*, George Orwell's 1949 novel *1984*, and Margaret Atwood's 1985 novel *The Handmaid's Tale*, for example, all present urban visions of a dark future. In Robinson's financial and political thriller of a changed future world, the people, at least for a while, seem to win. Robinson is aware of the mood of the novel, calling the final section, "The Comedy of the Commons." Comedies, of course, even dystopian ones, have to have happy endings.

See also: *Carbon Diaries 2015, The*; *Clade*; *Fifty Degrees Below*; *Flood*; *Forty Signs of Rain*; *Odds against Tomorrow*; *Orleans*; *Sixty Days and Counting*

Further Reading

Rothman, Joshua. "Kim Stanley Robinson's Latest Novel Imagines Life in an Underwater New York." *The New Yorker*. April 27, 2017.

Sobel, Adam. *Storm Surge: Hurricane Sandy, Our Changing Climate, and the Extreme Weather of the Past and Future*. New York: HarperCollins, 2014.

0

ODDS AGAINST TOMORROW

Nathaniel Rich's 2013 *Odds against Tomorrow* is a critically acclaimed popular novel about a host of potential natural disasters and the odds on any one of them occurring. It is also a novel about environmentalism, corporate greed, insurance scams, and a massive climate change–driven hurricane that hits New York City, turning it into a watery wasteland. The novel, which centers on Mitchell Zukor, a brilliant young mathematician with a strange ability to predict cataclysms, is also very funny.

Odds against Tomorrow begins with a volcanic eruption that destroys Seattle and ends with a monster hurricane named Tammy that destroys New York. The novel opens with Zukor as a mathematics major at the University of Chicago who wears gray T-shirts bearing the faces of legendary statisticians and has nightmares about disasters great and small. It follows his career as a well-paid prophet of doom working for FutureWorld, a New York consulting firm that advises corporate clients on the statistical probabilities of a variety of potential disasters. It ends with him as a survivor of the worst climate catastrophe in the history of New York and turning his back on fame and obscene amounts of money.

Mitchell Zukor is blessed with an amazing ability in mathematics and also cursed with an acute phobia about disasters. The only way he can avoid horrible nightmares, in which he imagines his body covered with hairy cockroaches, when he hears about a catastrophe is to figure out the odds of it happening. Once he learns, for example, that his odds of dying in an elevator accident are 1 in 10.44 million, he no longer fears riding the elevator to his small office on the seventy-fifth floor of the Empire State Building. Zukor only has two friends, Elsa Bruner, a pen pal from college who suffers from Brugada syndrome, a disease that can cause her heart to stop beating at any moment, and Jane Eppler, his assistant at FutureWorld, a consulting company that indemnifies corporations against liability in case of disasters. He worries about Elsa, who lives in a commune in Camp Ticonderoga, once a youth camp in Maine, and he calculates the probability of disasters, such as nuclear war, an outbreak of a pandemic, a meteorite smashing into earth, or a climate change–induced flood, with Jane. He lives alone in a tiny apartment, where he imagines disasters and

keeps a large percentage of his very good salary in piles of twenty-dollar bills in plastic bags in his freezer—just in case.

Every day on his way to work, where he will inform potential clients of the probability of disasters that might destroy their companies, Zukor passes street preachers who provide an ongoing commentary on the state of the world as seen through the eyes of avid readers of the book of Revelation. As a result, his sales pitches to his potential clients gets even more effective as he combines algebraic equations with images of the four horsemen of the apocalypse, plagues, earthquakes, and floods. FutureWorld becomes very successful. And then, one day, Zukor hears about Tammy, a large tropical storm brewing in the Caribbean. After calculating the odds of it becoming a Category 5 storm and heading for New York City, he gets very worried. He believes that Hurricane Tammy might be a repeat of the 1900 unnamed hurricane that completely destroyed the city of Galveston, Texas, which he had researched. He turns out to be correct.

The most dramatic parts of *Odds against Tomorrow* are the chapters dealing with the impact of the monster storm on New York City. As Zukor had predicted, Tammy skirts the Atlantic shore of New Jersey and slams into New York Harbor. Large portions of low-lying Brooklyn, Queens, Staten Island, and the Bronx as well as Lower and Central Manhattan are inundated. Subways and tunnels out of the city flood. Buildings collapse, power is lost, tens of thousands of people die, and millions flee, creating a refugee nightmare. Zukor and Jane survive, holed up in his apartment with two weeks of emergency rations, a windup weather radio, and a Day-Glo-painted canoe he had purchased on a whim the week before the hurricane.

From his disaster research, Zukor knows that Manhattan Island rises from 7 feet above sea level at Battery Park at its southern end to 265.5 feet above sea level at Bennett Park in the north, at West 183rd Street and Ft. Washington Ave. After several nights in his apartment, Zukor and Jane begin their two-day canoe trip north. Along the way, they discover a Coast Guard patrol boat sailing along Third Avenue, hundreds of floating bodies in flooded Grand Central Station, thousands of dead pigeons floating in the polluted water, and rioters wherever the water is receding. They keep to deeper water, where they are safe from other survivors. Eventually, they reach Central Park, where the East River had met the Hudson, forming a huge, deep lake. There they spend a quiet night. The next day, they continue their journey north, eventually reaching Bennett Park, where they abandon their canoe and join thousands of other refugees waiting to be ferried across the Hudson River to New Jersey to Federal Emergency Management Agency (FEMA) tents and eventual evacuation farther from the city.

One aspect of the aftermath of any major catastrophe, especially a climate change–induced weather event like Hurricane Tammy as depicted in *Odds*

against Tomorrow, is the logistical problems for the survivors and their rescuers. Zukor, who had researched both the details of the catastrophe and the odds of it occurring, knew what to expect. He remains calm as he and Jane are shuttled from one FEMA camp to the next, working their way to Camp Ticonderoga in Maine so that they can check on the health of Elsa Bruner, who has been in a coma for several weeks. When they arrive at the camp, they discover Bruner has gone and that the camp, once an idyllic commune, has been overrun by violent Tammy refugees. They decide to make their way back to New York, where they end up living in a large FEMA trailer camp along with thousands of other displaced New Yorkers who were waiting for federal permission to return to the city once it has been determined areas of New York are safe.

In the camp, Zukor becomes a reluctant celebrity. His picture had appeared on television after his clients, many of whom who had left New York before the storm, announced that he had predicted it, saving their lives and millions of dollars for their companies. As a result, he becomes known as "Mr. Prophet," and his fellow FEMA campers follow him around the camp, asking what will happen next. The only thing he knows is that he is going to get out of the camp somehow, even though federal, state, and city authorities are letting no one return to the ruined city until cleanup is complete. Most of New York City remains underwater or littered with toxic waste, but Zukor hears a rumor that some land in the eastern end of Brooklyn, near Jamaica Bay, is almost clear. With the help of Hank Cho, a burly former MTA employee who knows the city's rail system, Zukor and Jane walk a freight line to Flatlands, outside of Canarsie, where they settle.

Zukor and Jane find a bank that has not been washed away, and they clean it and stay for several months. Eventually, they hear that people are beginning to return to parts of Manhattan, which has been drained by large pumps. Jane returns to establish a new futures company, FutureDays. Zukor decides to stay in Flatlands. With Cho, he scavenges tools, equipment, food, and seeds from an abandoned warehouse and eventually builds a workable outdoor hot water shower, cleans a room in the bank in which to sleep, and plants a garden. There he intends to remain, not giving a thought about the future and no longer concerned about disasters.

Odds against Tomorrow is a novel about climate change that manages to avoid many of the clichés of contemporary environmental dystopias. Rich includes indictments of corporate irresponsibility, governmental corruption, environmental neglect, and public indifference. He also provides graphic descriptions of not only the climate change–induced superstorm but also the inevitable aftermath of displaced hungry refugees and toxic wastes. His description of New York City underwater could be read as a description of Hurricane Sandy, which struck New York on October 29, 2012, multiplied by a factor of ten.

Yet, despite the damage, death, and disasters that occur in the novel, his main characters, Mitchell Zukor and Jane Eppler, remain optimistic, if somewhat innocent, despite their experiences. Despite seeing New York destroyed by one storm and knowing more will be coming, Jane gamely returns to Manhattan and the futures business. Zukor, on the other hand, simply decides to stay where he is and tend his garden, much like an earlier famous character, Voltaire's Candide, upon whom Zukor is somewhat based, who at the end of his comic novel of disaster chooses to tend his garden despite the disasters about him.

Voltaire's 1759 novel *Candide, or the Optimist*, is a justly famous satire about humanity's faith in progress, science, and religion. The hero, Candide, experiences earthquakes, kidnapping, slavery, torture, and the loss of his love and still believes that he is living in the best of possible worlds. Mitchell Zukor believes he is living in the worst of all possible worlds, with climate change and other environmental disasters all about him. Nevertheless he, like Candide, ends up an optimist, content with being the person he has become and tending his garden as the potential disasters loom all about him.

See also: *Carbon Diaries 2015, The*; *Clade*; *Drowned World, The*; *Flood*; *Forty Signs of Rain*; *New York 2140*; *Orleans*

Further Reading

Cheuse, Alan. "Book Review: 'Odds against Tomorrow.'" NPR. April 1, 2013.
Sobel, Adam. *Storm Surge: Hurricane Sandy, Our Changing Climate, and the Extreme Weather of the Past and Future*. New York: HarperCollins, 2014.

ORLEANS

Orleans (2014) is a young adult climate change thriller by Sherri L. Smith. The novel is set in New Orleans after climate change–induced hurricanes have forced the United States to seal off the Mississippi Delta area with a wall to prevent a killer virus from spreading to the rest of the country. In addition, the U.S. government has withdrawn governance from the former states of Alabama, Florida, Georgia, Louisiana, and Texas. New Orleans has been hit the hardest, battered by sea rise, a series of killer hurricanes, and a deadly pandemic. The city is almost empty except for warring tribes of people divided by blood type, each tribe protecting its members from forced blood transfusion by other tribes. Survivors have dropped the "New" from the city's name because nothing new was left in it.

Orleans is told from alternating points of view. The first is that of Fen de la Guerre, a teenage girl from the PO (blood type O positive) tribe, who speaks in a creolized New Orleans slang. She is also the tribe's enforcer, chosen for her

fighting skills and tasked with keeping the tribe's chief safe. The second is that of Daniel Wells an immunologist from outside Orleans, who has been working on a possible cure for the pandemic. Fearing that the government might weaponize his vaccine, he enters Orleans disguised as a leper to test its efficacy and safety himself.

Smith's creation of post–climate change disaster Orleans is the strongest part of the novel. Her Orleans is a shell of the city that existed before the hurricanes, with buildings collapsed or falling and the swamps taking back much of what had been drained by the city's pumps. With rot and ruin everywhere, tribes have carved out separate areas of Orleans, with neutral grounds being the outdoor market in the French Quarter, cemeteries, and churches, where fighting is prohibited. Perhaps the most memorable part of the city is the Superdome, which serves as a vast mausoleum, with stacks of neatly piled bones in every chair. The Ursuline nuns, who remained in the city caring for the sick and the dead, have turned the Superdome into a catacomb.

The novel opens with Fen's failure. Her chief is killed while giving birth to a young daughter, and most of the PO tribe is killed. Fen saves the child, promising her chief to keep the child safe. Fen and the chief's daughter, which Fen calls Baby Girl, escape, but they are chased through the swamps of Orleans by hunters with dogs, who want their blood for transfusions to slow infections from the still spreading virus. Fen eludes her pursuers and manages to find sanctuary in a church, usually a safe sanctuary, only to find it to be a front for Mama Gentille, a voodoo priestess who sold Fen into slavery when she was a child. Mama Gentille mixes drugs with incense during a meal for those seeking sanctuary in her church, and during a voodoo ceremony, she takes them captive.

Meanwhile, Wells, wearing a disguised hazmat suit and posing as a leper, has crossed the wall into Orleans and begins to look for the Professors, a group of scientists who volunteered to enter the pandemic-stricken city years before in an attempt to help stop the pandemic from spreading. Some were rumored to still be alive. Wells is captured by Mama Gentille's followers as well and is put in the same makeshift cell as Fen. The basic narrative pattern of a thriller consists of a series of chases, searches, near escapes, and dramatic confrontations that lead to a resolution. *Orleans* follows this pattern.

Wells, Fen, and Baby Girl, using feigned leprosy as a ploy, escape from Mama Gentille's and head through Uptown Orleans, following the tracks of the old St. Charles Streetcar line. Along the way, the come across a carnival parade of masked survivors celebrating All Soul's Day in a macabre version of Mardi Gras. In Uptown, they are attacked by AB tribes but manage to find their way to what remains of the Tulane University Library, the onetime home of the Professors. It is empty, but nearby Sacred Heart Academy contains records of their work

with patients. Weaver soon realizes that Well's recent discovery will kill anyone infected with the virus, which would mean the death of all the remaining survivors in Orleans.

Again, Wells, Fen and Baby Girl are discovered and forced to escape, this time into the mud flats that engulfed the houses bordering the Mississippi River. While they make their way along the sunken houses and cars, Wells falls through the mud, losing his samples of vaccine. Fen rescues Weaver, and the three make their way to the home of Mr. Go, one of a series of volunteers who help the trio. Mr. Go is an Army Corps of Engineers' volunteer who came to Orleans to redesign drainage canals and then stayed to continue providing assistance to people whenever he can. Go helps the three to another volunteer who remained, Father John, a missionary priest, who advises Fen and Weaver to get Baby Girl out of Orleans before she is either killed or contaminated. Remembering her promise to Baby Girl's mother that she will give her a better life, Fen plans to lead the three to the wall and escape to what is left of the United States. Again they are pursued, but they reach the wall, where Fen draws the attention of the military assigned to guard the wall, allowing Weaver and Baby Girl to escape.

In many ways, *Orleans* is like other popular contemporary young adult dystopias, such as *The Hunger Games* and *Divergent*. Set in a postapocalyptic world destroyed by climate change and disease, a smart and tough young woman struggles against almost insurmountable odds to triumph over the sinister forces of the fallen world. This formula works for young adult readers, as seen in the popularity of *The Hunger Games* and *Divergent* as well as their sequels and adaptations.

Orleans, however, is in some ways a more interesting novel. First, Smith's effective use of dialect and two points of view adds a dimension of complexity to the novel. Second, her character Fen de la Guerre is far earthier than the protagonists of most other young adult dystopias. She is both aware of and willing to exploit sexuality and violence. Finally, Smith's depiction of a future New Orleans, a city becoming a swamp but still retaining a French Market and parades, is both horrific and effective. She describes a city battered by seven hurricanes in fifteen years with a population reduced to under 10,000 by climate change–driven storms and disease. Smith uses Hurricane Katrina and its aftermath as a well-known reference point, and Orleans is a description of New Orleans after having been visited by multiple Katrinas, a real possibility in a time of climate change.

See also: *Drowned World, The; Flood; Forty Signs of Rain; New York 2140; Odds against Tomorrow; Salvage the Bones*

Further Reading

Brinkley, Douglas. *The Great Deluge: Hurricane Katrina, New Orleans, and the Mississippi Gulf Coast*. New York: Harper Books, 2006.

"Orleans." *Kirkus Reviews*. January 7, 2014.

ORYX AND CRAKE

Oryx and Crake (2003) is the first of a trilogy of climate change novels by Canadian author Margaret Atwood. Atwood is an established poet, novelist, literary critic, feminist, and environmentalist. Her works in a variety of genres are well known worldwide. Perhaps her most famous work is *The Handmaid's Tale*, winner of the Arthur C. Clarke Award and later adapted into a feature film and a television series. The other two works in her climate change trilogy are *The Year of the Flood* (2009) and *MaddAddam* (2013). Calling much of her work speculative fiction, a broad genre that includes elements that do not exist in recorded history or observable fact, Atwood employs elements of science fiction, myth, and the fantastic in much of her work. She describes *Oryx and Crake* as speculative fiction and adventure romance. It is also one of the most significant climate change novels written to date, appealing to a broad spectrum of readers.

Margaret Atwood, author of *The MaddAddam Trilogy*, speaks in Toronto, Canada, in 2018. (Shawn Goldberg/Dreamstime.com)

Oryx and Crake is the story of a character named Snowman who has survived an environmental apocalypse that destroyed not only much of the environment but also nearly all of humanity as well. Snowman is living in a tree amid the discarded and rotting wreckage of civilization with a group of innocent humanlike genetically engineered creatures called Crakes, who see Snowman as their teacher. Needing supplies to survive, Snowman leaves the Crakes and returns to the ruins of the RejoovenEsense Corporation compound, where he lived before the disaster. The novel is primarily told through Snowman's flashbacks, which provide the story leading up to the dramatic events that change the world.

The world was in dire straits prior to the opening of the novel. Climate change had so deteriorated the environment that food was scarce, parts of the world uninhabitable, and governments useless. The results are that power resides with major corporations, whose employees are housed in compounds, such as the now destroyed RejoovenEsense compound, to keep the poor and often violent masses out. Snowman's name was Jimmy, and he lived in a HelthWyzer compound, where his father was a genetic engineer. There he meets Glenn, an extraordinarily gifted science student. Cut off from the outside world, they spend most of their time playing video games, including the game *Extinction*, in which Glenn uses the game name "Crake." They also smoke a drug called "skunkweed" and watch videos of executions and child pornography. They both become emotionally attracted to Oryx, a young girl they see in the pornographic videos. This does not bode well for Oryx, as Atwood has stated more than once that women will be the greatest victims of climate change.

Because of the degraded environment, bioengineering is necessary to provide food for the population, and drug use and violent games are encouraged to keep the masses entertained. After graduating from high school at the HelthWyzer compound, Crake studies bioengineering at the prestigious Watson-Crick Institute, and Jimmy studies humanities at the second-rate Martha Graham Academy. Bioengineering has become the key to keeping humanity fed and amused, creating such creatures as Pigoons, pigs with human genes; Wolvogs, a combination wolf and dog; and ChickieNob, a chicken without a brain and all breast meat. Eventually, Crake becomes a chief bioengineer at RejoovenEsense, where he creates Crakers, peaceful and humanlike bioengineered creatures. His purpose for the Crakers is to create models of potential children that parents might choose from when genetically manipulating their future children. Jimmy is also hired by the company to write advertising copy.

Crake is working on another project as well, BlyssPluss, a pill designed to provide sexual enhancement, emotional happiness, and physical well-being.

Unbeknownst to the buyers, however, it was also designed to cause sterilization to combat overpopulation, a major problem in the time of scarce resources. Not unexpectedly, BlyssPluss is a success. Jimmy and Crake then discover Oryx living with the Crakers, and they both begin a relationship with her. Crake hires her and makes her the caretaker and teacher of the Crakers.

Crake has also bioengineered another surprise in BlyssPluss, which has in a short time become the most successful bioengineered product in the world. BlyssPluss has been programmed to release a virus, which soon reaches pandemic proportions and wipes out almost all of the human race. Crake tells Jimmy that the three of them have immunity, but inexplicitly the virus kills. Jimmy responds by killing Crake, becoming, he thinks, the last human on earth.

All this is told through flashbacks as Snowman searches for supplies. During his search, he cuts his foot, which becomes infected. When he returns to the Crakers, he is told that three surviving humans are camping close by. At the end of the novel, he decides to approach them.

Oryx and Crake is an ambitious and extravagant novel. Atwood creates a world different from contemporary reality only in degree. Set in the not-too-distant future, *Oryx and Crake* builds on the present threats of climate change, environmental degradation, rising temperatures, droughts, class division, corporate power, potential disease spread, species extinction, and the inherent dangers in biotechnology. In her speculative dystopia, Atwood exaggerates, but only to a degree, as she did in her other speculative dystopia *The Handmaid's Tale*. In both novels, she suggests that political, social, and environmental disasters await if humanity continues on its present course.

Oryx and Crake was much anticipated and well received. Both reviewers and readers noted that one of the strengths of the novel is its successful creation of an imaginable dystopian future in which technology companies with private campuses for employees control access to resources at the expense of others. Atwood's depiction of the impact of violent gaming and pornography on viewers was also applauded as well as the reliance on technology as an answer to social problems, until the technology fails. The most impressive aspect of the novel is, of course, Atwood's creation of the end of civilization, which occurs as a result of multiple causes—climate change, technology, sexism, classism, and racism—all brought about by human hands and minds.

See also: *Handmaid's Tale, The*; *MaddAddam*; *Orleans*; *Parable of the Sower*; *Soylent Green*; *Windup Girl, The*; *Year of the Flood, The*

Further Reading

Cooke, Nathalie. *Margaret Atwood: A Critical Companion*. Westport, CT: Greenwood Publishing Group, 2004.

Howells, Coral Ann. *The Cambridge Companion to Margaret Atwood*. Cambridge: Cambridge University Press, 2006.

Nischik, Reingard M. *Engendering Genre: The Works of Margaret Atwood*. Ottawa: University of Ottawa Press, 2009.

OVERSTORY, THE

The Overstory (2018) is a Pulitzer Prize–winning novel by Richard Powers, author of such well-known works as *The Gold Bug Variations* (1991), *Galatea 2.2* (1995), *Orfeo* (2014) and *The Echo Maker*, which won the National Book Award for Fiction in 2006. Powers's novel, which is often cited as one of the most important climate change works of fiction written to date, is an ambitious work, containing nine central characters and covering several generations of American life. It is also a novel about the fate of millions of trees.

The Overstory begins with a tale about a family and a chestnut tree. Jørgen Hoel, a Norwegian immigrant, moves from Brooklyn to Iowa for free land before the Civil War and discovers six chestnuts in the pocket of his suit. He plants them. The novel then follows the growth of the chestnut tree and the Hoel family over generations. It also chronicles the relationship between other humans and other trees, each relationship reinforcing the idea that humans and trees need each other in ways humans barely understand.

Climate change is the reality forcing all the action in *The Overstory*. Throughout the novel, which covers the industrial period in the United States (1860 through the present), human interaction negatively impacts the environment. The nine major characters in the novel respond, some more quickly than others, to the growing realization that the trees that are being destroyed and are both essential for humanity and also part of a sentient community that has a far longer attention span than humanity. Through the course of the novel, they cross paths with each other, at times forming bonds and at other times betraying each other.

Nicholas Hoel, an artist and descendant of the immigrant who planted the tree, meets Olivia Vandergriff, a college senior who had a near-death experience and believes that she has been chosen to help save the last of the giant redwoods in the Northwest, which are threatened by logging. Together, they head west to join the anti-logging environmental movement. At the same time, Douglas Pavlicek, a Vietnam War veteran who spent years after the war planting trees for forestry companies, and Mimi Ma, whose father, an engineer who fled China at the outset of the Communist Revolution, see trees being cut in Portland, Oregon, and also become radicalized. Nick and Olivia join a radical nonviolent environmental movement and prepare to sit in a giant redwood to protect it from loggers. They end up spending a year in the tree. On the night before they are forced down, they meet Adam Appich, who is interviewing

environmentalists for his psychology dissertation. Eventually, the five take part in more violent protests against the Northwest logging companies, and in one arson attack, Olivia is accidentally injured and dies. The other four members disperse, vowing to remain silent.

Other characters move through the forest clearing and climate change events that are the constant background to the human activity. Dorothy Cazaly and her husband, Ray Brinkman, a property lawyer who becomes paralyzed, grow to appreciate the nature around their suburban house, which serves as a contrasting microcosm to the deforestation occurring in the Northwest. Neely Mehta, the son of Indian immigrants, is a computer programmer who creates a series of video games called *Mastery*. Mehta bases *Mastery* on his observations about deforestation and colonization, and it becomes a huge success, gaining millions of players. The final major human character is Patricia Westerford, a biologist with a special interest in studying trees and woody plants, who early in her career discovers that trees can communicate with each other. Her work is ridiculed by other biologists and the logging industry and then forgotten. She leaves academia and becomes a forest ranger, only to have her work validated later.

The novel follows the nine characters over half a century as their lives and stories either intertwine or provide a reflection of the major theme of the novel: humanity's greed and complicity in climate change as seen in the deforestation of the United States. The plot is driven by the growing radicalism of Hoel, Ma, Appich, Pavlicek, and Vandergriff and the aftermath of Vandergriff's death. After the death, the other four disengage from radical politics and each other until decades later, when Pavlicek is arrested and turns in Appich to save Ma. Appich and Pavlicek go to prison. Hoel ends up in the Northwest wilderness working on a piece of art that can only be seen from space, and Ma becomes a therapist. None of them regret their actions in attempting so save the redwoods.

The other characters also struggle against climate change, but in less dramatic and radical ways. Brinkman and Cazaly fall in love, marry, and slowly come to the realization that nature, especially the ordinary nature around them, is what gives meaning to their lives. They respond in small ways, turning their suburban home into a wilderness in miniature. Mehta's wildly popular game, *Mastery*, is a cyber-world analogy to the action in the novel. It is, Mehta realizes near the end of the novel, all about greed, and the game ultimately has no purpose because the acquisition of more as an end in itself fails to satisfy. He realizes in the world he has created that the building, acquiring, and hording within a visually stunning cyber world is a parallel to the greed behind capitalism, the destruction of the environment, and human-induced climate change, the very things he created *Mastery* to escape from. Finally, Westerford and her research into the community of trees is the thread that holds the novel together.

Her youthful discovery that trees can communicate and form communities, although they communicate in a much slower manner over a far longer period of time, creates the scientific explanation for the relationship all nine major characters have with trees. This makes the destruction of the trees, by logging, deforestation, increased fire devastation, and other forms of climate change, even more tragic for those who become aware of her findings, and for the readers as well.

Trees are central to *The Overstory*, collectively and individually. Much of the action in the novel takes place in the old-growth redwood forests of California and Oregon, where the radicalized major characters in the novel confront angry loggers and representatives of the logging industry, and the destruction of the American chestnut tree provides a warning of what is to come on a much larger scale because of deforestation and climate change in the first section of the novel. Individual trees are important to the novel as well. The first tree of note in the book is the Hoel chestnut tree, which the original Hoel decides to photograph on the same day of March every year. His descendants continue the tradition for generations, a record of America's last native chestnut tree, which manages to survive for decades after all the others succumb to chestnut blight. The second tree is Mimas, the giant redwood in which Pavlicek and Vandergriff, now calling themselves Maidenhair and Watchman, live for a year and which provides them with all they need to survive. It too dies, cut down by loggers at the end of the year's occupation. A third tree is a Banyan tree in Cambodia that saved Pavlicek's life when he fell from a helicopter during the Vietnam War.

Powers brings in other trees as well: the tree of the knowledge of good and evil that stood in the Garden of Eden; Yggdrasil, the world tree that ties together all of creation in Norse mythology; the Banyan tree under which Krishna preached in the *Bhagavad Gita*; and the Bodhi tree, under which the Buddha received enlightenment. Powers contrasts the sacredness of trees with their contemporary destruction caused by perverse human activity: greed and climate change. The significance of trees can even be seen in the structure of *The Overstory*. Powers labels the four sections of his novel "Roots," "Trunk," "Crown," and "Seeds," providing an organic structure to the novel.

Richard Powers's *The Overstory* is an ambitious book. Powers refers to the beginnings of his narrative as the time when the first single-cell organisms, from which both humanity and trees descended, appeared in the sea, and he suggests that the long evolution of both people and plants are intimately related in fundamental, if barely understood, ways. The tragedy in *The Overstory* is more than humanity's blatant disregard of the environment and the resulting inevitable devastation of climate change. It is the unwillingness on the part of

people to act in their own self-interest and to see that they are part of the natural world and not separate from it.

The Overstory was both a critical and popular success. It was a *New York Times* best seller and won the 2019 Pulitzer Prize for Fiction and the 2020 William Dean Howells Medal, which is given every five years for the most distinguished work of fiction published during that time period. The novel is very much part of the mainstream tradition of American literature in its depiction of the essential interrelatedness of individuals and nature. It can be read as a companion piece to other classic American nature writings, such as Herman Melville's *Moby Dick* (1851), Henry David Thoreau's *Walden* (1854), and Mark Twain's *Huckleberry Finn* (1884).

See also: *Barkskins*; *Clade*; *Friend of the Earth, A*; *History of Bees, The*

Further Reading

Dietrich, William. *The Final Forest: The Battle for the Last Great Trees of the Pacific Northwest*. New York: Simon & Schuster, 1992.

Rich, Nathaniel. "The Novel That Asks 'What Went Wrong with Mankind.'" *The Atlantic*. June 2018.

Speece, Darren Frederick. *Defending Giants: The Redwood Wars and the Transformation of American Environmental Politics*. Seattle and London: University of Washington Press, 2017.

P

PARABLE OF THE SOWER

Parable of the Sower (1993), written by African American science fiction writer Octavia Butler, is a dystopian climate change tale told in the form of the journal entries of Lauren Oya Olamina, a fifteen-year-old Black girl. Set in Los Angeles in the then relatively distant years 2024 through 2027, the novel presents an America in which global warming has created sea level rise, shortages of food and fresh water, and increases of crime and unemployment. Members of the middle class live in walled and gated communities, schools have been privatized, pharmaceutical companies have created smart drugs to enhance mental abilities, and police and fire services are too expensive for most people to afford. Violence and arson are common outside of the walled communities.

Parable of the Sower begins on the night before Lauren Oya Olamina's fifteenth birthday. Although she does not believe in her father's strict patriarchal version of Christianity that permits men to have multiple wives, she is willing to let herself be baptized the following day in a church outside her family's gated community of Robeldo, twenty miles outside of Los Angeles. She has also begun to develop her own religion, which she calls Earthseed, in which God is change, and the purpose of life is to spread humanity into space. She begins keeping journals to record her thoughts about her new faith.

Because of the drought, global warming, and the resulting collapse of economic and social life in the United States, violence has reached into Olamina's community. A three-year-old neighbor, Amy Dunn, the product of incest, burns down the family garage. Later, Amy is killed by someone firing random shots through the community's gate. Because of her mother's drug abuse when she was pregnant, Olamina suffers from hyperempathy, which causes her to experience the feelings of those about her, and when she is forced to kill a rabid dog, she passes out from feeling the animal's pain.

Olamina's younger brother, Keith, leaves Robeldo to experience life outside. He returns later beaten and having had his clothing stolen. His father gives him a BB gun, and he leaves again, this time returning with new clothes and a wad of dollars. Keith moves outside the community, and a year later, he is found dead, his body mutilated, a sign that he was killed by drug dealers. Olamina's father, believing the community no longer has a future, applies for the

family to live in a company-owned town away from Los Angeles. The family is accepted, but before the family can move, Olamina's father disappears and is presumed dead. Olamina preaches at her father's funeral, and several months afterward, someone drives a truck through the community's gate and sets fire to the town. Lauren her boyfriend, Curtis; Zahra Moss, the youngest wife of a dead neighbor; and Harry Curtis escape and head to Highway 101, where they join hundreds fleeing on foot from the collapse of Los Angeles.

An illustration of the biblical "Parable of the Sower," the source for Octavia Butler's novel of the same name. (New York Public Library)

What follows is a long march across an apocalyptic climate-changed landscape, a standard feature of many postapocalyptic dystopian narratives. Olamina and the other survivors of the attack on the community watch for predators who would take their few supplies from both within the fleeing group and from without. Along the way, Olamina begins to explain her new religion to her friends, telling them that "All that You touch / You change. All that you Change? Changes you. . . . God is Change." She also tells them about her hyperempathy. Zahra tells her that where she came from, all the children were born with drug-related abnormalities. As in other contemporary dystopias, disease follows climate change, affecting large segments of the surviving population.

As they walk north on California Highway 101, the survivors see other fires in the distance, signs of more burning and destruction. Along the way, they befriend an interracial family and, later, two young women who had been sold into prostitution by their father. After the group experiences an earthquake, more people join them, including a widowed fifty-nine-year-old Black doctor named Bankole, who will become Olamina's lover. Olamina explains her new religion to all of them and slowly makes converts among the refugees. They eventually reach the San Luis Reservoir, which is not quite empty. There the group rests. Olamina continues to instruct her new converts about her

developing new religion, and she and Bankole teach those of her followers who are illiterate to read and write.

The members of the new faith continue to walk north, leaving Highway 101 for Interstate 5. Bankole tells Olamina that he owns a 300-acre farm in Mendocino, California, and that the group is welcome to stay there. As they continue their journey, they are joined by more people who have suffered during the economic and social collapse, including two women who were forced to work as slaves on a California farm, and later they are joined by more people who have fled slavery. Again the group is attacked, and Olamina is shot. She survives and while recuperating discovers that four of the newest members of the group also have hyperempathy, as they tell her that they felt her pain after she was shot.

When the refugees finally reach Bankole's farm, they discover that the farmhouse has been burned. In addition, they discover the five skulls of Bankole's family members. Realizing that all the survivors have lost family members, Olamina holds a funeral service for the people that the members of the new faith have lost. After the service, they plant an acorn for each lost family member. They decide to build a new church community at the farm and call it Acorn. Finally, Olamina reads "The Parable of the Sower" from the Bible to them, emphasizing the importance of sowing seeds on good ground to her flock.

Parable of the Sower was well received by both readers and critics. It was nominated for the Nebula Award for the Best Novel in Science Fiction in 1995 and was named a 1994 *New York Times* Notable Book of the Year. With the growing awareness of the impact of climate change, however, the novel is more popular and more appreciated now than when it was written. It is often cited as one of the most influential early examples of climate change fiction. Writing in *The Great Derangement: Climate Change and the Unthinkable* (2016), Amitav Ghosh notes that the effects of climate change are potentially so catastrophic that writers who have taken up the subject have often turned to the genres of speculative fiction, science fiction, and fantasy to create narratives of climate change. He points to the work of Octavia Butler and Margaret Atwood as two of the best examples of such work. Writing in the *Los Angeles Review of Books*, Gerry Canavan observes that in *Parable of the Sower*, Butler offers the hope that perhaps solidarity offers some hope that humanity can overcome the destructive elements of human nature that led to climate change and the chaos that followed.

In 1998, Butler published *Parable of the Talents*, the second book in a projected series. *Parable of the Talents* takes place after Olamina's death and consists of parts of her journals as well as the activities of her estranged daughter. It describes how slavery was reintroduced in the United States to keep workers

from abandoning their jobs and includes a presidential candidate who runs on a ticket to "Make America Great Again" and who wishes to establish Christianity as the official religion of the United States and exile believers of all other faiths.

Parable of the Sower is a significant novel for a number of reasons. First, Octavia Butler was one of the few successful African American science fiction authors, and *Parable of the Sower* may be her most influential work. Second, Butler is effective in creating a picture of the human cost of climate change that goes beyond numbers. Her descriptions of the sufferings of Olamina and the others refugees, for example, is both graphic and realistic. Her depictions of the inability or indifference of government on all levels to function in the face of an ongoing climate disaster are insightful. Finally, Butler manages to make believable how a new religion could rise out of the ashes of a society slowly dying because of a ruined environment.

See also: *Bridge 108*; *Gold Fame Citrus*; *Great Derangement, The*; *MaddAddam*; *Ministry for the Future, The*; *Oryx and Crake*; *Year of the Flood, The*

Further Reading

Aguirre, Abby. "Octavia Butler's Prescient Vision of a Zealot 'Elected to Make America Great Again.'" *The New Yorker*. July 26, 2017.
Canavan, Gerry. "'There Is Nothing New / under the Sun, / but There Are New Suns': Recovering Octavia E. Butler's Lost Parables." *Los Angeles Review of Books*. June 9, 2014.

R

ROAD, THE

The Road (2006) is a postapocalyptic novel by American novelist, playwright, and screenwriter Cormac McCarthy. McCarthy is the author of such acclaimed novels as *Blood Meridian* (1985), *All the Pretty Horses* (1992), *The Crossing* (1994), *Cities of the Plain* (1998), and *No Country for Old Men* (2005). *The Road* won the Pulitzer Prize for Fiction in 2007. In addition, *The Road* was made into a successful film, as have several other of his novels, including *No Country for Old Men*, which was nominated for eight Academy Awards and won four.

The Road is an unusual postapocalyptic novel for several reasons. First, the exact cause of the apocalypse is never stated. Most postapocalyptic narratives—Kim Stanley Robinson's *New York 2140*, which focuses on the flooding of New York City, is a good example—describe the impact of a specific disaster. In *The Road*, McCarthy never relates what caused the collapse of civilization; disaster has happened, and the narrative centers on a pair of survivors. Second, McCarthy never names his characters; they are simply "the man" and "the boy." As a result, what the man and the boy experience is more universal. The two of them could be anyone, and they could also be everyone.

The Road is the narrative of a journey to survive in a wasteland full of dangers. Several years after the unnamed apocalyptic event, a father and a son walk south along state roads in the eastern United States. As in many postapocalyptic narratives, cities and towns have been emptied, the landscape is devoid of vegetation, and there are few animals or birds. There are also almost no people. They are cold and hungry, the man coughs up blood as he walks, and they carry all their possessions in backpacks and one shopping cart. They also have a pistol with just two bullets to protect them on their journey through the postapocalyptic wasteland. Along the way, they observe "bad guys," gangs of survivors who resort to cannibalism to survive. They come across one bad guy who attempts to grab the boy. The father kills him, using one of the bullets. The son wonders whether there are any good guys left. His father assures him there are. Soon thereafter, they come upon a plantation house and search it for food. In the basement, they discover human prisoners who are kept as food stock for the bad guys. Horrified but unable to help, they manage to escape as the bad guys return.

Hunger and thirst are constant themes in postapocalyptic fiction, as not only farming but the entire supply chain civilization relies on is destroyed by flood, superstorms, drought, warfare, disease, or other apocalyptic events. Constantly hungry, the father and son find an apple orchard and a well, and they are able to eat and drink for a while before that food runs out. Starving again, the father and son discover an abandoned bomb shelter full of supplies and food. After resting there for several days and restocking their supplies, they head south, and again they run out of food. They come upon an empty house and find cases of food, which they take and then continue their walk to the coast.

Eventually, they do reach the coast, but they discover the sea is covered with ash and is as lifeless as the roads they have walked upon. They do, however, discover a wrecked boat that contains canned food and a flare pistol. Feeling completely isolated, they set off the flare pistol in the vain hope of attracting some of the good guys they had hoped to find. While camping on the beach, the boy gets a fever, and his father nurses him back to health. One day, after exploring along the beach, they discover that their shopping cart and supplies have been stolen. They search for and find the thief. The man threatens the thief with the pistol, takes back their cart and supplies, and, despite the boy's pleas, leaves the thief naked by the side of the road. The boy realizes they have left the thief to die and wonders whether he and his father have become bad guys.

After the man and the boy leave the coast, they turn inland and continue to walk south to find warmer weather. Leaving what they think is an abandoned town, the man is shot in the leg with an arrow. The man kills the shooter with the flare pistol, but his wound becomes infected. As in many postapocalyptic narratives, the absence of medicine can be as deadly as starvation or violence. The man continues to cough up blood and soon realizes he is becoming too ill to walk. Knowing he is going to die, the man plans to shoot the boy, saving him from having to survive in the ruined world at the mercy of cannibals and killers, but he cannot bring himself to do it. Instead, her urges the boy to continue going south and to keep "carrying the fire" and search for good guys.

The boy spends three days with the body of his father and then continues to walk south. He encounters a family, a man, a woman, and a boy and a girl. He decides they are good guys, and he believes them when they invite him to join their family. Together, the new family continues to walk.

In 2009, Dimension Films released a film adaptation of *The Road* directed by John Hillcoat and starring Viggo Mortensen, Kodi Smit-McPhee, and Robert Duvall. The film was a critical success and was nominated for numerous international awards. Film critic Peter Travers of *Rolling Stone* called the film "a haunting portrait of America as no country for old men or young," and Joe Morgenstern of the *Wall Street Journal* wrote that the film contained "powerful acting and persuasive filmmaking."

In *The Road*, Cormac McCarthy employs many of the standard tropes of postapocalyptic narratives. He does so with spare language and realistic descriptions, avoiding the spectacle and drama that make many popular narratives. McCarthy's picture of life after civilization has been destroyed by war, climate change, or disease seems realistic compared to descriptions of apocalyptic disasters such as floods, earthquakes, or volcanic eruptions that often seem to be examples of fantasy or science fiction. His depiction of a dying landscape, empty towns and cities, survivors facing starvation and attacks by others, and a realization that the environment will not return to what was once considered normal are standard elements of climate change fiction.

What makes *The Road* an especially effective example of the genre is that McCarthy focuses almost exclusively on the impact of the apocalypse on just two characters. The man and the boy know that their survival is improbable, yet they walk on through the wilderness, starving and feverish, with grim determination. Writing in "'My Job Is to Take Care of You': Climate Change, Humanity, and Cormac McCarthy's *The Road*," Adeline Johns-Putra writes that McCarthy's novel resonates to contemporary readers who have become aware of the anxieties of planning for the future in a time of climate change.

See also: *Gold Fame Citrus*; *Mad Max* Series, The; *MaddAddam*; *Marrow Thieves*, *The*

Further Reading

Johns-Putra, Adeline. "'My Job Is to Take Care of You': Climate Change, Humanity, and Cormac McCarthy's *The Road*." *Modern Fiction Studies*. September 2016.
Warner, Alan. "The Road to Hell." *The Guardian*. November 4, 2006.

S

SALVAGE THE BONES

Salvage the Bones (2011) is a National Book Award–winning novel by Jesmyn Ward. Set in coastal southern Mississippi in the days leading up to Hurricane Katrina, the novel follows five members of a poor Black family as they prepare for and experience the hurricane that devastated both New Orleans and the Mississippi Gulf Coast.

Hurricane Katrina, a Category 5 storm, struck the Louisiana and Mississippi Gulf Coast on August 29, 2005. It was the costliest tropical storm on record, causing $125 billion in damage and over 1,200 deaths. The rain, winds, and storm surge from Lake Pontchartrain flooded over 80 percent of New Orleans, forcing thousands to flee and other to be housed in temporary shelters such as the Superdome, which became unsafe and had to be evacuated when the power failed. Hurricane Katrina became a symbol for climate change, as sea level rise, monster storms, and flooding have become synonymous with global warming and climate change. Although scientists cannot say that climate change caused Hurricane Katrina, they do agree that climate change conditions create a situation that makes massive hurricanes like Katrina more probable. Nevertheless, Katrina and climate change have become linked in popular imagination.

In *Salvage the Bones*, author Jesmyn Ward clearly links Katrina to climate change. In her novel, the disasters predicted by climatologists are seen as Hurricane Katrina disrupts the lives of one family.

Salvage the Bones is divided into twelve chapters, one for each day before, during, and after Hurricane Katrina hits the Gulf Coast. The novel is narrated by pregnant fifteen-year-old Esch, who is the only girl in her family, which consists of her father, called Daddy in the novel, and her brothers, Randall, Skeetah, and Junior. The novel is as much a story of a girl growing up in a world full of men as it is a story of a catastrophic storm and its impact on one family. Readers see everything in the novel through Esch's eyes and hear everything through her voice, which is a compelling combination of Black teenage slang, rich and detailed observation, and classical allusions.

The novel opens with a birth and tales of violence. Esch describes how all the members of the family are in the shed watching China, Skeetah's pit bull, give birth to a litter of pups. While the family watches and recounts stories of

An aerial view of flooded New Orleans on August 31, 2005, after Hurricane Katrina devestated the area. (Department of Defense)

China's many dog fights, Esch remembers that earlier in the day her father had said a big storm was coming, and he had asked her and her younger brother to pull empty moonshine bottles from under the house to wash and fill. They stacked them by the junked cars and wrecked RV in the yard. One of the pups, a runt, looks sickly.

Preparations for the storm continue for the next several days. Daddy begins to nail plywood to the windows of the house. He tells Esch to find all the eggs the chickens have made because boiled eggs can keep, and he tells her brothers to take stock of the family's food, which is almost all canned, since Daddy did not cook after his wife died while giving birth to Junior. Esch finds canned vegetables, Vienna sausages and Spam, and Ramen noodles. Daddy tells Esch they need more.

At the same time as the storm approaches, normal life goes on. Skeetah cares for China and her puppies, worried that they may not survive. Randall, hoping to be selected for a basketball camp, shoots endless free throws and dribbles on the family's dirt court. Junior watches television. Daddy worries about the storm, continues to patch the house, and boils water for drinking. Esch, sexually active since she was twelve, thinks she might be pregnant. Having read a book on classical mythology and fallen in love with the story of Medea and Jason, she wonders whether she will be left, like Medea, when her boyfriend, Manny, finds out she is pregnant. Throughout the novel, Esch will compare her life to Medea's,

aware that her classical hero has been used and abandoned by Jason. On a trip into town, Esch steals a pregnancy test, and she and Skeetah later break into a neighbor's barn to steal some heartworm medicine for China and her puppies.

Troubles continue for the family. China, still sick from giving birth, kills one of the puppies. Skeetah gets into an argument with the owner of Kilo, the pit bull that impregnated China, and China is forced to fight Kilo, even though she has not recovered from birthing the puppies. She wins. Manny finds out Esch is pregnant, refuses to accept the fact that he is the father, and leaves her. Randall picks a fight with Manny during the basketball camp tryout to support his sister and loses his chance for an invitation to basketball camp. Finally, Daddy, who wants to tear the chicken coop down for more plywood to prepare the house for the approaching Hurricane, has a tractor accident, loses several fingers, and has to be rushed to an emergency room.

As Katrina draws nearer the coast, the family continues its attempts to prepare for what is now being predicted as a monster storm, driven by higher-than-normal temperatures in the Gulf of Mexico. Ward emphasizes the vulnerability of people without resources in an extraordinary climate event by focusing on the minute details of the family's attempts at preparation for the storm. With only a little money, they head to the local store only to find the shelves empty. On the way home, they break into a neighbor's empty house but find no food there either. Upon their return, they find Daddy, who is mixing beer with pain medication, unable to help because of his injured hand. Esch and her brothers finish putting up plywood and bring water bottles inside. Their food supply consists of their few cans of vegetables, canned meat, and dry Ramen noodles. Night falls, and as the hurricane-force winds and squalls from the outer bands of Katrina sweep over the house, the power goes out.

Hurricane Katrina destroys much of New Orleans and the Gulf Coast with flooding, torrential rain, and wind. Esch and her family are battered by all three. In the middle of the night, Katrina's winds, clocked at 178 miles per hour, tear the plywood from the house and knock a tree through the roof and into Daddy's room. Water, backing up from the bayou, nearly floods the house, forcing the family upstairs and then out of the house. The family, holding on to a tree trunk, make their way to their grandparents' abandoned house on a small rise. Along the way, Esch tells Daddy she is pregnant and slips from the tree trunk. Skeetah saves her, but in the chaos, she drops the puppies. China escapes from Skeetah's tether and floats away.

The next day, Katrina has passed, and the family members view the wreckage. Their house is flooded, and a tree lies across and through the roof. Trees have been stripped of their leaves and uprooted. Mud is everywhere. The family has almost no food. Big Henry, a friend of the family, invites them to stay at his house. They accept, all save Skeetah, who remains at the family's house,

waiting for China to return. They next day, the family joins Skeetah to wait for China to return. Daddy tells Esch that he will find her a doctor to ensure her baby's health. Poor and homeless, they remain a family. Still poor but not homeless, they remain a family with almost nothing but hope.

Salvage the Bones was widely praised upon publication, and it achieved a much wider audience after winning the National Book Award in 2011. Critics pointed to Ward's effective use of both realism and metaphor, noting how effortlessly she manages to make Esch's identification with Medea a central part of the narrative, linking her suffering to that of the classic tragic hero. More importantly, *Salvage the Bones* personalizes the devastation caused by Hurricane Katrina. It makes the devastation of a monster storm in a time of climate change, when storms occur more frequently and with greater force, as Daddy point out early in the novel, more personal. National media covering Hurricane Katrina and the flooding of New Orleans were compelled to describe the chaos in large terms, providing grim statistics. Ward, on the other hand, conveys the same destruction and sense of helplessness in a more personal way, letting readers get inside the heads and hearts of characters who were impacted by the first monster storm of the climate change era.

See also: *American War*; *Carbon Diaries 2015, The*; *Drowned World, The*; *Flood*; *New York 2140*; *Odds against Tomorrow*; *Orleans*

Further Reading

Brinkley, Douglas. *The Great Deluge: Hurricane Katrina, New Orleans, and the Mississippi Gulf Coast*. New York: Harper Books, 2006.
Charles, Ron. "Jesmyn Ward's 'Salvage the Bones.'" *Washington Post*. November 8, 2011.
Martin, Michael. "In 'Salvage the Bones,' Family's Story of Survival." NPR. December 5, 2011.

SEA CHANGE

Sea Change (2020), by American science fiction writer Nancy Kress, who is best known for her award-winning novels *Beggars in Spain* (1991) and *After the Fall, before the Fall, and during the Fall* (2012), is a short novel set in the Pacific Northwest soon after climate change has altered the environment. In response, scientists attempting to genetically engineer food inadvertently create a blight that causes the deaths of tens of thousands of children. Other technological advances lead to worldwide food shortage and a ban on genetic engineering. Nevertheless, an underground organization of genetic engineers keeps working on a potential solution.

The novel begins as paralegal Renata Black see a house with Tiffany Teal paint moving down the street in Seattle, Washington. In a world stricken by

climate change, dead zones in the ocean, food shortages, and extreme weather, science has managed advances in computer technology that make small driverless homes and miniature surveillance drones possible. Recognizing the house as one owned by a member of her secret bioengineering cell, Black investigates and finds it empty. Realizing her fellow cell mate may have been picked up by the police or that the house may be a police trap, she begins to worry.

What follows in a classic thriller in which the good guys, in this case Renata Black and the members of Org, the biological engineering underground, run from the police, the federal government, and members of the anti-science public. All are reacting to the Catastrophe, when a genetically modified plant strain escaped from an Indiana farm and contaminated much of the world's wheat, soybean, and corn crops, adding to the food shortage caused by the climate change–induced destruction of much of the oceans that has created dead zones around the globe. Members of the Org, however, believe that a few dedicated people can change this world.

Kress alternates chapters between 2032, the setting of the novel, and the years leading up to it to provide background for Black: educated at Yale, had a turbulent marriage to a successful actor, and works as a paralegal for an attorney specializing in cases for Native American tribes in the Northwest. The background chapters also allow Kress to present the Catastrophe, the bioengineering debacle by a major agribusiness consortium, that disrupted the world's food chain just as global warming caused crop failures. The result was a ban on research into genetic modification. Researchers and biotech scientists were fired from universities and government agencies, and many genetic researchers were arrested as part of a worldwide criminal conspiracy.

The hunt for the so-called bioterrorists and chase make up most of the chapters set in 2032. Only one person in each cell of the Org knows a person in another cell, and once a member of Black's cell is arrested, she is tasked with notifying the next cell that they have been exposed. Cell members try to complete their work or hide their research. Black's cell has been working on genetically modified carrots that can survive in the drought-like conditions of much of the western United States. Black realizes that the government had known that Tiffany Teal paint is the identifier for Org and had used the moving house as a plant, knowing that a cell member would access the house to check on its status. Understanding that her cover has been broken and her associates are in danger, she goes on a run to the Quinault Nation to warn Joe Peck, a Native American cell member, of the breach in security.

Black meets Peck, who turns out to be the regional coordinator of Org. One step ahead of federal agents in helicopters, Peck leads Black to the regional headquarters, where he launches preprogrammed rockets. As he and Black escape to the coast of Washington, he tells her that he has been working on a

genetically modified virus that will attack the algae bloom that had produced a toxin that killed tens of thousands of people years before. He tells her that the members of the Quinault Nation were not generally supporters of bioengineering, but they realized changes had to be made to ensure the safety of their nation and their land.

Black manages to escape to Canada, which has become a refuge for many American exiles in dystopian fiction, perhaps most famously serving as the terminus of the new underground railroad in Margaret Atwood's *The Handmaid's Tale*. From Canada, Black watches as the Org releases an online propaganda attack, using both dramatic images of dying sea life and copies of government reports to indict both agribusiness and the American government for complicity in poisoning the air and soil as well as neglecting to combat climate change. Hunger, the ads argue, should not be a business opportunity.

Sea Change is as much about technology as it is about climate change, but the two subjects are interrelated. Technology, primarily but not solely the use of fossil fuels that ignited the Industrial Revolution, is one of the major causes of climate change. But technology, especially the use of new and developing green technology may be part of the solution as well. Just as interesting is Kress's depiction of the fear of technology and the disbelief in science in the novel. One of the results of the politicization of climate change, as well as the ongoing COVID-19 crisis, has been the questioning of scientific information and the distrust of experts. In her depiction of the wave of fear triggered by the Catastrophe, a bioengineered crisis on top of global warming, Kress captures the uncertainty many Americans have about scientific objectivity.

See also: *Handmaid's Tale, The*; *Water Knife, The*; *Windup Girl, The*

Further Reading

Jones, Jeremy L. C. "To Save Ourselves: An Interview with Nancy Kress." *Clarkesworld* no. 70 (July 2012). https://clarkesworldmagazine.com/kress_interview/
Kress, Nancy. *Sea Change*. San Francisco: Tachyon, 2020.

SHERWOOD NATION

Sherwood Nation (2014), by Benjamin Parzybok, is a dystopian climate change novel set in Portland, Oregon. In the novel, Portland, along with most of the western United States, has become a drought-stricken desert. Climate change has not only increased daily temperatures worldwide but also shifted weather patterns so that the once perpetually green Washington/Oregon coast is now experiencing the same weather as Arizona. As a result, those with the means to leave have fled to Canada or the East Coast. The citizens of Portland who remain are faced with daily power blackouts, failing schools and businesses,

shortages of essentials, and a water ration of one gallon a day per person, which is supplied by the National Guard.

As the novel opens, the mayor of Portland is proposing the city dig a 100-mile canal to the Pacific Ocean, as much to give citizens something to do as to bring saltwater to the city to be desalinated. The city council rejects the plan, calling it a form of indentured servitude. Ordinary citizens, who have to line up behind National Guard water tankers to receive their daily water rations, are convinced there is a black-market on water. The hero of the novel, Renee, a part-time student and out-of-work barista, has become a water activist and plans on taking part in the highjacking of a water truck heading to a wealthy section of town to prove the city's collusion in the black market. Unable to escape with the truck, Renee provides free water for anyone nearby. Her action, caught on tape, makes her a local hero, and she is given the name "Maid Marian," in reference to her Robin Hood–like gesture of stealing from the rich to give to the poor. The mayor is not amused.

To hide from arrest, Renee escapes to the unpoliced neighborhoods in the northeastern part of Portland, where she is recognized and applauded for her actions. With the help of her boyfriend, Zach, who has lost his job in advertising because there is nothing left to advertise in Portland, Renee adopts the persona of Maid Marian and declares the neglected neighborhood the free state of Sherwood. Her impoverished neighbors, feeling abandoned by city government, agree to support her.

What follows is the establishment of a utopian community in the midst of a deteriorating and very thirsty city. Promising to rid Sherwood of corruption, crime, and hopelessness, Maid Marian calls for volunteers to clean the streets, distribute water rations, provide essential medical service, keep the peace, defend the new state's borders, and pay taxes. Surprisingly, it works. Sherwood's residents, including several neighborhood gang members, voluntarily take over city services that Portland's government had failed to deliver. In short order, garbage is collected, clinics are set up, and water is delivered. The National Guard even agrees to provide water to the residents of Sherwood and lets Maid Marian's green-shirted "rangers" deliver it, avoiding having to do it themselves. Local media report on the success of Maid Marian and the nation of Sherwood, and soon adjoining neighborhoods declare independence from Portland and join Sherwood, finding voluntary association a more effective form of government.

Maid Marian faces a political dilemma in Sherwood. As the leader of a government that is attempting to impose order on chaos as well as providing necessities, she is forced to take on dictatorial powers as the first step on the way to establish a people's democracy. The irony does not escape her. Marian, Zach, and Gregor, a local drug dealer and gang leader who has become a supporter

of Marian, issue proclamations while also issuing apologies and explanations that Marian's dictatorship is temporary; as soon as Sherwood is secure, she will step down.

Portland's mayor takes Maid Marian's success and popularity as both political and personal affronts. He orders the Portland Police to arrest Marian, but the police cannot enter Sherwood without causing a battle with the rangers, some of whom are armed. After one confrontation, in which citizens of Sherwood and several police are killed, the Portland Police take back one neighborhood by force. Maid Marian responds by annexing another part of the city of Portland and urges people living in other neighborhoods to join her free state.

Violence continues on the border between Portland and Sherwood. Old rivalries between gang members in Portland and former gang members turned rangers in Sherwood explode in gun battles, and the citizens of Sherwood prepare for an attack by the police forces of Portland in a prophetic scene suggestive of the conflict between police and protestors in American cities after the death of George Floyd. Unexpectedly, however, the National Guard invades Sherwood, as the Guard's commander, General Aachen, decides that both Portland and Sherwood need to be occupied and governed by the military.

The National Guard invades Sherwood with tanks and armored vehicles, sweeping aside the lightly armed rangers as well as the city police. Gregor leads a contingent of rangers to City Hall and captures the mayor, who is wounded in the encounter. The leaders of the Sherwood rebellion are either dead or missing as General Aachen begins to establish military control over the area, but members of his own staff, realizing the futility and illegality of their actions, begin to desert him. In a postscript to the novel, Renee, no longer Maid Marian, writes Zach from Canada that she has survived and is pregnant and waiting for Zach to join her.

Sherwood Nation is a thoughtful novel that explores both the political and personal costs of the chaos predicted when climate change impacts the lives of people in American cities. Parzybok's descriptions of both the breakdown of social services and community life as water becomes scarce, something already underway in parts of the American West, as well as the steps taken by the emerging free state of Sherwood are both detailed and insightful. Early in the novel, readers may get the impression that this might just work. The opposition to a people's democracy established from the ground up, both by the mayor of Portland and the military, is a warning that good ideas alone will not defeat entrenched power, even in the face of climate change disasters.

Parzybok's description of the establishment of Sherwood is also interesting. Maid Marian's Sherwood is, for a time, an example of what might have occurred if the "liberated" areas occupied by protestors in cities during the Black Lives Matter protests had had the opportunity to develop. Parzybok is

aware, however, that even in an endless drought, "utopia" is a Latin word that translates as "nowhere," and the powers that be will do almost anything to remain in power.

See also: *Gold Fame Citrus*; *Memory of Water*; *Parable of the Sower*; *Water Knife, The*

Further Reading

Parzybok, Benjamin. *Sherwood Nation*. Easthampton, MA: Small Beers Press, 2014.
"Sherwood Nation." *Kirkus Reviews*. September 9, 2014. Retrieved January 1, 2022. kirkusreviews.com/book-reviews/benjamin-parzybok/sherwood-nation/

SHIP BREAKER

Ship Breaker (2010) is a young adult dystopian novel by Paolo Bacigalupi set after climate change and global warming have melted the polar ice caps, destroyed most coastal cities, and interrupted world trade. In addition, climate change caused nations around the globe to ban the use of fossil fuels. Bacigalupi has set several of his novels in the post–climate change world, most notably *The Windup Girl* (2009) and *The Water Knife* (2015). *Ship Breaker* is the first in a series of three young adult novels. It was followed by *The Drowned Cities* (2012) and *Tool of War* (2017). *Ship Breaker* was a finalist for the National Book Award for Young Adult Fiction.

Ship Breaker opens along the Gulf Coast of the United States. Ocean rise has dramatically altered the shoreline, and Category 6 hurricanes blow abandoned ships onto the new shoreline, where wrecking crews composed of the poor have organized into tribes and salvage anything of value. Nailer, the protagonist of the story, is a fifteen-year-old boy who works with a light crew, a group employed to strip ships of lightweight, valuable material. They crawl through ductwork and pull wire and other metal for resale. His father, Ricard Lopez, is a drug addict who works as a member of a heavy breaker crew, a group employed to break up large pieces of salvage. As the tribes struggle to make their daily quota of salvage, Nailer falls into an oil pocket of a ship and is injured while escaping after a member of his crew leaves him, hoping to sell the oil herself. For violating the crew's commitment to help one another, the crew member's identifying tattoos are scarred, and she is exiled from the beach.

Shortly after Nailer's escape, a major storm blows out of the Gulf, flooding the scavenger's camp. Nailer saves his father, who has passed out from a drug overdose, as the water rises. The next day, after the storm has passed, Nailer and another crew member, Pima, search the shore for wreckage and discover the wreck of a large and luxurious clipper ship—sails having replaced carbon-based propulsion by international law after the massive sea rise. Nailer and

Pima discover one survivor aboard the wrecked ship, a young woman they call Lucky Girl because she alone survived the wreck. They decide to save her rather than take her jewelry and leave her. On shore, Nailer's father first wants to kill Lucky Girl, as it would be easier to sell the clipper's salvage if she were dead. He then decides to take Lucky Girl and attempt to ransom her to her father, hoping to make more money than he would in a lifetime of salvaging.

Lucky Girl, whose real name is Nita, tells Nailer and Pima that she is indeed the daughter of a wealthy shipping company owner who would pay for her safe return. Not trusting his father to keep Lucky Girl safe, Nailer and Pima hop a train heading north, past the sunken city of New Orleans, to the new Gulf seaport near what was once Baton Rouge. For many writers of climate change narratives, New Orleans has become the most recognizable example of the powers of killer storms and sea rise, and Bacigalupi is no exception. His description of New Orleans as a city underwater with only the tops of decaying buildings showing is both eerie and effective.

When Nailer, Pima, and Lucky Girl arrive at the new port, they get work on the docks loading ships while waiting for one of Lucky Girl's father's ships to arrive in port. They must be careful, however, as some of her father's ship captains have remained loyal while others have gone rogue, willing to smuggle oil to countries that are okay with violating international prohibitions against the use of fossil fuels. Rogue captains would hold Lucky Girl for ransom rather than returning her to her father. Just as the *Dauntless*, one of her father's ships, is identified, Nailer's now well-dressed father arrives and takes Lucky Girl. Nailer correctly assumes that his father has told the sailors of a rogue ship of Lucky Girl's existence. Nailer boards the *Dauntless* and tells the ship's captain that Nita has been taken by his father, and he suspects they are both aboard one of the rogue ships.

What follows is an old-fashioned chase narrative, one of the staples of young adult fiction. The captain of the *Dauntless* takes Nailer aboard and assigns him to a crewman who teaches him how to clean and oil the gears that release the ship's sails. He also teaches him to read. The *Dauntless* spies one of the rouge ships and in classic pirate fiction form chases, boards, and captures it. Unfortunately, a much larger rouge ship has been shadowing the first and begins to stalk the *Dauntless*. Outmanned and outgunned, the *Dauntless* seems doomed, until Nailer tells the captain that the uncharted ruins of a city lie off the beaches where he had been a salvager. With the *Dauntless*'s shallow draft, it would be able to sail over the city, while the pursuer's deeper draft would cause it to wreck on the submerged ruins.

The captain follows Nailer's suggestion, and the plan works perfectly. The *Dauntless* glides over the hidden ruins, and the pursuer founders. The crew of the *Dauntless* then board their pursuer and take over the ship. Nailer discovers

his father holding Lucky Girl captive, and he threatens to kill her. Instead, Nailer manages to kill his father and save the girl. *Ship Breaker* ends, like all good pirate stories, with the heroes safe on shore awaiting further adventures, which come in the next two novels in the series, *The Drowned Cities* and *Tool of War*.

Although written for young adults, *Ship Breaker* is very much part of the post–climate change world created by Bacigalupi in such adult novels as *The Water Knife* and *The Windup Girl*. Sea rise has obliterated cities, fossil fuel use has been replaced by wind and solar power, bioengineered people mix with ordinary humans, and corporate greed impels people to try to make profits on the illegal use of petroleum products. Characters also resort to drug use to escape the hardships of life after climate change. In all his climate change fiction, Bacigalupi creates well-developed postdisaster worlds in which his characters live and act. Although the main narrative of *Ship Breaker* is clearly influenced by such adventure classics as Robert Louis Stevenson's *Treasure Island* (1883) and the film *Captain Blood* (1935), Bacigalupi effectively translates those narratives into a world clearly altered for the worse by climate change.

See also: *Bridge 108*; *Children's Bible, A*; *Orleans*; *Water Knife, The*; *Windup Girl, The*

Further Reading

Ness, Patrick. "*Ship Breaker* by Paolo Bacigalupi." *The Guardian*. August 19, 2011.
Seggel, Heather. "*Ship Breaker*." BookPage. May 2010.

SILENT SPRING

Silent Spring (1962), by American environmentalist Rachel Carson, is the best-selling work that documented the impact of pesticides on the environment. In addition, *Silent Spring* is credited with bringing public attention to the negative impact of human behavior on the environment. Carson's work is often cited as the most significant publication in establishing the credibility of environmentalism and making the case for the ability of humanity to dramatically alter the environment, which is the basis for understanding the causes of climate change.

During World War II, the U.S. military had a degree of success using synthetic pesticides such as DDT (dichloro-diphenyl-trichloroethane) to combat malaria, typhus, and other insect-borne diseases among both military and civilian populations in Europe and Asia. During the 1950s, the federal, state, and local governments began employing aerial spraying of synthetic pesticides mixed with fuel oil on public and private lands to combat invasive insects such as fire ants, mosquitoes, and Japanese beetles. Carson, a well-known and

A statue of Rachel Carson, environmentalist and author of the influential *Silent Spring*. (Rosemarie Mosteller/ Dreamstime.com)

award-winning science writer, whose *The Sea around Us* (1951) won the National Book Award for Nonfiction, became aware of public concern over reports of the death of birds in areas sprayed with insecticides. With the support of the Audubon Society, Carson began a four-year study of the impact of the use of synthetic insecticides on the environment, including research at the National Institute of Health and the National Cancer Institute. Originally published as a series in *The New Yorker*, *Silent Spring* was both applauded as a coherent and well-written defense of the environment and vilified as an attack against science and industry.

Carson opens *Silent Spring* with a chapter entitled "A Fable for Tomorrow" that provides both an introduction and an overview of the book. She describes "a small town in the heart of America where all life seemed to live in harmony with its surroundings." She then describes a blight taking over the town, killing all the animals and plants, and eventually driving the people away as well. She asserts that the disappearance of the birds, the "silencing of the voices of spring," is caused by the use of synthetic pesticides and that her book is an attempt to explain what is already occurring in the United States.

The thesis of *Silent Spring* is relatively simple. Synthetic pesticides, of which DDT was only the first, cause massive unintended damage to the environment for several reasons. First, synthetic pesticides attack more than the target insect. Aerial spraying of DDT to combat mosquito populations in Florida, for example, destroyed other insects, including beneficial ones, when sprayed in coastal waters during the 1950s. Second, while spraying synthetic chemicals may destroy a large number of insects in a targeted population, Japanese beetles in New Jersey, for example, those that survive pass on their resistance to the

pesticide to future generations of beetles. Third, and perhaps one of the most significant assertions of *Silent Spring*, is the unintended impact of synthetic pesticides on the food chain.

Carson was one of the first writers to call attention to the almost complete disappearance of the American bald eagle in the 1950s. Pesticides delivered to combat invasive insects found their way into the fish that ate those insects and finally into the birds of prey, especially the bald eagles, that were feeding on the infected fish. Before the use of DDT was banned in the United States, it is estimated that there were only 500 nesting bald eagles in the continental United States. The impact of the accumulation of synthetic pesticides in plants and animals had not been studied prior to their use in the United States. Finally, Carson documents the increases in human cancer rates that occurred with the increased use of synthetic pesticides. Human beings are, after all, both users of pesticides and members of the food chain.

In *Silent Spring*, Carson describes how synthetic pesticides were being used against a variety of "invasive pests" in the 1950s. Aerial spraying, often over civilian populations, was being used to kill fire ants in the South, Japanese beetles in New England and the mid-Atlantic states, gypsy moths in the eastern United States, and insects that attacked crops and livestock throughout the central and western United States. Carson does not deny that invasive and destructive species of plants, insects, and animals do exist. She does assert, however, that there is a balance in nature and that the use of natural predators is a more effective and less expensive way to control species that spread disease among plants, animals, and humans.

Both Carson and her publisher, Houghton Mifflin, anticipated opposition to the publication of *Silent Spring*. Prior to the book's publication, Carson attended a White House conference on conservation and shared her findings with participants. In addition, upon serialization in *The New Yorker*, the *New York Times* ran a positive review and *Audubon Magazine* published excerpts from *Silent Spring*. Most significantly, the editors of the Book of the Month Club chose *Silent Spring* as a featured selection, guaranteeing best-seller status.

Prior to publication, the chemical industry prepared a response. DuPont, the maker of DDT, and Velsicol Chemical Company threatened lawsuits against Carson and Houghton Mifflin, and the Monsanto Company published 5,000 copies of a parody, called "The Desolate Year," that imagined hunger and plague in a world without pesticides. After the publication of *Silent Spring*, chemical industry spokespersons argued that banning pesticides would result in a "return to the Middle Ages," with vermin overrunning fields and infesting human habitations. Carson was also attacked personally, being called a "fanatic defender of the cult of the balance of nature" and a communist, the most significant attack that could be made in the postwar era.

Despite the coordinated attack on Carson and her arguments, *Silent Spring* was both successful and influential. Academic scientists supported her conclusions, and Carson was invited to testify before President Kennedy's Science Advisory Committee as well as the U.S. Senate. Carson was awarded medals by the Audubon Society and the National Geographic Society, and she was inducted into the American Academy of Arts and Letters. *Silent Spring* has been seen as a major factor in the passage of the Environmental Protection Act in 1970 as well as in bringing environmental issues to the forefront of American public awareness. The book has sold over six million copies since its publication, and it has been translated into over thirty languages.

In addition to providing enormous publicity for and awareness of the developing environmental movement in the United States, the publication of *Silent Spring* provided a model of responses to later environmental issues, such as nuclear power plants, fracking, and climate change. In each case, public awareness of an environmental or sustainability issue was triggered by a disaster and a well-publicized report or publication. In the case of climate change, Al Gore's *An Inconvenient Truth* (2006) created public awareness of the impact of greenhouse gases on the biosphere and the link between the use of fossil fuels and global warming, sea rise, and climate change. The response from the fossil fuel industry was denial of the problem, denial of the correlation between human activity and climate change, attacks on the science used, and finally an argument against the costs of changing from fossil fuels to clean forms of energy.

Silent Spring is one of the most influential environmental books ever written. Its publication has been credited with moving environmentalism from the fringes of scientific discussion to the mainstream of public awareness and political action. In addition, *Silent Spring* provided a model for later environmental writers, especially those writing about climate change. Rachel Carson demonstrated that an audience existed for nonfiction works about science and that an audience could be moved to action when complex scientific issues were presented in an accessible format.

See also: *Field Notes from a Catastrophe*; *Inconvenient Truth, An*; *Six Degrees*; *Sixth Extinction, The*; *Story of More, The*; *This Changes Everything*

Further Reading

Brooks, Paul. *The House of Life: Rachael Carson at Work*. New York: Houghton Mifflin, 1972.

Matthiessen, Peter, ed. *Courage for the Earth: Writers, Scientists, and Activists Celebrate the Life and Writing of Rachael Carson*. New York: Mariner Books, 2007.

Moore, Kathleen Dean, and Lisa H. Siders. *Rachael Carson: Legacy and Challenge*. Albany, NY: SUNY Press, 2008.

SIX DEGREES

Six Degrees: Our Future on a Hotter Planet (2007), by British environmental writer Mark Lynas, is a popular work of climate change nonfiction that was made into a National Geographic series for television in 2017. Unlike other books that examine the impact of climate change through interviews with scientists and on location reports of environmental degradation or the extinction of species, such as Elizabeth Kolbert's Pulitzer Prize–winning *The Sixth Extinction*, *Six Degrees* uses research to present the changes that will occur for each degree of global warming. The results are a frightening read.

In an earlier book about climate change, *High Tide* (2004), Lynas traveled around the world to document the effects of climate change. In *Six Degrees*, he takes a different approach. Keeping his carbon footprint to a minimum, he used the Radcliffe Science Library at Oxford University to read thousands of scientific papers and recorded his findings on spreadsheets. Lynas borrows this structure from Dante's *Inferno*. Like Dante, Lynas leads his readers through the increasingly hotter and far more unpleasant circles of global warming until the earth, at six degrees warmer, becomes a literal hell.

In the beginning of *Six Degrees*, Lynas establishes a baseline for his book. He states that average global temperatures have risen one degree centigrade in the last forty years, and a one-to-six-degree rise is possible over the next century. Global warming and climate change are now taking place today in the course of decades rather than millions of years. Finally, he observes that global warming increases in correlation with the use of fossil fuels—coal, oil, and natural gas—which provide the energy for the Industrial Revolution and make up 98 percent of current energy use. The average world temperature has risen 0.7 degrees centigrade over the past ten years. He then proceeds to introduce his data.

Lynas writes that some of the effects of the one-degree temperature rise are already noticeable. Glaciers, ice caps, and water are among the first things impacted by global warming. Africa will lose one-half of its glacial area, affecting water supply as well as plant and animal diversity, with one degree of global warming. Hurricanes will increase in number and intensity. He notes that in 2004, Hurricane Vince landed in Huelva, Spain, the first hurricane ever recorded in Europe. In 2005, Hurricanes Katrina, Wilma, and Rita killed over 1,000 people, left over one million people homeless, and caused $200 billion in damages. Drought will increase and is already noticeable in parts of Central America and the American Southwest.

At two degrees of global warming, the situation gets worse. Changes will no longer be gradual. Glacial melt rates will double. Greenland's glaciers will begin disappearing; one Greenland glacier has already thinned by 15 percent. When Greenland's glaciers do melt (at 2 percent global warming, this will take

140 years), cities such as Miami, New York, London, Mumbai, Bangkok, and Shanghai will be inundated. The tundra will disappear, releasing large amounts of greenhouse gases, primarily carbon dioxide and methane. Crop production will be cut in Africa and South America, while crop production will increase in the American Midwest and Canada. Water shortages will occur in the Mediterranean region. Monsoons will increase in Bangladesh and India, leading to mass migrations. Polar bears will be threatened with extinction.

At three degrees of global warming, the problems accelerate. The ice caps in the Alps will disappear, causing freshwater shortages throughout Europe. The glaciers in the Himalayas will begin to melt, causing floods, at first, and then droughts in India and China. Eighty percent of Arctic sea ice will melt, and the Amazon rainforest will dry out, causing a cycle of drought, fire, and then more drought. Drought will spread across the western United States and become permanent in subtropical Africa, Australia, and Central America. New York and London will be vulnerable to increasing sea rise. North Africa will become more fertile, and South Africa will experience drought. The temperature in the Gulf of Mexico will rise, causing major hurricanes along the Gulf Coast of the United States and in the Caribbean. A large number of plant species will become extinct. The southern United States will become too hot to successfully farm, while the growing season in Scandinavia will lengthen. Mass migrations will occur as a result of drought and food shortages. This will lead to refugee problems and war. Wildfires become common around the globe.

At four degrees of global warming, the acceleration of catastrophes increases exponentially. The Greenland ice cap continues to melt. The permafrost in Siberia and Alaska melt, releasing massive amounts of methane that will accelerate the global warming process. A fifteen-foot sea rise will occur, causing massive migrations from coastal areas. There will be a worldwide decline in agricultural production: Australia, India, South Africa, the Southwest United States, and Central America will not be able to produce food. Sea level rise becomes irreversible. International competition for basic resources leads to more mass migration and war. Outbreaks of diseases increase.

Lynas writes that at five degrees of global warming, "the planet as we know it becomes unrecognizable." No ice sheets and no rainforests will remain. Sea level rise will eradicate the coasts of all the continents. Droughts and floods increase, causing mass migrations to habitable areas. Russia and Canada will have increased agricultural production, but that will be more than offset by expanding deserts worldwide. Methane will escape from the ocean floor due to changes in deep ocean temperatures. The release of methane will cause tsunamis around the world. Areas available for human habitation will move toward the North and South Poles. Modern civilization will break down, requiring new nondemocratic forms of government. Billions of people will die.

At six degrees of global temperature rise, sea levels will have risen sixty feet. Many cities will be abandoned, and deserts will spread throughout the world. Climate volatility will increase, causing massive hurricanes. Humanity may not survive.

Six Degrees does not end in total dystopian despair. Lynas imagines a response scenario in which humanity creates six "wedges," or steps, that must be taken to keep the climate change that has already begun at a standstill. The six wedges are achievable, but Lynas argues they must be done fully and immediately to stabilize climate change. To stop, not reverse, global warming, humanity must do the following:

1. Increase fuel economies from 30 mpg to 60 mpg.
2. Move to more efficient buildings for business, industry, and housing.
3. Create more efficient power generation.
4. Stop all power generation from coal. Create 700 nuclear power plants.
5. Create two million one-megawatt wind turbines.
6. Create a 700-fold increase in solar power.
7. Undertake a massive reforestation effort worldwide.

Six Degrees: Our Future on a Hotter Planet is not a pleasant read, nor is it intended to be. Lynas does assume the role of a climate change prophet, but his is not a voice crying out in the wilderness but rather a voice methodically laying out scientific data and drawing conclusions from it. In 2007, he argued that time was running out. In 2020, Lynas published a second book on the subject, *Our Final Warning: Six Degrees of Climate Emergency*, and in it, he adopts a more urgent tone, noting that little has been done since the publication of his first book. In fact, Lynas asserts that the grim timelines he suggested in 2007 are out of date. He states that because nations have adopted a business-as-usual policy, "we could see two degrees as soon as the early 2030s, three degrees about mid-century, and four degrees by 2075." Some of Lynas's new findings indicate that at two degrees of global warming, China will see hundreds of millions of people experiencing temperatures they have never encountered before, creating a demand for even more energy. With a three-degree rise, major hurricanes the size of superstorms Katrina and Sandy will strike three times a year. At four degrees global warming, states such as Texas, Missouri, Oklahoma, and Arkansas will have temperatures surpassing those of Death Valley today. Extinction on the earth will be as severe as that at the end of the Cretaceous period, when an estimated 75 percent of all species on earth became extinct. Global warming of five and six degrees will be even worse.

In his second book, Lynas still argues that the six wedges he presented in *Six Degrees: Our Future on a Hotter Planet* will stabilize climate change, but at a higher temperature. He suggests, however, that inertia is a governmental as

well as physical force and that little has been done to date. Governments have either refused to abide by or modified promises made in the Kyoto Protocol and the Paris Agreement. In *Our Final Warning: Six Degrees of Climate Emergency*, Lynas's prophetic voice becomes more intense.

See also: *Field Notes from a Catastrophe*; *Inconvenient Truth, An*; *Sixth Extinction, The*; *Story of More, The*; *This Changes Everything*

Further Reading

Lacey, Josh. "On the Ski Slope to Hell." *The Guardian*. April 14, 2007.
McKibben, Bill. "130 Degrees." *New York Review of Books*. August 20, 2020.

SIXTH EXTINCTION, THE

The Sixth Extinction: An Unnatural History (2014) is a Pulitzer Prize–winning work of nonfiction by Elizabeth Kolbert that argues that the earth is undergoing a mass extinction caused by human activity. Kolbert is a noted environmental writer, whose earlier work, *Field Notes from a Catastrophe: Man, Nature, and Climate Change* (2006), has been called one of the most essential books on climate change. In *The Sixth Extinction*, Kolbert combines research from biology, geology, paleontology, and anthropology to argue that the earth is currently undergoing the sixth mass extinction event in its history and the first one to be caused by humans.

Kolbert's title refers to the paleontological geological evidence that demonstrates there have been five mass extinction events (prior to the one Kolbert argues the earth is now undergoing) in the history of the earth. A *mass extinction* is defined as a time period in which a large percentage of all living species go extinct, and the primary source for information about mass extinctions is the fossil record. The first mass extinction is called the Ordovician–Silurian extinction, and it occurred approximately 440 million years ago, during the Ordovician period of the Paleozoic era, when 85 percent of living species were

The threatened Panamanian golden frog, whose near extinction has been connected to climate change. (Smithsonian Institution)

AUKS EXTINCT AND REMOTE

Like the dodo, the great auk (left) is a creature now extinct. It was once common in the Spitsbergen region. The crested auklet (right) is an equally strange bird, but you would have to visit the far-off Pacific to find one. The photograph shows the male and female of the species.

Drawing of the great auk, driven to extinction in the mid-nineteenth century. (Michelle Bridges/Dreamstime.com)

eliminated. During the Ordovician extinction, an ice age first occurred, followed by a sea level rise that caused a drastic drop in the earth's oxygen level.

The second mass extinction, the Devonian mass extinction, occurred approximately 375 million years ago, during the Devonian period of the Paleozoic era, when plants adapted to life on land, causing loss of oxygen in the sea. In addition, volcanic eruptions and meteor strikes contributed to the loss of 80 percent of species.

The third mass extinction, the Permian mass extinction, during the Permian period of the Paleozoic era, occurred about 250 million years ago, when volcanic activity and meteor strikes increased methane and basalt in the atmosphere, causing rapid climate change and loss of oxygen. It is estimated that 96 percent of all living things died during what paleontologists call the "Great Dying."

The fourth mass extinction, the Triassic–Jurassic extinction, at the end of the Triassic period of the Mesozoic era, occurred about 200 million years ago, when volcanic activity again increased methane and basalt in the atmosphere, leading to oxygen loss and climate change. An estimated 50 percent of living things were killed off.

A child snorkeling in the climate change–challenged Great Barrier Reef, Queensland, Australia. (Rafael Ben Ari/Dreamstime.com)

The fifth mass extinction, the K-T mass extinction at the end of the Cretaceous period of the Mesozoic era, about sixty-five million years ago, is the most famous extinction. It not only wiped out the dinosaurs but also 75 percent of all living things. This extinction was caused by a major asteroid impact that threw debris into the atmosphere, creating major climate change, sometimes called "impact winter." Kolbert notes that some scientists refer to the present as the Anthropocene era, a period of time in which human activity is changing the climate in ways similar to other mass extinctions, and she begins her examination of the evidence with an examination of the Panamanian golden frog.

The Sixth Extinction is not a science textbook; it is a readable narrative in which Kolbert introduces fascinating stories about people and animals to develop a comprehensive yet understandable story of the potential impact of climate change and humanity's place as both cause and victim. The Panamanian golden frog serves as Kolbert's first example. Once abundant in Panama, golden frogs have almost disappeared. Kolbert travels to the El Valle Amphibian Conservation Center in Panama to interview Edgardo Griffiths, a specialist in the study of amphibians, who pointed out that the golden frogs are now extinct in the wild; the few survivors are housed at the conservation center. She learns that amphibians are now the most endangered species on earth, primarily because a fungus for which the frogs have no immunity was introduced into the region by humans. Because fungi, and other organisms, can now travel around the world, animals and plants can be infected by organisms for which they have no

immunity. Interconnectivity, one of the hallmarks of contemporary society, has had the unintended consequence of creating pandemics for both Panamanian golden frogs and humans, as the COVID-19 pandemic clearly proves.

In the second chapter of *The Sixth Extinction*, Kolbert introduces paleontology, the study of life prior to the Holocene epoch, or before approximately 12,000 years ago, with a study of the American mastodon and the nineteenth-century scientists, such as Georges Cuvier and Charles Darwin, who developed the theories of natural selection and mass extinction. Kolbert outlines the scientific debates surrounding the discovery of both mastodon teeth and bones in Kentucky and ichthyosaur fossils in Europe. She describes how fossil evidence as well as the acceptance of Darwin's ideas led to the belief that mass extinction events must have occurred to explain the disappearance of species that were being unearthed and studied.

Kolbert next examines the story of the extinction of the great auk, which existed in the millions when Europeans first settled in Iceland, which was their habitat. She describes how the auks were hunted for their meat for food, their fat for oil, and their feathers for pillow stuffing until they became extinct in 1844. She uses the auk as the primary example of how human exploitation of nature is one cause of mass extinction. She then examines the extinction of ammonites, which disappeared during the K-T mass extinction. She notes that the asteroid did not wipe out this species—or the dinosaurs—but rather the resulting climate change caused by the dust that was sent into the atmosphere, causing the "impact winter."

Kolbert uses the ammonite extinction to lead into her discussion of the Anthropocene, the proposed geological period in which human activity has impacted the environment. Kolbert notes that the term *Anthropocene* was invented by Paul Crutzen, a Dutch chemist who received the Nobel Prize for discovering the effects of ozone-depleting substances. He thought that the geologic term for the period after the last ice age, the Holocene, was inadequate, as the period is more accurately described by a word suggesting human impact on the environment. Crutzen also noted that human activity had transformed between one-third and one-half of the planet, that most of the world's major rivers have been dammed, that fertilizer plants produce more nitrogen than all terrestrial ecosystems, and that humans use over half of the world's water. Kolbert also observes that the negative human impact on the environment is increasing at an alarming rate.

In the following chapters of *The Sixth Extinction*, Kolbert focuses on humanity's impact on the environment during the Anthropocene. She begins by looking at the world's oceans. She notes that since the beginning of the Industrial Revolution, humans have added 365 billion metric tons of carbon to the atmosphere and that deforestation has added another 180 billion tons. As a result,

the concentration of carbon dioxide in the atmosphere is higher than it has been in 800,000 years, and if current trends continue, the amount could double by 2050. The result is not only higher temperatures but also higher ocean acidity, which destroys organisms at the bottom of the ocean food chain. She notes that ocean acidification was the cause in at least two of the previous mass extinctions, and it is a contributing factor in the ongoing one. To illustrate this point, Kolbert describes a journey to join a scientific maritime study on One Tree Island at Australia's Great Barrier Reef. She describes both the rich variety of sea life supported by the reef and the rate at which the reef is calcifying. The end result will be the end of reefs and the sea life they support.

One of the most interesting and unusual sections of *The Sixth Extinction* is Kolbert's description of her visit with Wake Forest University forest ecologist and conservation biologist Miles Silman in Peru, where Silman has seventeen plots of land along a ridge that ranges from high in the Andes to the floor of the Amazon Forest. Each is at a different elevation, and each has a different annual average temperature. Silman has observed the migration of plants. Trees, grasses, and other plants that have an ecological niche at one temperature either die out or migrate, by the spread of seeds through a variety of processes, to a more favorable elevation as temperatures change.

Kolbert notes that because of climate change, global warming is occurring ten times faster than at the end of the last ice age, or the beginning of the Anthropocene. As a result, plants will have to migrate ten times more quickly to survive. In addition, animals and insects migrate as the climate changes. Because of global warming, many plants will not be able to migrate. She observes that British biologist Chris Thomas, of the University of York, estimates that 9–13 percent of the world's species of plants have already been "committed to extinction."

Kolbert continues to examine the effects of humans on the environment by examining patch dynamics, which is how fragmentation of an environment impacts species. Focusing on the deforestation and establishment of farming and ranching in the Amazon basin, she finds that "islands" of habitat, separated from other segments of the same habitat, reduce biodiversity. Traveling in the Amazon with American ornithologist Mario Cohn-Haft, she learns that in areas of the Amazon where deforestation has created series of islands of habitats, the number of species has dropped. Cohn-Haft told her that in one such island, the number of bird species dropped from fifteen to two. In another, the white-plumed antbird, dependent on army ants for food, has disappeared entirely.

Although patch dynamics threatens species, another human phenomenon, globalization, or the new Pangaea, named after the supercontinent that existed during the late Paleozoic and early Mesozoic eras, threatens species as well. As an example, she meets with Al Hicks of the New York State Department of

Environmental Conservation, who was one of the first professionals to note the deaths of millions of American brown bats in 2007. Hicks told her that one of the basic principles of biodiversity is the development of species to respond to threats, including viruses, in a specific environment. With the advent of global travel and global commerce, insects, plants, animals, and viruses can now spread rapidly throughout the world. The appearance of pythons in the Florida Everglades is one well-known example. Although found in bats in Europe and Asia, white-nose syndrome is fatal to bats in North America. Biologists believe it was introduced to the bat population by a caver who carried the virus from either Europe or Asia. In addition to the loss of bats, white-nose syndrome will also have the effect of increasing the insect population, especially that of disease-carrying mosquitoes, thus directly affecting the human population that brought the threat to the United States.

Kolbert provides two other examples of the environmental impact of globalization. The first is the proliferation of starlings across the United States. Fewer than one hundred birds were let loose in Central Park in 1890, and with few natural enemies, they spread rapidly, taking over nesting areas from other birds. More seriously, the second example is the inadvertent introduction of chestnut blight to the United States in 1904, when Japanese chestnut trees were imported into the United States for commercial purposes. The blight, which is not fatal in Japanese chestnut trees, destroyed almost all Native American chestnut trees by 1940.

In the final sections of *The Sixth Extinction*, Kolbert describes two examples of more direct human involvement with extinction. The first begins with a visit to the Cincinnati Zoo, where Kolbert visits Suci, a Sumatran rhino, who is undergoing in vitro fertilization as part of a captive breeding program. Sumatran rhinos are nearly extinct, having been hunted for their tusks and having their habitat encroached by deforestation and other human activity. Kolbert compares the fate of Suci with that of other large species that are now extinct because of human interaction.

The second example is an examination of one of *Homo sapiens'* earliest extinctions, that of their cousins, the Neanderthals. Kolbert begins with a visit to the Neander Valley in Germany, where, in 1856, the first Neanderthal bones were unearthed and where the Neanderthal Museum exists today. She describes the discovery and early speculation about Neanderthals as well as the most recent scientific evidence that reveals Neanderthals lived in what is now Europe for at least 100,000 years, but about 30,000 years ago, they vanished. *Homo sapiens* arrived in Europe about 40,000 years ago. Molecular sequencing has revealed that non-African humans have between 1 percent and 4 percent Neanderthal DNA, suggesting that over 10,000 years, humans bred with Neanderthals and eventually made them extinct.

The Sixth Extinction is an important book for a number of reasons, and both readers and critics have recognized its value. The book's review in the *New York Times* was written by former vice president Al Gore, himself a writer of a significant nonfiction work on climate change, *An Inconvenient Truth*. He notes that *The Sixth Extinction* "is a clear and comprehensive history of the earth's previous mass extinctions—and the species we have lost—and an engaging description of the complex nature of life." Writing in *The Guardian*, Caspar Henderson notes that Kolbert, "a staff writer for the *New Yorker*, offers well-composed snapshots of history, theory, and observations that will fascinate, enlighten, and appall many readers."

Kolbert's examination of the state of the environment at the beginning of the third millennium is bleak. For example, she observes that up to half the species in the world will be gone by 2050 and that humanity has managed to endanger species as efficiently as volcanic eruptions, tectonic plate shifts, and asteroid hits. She observes that humans are the only species that has managed to make the earth potentially uninhabitable. Yet, *The Six Extinction* itself is not bleak. Kolbert's fine writing and her combination of personal narrative with scientific observation make reading a book about extinctions an engaging and enlightening experience. *The Sixth Extinction* is, in the end, a warning as well as a eulogy that people will read.

See also: *Clade*; *Eden*; *Flight Behavior*; *Friend of the Earth, A*; *Inconvenient Truth, An*; *Overstory, The*

Further Reading

Gore, Al. "Without a Trace." *New York Times*. February 10, 2014.

Henderson, Caspar. "'The Sixth Extinction' by Elizabeth Kolbert—Review." *The Guardian*. February 14, 2014.

Kolbert, Elizabeth. *Field Notes from a Catastrophe: Man, Nature, and Climate Change*. New York: Bloomsbury USA, 2006.

SIXTY DAYS AND COUNTING

Sixty Days and Counting (2007), by American writer Kim Stanley Robinson, is the third novel in the *Science in the Capital* trilogy. The other two novels in the series are *Forty Signs of Rain* (2004) and *Fifty Degrees Below* (2005). In 2015, he published a revised one-volume edition of the trilogy called *Green Earth*. Robinson has won the Hugo, Nebula, and World Fantasy Awards for his fiction. In addition, he has been praised as a master of hard science fiction (science fiction that relies on actual science rather than fantasy as a source). Like many of his other works, *Sixty Days and Counting* combines Robinson's interest in politics and the environment.

Set in contemporary Washington, DC, *Sixty Days and Counting* takes place immediately after the events of *Forty Signs of Rain* and *Fifty Degrees Below*. In the previous two novels, climate change–induced superstorms have destroyed a Pacific Island nation, washed away much of the Southern California coast, and flooded Washington, DC. In addition, loss of Arctic and Antarctic ice has caused the cessation of the Gulf Stream, dropping the Northern Hemisphere's temperature to that experienced during the last ice age. The trilogy's main characters—Frank Vanderwal; Anna Quibler; Diana Chang, of the National Science Foundation (NSF); Charlie Quibler, the science adviser to Senator Phil Chase, who has become a candidate for president of the United States; and others, including Buddhist monks and government agents—have managed to establish a scientific "Marshal Plan," restart the Gulf Steam, and avoid a team of rogue secret agents acting on behalf of the fossil fuel industry.

As *Sixty Days and Counting* opens, Phil Chase is elected president and promises that his administration will face up to the challenges of climate change. With the advice of members of the NSF, Chase outlines a dramatic plan to address the crisis, declaring that climate change is a matter of national security. First, Chase's administration nationalizes national power generation and enlists the navy to provide emergency power with the generators on nuclear submarines and the air force and NASA to create energy using space-based solar collectors. In addition, his program mandates the use of biofuels and carbon capturing to reduce greenhouse gas emissions. The government takeover of the energy production in the United States is vigorously opposed by the fossil fuel industry.

Because of the disruptions in energy production, distribution, and use, all the characters are forced to alter the ways in which they live. Sharing and communal living, inspired by the refugee Buddhists, are adopted by some, and Vanderwal attempts to drop off the grid, except when he is working for the NSF, by living with the Vietnam veterans who have returned to Rock Creek Park.

In the midst of these crises, another disaster occurs. The West Antarctic Ice Sheet detaches from the main shelf and begins to melt, threatening to transform the global climate beyond what has already occurred. Vanderwal, the Quiblers, and others at the NSF propose an international plan to remove rising sea water and transport it to major desert areas around the world, terraforming the earth to create more productive zones. Eventually, the Chase administration convinces the World Bank and some of the world governments to back the plan, but China holds out until massive drought begin to dry up the Yellow and Yangtze Rivers' headwaters, creating a threat of social and political collapse. After negotiations with the West, and granting independence to Tibet, the Chinese agree to the plan.

Such government-backed major transformations in the structure of national and international norms does not occur without opposition. An assassination

attempt is made on President Chase, who survives and commits himself to an even more progressive agenda. He calls for population control, fuel efficiency standards, gun control, national health care, and full employment. He argues for an end to imperialism and a worldwide permaculture: a job, education, health care, and human rights for everyone.

Amid these radical changes, life works out well for most of the characters in the trilogy, many of whom have undergone personal growth in facing the climate crisis. Vanderwal, who has been reading nineteenth-century American philosophers Emerson and Thoreau daily as a form of inspiration, agrees to have brain surgery for an injury that occurred in the first novel. He also marries the former agent he has loved through the series. The Quibler family moves in with the refugee Tibetan monks, who have been influential in negotiations with the Chinese for Tibetan independence. The agents responsible for the plot against the president turn out to be the same agents who have been monitoring Vanderwal throughout the series. They are arrested. President Phil Chase agrees to run for a second term to push for his idea of a world permaculture as the only way for humanity to survive.

A great deal happens in *Sixty Days and Counting*: droughts, floods, assassinations, philosophic speculations, scientific breakthroughs, marriages, and happy endings. Because of science and those who believe in it, humanity just might have a chance to survive. That is a theme in much of Robinson's fiction, and in the *Science in the Capital* trilogy, he embodies it in what he calls Frank's (Vanderwal's) principle, "Saving the world so science can proceed."

The heroes through Robinson's three novels are scientists and those people who believe in science. The villains are science skeptics and science deniers, people who, for whatever motive, refuse to believe that science is rational, objective, and essentially apolitical. Robinson's heroes in the trilogy are also politically progressive, as can be seen by both Vanderwal's observation on human nature and Phil Chase's political proposals that go beyond the simply scientific solutions to climate change and embrace basic redistribution of wealth and power to ensure human survival and happiness. The presence and teachings of the Tibetan refugee monks throughout the trilogy, with their emphasis on compassion and right action, offer both an inspiration to the characters who come into contact with them and a critique of the climate deniers, profiteers, and other self-indulgent and self-satisfied characters who attempt to thwart the work of Chase, Vanderwal, and others.

The three books of the *Science in the Capital* trilogy consist of nearly 1,500 pages of text yet cover only three years in time. For dramatic purposes, Robinson compresses an enormous amount of climatic disaster into a short time frame. He also keeps his list of major characters closely knit and consistent throughout the series, allowing the major characters to grow in relation to the

dramatic events they experience. Although Senator/President Phil Chase is the author's voice for political solutions to the problems facing the contemporary United States, climate scientist Frank Vanderwal is the most essential character. Vanderwal's scientific observations and plans, his sociobiological experiment in living off the grid, and his readings of Emerson and Thoreau make his point of view the intelligent and compassionate one that holds the trilogy together.

See also: *City Where We Once Lived, The*; *Ecotopia*; *Fifty Degrees Below*; *Forty Signs of Rain*; *New York 2140*; *Sherwood Nation*

Further Reading

Beauchamp, Scott. "In 300 Years, Kim Stanley Robinson's Science Fiction May Not Be Fiction." *The Atlantic.* April 1, 2013.
Canavan, Gerry. "Utopia in the Time of Trump." *Los Angeles Review of Books.* March 11, 2017.

SNOWPIERCER

Snowpiercer (2013) is a postapocalyptic climate change film directed by Bong Joon-ho. It was adapted from the 1982 French graphic novel *Le Transperceneige* by Jacques Lob, Benjamin Legrand, and Jean-Marc Rochette. The film stars Chris Evans, Song Kang-ho, Tilda Swinton, Jamie Bell, Octavia Spencer, Ewen Bremner, John Hurt, and Ed Harris. *Snowpiercer* is a South Korean–Czech production with nearly 85 percent of the dialogue in English.

Snowpiercer is based on the premise that climate change, specifically global warming, has impacted the world so severely that a climate engineering attempt to reverse the earth's warming is undertaken in 2014. By seeding the atmosphere to block out some of the sun's rays and let heat escape, scientists hope to reverse global warming, but the attempt fails dramatically, turning the earth into a ball of ice and killing nearly all plant and animal life. The result had not been unforeseen, however, as a rich technocrat named Wilbur had planned for disaster by creating a train that can run on ice and circle the globe once each year. The surviving remnants of humanity board the train, and the inevitable happens; elites move into the first-class cars, and the rest of the survivors are shuttled into steerage in the rear of the train.

Snowpiercer begins eighteen years after the deep freeze, and the class divisions that were introduced as the train filled have been exacerbated by time. In the front of the train, the elite passengers live in comfort, enjoying livestreamed television, a library, an aquarium, and a nightclub. In the rear, the less fortunate shiver in the cold, eating protein bars of questionable origin under the watchful eyes of armed guards. Revolution is inevitable, and car by car revolution is the narrative line that drives the film.

Gilliam (Hurt) is the emotional and spiritual leader of the people in the rear. Once, when the passengers in the rear were forced to resort to cannibalism to survive, he gave his arm to save a child from being eaten. He convinces his son Curtis (Evans) that revolution is necessary for survival of the people at the back of the train. Curtis and his friend Edgar (Bell) free Namgoong Minsoo (Kang-ho), a security expert who designed the train's defense systems, and start the attack through the train after he learns the train's security guards' guns have no ammunition. As the uprising moves through the train, Bong Joon-ho creates a visually stunning series of obstacles for the revolutionaries to overcome as they fight their way forward, car by car. Eventually, as they near the front of the train, they encounter Minister Mason (Swinton), Wilbur's spokesperson and the leader of the train's guards. In the confrontation that follows, Curtis must choose between capturing Mason, which might convince Wilbur to surrender, or saving his friend Edgar. He chooses to capture Mason and sees Edgar die.

As the revolutionaries move to the front of the train, they enter a classroom in which a teacher is extolling Wilbur's virtues to the children of the rich and celebrating the eighteenth yearlong circumnavigation of the frozen earth. There the fighting continues, as Curtis learns that guards have recaptured cars in the train's rear and killed Gilliam. In retaliation, Curtis kills Mason and continues his advance to the front of the train.

The confrontation in the train becomes personal when Curtis confronts Wilbur, demanding to know why Wilbur created a closed ecosystem, knowing what the results would be. Wilbur responds by telling Curtis that he and Gilliam had planned the revolution, hoping to reduce the number of train passengers to a sustainable level. He then orders 74 percent of the train's passengers to be killed and offers Curtis control of the train. Yona, Namgoong's telepathic daughter, who fought with the rebels through the train, enters the car, opens the floorboards, and shows Curtis children who have been taken from the back of the train working the engine as slaves. Yona manages to save Timmy, one of the children. Curtis and Namgoong set off explosives to kill Wilbur but die in the resulting explosion, which sets off an avalanche that derails the train. The film ends as Yona and Timmy emerge from the train wreckage and see a polar bear, suggesting that there has been a thaw and there may be life outside of the train.

Snowpiercer was financially successful internationally as well as domestically, even though it was burdened with a limited release in the United States. In addition, it was adapted as a television series that premiered in 2020. Surprisingly, for an action/disaster film, *Snowpiercer* was well received by critics. Writing in the *New York Times*, A. O. Scott praises the film for relevance and it visually exciting action scenes. Roger Ebert called the film "visually stunning" as well as having a powerful combination of humor and human drama.

Critics also praised Bong Joon-ho's direction, noting that he was both playful and thoughtful in his direction of an action adventure film, providing exciting visual fight scenes amid moments of eerie calm.

Although a successful postapocalyptic adventure film, *Snowpiercer* is more than just entertainment. The science in the film may be fantastic; its premise, that the earth could freeze into a solid ball of ice in a few years, is clearly impossible. However, as a metaphor for climate change's disastrous impact on human life, the world freezing solid is as apt as the world being entirely covered with water, as seen in narratives such as the film *Waterworld*, by Kevin Costner, and the novel *Flood*, by Stephen Baxter. More importantly, *Snowpiercer's* use of the train as a microcosm of society dramatizes just how damaging class divisions can be in a climate crisis. The long and brutal choreographed battle inside the sleek train running through a world of ice is an apt metaphor for what will happen if the stark predictions of the impact of climate change in such nonfiction works as Mark Lynas's *Six Degrees* or Elizabeth Kolbert's *Field Notes from a Catastrophe* occur. Because of dramatic climate change, there will be too little food, power, or shelter and too many people struggling for scarce resources. *Snowpiercer* shows one possible result.

See also: *Colony, The*; *Day after Tomorrow, The*; *Field Notes from a Catastrophe*; *Fifty Degrees Below*; *Flood*; *Six Degrees*; *Waterworld*

Further Reading

Ebert, Roger. "*Snowpiercer*." RogerEbert.com. June 27, 2014.
Scott, A. O. "Stuck in Steerage for the Apocalypse." *New York Times*. June 26, 2014.

SOLAR

Solar (2010) is an unusual climate change novel by noted British author Ian McEwan, a fellow of the Royal Society of Literature and winner of the Man Booker Prize, which is awarded to the best original novel written in English and published in Britain. Much climate change fiction is dystopian in nature. The ecological, political, and social disasters associated with ongoing climate change are usually set in narratives in which protagonists struggle in postapocalyptic scenarios of doom and destruction. McEwan instead writes about climate change in a comic mode.

The protagonist of *Solar* is Michael Beard, a Nobel Prize–winning physicist. Beard's early award-winning work was on the photoelectric effect, or the emission of electrons when electromagnetic radiation, such as light, hits a material (the Beard Einstein Conflation), which suggested new ways of harvesting energy from sunlight. Since his discovery in his late twenties, Beard has done little actual physics. Instead, he lives off his moment of fame, sitting

on scientific boards, making speeches, and becoming a spokesperson for the advancement of science. He has also grown weary of his wife, Patrice, whom he believes is having an affair with Tarpin, the family handyman. In addition, he has also grown fond of drinking before noon and eating junk food; as a result, he has grown fat.

As a scientist, Beard is aware of climate change. In fact, he was the chairman of Britain's National Center for Renewable Energy. He became chairman to lend some credibility to the underfunded Center, and he believes in climate change, even if he is put off by the almost medieval doomsayers who keep harping about the end being near in apocalyptic terms. He does believe science can find an answer to the problem, but he hopes that the answer will not interfere with his comfortable life. He is especially bothered by his postdoctoral assistant, Tom Aldous, who is continually exhorting him to work on artificial photosynthesis as a solution to climate change.

To escape Aldous's pleading and his wife's infidelities, Beard agrees to attend a global warming conference in the Arctic. Instead of sitting in a hot tub drinking vodka, as he had imagined, Beard finds himself drunkenly riding a snowmobile and nearly emasculates himself trying to urinate in subzero weather, humiliating himself in front of his peers.

Beard returns to London to find his wife has broken off her affair with the handyman and begun one with Beard's assistant, Tom Aldous. Aldous also continues to badger Beard about artificial photosynthesis, which Aldous believes in the key to developing clean fuel and combating the effects of climate change. While arguing with Beard, Aldous has a panic attack, falls, hits his head, and dies. Beard, terrified that he might be accused of murder, plants evidence to implicate Tarpin, the handyman, who is convicted and sent to prison. Beard feel no remorse, rationalizing that Tarpin was guilty of sleeping with his wife, which, he believes, must surely be a surely a crime.

The next section of the novel takes place five years later. Beard is now divorced and remarried. He also continues to eat and drink heavily, gaining over twenty pounds. He has been removed as chairman of the National Center for Renewable Energy because of comments he made about the scarcity of women in theoretical physics and the possibility of women being innately unable to understand hard science. Ridiculed in the press, Beard, using Aldous's notes and proposals, transforms himself into an alternative energy expert. He spends his time applying for patents and attempting to raise funds for companies he is setting up to produce large quantities of energy from sunlight.

Beard's attempts at salesmanship are initially as productive as his Arctic global warming conference. He shows up late for a major meeting with investors. Slightly hungover and hungry, he grabs a smoked salmon sandwich from a vending machine. While at the podium delivering his pitch on the potential

of solar energy, he begins to feel nauseous and has to pitch his ideas to the audience while attempting not to vomit, again making a spectacle of himself.

Beard tells his new wife, Melissa, that it would be unfair to bring a child into a world facing climate change, and she agrees. However, Melissa, unbeknownst to Beard, has stopped taking her birth control pills. When she informs him that she is pregnant, his first thought is that he will leave, and he imagines himself living a life free of obligations. Upon further consideration, he decides leaving will be too much trouble.

In the next section of the novel, Beard is in New Mexico to open a prototype of a new solar panel based on advanced photosynthesis. The prototype, consisting of thousands of solar panels, could be a major step in moving energy production away from fossil fuels, and Beard is excited. He is also in terrible physical shape. His doctor has told him that unless he changes his diet, stops drinking, and loses at least twenty pounds, he is a prime candidate for a heart attack. Nevertheless, he is sitting in a bar and wondering whether he should attempt to pick up the waitress, but he decides it may be too much effort.

As Beard is planning for the prototype's opening, and thinking about how he will be recognized for his genius a second time—the Nobel Prize award was a long time ago—his past catches up with him. Tarpin, the handyman Beard had set up for murder, has been released from prison, still claiming he is innocent, and is flying to New Mexico to confront Beard. In addition, the new chairman of the National Center for Renewable Energy sends a cease and desist order to Beard, claiming most of Beard's work had been taken from his assistant's work on advanced artificial photosynthesis. The letter claims that the patents as well as the prototypes and any profits made from either belong to Tom Aldous's family and the National Center for Renewable Energy.

Ignoring Tarpin, the Center's new chairman, and the advice from his doctor, Beard wakes up the next morning and goes to the motel restaurant. While he waits, he sips gin from a flask. His food consists of a skinless chicken breast and three minute steaks, all wrapped in bacon, with two twice-baked potatoes with butter and honey. When he sees his wife and daughter, who had flown in from London to see the opening of the prototype, Beard has a massive heart attack and dies.

Solar is a dark comedy, and Michael Beard is not a very sympathetic protagonist. The structure of comedy usually requires a happy ending or a change of heart in the protagonist. The readers of *Solar* may well expect Beard to change his entitled ways or his work on artificial photosynthesis to be a success and save the world from the perils of climate change disasters. Neither is the case.

McEwan is clearly doing something else in *Solar*. The novel is actually a clever indictment of the first world's response to climate change. Like Michael Beard, people in the industrialized world have acted out of entitlement to the

climate change crisis. Most people, aside from some politicians who consider climate change a hoax, having recognized that disaster is on the horizon, have responded by concern if the solution will not interfere too much with progress and profits or a comfortable way of life. The response has been to continue to consume and hope that science will create a miracle and that no hard work or inconvenience will be necessary. As McEwan indicates in his subversive *Solar*, however, consumption and overindulgence most often lead to tragedy, not comedy.

See also: *Friend of the Earth, A*; *How to Avoid a Climate Disaster*; *Odds against Tomorrow*

Further Reading

Cowley, Jason. "*Solar* by Ian McEwan." *The Guardian*. March 13, 2010.
McAlpin, Heller. "'Solar': McEwan's Coldhearted Scientist Melts Down." NPR. April 1, 2010.

SOUTH POLE STATION

South Pole Station (2017), by Ashley Shelby, is an engaging and well-written novel that takes place in 2003–2004. Set at the U.S. scientific station at the South Pole, the novel follows Cooper Gosling, an artist who received a National Science Foundation grant to spend a year at the South Pole, as she interacts with the scientists, technicians, and other artists at the station. The conflict in the novel occurs when a climate change–denying scientist, sponsored by two conservative members of the House of Representatives, arrives, upsetting the lives and work of the scientific community there.

Cooper Gosling is a thirty-year-old artist who was once famous but has not produced anything new for years. Her twin brother recently committed suicide. When she was young, her father read to her every night from Apsley Cherry-Garrard's book *The Worst Journey in the World*, the story of Robert Scott's disastrous exploration of the South Pole in 1912. Scott's expedition is best remembered for its failure to be first to the South Pole—Norwegian explorer Roald Amundsen beat Scott's team by five weeks—as well as for the deaths of all five members during the journey. Despite her reservations about her own ability, and undaunted by her familiarity with *The Worst Journey in the World*, Gosling submits to the application process, which tests applicants' ability to not only withstand subzero temperatures but also extreme isolation. Somewhat surprisingly, she is accepted.

The early sections of the novel document life in the Antarctic at the South Pole Station. Shelby carefully describes the lives of a diverse set of people living isolated from the rest of the world by distance and climate and in close

McMurdo Station, the setting for *South Pole Station*. (Jonathan Lingel/Dreamstime.com)

contact with each other. Despite their differences, all believe in the importance of the mission and its scientific relevancy. People at the South Pole Station can be divided into three groups: "Beakers," "Nailheads," or "Artists." The Beakers are the scientists, climatologists, astrophysicists, and cosmologists conducting experiments at the South Pole. The Nailheads are the construction workers, maintenance staff, and food service workers who keep the station running. And the Artists are the writers, painters, poets, and dancers who received grants to work at the South Pole.

All of Shelby's characters are misfits to a degree. One of the Beakers jokes that one has to be partly insane to apply to work at the South Pole. Not being able to live or work in normal society appears to be a requirement for being offered a position at the Amundsen-Scott South Pole Station. The scientists generally keep to themselves, jealous of each other's equipment and computer time. The two cooks at the station plot against each other, hiding cookbooks and switching menus. Everyone looks down on the artists, who are assigned the worst quarters at the station and are given to planning projects like a performance of an interpretive dance of the penguins.

Cooper Gosling is perhaps the sanest of the mixed lot and manages to befriend artists, scientists, and staff. She is even allowed to drink in the separate bars that each of the groups frequent. Much of the early part of the novel is taken up with the daily lives of the "Polies," as Shelby calls the inhabitants of

the station. The staff prepares for the coming months of darkness, the scientists continue their experiments, the artists think about creating, Gosling begins to paint mittens, and they all drink a great deal. The novel turns serious when Dr. Frank Pavino, a climate change–denying scientist appears, having received a grant to support his theory of intelligent design.

The scientists at the station see Pavino's inclusion as a threat to both their work and belief in scientific inquiry, so they organize a series of lectures on their work. Shelby focuses on two: Sal Brennan's work on the big bang and Frank Pavino's research on the flaws of climate science and the probability of intelligent design, or, as the Beakers call it, creationism. Both approach the boundary between science and belief. Brennan's work involves the origins of the universe, combining string theory and quantum mechanics, and questions whether the big bang was a singularity of part of a repeating chain of creations, and Pavino's involves a reinterpretation of data contained in the polar ice, calling into question global warming and the methodology and motives of climate scientists. The scientists isolate Pavino, arguing that his inclusion means that a real climate scientists lost a grant. They take special delight in pointing out his early work in support of the validity of the Noah story in the Bible. Gosling, however, befriends Pavino and is invited to be his research assistant when he has time out on the polar ice.

Disaster occurs when Pavino is denied the use of an ice drill during his allotted time at a research site away from the station. When he "borrows" one without permission and asks Gosling to help him use it, he badly injures Gosling, cutting off her thumb, and creates a medical emergency for the station. In the inquiry that follows the accident, the scientists and managers of the station are blamed by Pavino's sponsors, two influential Republican congressmen, for sabotaging his experiment, and they threaten to close down the station. They also accuse the scientists of scientific dishonesty by refusing to evaluate Pavino's work in a manner the congressman consider fair.

The congressmen hold up funding, forcing the removal of the staff, scientists, and artists of the Amundsen-Scott station, except for a small group, including Gosling and Brennan, who refuse to leave. In the uproar that follows, other nations' Antarctic stations provide food and fuel for the holdouts. In addition, the scientists remaining at the station provide interviews to international reporters, exposing flaws in Pavino's methods and motives.

It is revealed that Pavino, who had studied as an astrophysicist, had plagiarized parts of his dissertation, and he was unable to find an appropriate academic position of support until he agreed to be an anti–climate change spokesperson for the fossil fuel industry. Pavino was supported by that industry group and members of Congress from oil-producing states. He lectured around the country, creating doubt on climate change and global science and arguing

that climate change and global warming were hoaxes. He received his research grant to work at the South Pole and had expected to be denied support upon his arrival, casting doubt on the fairness of the scientists and administrators working there. His whole project was a scam that was set up by conservative politicians and fossil fuel industry executives to cast doubt on climate change science and global warming.

The novel ends with Pavino and his climate change–denying supporters being exposed and Brennan's data supporting the theory of the big bang singularity. Gosling is invited to reapply for another season at the pole, and her portrait of Brennan with a mitten is selected as an outstanding work of art.

South Pole Station is an entertaining and well-written novel that provides insights into scientific research methods at the South Pole and reveals what daily life is like at the bottom of the world. More importantly, Shelby's novel highlights both the methodology and financing behind many climate change deniers. *Merchants of Doubt: How a Handful of Scientists Obscured the Truth on Issues from Tobacco Smoke to Global Warming* (2010), written by Naomi Oreskes and Erik M. Conway, explores how fossil fuel and tobacco industry groups kept controversies alive by creating scientific doubt that exposed the dangers of product use. The study demonstrated how well-paid scientists worked with conservative think tanks and industry representatives to discredit research that indicated both the dangers of tobacco use and the human impact on climate change. In *South Pole Station*, Ashley Shelby tells much the same story in a far more entertaining but just as damning narrative.

See also: *Friend of the Earth, A*; *Odds against Tomorrow*; *Solar*

Further Reading

Cherry-Garrard, Apsley. *The Worst Journey in the World.* London: Constable and Company; New York: George H. Doran Company, 1922.

Drabelle, Dennis. "In This Heat, You Need a Trip to 'South Pole Station.'" *Washington Post.* July 14, 2017.

SOYLENT GREEN

Soylent Green (1973) is a dystopian science fiction thriller directed by Richard Fleisher and starring Charlton Heston, Edward G. Robinson, Leigh Taylor-Young, and Joseph Cotten. Set in the then distant future date of 2022, *Soylent Green* takes place in New York City after climate change, species extinction, and population growth have created worldwide shortages of food, water, and housing. Decades before climate change is widely recognized as a problem, *Soylent Green* depicts a futuristic world that hardly seemed possible at the time of the film's release but is quite recognizable today.

Based loosely on American science fiction writer Harry Harrison's 1966 novel *Make Room! Make Room!*, *Soylent Green* follows the formula of police procedural. In the film, New York City has over forty million inhabitants, and there is a massive gulf between the extremely rich and the poor. As predicted by some futurologists, the middle class has ceased to exist. Because both real food and real animals have become extinct, Soylent Industries, whose name is derived from "soy" and "lentil," controls over half of the world's food production and provides artificially produced food wafers that are bland and tasteless but do provide protein. At the beginning of the film, Soylent Industries introduces Soylent Green, supposedly made from ocean plankton, as its newest and far more tasty product, but it is expensive and in short supply.

The plot begins with the murder of William R. Simonson (Cotten), one of the board members of Soylent Industries. New York police detective Frank Thorn (Heston) begins an investigation and quickly discovers that Simonson was assassinated. With the help of his friend Sol Roth (Robinson), an older man who remembers the old days of real food and animals and provides Thorn with research for his investigations, Thorn locates a priest Simonson confessed to before his death. The priest will not reveal what he learned in confession, although he implies that Simonson revealed something disturbing. After meeting with Thorn, he is also assassinated. Soon after, Thorn is told by the governor of New York that both deaths are to be called suicides and he is to drop his investigation.

Of course, Thorn does not, and soon the hunter becomes the hunted, which is always a possibility in a thriller. Soon Thorn and Shirl (Taylor-Young), Simonson's former lover who is now helping Thorn, are being tracked by the assassin throughout New York. However, during a food riot, a common occurrence in future New York, where the poor often dig through dumpsters in search of food, the assassin is crushed by a police vehicle attempting to break up the riot.

Meanwhile, Roth has been trying to figure out where the source of protein for Soylent Green is coming from, as he has learned that climate change and ocean acidification have reduced the amount of plankton in the ocean; there is not enough surviving plankton to be the source for the new food product. Tired of living in the world of extinction and climate change and disturbed by what he imagines might be the source, Roth decides to end his life at one of the much-advertised government-run euthanasia centers. There he is treated to a short but spectacular audiovisual film of life as it once was: green forests, wild animals and birds, free-flowing rivers, and spectacular sunsets. As he is dying, Roth tells Thorn he has discovered the source of the protein and begs him to find proof. He then dies.

Following Roth's lead, Thorn hides on the truck moving euthanized bodies from the center. He discovers that they are being taken to a recycling plant,

where they are reprocessed into Soylent Green. Thorn is discovered by Soylent Industries agents and wounded, but he manages to kill his attackers. The film ends with Thorn asking the police chief to begin legal action against Soylent Industries and shouting to people as he is being led to an ambulance, "Soylent Green is people!"

Soylent Green was a modest success upon release. Although the previously released *Planet of the Apes* (1968), also starring Charlton Heston, was a major success, science fiction films were generally not successful with mainstream audiences. The success of *Star Wars* (1977) would change that, making science fiction films popular with a much wider audience. Critics noted that the film stresses action over the depiction of the degradation of the environment and that the events—overpopulation, food shortages, and the potential of a changing climate—were plausible. More interestingly, Penelope Gilliatt of *The New Yorker* found the film brainless, placing her faith in the enlightened self-interest of the American people. She suggests democracy and an uprising of the poor would keep these kinds of disasters from happening.

Contemporary critics have been inclined to disagree with Gilliatt. Writing in 2016, Maria Violet notes that although the film was released over forty years ago, many of the film's environmental and political themes are more applicable now than they were then. She observes that human-induced climate change and overpopulation is bringing about the changes suggested in *Soylent Green*. She also notes, as does Margaret Atwood in discussing her dystopian works, such as *The Handmaid's Tale* and the *MaddAddam* trilogy, that in times of political and economic stress, women and children suffer the most. Other critics have also noted that *Soylent Green* is one of the earliest examples of a mainstream Hollywood film dealing with issues of climate change.

Soylent Green remains a notable film. Science fiction has always been a genre that is comfortable for writers of dystopian narratives. *Utopia*, which mean "nowhere" and was the title of Thomas More's 1516 novel about an impossibly good place, spawned its more exciting and more popular antithesis, dystopian narratives. Impossibly good places are by definition boring; they contain almost no conflict. Dystopias, however, are far more exciting, as they exist within a state of conflict and little character development. Creators of dystopian narratives often set their works in the future, distancing the social, political, and environmental ills they describe and exaggerating them in critiques of their own times and places.

Soylent Green is clearly a climate change film, and it contains many of the major themes that reoccur in much later climate change narratives. Most obviously, disaster has been caused to the environment, resulting in an overheated planet as well as the extinction of entire species of plants and animals. Perhaps the most effective evocation of life before the radical change in the environment

in the film occurs near the end, when Sol Roth is in the euthanasia center and is treated to a short montage of the way things once were, perhaps equating nature before the fall with paradise. The film also dramatically depicts the breakdown of social order and the increasing gap between the wealthy and the masses that many contemporary creators of climate change narratives explore. The film is also prophetic in its depiction of the complicity of government and big business in creating the illusion that the environmental situation is not as dire as it clearly is, something that recent political events suggest is very much part of climate politics.

See also: *Handmaid's Tale, The*; *History of Bees, The*; *MaddAddam*; *Six Degrees*

Further Reading

Ebert, Roger. "*Soylent Green.*" RogerEbert.com. April 27, 1973.

Gilliatt, Penelope. "The Current Cinema." *The New Yorker*. April 28, 1973.

Harrison, Harry. *Make Room! Make Room!* New York: Doubleday, 1966.

Violet, Maria. "*Soylent Green*: Environmental Crisis or Sexism." Marianne de Pierres. January 7, 2006. Retrieved October 8, 2020. http://www.mariannedepierres.com /soylent-green-energy-crisis-overpopulation-and-sexism/

STATE OF FEAR

State of Fear (2004) is a technological thriller by American writer and filmmaker Michael Crichton. Crichton, who received a medical degree from Harvard, often writes thrillers with a scientific basis. Many of his films have been made into successful Hollywood movies. Among his best-known science-based novels are *The Andromeda Strain* (1969), *Jurassic Park* (1990), *The Lost World* (1985), *Prey* (2002), and *State of Fear*. In *State of Fear*, Crichton raises questions about the state of climate science as he presents a narrative in which radical climate activists attempt to create a man-made disaster to blame on global warming.

State of Fear opens with the mysterious death of a climate science researcher outside of Paris followed by an illegal purchase of industrial equipment in Malaysia. Much of the novel is a search to link the two events. The novels protagonist, Peter Evans, is a lawyer for philanthropist George Morton, who has been supporting the Natural Environmental Research Fund (NERF). Evans begins to doubt the NERF when he discovers its director, Nicholas Drake, has misused some of Morton's funds. Evans becomes even more suspicious after two international law enforcement agents, posing as MIT researchers, inform him that and ecoterrorist group the Environmental Liberation Front (ELF) is attempting to manufacture natural disasters to convince the public of the what the protagonists of the novel consider the dangers of global warming. They

also inform Evans that the group may have connections with Drake. Evans learns that ELF members are planning a series of disasters to coincide with a NERF-sponsored climate conference and that they plan to kill as many people as necessary to convince the public of the righteousness of their cause.

Evans and the two agents, John Kenner and Sanjong Thapa, follow the trail of the ELF terrorists as they attempt to stage a series of catastrophes, including breaking off a massive part of the Antarctic ice sheet with explosives and triggering a flash flood with artificial lightning in McKinley State Park, outside of Austin, Texas. As they follow the terrorists around the globe, they manage to thwart the villains, but a number of deaths occur along the way.

Eventually, Evans, Kenner, and Thapa discover that Drake is connected to ELF. At a climate change conference, they meet Professor Norman Hoffman, who doubts the science behind climate change and believes a politico-legal media complex is controlling the distribution of information about climate and creating fake threats, such as global warming. During the conference, Evans, Kenner, and Thapa witness the obvious inaccurate manipulation of scientific data to make global warming appear to be a far more dangerous threat than it is.

The final sections of the novel involve a race to the Solomon Islands, where ELF members are planning to use the industrial equipment they bought at the beginning of the novel to set off a tsunami intended to strike the Pacific coast of California. When Evans and his party arrive on the island of Gareda, they are captured by cannibals but manage to escape, although they fail to stop the tsunami. Fortunately for Californians, the tsunami triggered by the ELF terrorists is too small to do serious damage to the Pacific coast. At the end of the novel, ELF is exposed as a terrorist organization, NERF's manipulation of scientific data is publicized, and the threat of climate change and global warming are seen as exaggerated threats. In addition, philanthropist George Morton establishes a new environmental organization dedicated to unbiased, depoliticized science.

State of Fear generated a good deal of critical comment. In 2006, the American Association of Petroleum Engineers awarded the novel its journalism award, which is an especially unusual award because Crichton's book is a work of fiction, not journalism. Senator Jim Inhofe, who once labeled global warming "the greatest hoax ever perpetrated on the American people," made *State of Fear* required reading for the Senate Committee on Environment and Public Works. On the other hand, Peter Guttridge, writing in *The Guardian*, argued that although Crichton attempts to be unbiased in his opinions, the thrust of the novel questions the validity of climate science. Writing in *Grist*, David Roberts finds the novels science and politics disturbing in their denial of climate science.

In *State of Fear*, Michael Crichton includes an explanatory appendix as well as an extensive bibliography. In both, Crichton argues for the unbiased gathering and use of scientific data without the interference of political filters. However, the response to the novel generally fell along philosophical or political lines. Readers who doubted the validity of climate science in general and global warming in particular had favorable impressions of the book, while those readers who believed climate change to be a threat found the novel's environmental villains disturbing. Crichton's foray into climate science turned out to be more controversial than his recreation of the dinosaurs in *Jurassic Park* or his alien invasion in *The Andromeda Strain*.

See also: *Friend of the Earth, A*; *Great Derangement, The*; *Inconvenient Truth, An*

Further Reading

Barcott, Bruce. "State of Fear—Not So Hot." *New York Times.* January 30, 2005.
Guttridge, Peter. "Well, the Bibliography Sings." *The Guardian.* January 15, 2005.
Roberts, David. "A Review of the Distorted Plot and Politics of Michael Crichton's *State of Fear*." Grist. February 2, 2005.

STORMING THE WALL

Storming the Wall: Climate Change, Migration, and Homeland Security (2017) is an analysis of the impact of climate change on world migration by Todd Miller, author of *Border Patrol Nation* (2014) and *Empire of Borders* (2019). Although most people associate climate change with such catastrophes as ocean rise and strengthened hurricanes, worldwide migration has already been impacted by climate change. In his study, Miller looks at a climate change–caused migration that has impacted both American political decisions and security planning.

Miller begins his book by providing a sense of the scope of the climate migration problem. He cites a United Nations report that estimates over 250 million people will be displaced by climate change by the year 2050. He notes that the International Displacement Monitoring Center reports that 21.5 million people have been displaced each year between 2008 and 2015 because of the impact and threat of climate-related hazards. At present, 244 million people live outside their country of birth, up from 80 million in the 1980s. Even more significantly, a survey indicated that 12 percent of the world's population believe environmental problems will force them to leave their homes within five years.

Miller moves from presenting numbers to examining specific cases of climate migration already underway. He points out that the civil war in Syria that began in 2011 was preceded by a major drought and that refugees from that conflict, along with refugees from droughts in Africa, have created a mass migration problem for European nations. He writes that those nations are

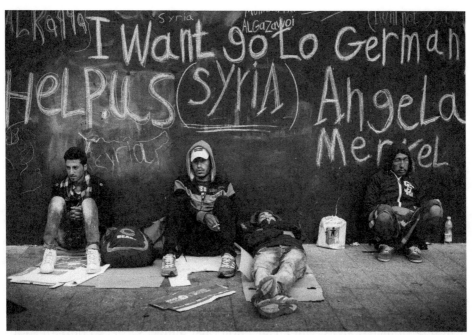

Refugees, most of whom are fleeing violence in Syria, gather at the Keleti train station in Budapest, Hungary, on September 4, 2015. Based on the United Nations High Commissioner for Refugees (UNHCR) data, the number of asylum seekers in Europe reached 350,000 applicants in 2015. (István Csák/Dreamstime.com)

attempting to control their member states' borders by relying on "the three Gs"—guns, guards, and gates—according to Lina Kolesnikova, a homeland security researcher for the *Homeland Security Journal*. He points out that the same climate situation, an extended drought, is driving the migrations of people from Central America to the southern border of the United States, where, under the Trump administration, a border wall was added to guns, guards, and gates in an attempt to stop the migration.

Miller then describes a less observable migration in a chapter called "Threat Forecast: Where Climate Change Meets Science Fiction." He writes about the beginning of "elite panic," a phenomenon in which elites and authorities fear that any disaster will result in chaos. As a result, they plan for disasters, such as climate change–induced disasters, as military operations, often with the primary purpose of securing stability for the privileged, who are the least likely to be impacted.

Miller then analyzes a relatively unreported aspect of climate change–induced migration, internal migrations. To illustrate the impact of climate change on a specific country, Miller points to the American Southwest, where an ongoing drought, along with temperature rise, has severely impacted the region. He observes that because of the mix of heat, drought, and high winds, fires in

the area have been increasing and that in Phoenix, Arizona, temperatures hit 100 degrees about 100 days a year, and scientists expect the temperature to reach 100 degrees 163 days a year by 2100. As a result, millions of people can be expected to flee the area, creating a migration similar to that of the early 1930s, when hundreds of thousands of people from Arkansas, Oklahoma, and Texas were forced to flee from their homes in the Dust Bowl, depicted most graphically in John Steinbeck's *The Grapes of Wrath* (1939) and its Academy Award–winning film adaptation (1940). Miller then points to the mass exodus of climate refugees from New Orleans and southern Louisiana in 2005 as another example of what is to come.

One of the effects of climate change already observed is the increase in the number and severity of major storms, including the superstorms Katrina (2005) and Sandy (2012), and the resulting loss of life and property. Miller describes an even more devastating example from 2013, when a Category six typhoon, Haiyan, slammed into the Philippians with the force of a 260-mile-wide tornado. The results were catastrophic. Miller notes that most of the world's population lives near the ocean and that the impact of future storms, some of which will hit populated areas, will create additional refugees in need of both short- and long-term assistance.

Storming the Wall: Climate Change, Migration, and Homeland Security is an in-depth look at just one result of the chaos expected as climate change impacts how and where people live. The book is a significant addition to the understanding of how changes in the climate will create future chaos. The study is important for two reasons. First, it demonstrates that despite official denials, governmental authorities are aware of the coming impact of climate change and are already working on potential solutions to what is perceived as a migrant problem. Second, Miller's book demonstrates the degree that mass migration will increase and the potentially authoritarian responses governments may undertake. This scenario has been examined in a variety of climate change novels. Among the most significant of those narratives are J. G. Ballard's *The Burning World* (1965), Paolo Bacigalupi's *The Water Knife* (2015), and Claire Vaye Watkins's *Gold Fame Citrus* (2015).

See also: *Bridge 108*; *Burning World, The*; *Gold Fame Citrus*; *Grapes of Wrath, The*; *Water Knife, The*

Further Reading

Buxton, Nick, and Ben Hayes. *The Secure and the Dispossessed: How the Military and Corporations Are Shaping a Climate-Changed World*. London: Pluto Press, 2016.

Parenti, Christian. *Tropic of Chaos: Climate Change and the New Migration*. New York: Nation Books, 2011.

Solnit, Rebecca. *Paradise Built in Hell: The Extraordinary Communities That Arise in Disaster*. London: Penguin Books, 2009.

STORY OF MORE, THE

The Story of More: How We Got to Climate Change and Where to Go from Here (2020), by American geochemist and geobiologist Hope Jahren, is a scientific look at climate change for nonscientific readers. Jahren's book places concerns about the climate change crisis within the larger cultural and historical context of the development of human social development. In an engaging overview, Jahren shows how human inventions have enabled population growth and the development of a worldwide middle class. She also demonstrates how these same developments have led to the current climate crisis and the existential threat to life on the planet.

Jahren begins her examination of the culture of more with the observation that human population has been increasing exponentially for thousands of years. Until today, despite the warnings of Aristotle in *Politics* (350–323 BCE) and Thomas Robert Malthus in *An Essay on the Principle of Population* (1798), scientific innovation has permitted humanity to avoid both the political and the economic perils of overpopulation. In *The Story of More*, Jahren asserts that humanity has only four resources: earth, water, sky, and each other. Because of humanity's desire to have more of everything, humans have threatened all of those resources.

In describing how people in Western nations eat, Jahren focuses on two significant aspects of agriculture: innovation and waste. Innovation in agriculture, primarily the development of genetically modified (GM) plants and pesticides have increased yields of essential crops. The same innovations have also led to dependency on continued use of GMO products. Much of the corn grown in the United States, Jahren argues, is used for high-fructose corn syrup, an artificial sweetener that is both addictive and unhealthy. She also points out the Western reliance on red meat, which requires considerable use of corn for feed, produces both an excess of meat, much of which is thrown away, and greenhouse gases produced by cattle. She argues that a change in Western diets would feed millions in the developing world as well as lessen greenhouse gas production.

Jahren argues that the desire for the accumulation of more also impacts modern energy consumption and transportation, both of which have major impacts on climate change. She notes that the global geography of need has remained unaltered in fifty years. Sixteen percent of the world's population, 1.2 billion people, have no access to electricity, while rich nations mostly consume electrical power from fossil fuels, causing increases in greenhouse gases and

An example of urban crowding, the central theme of *The Story of More*. (Denys Hedrovych/Dreamstime.com)

climate change. She observes that if the average use of electricity were evened out worldwide, every human being on the planet would be able to consume as much electricity as the average citizen of Switzerland in 1960. Jahren points to the American use of the automobile as a major culprit in causing climate change. She writes, for example, that Americans' fascination with large and fast vehicles as well as the growth of the multicar family have driven the development of infrastructure that makes mass transit difficult.

After demonstrating that Western culture has been driven by the desire to accumulate more of just about everything—food, automobiles, clothing, power, and so on—Jahren focuses on the impact of the desire for more on the land, air, and water. As a scientist, Jahren is comfortable with facts, and although she uses emotional appeals when discussing alternatives to accumulative behavior, when she writes about climate change, she provides facts and examples. She notes that since 1856, scientists have been aware of the correlation between the increase in carbon dioxide in the air and a rise in temperature. For over 100 years, scientists have been urging politicians to work on the problem. In 1896, Swedish Nobel Prize–winning chemist and physicist Svante Arrhenius published a paper warning that burning fossil fuels would lead to global warming. Politicians did not take head of his warning.

Jahren writes that science has proven that the earth is warming. She cites studies that show that the atmosphere has warmed 1.5 degrees Fahrenheit in

the past two centuries, and the rate of heating is accelerating. The ten-year period between 2005 and 2016 saw the fastest rise in temperatures since the invention of the thermometer. In addition to noting that the rise in temperatures correlates with the rise in greenhouse gases in the atmosphere, she cites data and provides personal observations of both ice melt and sea level rise, two of the most obvious signs of global warming and climate change. She warns that those trends are likely to continue and that some places, Miami and Bangladesh, for example, are already experiencing problems. She also notes that the desire for more and climate change have combined to impact plant and animal species worldwide, noting that species are becoming extinct at an accelerating rate.

Jahren refuses to be an alarmist, however. She writes that the answer to fear of climate change is not to create more fear but rather to offer people choices. She notes, "Again, I'm just a lab girl, but the idea of scaring the public for the sake of scaring[,] it scares me. People don't make good decisions out of fear." She argues that the point of her book is not to alarm readers but to inform them, because experience has taught her that fear makes people turn away from an issue. Perhaps most importantly, she writes, "It's not time to panic, it's not time to give up—but it is time to get serious."

Near the end of *The Story of More*, Jahren writes that the earth, along with its air, water, plants, and animals, is a finite resource, and if the population of the world keeps growing and everyone wants more goods, more profits, and more income, disaster lies ahead. She suggests her readers consider evaluating their own values and act accordingly. She asks her readers to take four steps: examine their values, gather information, make personal decisions consistent with their values, and make personal investments consistent with their values.

The Story of More is a personal narrative. Jahren neither offers grand political solutions nor hopes for spectacular innovations to solve the problem of climate change. Instead, in an almost conversational tone, she asks her readers to seriously consider how they live and to make appropriate adjustments to preserve the possibility of a good life for all people.

See also: *Field Notes from a Catastrophe*; *How to Avoid a Climate Disaster*; *Inconvenient Truth, An*; *Six Degrees*; *Sixth Extinction, The*

Further Reading

Gall, John. "Facing the Climate Change Crisis, Three Books Offer Some Ambitious Proposals." *New York Times*. April 10, 2020.

Jahren, Hope. *Lab Girl*. New York: Alfred A. Knopf. 2016.

Lida, Gretchen. "*The Story of More: How We Got to Climate Change and Where to Go from Here*." *Washington Independent Review of Books*. April 1, 2020.

THIS CHANGES EVERYTHING

This Changes Everything: Capitalism vs. The Climate (2014), by Canadian author Naomi Klein, is an impassioned analysis of the connections between corporate capitalism and climate change. In her examination of the relationship between the economic and political structures of the United States and the growing threat of climate change, Klein argues that the threat of climate disaster has never received the attention it deserves. She also asserts that the only way to combat the disaster facing the world is to radically alter the structure of American political and corporate life.

In *This Changes Everything*, Klein recognizes that climate change poses an immediate existential threat to humanity, but she is not surprised that people have not risen to the challenge they face. She argues that such dramatic action would directly challenge the reigning economic paradigm of Western culture: deregulated capitalism combined with public austerity. Such action would also challenge one of the basic myths of Western culture, that humanity stands apart from nature and can discover ways to overcome nature's limitations. Actions to combat climate change would also threaten many of the ways

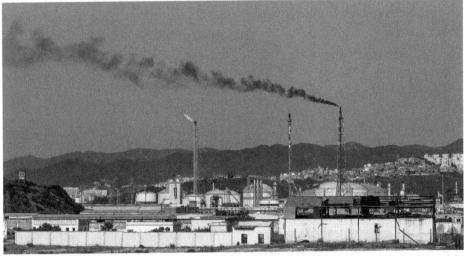

Oil burn-off, a part of the fossil fuel release of carbon dioxide into the atmosphere. (Hamdi Bendali/Dreamstime.com)

An abandoned oil pipeline stands as an example of the reliance on fossil fuels. (Amelia Martin/ Dreamstime.com)

people in Western cultures define themselves, such as shopping, acquisition, and living virtually. Perhaps most significantly, she argues that actively working to combat climate change would require the "extinction of the richest and most powerful industry the world has ever known—the oil and gas industry."

Like other critics of the responses to the challenges of climate change, most notably Elizabeth Kolbert in *Field Notes from a Catastrophe* (2006) and Mark Lynas in *Six Degrees* (2007), Klein points to the way spokespersons for the oil and gas industries first denied the existence of climate change and then downplayed its potential impact. Her major premise is that free market ideology suffocates the potential for climate action. To provide illustrations, she points to numerous examples of scientists who were sponsored by the oil and gas industries who spoke at congressional hearings to dispute the growing scientific consensus on climate change. She also cites the industry-sponsored publications that denounced the growing body of evidence supporting climate science and the need for dramatic action. Klein writes that the "extraction industry," her term for the oil and gas companies and their related industries, have had a major say in the development of Western culture's view of normalcy. She notes the long history of the automobile and petroleum industries' negative impact on the development of mass transit, alternative forms of energy,

and environmental regulations. She points out, for example, that the American Petroleum Institute, the National Association of Manufacturers, and the U.S. Chamber of Commerce all opposed climate legislation put forward during the administration of President Obama.

In a chapter entitled "No Messiahs," Klein writes that the green billionaires will not save us. She examines at some length the green credentials of Richard Branson, the founder of the Virgin Group; Warren Buffet, the chairman and CEO of the investment firm Berkshire Hathaway; and Bill Gates, the founder of Microsoft. All three are major philanthropists as well as successful entrepreneurs, and all have made commitments to address climate change. Klein believes that those commitments, although well-intentioned, are not enough to address the issue. She describes how Branson acknowledges he had a "road to Damascus" moment when he met with Al Gore for a private presentation of Gore's lecture, *An Inconvenient Truth*. Branson promised to establish a $3 billion alternative fuel initiative and to turn the transportation components of his financial empire green. Klein notes that nearly a decade after Branson's pledge, far less has been invested in alternative fuels. Klein also points out that although Warren Buffet has gone on record agreeing that climate change is real, his investment portfolio still contains large stakes in coal-burning utility companies and ExxonMobil. She further observes that Bill Gates also became convinced of the reality of climate change after meeting with Al Gore. In his own book on climate change, *How to Avoid a Climate Disaster* (2020), Gates writes how he came to realize that climate change would accentuate the problems of worldwide poverty, disease, and inequity. Klein applauds Gate's concern, but she writes that he invests most of his climate change enthusiasm in advocating for scientific breakthroughs, a solution that would come without cost to wealthy corporate Americans.

Following her analysis of the lack of climate messiahs, Klein examines in depth the one scientific proposal to alter climate change and stop global warming for which technology already exists, geoengineering. The most frequently mentioned geoengineering technique is known as solar radiation management (SRM), and the most practical method would be to spray sulfate aerosols into the stratosphere, recreating the effect of a large volcanic eruption, which would lower the earth's temperature by reflecting sunlight back into space. Huge orbiting or floating mirrors have also been proposed, but present technology prohibits their immediate use.

Klein notes that the technology for SRM exits; aerosol particles could be deployed from retrofitted airplanes or helium balloons. The problem with SRM is that no one knows the impact of such a technique. One concern that climate scientists have in using SRM to cool the planet is that it could create a different climate disaster, either permanent cooling to some parts of the globe and

overheating of others or uncontrollable cooling, where temperatures continue to drop. Klein argues that although employing a technological fix to global warming might sound attractive, the risks far outweigh the rewards.

In the next chapter of *This Changes Everything*, Klein introduces her readers to the concept of "Blockadia," where regions of the globe are off limits to citizens or the press because the extraction industries are currently destroying the environment. She focuses on the development of the Keystone Pipeline, a continent-crossing construction project designed to move gas and oil from Canadian shale deposits across the United States to ports along the Gulf Coast. Klein argues that the pipeline, and other massive extraction projects, impact communities least able to defend themselves—Native American communities in the case of the Keystone Pipeline—to enable gas and oil companies to make major profits with little risk. In addition, she notes that destroying the environment in one region impacts the entire globe by increasing greenhouse emissions worldwide.

Klein concludes *This Changes Everything* with economic, scientific, and moral arguments that add up to a call for political action. She argues that although industry leaders know that climate crisis is real, the demand for profits, and the public demand for cheap oil, keeps them from responding responsibly. Politicians are indebted to their financial supporters. Specifically, she points to democratically elected socialized governments that nationalized major parts of their industrial structure as the only way out of the climate dilemma. Anything less radical, she argues, simply will not work.

This Changes Everything was named one of the 100 Notable Books of 2014 by the *New York Times*, and *New York Times* reviewer Rob Nixon called the book "the most momentous and contentious environmental book since *Silent Spring*." Writing in *The Guardian*, John Grey notes that one of the strengths of Klein's work is her insistence on the idea that the marginalization of climate change in the political process is a result of the machinations of corporate elites.

This Changes Everything is not without its critics, however. Jonathan Chait, writing in *New York Magazine*, asserts that contrary to Klein's arguments, industries and governments are beginning to address climate change. Conservative responses have been even more strident, decrying Klein's call for socialism and saying her ideas, as well as those proposed in the Green New Deal, violate the principles upon which the country was founded. In 2015, a documentary film based on *This Changes Everything* was released. The film, narrated by Klein, provides interviews with a number of climate change activists.

This Changes Everything: Capitalism vs. The Climate is a significant study of climate change and the dilemmas it poses for several reasons. First, Klein is willing to ask the uncomfortable question of who is making a profit from the current untenable situation, and she calls the extraction industry to task.

Second, Klein is insightful in her observation that reliance on new technologies or miracle fixes to global warming and climate change will only delay the hard decisions about the use of fossil fuels that must be made. Finally, Klein is willing to connect political action, or political inaction, to powerful business interests, and she calls for radical structural change as perhaps the only way to solve the climate problem.

See also: *Field Notes from a Catastrophe*; *How to Avoid a Climate Disaster*; *Inconvenient Truth, An*; *Six Degrees*; *Sixth Extinction, The*; *Story of More, The*

Further Reading

Chait, Jonathan. "Is Naomi Klein Right That We Must Choose between Capitalism and the Climate?" *New York Magazine*. October 23, 2014.

Gray, John. "*This Changes Everything: Capitalism vs. the Climate* Review—Naomi Klein's Powerful and Urgent Polemic." *The Guardian*. September 22, 2014.

Kolbert, Elizabeth. "Can Climate Change Cure Capitalism?" *New York Review*. December 4, 2014.

Nixon, Rob. "Naomi Klein's 'This Changes Everything.'" *New York Times*. November 6, 2014.

W

WALL, THE

The Wall (2019), written by British author John Lanchester, is a dystopian climate change narrative that suggests that the impact of climate change will have effects that exacerbate the problems that impact society today. This is not an unusual thesis for climate change fiction, but by focusing on the idea of national security and drawing on both ancient history and contemporary politics, Lanchester creates a very real and frightening picture of a possible future.

The Wall takes place in an unnamed island nation, like Great Britain, in the near future, one generation removed from the Change. Although the exact nature of the Change is never fully explained, it is clearly climate related and clearly catastrophic. Kavanagh, the narrator of *The Wall*, does provides details of the Change: sea levels have risen, millions of people have died, countries have disappeared, food is scarce, nation-states have been overturned, and there is a worldwide refugee problem. In addition, the young blame the older generation for doing nothing to stop the Change, and most of the young do not want to bring children into the new grim world.

More importantly for the novel, the unnamed island nation is surrounded by a 6,000-mile wall that was designed to keep Others, driven by hunger, disease, and violence, out. Others are anyone from outside the wall. To defend the country, everyone, aside from a few elites, must serve two years as a Defender; their task is to keep Others from breaching the wall. Defenders serve twelve-hour shifts on the wall, staring out into the sea, and are trained to shoot at anyone approaching the wall. After two years, the Defenders who have survived return home to ordinary lives.

The novel opens on Kavanagh's first night on the wall. He has received six weeks of training and has learned how to hold, clean, look after, and fire a weapon. He has also learned that discipline trumps courage and that in a fight, those who do what they are told will win. On the wall, he learns that the world consists of five things: sky, cold, water, concrete, and wind. The worst is the cold, which permeates the lives of the Defenders. They are forced to wear so many layers of clothing that Kavanagh cannot tell whether the Defenders 100 meters on each side of him are men or women. On his first day on the wall, he also learns that time can feel endless, that the sea merges with the sky, and for

every Other that makes it over the wall, a Defender is thrown over the wall and put to sea in a raft, becoming an Other Kavanagh nervously waits and watches.

The inevitable happens, and a group of Others attempt to cross the section of the wall Kavanagh and his squad are defending. The resulting firefight is chaotic, but although wounded, Kavanagh and his fellow Defenders manage to keep the Others out. As a result of their success, the squad members are given a furlough to return home. Kavanagh's trip home to visit his parents provides Lanchester with the opportunity to describe life after the Change away from the wall.

Much is familiar. Returning Defenders, like returning service members, tend to drink too much and spend time with other Defenders. Defenders away from the wall think about plans for after their service. Kavanagh has a vague notion about making enough money to live like an elite, but he has no idea of how to do it, except maybe to go to college. He has no idea what he wants to study. The differences are also real. Parents, guilty of allowing the climate change to occur, avoid talking about the wall and their children's required service. In addition, Helpers are everywhere. Helpers are Others who made it over the wall and accepted life in servitude, in essence slavery, over execution. The existence of the Helpers, as well as the awareness of the dire circumstances that drove them to attempt to cross the wall, makes everyone, the young, the old, and the Helpers themselves, uneasy. After two weeks, Kavanagh is relieved to return to his squad.

Kavanagh's squad is sent for training exercises after their furlough. Training is better than service on the wall, as squads get to assume the roles of both Defender and Others while playing war games with blanks. They all agree that attacking the wall is more fun than defending it. Kavanagh also agrees to become a Breeder with Hifa, one of his squad members. Although uneasy about bringing new life into the world behind the wall, their decision allows the two both intimacy and some degree of privacy. Even when the squad is ordered back to the wall in the far north, life is almost bearable.

Disaster occurs when an attack on the wall happens at night during a power failure. Most of the members of Kavanagh's squad are killed, and in the inquest that follows, it turns out that the squad's captain, a former Others was involved in the planning of the attack. The survivors, including the captain, Hifa, and Kavanagh, are taken over the wall and put out to sea.

Once becoming Others, the exiled squad members struggle for survival. At the captain's urging, they row south, rationing food and water, until they come upon an island. Unfortunately, it is without landing places, as sea rise has left only the tops of steep hills above water. On the lee side of the island, however, they come upon a small community of about a dozen small boats tied together, a floating village. They are welcomed as fellow refugees and survive for several months by fishing, catching rainwater, and harvesting seaweed and scallops.

The island idyll ends, however, when a motor-powered ship approaches. The ship is a raider whose crew is looking to take anything of possible use in the resource-scarce existence outside the wall. The pirate crew kills the captain and several community members before stripping the floating village of food, water, nets, and anything else of value. As the raiders are forcing three young girls onto their ship, one of the exiled Defenders rushes the ship with a concealed hand grenade, killing himself, the raiders, and the people of the island. Alone and with almost no provisions, Kavanagh and Hifa sail south again.

Almost out of supplies and water, Kavanagh and Hifa come upon an abandoned oil rig, and after floating near one of the legs, they discover a ladder has been let down. On the rig, they find a solitary survivor who welcomes them, providing food, water, and shelter. The novel ends with the three Others alone on the abandoned oil rig, grateful to be alive.

The Wall is a spare novel. Much of the time, Lanchester writes about boredom, the boredom of defending the wall and the boredom of rowing a boat at sea. He also writes about the empty spaces of both wall and sea, but the novel is neither boring nor empty, as the bleakness of life after the Change is successfully portrayed in Kavanagh's responses to his environment. Life is grim after climate change.

It is impossible for readers of *The Wall* not to be reminded of other walls built at other times to keep "Others" out, and Lanchester's naming of those outside the wall as "Other" reinforces these associations, both literal and literary. The most obvious reference is to President Donald Trump's "beautiful border wall" planned for the U.S.-Mexican border, designed to secure the border from the "dangerous others" who attempt to cross into the country. In the novel, the fact that those who make it work as enslaved Helpers, not citizens, is also a telling commentary on the U.S. guest worker program. Readers will also recognize the Great Wall of China and Hadrian's Wall along the English-Scottish border, both built to mark the end of the civilized world and to keep barbarians out of it—both ultimately failures. Finally, the cold of *The Wall* is reminiscent of the opening sections of George R. R. Martin's *A Song of Ice and Fire* series of novels and the *Game of Thrones* television series, which included another great wall designed to keep others out.

A number of elements of the environmental disruptions of climate change, such as sea rise, drought, and extreme weather, are relegated to the background of *The Wall*. What Lanchester foregrounds is the loss of resources, the breakdown of worldwide civil society, and the mass migrations that result from the environmental changes. At the center of the novel is, of course, the wall itself, a symbol of what extremes people will go to find food and shelter after climate change as well as what people will do to protect what they have after climate change.

See also: *Blackfish City*; *Bridge 108*; *Inconvenient Truth, An*; *Storming the Wall*

Further Reading

Charles, Ray. "'The Wall' Imagines the Wall of Donald Trump's Dreams." *Washington Post*. March 4, 2019.

Goldsworthy, Adrian. *Hadrian's Wall*. New York: Basic Books and Hachette Book Group, 2018.

WALL-E

WALL-E, a computer-animated science fiction film produced by Pixar Animation Studios, was released by Walt Disney Pictures in 2008. The film, an animated love story set both in outer space and on an environmentally devastated earth in the future, was both a critical and popular success, winning Golden Globe and Hugo Awards and grossing over $500 million. Directed by Andrew Stanton and written by Stanton and Jim Reardon, *WALL-E* employed the sophistication of Pixar Studio's animation with Disney Picture's sentimentality to provide viewers with a romantic morality tale of love on a ruined planet.

WALL-E, despite its dystopian setting, is a romantic comedy. In a romantic

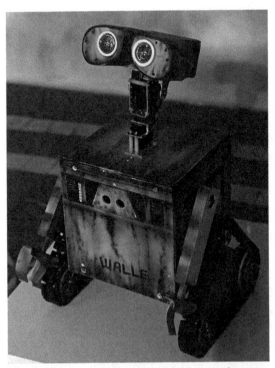

Robot WALL-E toy character. WALL-E is the environmental hero of the film *WALL-E*. (Inna Felker/Dreamstime.com)

comedy, the hero, usually a young person, alone and unappreciated, discovers someone they love. Unsympathetic older people, often those in positions of power, attempt to keep the young lovers apart. At the end of the story, they unite and move from outsiders to valued members of a larger community. Or, as in the traditional Broadway musical, "boy meets girl, boy loses girl, boy gets girl back." In this case, however, the "boy" is WALL-E, a Waste Allocation Load Lifter (Earth-Class), a forgotten garbage removal robot, and the "girl" is EVE, an Extra-Terrestrial Vegetation Evaluator.

The setting for their love affair is no Garden of Eden. WALL-E is the lone surviving

trash-collecting robot on an ecologically barren Earth. Seven centuries before the film opens, humans left the dying planet. It had been destroyed by rampant consumerism and industrialization that resulted in the destruction of a viable atmosphere. Unlike the actual consequences of climate change and the resulting ecological devastation, in which there is little chance for a deus ex machina, humanity is saved by the corporate/political colossus Buy n' Large. The corporation created large star liners that evacuate Earth's population, after causing the problem by encouraging mass consumption and environmental degradation. While humanity evolves in space, WALL-E picks up trash on a dead Earth.

The narrative pace accelerates after EVE is sent to evaluate the possibility of reestablishing plant life on Earth and thus creating an environment that would permit the return of humanity—her "directive." As EVE surveys the garbage dump Earth has become, she comes across WALL-E, and, of course, WALL-E is smitten. The course of true love does not run smoothly, especially in postapocalyptic films, and obstacles quickly come between WALL-E and EVE.

Most of the obstacles occur aboard the *Axiom* starliner after EVE and WALL-E return to the ship. First, the plant WALL-E and EVE have discovered on earth is missing, and as a result, EVE is considered defective and is deactivated, as have been other robots. WALL-E manages to activate her and the other "defective" robots. Soon, a confrontation takes place between the ship's human captain, who supports a return to Earth, and his robotic first mate, who actually runs the ship and is driven by a nonreturn directive instituted by Buy n' Large. WALL-E is crushed during the confrontation, but EVE manages to restore his memory as they return to Earth and with a kiss brings him back to life. The film ends, as do most romantic comedies, with the opposing forces, here of humans and robots, united, as are WALL-E and EVE, working to reestablish life on a once dead planet with a new green economy. They plant crops, the first step in recreating a healthy environment for both plants and humans by restoring the carbon balance to pre–climate change levels.

In addition to its box office success—it was the ninth-highest-grossing film of 2008—*WALL-E* was well received by critics. Many reviewers noted the quality of the film's animation, and the successful creation of the nonhumanoid robotic characters was often mentioned, as was the effective depiction of the ruined Earth. Pixar, established in 1986, has been recognized for its effective use of computer animation with other successful films, such as as *Toy Story* (1995), *Monsters, Inc.* (2001), and *Finding Nemo* (2003). There was also praise for was the film's effective use of limited dialogue and music to drive the film's narrative. Several critics noted the film's similarities to the silent films of Charlie Chaplin, many of which were romantic comedies featuring Chaplin's signature character the "Little Tramp," a poor, loveable young outcast who manages to

find love in the midst of squalor. Also often noted was *WALL-E's* referencing of other science fiction films, particularly *Star Wars* (1977) and *2001: A Space Odyssey* (1968); its unusual social criticism for a film primarily aimed at young audiences; and its use of religious motifs.

WALL-E's addressing climate change was also noticed. Critics pointed out the film's critique of both mass consumption and the resulting destruction of the environment as well as the depiction of humans as hopelessly addicted to consumerism. Not surprisingly, environmentally concerned critics loved the film, while climate change critics complained the film was both inaccurate and too political.

Screenwriters Stanton and Reardon's grounding of their film in Judeo-Christian images and themes can be seen most clearly in their use of the biblical book of Genesis. The biblical story of the creation of Adam, Eve, and the Garden of Eden as well as the story of Noah and the ark serve as sources for the film's storyline. The film uses the creation story in Genesis, in which Adam and Eve are alone in the Garden of Eden, as an ironic parallel to WALL-E and EVE, the only two sentient beings on Earth, alone in a ruined world. Similarly, the destruction of the earth by climate change and pollution is a parallel to the biblical flood. Viewers are also encouraged to see Buy n' Large's star liners as updated versions of Noah's ark.

Popular cultural artifacts often reflect the concerns of a given culture at a particular time, and at times, they are books and films aimed at young readers and viewers. For example, Dr. Seuss's *The Lorax* (1971) and Carl Hiaasen's *Hoot* (2002) both articulated the dangers of human-induced, greed-driven, environmental destruction to young readers. Likewise, *WALL-E* makes a strong argument for environmentalism and against climate change, pollution, and the inevitable negative impacts on the environment of both.

Public awareness of and concern for man-made environmental destruction, whether by pollution, use of pesticides, overpopulation, or global warming, has been part of American popular culture since at least the release of Rachel Carson's best-selling *Silent Spring* in 1962. In addition, the problems of climate change and global warming became part of American popular and political culture at least since the publication of Al Gore's best-selling documentary *An Inconvenient Truth* in 1996. *WALL-E*, combining a dystopian setting with a space adventure and a love story, dramatized the possibility of environmental destruction to a generation of young moviegoers and their parents in a visually stunning and compelling animated story. Sometimes, to use a reference from an earlier Walt Disney production, "A spoonful of sugar helps the medicine go down."

See also: *Inconvenient Truth, An*; *Lorax, The*; *Silent Spring*

Further Reading

Hauser, Tim. *The Art of* WALL-E. San Francisco: Chronicle Books, 2008.
Scott, A. O. "In a World Left Silent, One Heart Beats." *New York Times*. August 27, 2008.

WATER FARMER, THE

The Water Farmer (2021), by Kellee L. Greene, is a dystopian coming-of-age novel set in the future, after climate change has destroyed civilization. The novel takes place in what was once the United States, where more than 100 years before the story begins, "earth was a beautiful place with colorful flowers and lush green forests." Climate change created a massive wasteland as temperatures and seas rose, destroying cities and the world's economies. As the heat continued to rise, the water evaporated, and fires swept throughout the world. After the fires and droughts, the survivors established a city, New Chicago, ruled by a dictator, near one of the few remaining bodies of fresh water. The privileged lived in the city, while the rest of the survivors, the poor and those accused of crimes, were sent to work on farms to provide food for the elite in the city.

The narrator of the novel is Cory Church, a young woman who once lived in the city but now works as a water farmer. She is forced to spend each day carrying buckets of water from a nearby well to pour into irrigation ditches for crimes she does not remember, but she is certain she is guilty or she would not be a water farmer. Cory Church has a bad attitude. She carries more scars from punishment whippings than anyone else on her farm, and the Watchers and Keepers, the overseers and guards, respectively, constantly remind her of her lack of respect.

As *The Water Farmer* begins, Cory Church sees another young woman being punished for splashing a few drops of water from her water bucket. Aware of the risks of interfering, she nevertheless attempts to stop a Watcher from beating the woman. Instead of being punished, she is taken away by another Watcher, named Brody, who takes her to his cabin, offers her water, and lets her rest before returning her to work. Brody continues to demonstrate affection for Church, even after she again attempts to interrupt the punishment of another young water farmer. For this offense, she is severely beaten and thrown into a pit with two other prisoners for five days. When released, she is still unrepentant.

As the novel progresses, Church describes her life as a water farmer as an unrelenting round of work, eat, sleep, and enforced prayer. She and her roommates begin and end the day thanking the Mother, Mother Nature, for the gift of life and the opportunity to work in mandatory supervised prayer sessions.

Two events interrupt the exhausting and mind-numbing work, however. The first is a visit from the Supreme Lord, who has come from the city to visit his farms. During the visit, one of the Supreme Leader's guards gives Church a gift from the Leader, raising unanswered questions about the nature of Church's life before her sentence to the farm. The second is the murder of Jaci, one of her roommates, who had been taken away by several Watchers the day before she was found hanging from a tree. Shaken by the death, Church begins to meet with some of Jaci's friends, who are trying to find a way to escape from the farms and find a way to the city. One friend, called Wolf, fascinates Church, and they eventually begin a relationship.

Church continues to be attracted to both Watcher Brody and Wolf, and although she cannot openly show affection for either, she finds her life less oppressive on the farm, until she happens upon another young woman about to be murdered. Out one night to visit Wolf Church comes across a group of Watchers drinking and chanting to the Great Mother to accept their sacrifice. She watches as the Watchers surround a young girl and cut her throat. As they continue to chant, raindrops begin to fall, and one of the Watchers proclaims that the Great Mother has accepted their sacrifice and answered their prayer. Shaken, Church decides she must escape the farm before she becomes a sacrifice to ensure rain.

A week after the sacrifice, Church and one of her roommates attempt to escape. They are stopped by Watcher Brody, who warns them that other Watchers are approaching. As they continue their escape, Brody turns on the pursuing Watchers and shoots them, urging Church and her friend to keep running.

The Water Farmer ends with that cliff-hanger, and several serious questions remain. Will Cory Church's escape succeed? What will she find out about her past life in the city? Will she be reunited with Brody or Hawk? Will the oppressive regime of the Supreme Leader be overthrown? The answers might be found in upcoming volumes, as clearly *The Water Farmer* is the first in a planned series of dystopian novels.

Young adult dystopian fiction featuring female protagonists has become one of the most popular genres in recent decades. Such well-known and successful series as *The Hunger Games* series by Suzanne Collins and the *Divergent* series by Veronica Roth established the narrative conventions of a young protagonist living in harsh social and economic conditions who must come of age, find true love, and lead her companions to a new and better life by overthrowing an oppressive regime. Clearly Kellee L. Greene is following those conventions in *The Water Farmer*. Although climate change was one of the causes of the societal breakdown that is described in *The Hunger Games* and the following novels in Collins's series, the focus in those novels is clearly on the class divisions between the areas and the authoritarian nature of the games themselves

as repressive spectacle. In *The Water Farmer*, however, the impact of climate change is foregrounded. Drought, heat, and suffering are everywhere, and the water farms exist out of necessity. Another question that remains at the end of the novel is, how will Cory Church find love and redemption in such a barren, post–climate change world?

See also: *Burning World, The*; *Dry*; *Gold Fame Citrus*; *Hunger Games, The*; *Water Knife, The*

Further Reading

Day, Sara K., Miranda A. Green-Barteet, and Amy L. Montz, eds. *Female Rebellion in Young Adult Dystopian Fiction*. Oxfordshire: Routledge Press, 2016.

Mehnert, Antonia. *Climate Change Fictions: Representations of Global Warming in American Literature*. London and New York: Palgrave Macmillan, 2016.

WATER KNIFE, THE

The Water Knife (2015) is a climate change thriller written by Paolo Bacigalupi. By definition, a *thriller* is a narrative with an emphasis on plot that usually involves crime or espionage and often contains scenes of explicit violence. Bacigalupi sets his novel in the American Southwest in the near future. Climate change has transformed much of the western United States into a desert, and people are literally killing each other over water.

Climate change projections indicate different parts of the globe will be impacted in different ways. Glaciers will melt in Greenland; sea levels will rise, inundating coastal cities; and droughts will increase in the Southwest United States, where communities such as Phoenix, Arizona, and Las Vegas, Nevada, are already experiencing water rationing. As the ongoing climate change crisis continues, more stress will be put on scarce water resources, especially the Colorado River, as the demands for water by growing cities and expanding agriculture increase.

The Water Knife takes place primarily in Phoenix, Arizona, a city dying of water loss, as places with older water rights (percentages of water taken from the river by various Western states according to a 1922 treaty), such as California and Colorado, take larger percentages of the decreasing supply. In addition, municipal agencies, such as Las Vegas's Southern Nevada Water Association, use violence and intimidation to take water from New Mexico. Because of the climate change–induced drought, Mexico has been broken into several warring drug cartel states, and Texas and Arizona have turned into deserts, forcing millions to flee. States with water, such as Colorado, Nevada, and California, have built border fences to keep out migrants from other states, and what little is left of federal authority in the drought-ridden West is either indifferent or

looks the other way, bribed by Chinese investors who have invested heavily in the Western states with water.

The narrative in *The Water Knife* follows three major characters whose lives intersect in the rapidly deteriorating Phoenix. The first, Maria Villarosa, is a young refugee from Texas, who crossed the border into New Mexico, along with hundreds of thousands of others, in an exodus reminiscent of fleeing Oklahomans during the Dust Bowl. She survives by stealing water from municipal pumps and then selling it by the cupful to day laborers. The second major character is Lucy Monroe, a Pulitzer Prize–winning writer who stays in Phoenix to record the city's slow and violent death by greed, violence, and thirst. The final character is the water knife, or hired mercenary, of the title, Angel Valesquez, who fled violent gangs in Mexico as a child only to become a gang member, prisoner, and finally private spy and enforcer. He works for Catherine Case, who controls the Southern Nevada Water Association and makes a fortune building, along with wealthy Chinese investors, climate-controlled casinos and condominiums for the very rich who have decided to live in or visit Las Vegas.

The story opens with a brutal show of force. Valesquez leads a military-style helicopter assault on a town in Arizona, destroying a water treatment plant and killing its manager and a number of employees to ensure the continuation of water flow to Las Vegas. Upon his return, he is sent to Phoenix, as his boss has learned that that city may have found a way to remove more water from the Colorado River, thus threatening Las Vegas's supply.

In Phoenix, Villarosa peddles water to patrons at a roadside taco stand while paying protection money to a gang lord. Constantly behind, she dreams of somehow saving enough money to pay for someone to smuggle her into California, even though the Phoenix Police have just discovered a smuggling ring had taken money from hundreds of people trying to cross the border and left them in the desert to die.

Monroe chronicles the victims of climate change, writing stories about smugglers, dead migrants, gang lords, and gang victims. Her path crosses Valesquez's when she is at a makeshift morgue and discovers the dismembered body of James Sanderson, a lawyer involved in researching water rights to the Colorado River for the city of Phoenix, the same lawyer Valesquez is hunting.

Everyone in Phoenix is touched by the climate change–induced water shortage, poverty, and crime. The few rich remaining have retreated to climate-controlled condos. Those who could flee have long left. Gangs control the streets, extorting protection money from those who could not leave and killing for sport. Valesquez and Monroe realize they are both being followed after inquiring about the dead lawyer, he by the California State Police and she by gang members. As they escape from the morgue, Villarosa is caught up in the chase, as she is seen as Valesquez's accomplice.

The novel's plot follows a familiar thriller pattern as the three central characters are chased and attacked, and as they run, they wonder why Sanderson was tortured and killed. Violence explodes throughout Phoenix wherever the hunted run. Eventually, the pent-up anger explodes when an innocent bystander is killed. Migrant Texans, thinking he was assassinated by gangs, form vigilante groups and launch a war against the gangs.

While drought refugees battle hired protectors of the privileged, Valesquez and Monroe learn that Sanderson had discovered that the water rights to Phoenix actually belong to a small Native American tribe. They realize all the players in the water game, Phoenix, the State of California, and the Southern Nevada Water Association, would do anything to get the rights to the ever-dwindling supply provided by the Colorado River. The novel ends with the three of them in possession of a record of the treaty granting water rights, but they are at odds over what to do with it.

Climate change and the resulting droughts, higher temperatures, and loss of snowpack in the Rocky Mountains, as well as the dramatic increase in population in the American Southwest, have already created a water crisis in the American West. Urban and agricultural interests are already arguing in federal courts over the use of the Colorado River's water. In addition, the 1922 compact among the states allocating water use was signed in a twenty-year period of exceptional rain, making present projections of need and use impossible. The result of drought can already be seen in the increase of migration from Central America, where climate change drought has impacted farming, causing millions to flee north.

In his study of the social and political impact of climate change in *Storming the Wall: Climate Change, Migration, and Homeland Security*, Todd Miller includes a chapter entitled "Phoenix Dystopia: Mass Migration and the Homeland" that discusses the impact of drought and increased temperatures on Phoenix, Arizona. He concludes that because of climate change, there are already signs of "elite panic," fear on the part of the wealthy that their comfortable way of life might not be sustainable as heat and drought force both external and internal migrations in the United States. He notes that the elite also fear the increase of crime and social disorder.

Paolo Bacigalupi's *The Water Knife* can be read as a fictional recreation of Miller's observations. Rather than using government reports and interviews to make his point, Bacigalupi uses the conventions of the thriller, strong characters, an action-dominated plot, and a mystery, to tell his story. Both assert that climate change is causing the Southwest to dry up, and violence and fear will follow the drought.

See also: *Burning World, The*; *Chinatown*; *Gold Fame Citrus*; *Storming the Wall*

Further Reading

Ingram, B. Lynn, and Frances Malamud-Roam. *The West without Water: What Past Floods, Droughts, and Other Climatic Clues Tell Us about Tomorrow.* Berkeley: University of California Press, 2015.

Tobar, Hector. "Imagining a Thirsty Future in Paolo Bacigalupi's 'The Water Knife.'" *Washington Post.* May 28, 2015.

WATER THIEF, THE

Nicholas Lamar Soutter's *The Water Thief* (2012) is an urban dystopian novel set in the future, when climate change has made resources, including clean air and fresh water, scarce. Numerous other novels, such as Kim Stanley Robinson's *New York 2140*, Nathaniel Rich's *Odds against Tomorrow*, and J. G. Ballard's *The Drowned World*, have used this same setting and conflict. What sets *The Water Thief* apart from these and other works that depict how climate change impacts the lives of city dwellers is that in this novel, governments have not only failed to respond to climate change but have ceased to exist, replaced by corporations that have taken over the functions of government and operate them for profit.

The novel's protagonist, Charles Thatcher, is a perceptions manager for the Ackerman Brothers Securities Corporation, one of the world's largest companies. His job is to take news items and rewrite them in ways that favor the public perception of the company. Looking for a successful rewrite, one that will give him a bonus in credits, he rewrites a story about a woman arrested for stealing rainwater, suggesting that the woman is not only a thief but also an anarchist revolutionary planning to overthrow the world's corporate control. With the price of air, water, food, and power increasing as corporations attempt to become more profitable in managing the world's dwindling resources, he believes he needs more credits to maintain his meager standard of living. When the woman disappears, apparently into Ackerman Brothers Securities' private prison system, he begins to regret his action.

In *The Water Thief*, there are two penalties for crimes, a fine or an execution; both make a profit for Ackerman Brothers Securities Corporation. If a person is wealthy, a fine provides income for the corporation and keeps a profitable worker. The poor, on the other hand, are publicly executed, providing a source of popular entertainment as well a deterrent to crime. Their bodies are also recycled, melted in lye vats into soap, a popular product sold in company stores.

Thatcher has not received a bonus for his revision and begins to grow dissatisfied with his position in the corporation. After talking with his mentor, who believes that corporate control of society is in the best interests of everyone since everyone is responsible for their own choices and actions, Thatcher

begins to have doubts about the morality of the current system. His unease grows after he meets Kate, a young woman who was a friend of the water thief. Kate is educated and energetic, yet she lives off the grid in a slum area. More importantly, although she works in a low-level job for Ackerman Brothers Securities Corporation, she is not a corporate believer; she is something far more radical, a citizen.

At first, Thatcher cannot believe how anyone could hold such dangerous and impractical beliefs in such antiquated ideas as government and citizenship. He argues that the world had tried those ideas, and governments, of various kinds, had been unable to deal with the problems society faced when climate change caused social disruptions and scarcities. Capitalism, unfettered, was the only answer because people were essentially selfish.

Kate scoffs at his responses, arguing that the idea of government, in which all citizens have a say, is far fairer. As Thatcher and Kate become better acquainted and wander about the slums, or noncorporate areas, of the city, they continue their debates. At times, the discussions turn philosophical. Thatcher paraphrases arguments from Ayn Rand's 1957 novel *Atlas Shrugged* and English political philosopher Thomas Hobbes's 1651 treatise *Leviathan*, founding documents of the new corporate state, to support his position. He echoes Herbert Spencer's theories of social Darwinism, which theorizes that human groups and races are subject to the same laws of natural selection that Charles Darwin recognized in plants and animals. He parrots the views of his mentor, saying that all life is competition and only the fittest survive.

Kate believes none of Thatcher's claims, arguing that cooperation rather than competition is a more effective and fairer organizing principle. She points out that empathy is a real human emotion and that Thatcher is actually beginning to feel it. She also notes that if Thatcher knew any history, which he does not, he would know that corporations were instrumental in the destruction of civil government. Thatcher comes to question the foundations of the corporate system, and when Kate informs him that Ackerman Brothers Securities Corporation is about to go bankrupt, he decides to help the citizens in its collapse.

Before he can serve as the citizens' mole in the Ackerman Brothers Securities Corporation, Thatcher is arrested. Ackerman's private police have been aware of the citizenship movement and Thatcher's role in it from the beginning. Instead of jail, Thatcher is taken to a plush apartment and confronted by an examiner, who listens to Thatcher's arguments for revolution. The investigator manages to convince Thatcher that any hope for revolution is groundless and that he had been duped by the citizens. Reluctantly, Thatcher agrees. When he asks whether he will be returned to his job with the corporation because of the investigator's efforts to convince him of his mistakes, he is told no; he is too poor. Instead, he will be taken for public execution and the lye vats.

In *The Water Thief*, climate change remains in the background as the source of shortages of essential items, like clean air and water, and of the dystopian corporate-controlled social structure. Nevertheless, it follows the pattern of many other climate change novels, showing how changes in climate and the resulting social disruptions lead to authoritarian control. What is most interesting about Soutter's novel is that climate change does not lead to government control but rather corporate control, which in this novel is worse.

In much dystopian fiction, authoritarian governments assume control to impose law and order on a society wracked by the social and environmental disasters brought on by climate change: flooding, mass migration, and pandemics. In *The Water Thief*, Soutter imagines another scenario, corporate capitalism without any governmental interference. The result is just as bad; private authoritarianism is just as oppressive as governmental authoritarianism.

Readers will note a similarity in structure between *The Water Thief* and George Orwell's classic 1949 novel *1984*, especially in the conclusion when an investigator manages to make the protagonist renounce his new beliefs. In this post–climate change dystopia, international capitalism has become Big Brother.

See also: *Burning World, The*; *Gold Fame Citrus*; *Sherwood Nation*; *Water Knife, The*

Further Reading

Mehnert, Antonia. *Climate Change Fictions: Representations of Global Warming in American Literature*. New York: Palgrave McMillan, 2016.

WATERWORLD

Waterworld (1995) is an American postapocalyptic climate change film directed by Kevin Reynolds and produced by Kevin Costner, John Davies, Charles Gordon and Lawrence Gordon. The film, starring Kevin Costner, Dennis Hopper, Jeanne Tripplehorn, Tina Majorino, and Michael Jeter, was distributed by Universal Pictures. *Waterworld*, which was the most expensive film ever made at the time it was released, opened to mixed reviews and failed to make a profit in its initial release, although it was eventually successful due to video sales.

The film is set in the year 2500. Global warming has melted the polar ice caps, and the entire earth is underwater. The implication is that nearly all of the predicted bad outcomes of climate change have come to pass. Not only has dramatic sea rise occurred, but it has occurred far in excess of any scientific predictions, reaching biblical proportions and not receding after forty days and forty nights. Most of humanity as well as most animals and plants have been destroyed. Civilization has disappeared. The only survivors live in small floating communities known as atolls. Although most of the prediluvian period's

The *Waterworld* set at Universal Studios, Hollywood, California. *Waterworld* is the most expensive climate change film to date. (Justin Haw/Dreamstime.com)

knowledge has been lost, the survivors retain a belief that a place called Dryland still exists somewhere in the world of water.

Like a number of other postapocalyptic dystopian narratives, *Waterworld* is a wilderness adventure, a genre that usually requires a somewhat larger-than-life hero, a search for some essential object or a societal problem to solve, an appropriately evil villain, and someone, most often in traditional Hollywood westerns a beautiful young woman, to be saved. *Waterworld* meets all of these requirements.

Kevin Costner plays the Mariner, a drifter with both lungs and gills as well as webbed feet, who trades dirt, a necessary and rare commodity in a world without land, for food and other necessities. Deacon, played by Dennis Hopper, is the leader of the Smokers, a pirate gang searching for a young woman named Enola, played by Tina Majorino, who is believed to have a map of Dryland tattooed on her back. She has a guardian named Helen, played by Jeanne Tripplehorn, who tries to protect her.

The film opens with the Mariner trading dirt. However, when the people of the atoll see he has gills and webbed feet, they decide to kill him. This is a common trope in many postapocalyptic narratives; survivors view outsiders in general and anyone who is different as a threat that must be eliminated because survivors in a postapocalyptic world see the outsider, or "other," as dangerous. As the execution is about to begin, the atoll is attacked by the Smokers, who are seeking Enola and the tattooed map of Dryland. The Mariner, Enola, and Helen manage to escape with the help of Gregor, who pilots the atoll's hot air balloon.

Universal Studios Hollywood Waterworld, a live stunt show based on the 1995 film of the same name. (Eniko Balogh/Dreamstime.com)

From this point, the film follows the plot of western adventures as the Mariner, Enola, and Helen are pursued by Deacon and the Smokers. As the Mariner, Enola, and Helen flee, Helen tells the Mariner that she believes humans once lived in a mythical place called Dryland, and she asks the Mariner where he obtains his dirt. He shows her a diving bell that he had found and takes her below the surface to show her the remains of a city. Again, Deacon and the Smokers arrive, hunting Enola, and in a confrontation with the Mariner, Deacon tells the Mariner that finding Dryland would enable him to have control over the most precious commodity in the world of water, dirt, which is necessary to grow the few fruits and vegetables that exist on the atolls. It is almost a cliché, but villains in postapocalyptic dystopias tend to want to rule what is left of the world or have complete power over survivors, or both.

Enola is captured, and the Mariner tracks Deacon and finds him aboard the rusting *Exxon Valdez*, a not-so-subtle reminder of fossil fuel's role in causing climate change. Again, there is a confrontation between Deacon and the Mariner in which the Mariner rescues Enola again and destroys Deacon, the Smokers, and the *Exxon Valdez* by dropping a flare into the oil that is still on the rusting tanker.

Gregor, the hot air balloonist from earlier in the film, returns and figures out that the tattoo on Enola's back is a map with the directions reversed. Together,

the Mariner, Enola, Helen, and Gregor follow the map and discover that Dryland does exist on top of what was once Mount Everest, the tallest peak on earth. They also discover a wooden boat and wooden hut, and inside the hut are the remains of Enola's parents. The Mariner decides that he cannot stay on land. He takes a boat that had been resting on Dryland and heads out to sea, with Helen and Enola remaining.

Waterworld received mixed critical reviews and failed to recoup its large $175 million production cost mostly due to Costner's decision to film the entire movie on location at sea. Reviewers generally agreed that the sets were spectacular and the action sequences effective, but the characters were one-dimensional and flat. Many critics noted that the film was similar to both traditional Hollywood westerns and the *Mad Max* films that were also set in a postapocalyptic world, albeit a desert one.

The similarities of *Waterworld* to the *Mad Max* films should come as no surprise, as screenwriter Peter Rader came up with the idea of the film as *Mad Max* on the ocean. The *Mad Max* films themselves are modeled on classic Hollywood westerns in which a lone hero rides into a town and confronts societal problems, only to ride away into the wilderness from which he came after he has solved them, usually through violence. Rader also suggested that elements of biblical stories as well as the story of Helen of Troy from the *Iliad* influenced the screenplay.

The biblical elements in the film are fairly obvious. The most significant one is the story of Noah and his ark in the book of Genesis. In that story, God tells Noah to build an ark and put two of every animal and his family in it, as He is about to destroy the entire earth because of humanity's wickedness. It serves as a narrative model for creators of climate change narratives dealing with sea level rise. It also serves as an ethical model, as, once again, the wickedness of humanity, in the case of contemporary narratives the destruction of the environment and the resulting climate change, destroys the earth. The ending of the film, in which the Mariner finds a wooden boat sitting atop a mountain, is also a reference to the ark.

Waterworld, unlike such other climate change flood narratives as Kim Stanley Robinson's *New York 2140* or Nathaniel Rich's *Odds against Tomorrow*, is not based on scientific predictions or actual climate science, as no model suggests the possibility of a sea level rise that covers the entire earth. It is however not unique; Stephen Baxter used the same idea in his 2008 climate change novel *Flood*, the sequel to which is not surprisingly called *Ark* (2009).

See also: *After the Flood*; *Always North*; *Blackfish City*; *Drowned World, The*; *Flood*; *Forty Signs of Rain*; *New York 2140*; *Odds against Tomorrow*

Further Reading

Ebert, Roger. "*Waterworld*." *Chicago Sun Times*. July 28, 1996.

Nashawaty, Chris. "*Waterworld* Is Known as a Massive Hollywood Failure. Really, It Was ahead of Its Time." *Esquire*. July 20, 2020.

WEATHER

Weather (2020), by Jenny Offill, is an unusual climate change novel that has received a good deal of critical praise. Many writers of climate change narratives choose to structure their stories around dramatic climate events and their impacts on survivors. In *Flood* (2008), for example, Stephen Baxter imagines a sea level rise that not only inundates coastal cities worldwide but also covers the entire earth. In *Gold Fame Citrus* (2015), Claire Vaye Watkins creates an American Southwest suffering from a drought so severe that the entire region has been turned into a desert. Offill tells a different kind of climate change story. In *Weather*, set in the present, she presents the very real story of a woman going about her life in very ordinary ways as the world begins to change about her.

Weather consists of the thoughts, observations, and diary-like entries of Lizzie Benson, a onetime doctoral student living in Brooklyn with her husband, Ben, who has a PhD in classics but designs video games, and their son, Eli, who attends first grade in a large public school. She works as a university librarian in Manhattan and worries about her brother, a former addict now in Narcotics Anonymous and a new father whose marriage recently broke up. Paragraph by paragraph, Lizzie records city life as the world begins to take a turn toward disaster.

Lizzie is observant, and she enjoys observing the people around her at the university library. The novel opens with her helping a doomed adjunct professor who has been writing a dissertation for eleven years and then watching "a blonde girl with nails bitten down to the quick" steal rolls of toilet paper. At home, she listens to a podcast on climate change called *Hell and High Water* by her former mentor, Sylvia, who always asks whether she is still squandering her promise. She always answers yes. She also worries about whether her son is gifted and whether the drug dealer in apartment 5C in her building is flirting with her.

To make extra money, Lizzie takes a job with Sylvia answering letters from listeners to her podcast. She notices that most of the letters are dreary. The ones from the hippies about composting toilets are as bad as the ones from survivalists about guns, she tells Sylvia. When her brother, Henry, loses his apartment, she allows him to move in with her, and together they watch movies. She notices he always likes disaster films in which only one person can save the world. She begins to worry about the climate crisis. She reads that "New

York will experience dramatic, life altering temperature changes by 2047." After hearing that technology billionaires are buying land in New Zealand, she wonders whether she should move there. Halfway through the novel Donald Trump is elected president. Her husband tells her to carry her medical information with her at all times in case they lose their health insurance.

Sylvia invites Lizzie to go with her on a lecture tour, and they discover that even the people who come to Sylvia's talks are growing tired of hearing about climate change. Lizzie tells Sylvia that "people are really sick of being lectured to about glaciers." After having dinner with some Silicon Valley executives, Sylvia observes that these people "long for immortality but can't wait ten minutes for a cup of coffee." Finally, after one grueling trip, Sylvia tells Lizzie that "there is no hope anymore, only witness." She longs to find the "darkest place in America" and live in a trailer.

Lizzie returns to her life in Brooklyn. She continues to worry about her brother, who still lives with her and is beginning to upset both her husband and her son. She continues to worry about the fact that her very small son is going to first grade in a very large school where the textbooks are twenty years old. She continues to watch the anxious behavior of the untenured faculty and the entitled behavior of the tenured faculty at the university library. She also strikes up a friendship with Will, a war correspondent with whom she drinks in a local bar after work.

Lizzie is attracted to Will, and although she imagines what an affair with him would be like, she decides not to have one. One afternoon, she asks Will if how people are feeling is similar to what people feel in a war zone. He tells her that it is more like a war that is about to happen. Her husband tells Lizzie that she is beginning to sound like a "crazy doomer." She continues to worry and wonder what life will be like when her son grows up and what she should teach him. Despite the ongoing warnings of impending climate change, life goes on. Lizzie records not only her fears but also her mundane observations about newspaper articles she has read, YouTube videos about cute cats, and conversations overheard at meditation classes.

Weather has been well received by critics and reviewers, and almost all of them have commented on the novel's structure. Writing in *The Guardian*, Alex Preston notes that Offill writes in "sharp, intimate, obliquely connected paragraphs" and that "her sentences resonate powerfully, drawing you in with their humor before sideswiping you with their veracity." Laura Miller, writing in *Slate*, observes that Offill's "signature method involves the patching together of fragments—some anecdotal, others aphoristic, still others resembling diary entries—that eventually coalesce into a coherent narrative."

Writing in *The Great Derangement: Climate Change and the Unthinkable*, Amitav Ghosh suggests that most writers employ the conventions of science fiction,

speculative fiction, or fantasy to write about climate change, as realistic fiction is unable to capture the catastrophic nature of that subject. In *Weather*, Jenny Offill demonstrates that the contrary is true. By creating a realistic protagonist who records daily life in the world of a changing climate, she has created a narrative that is both realistic and dire in its depiction of how we continue to live our lives in the face of disaster.

See also: *Flight Behavior*; *Flood*; *Gold Fame Citrus*; *Great Derangement, The*; *New York 2140*; *Odds against Tomorrow*; *Sherwood Nation*

Further Reading

Miller, Laura. "Life Works Exactly Like This." *Slate*. January 31, 2020.
Preston, Alex. "*Weather* by Jenny Offill Review—A Storm Gathers in Trump's America." *The Guardian*. February 10, 2020.

WIND FROM NOWHERE, THE

The Wind from Nowhere (1961) is the first of a series of four environmental disaster novels written by British author J. G. Ballard, who is best known for his semi-autobiographical novel *Empire of the Sun* and *Crash*, a novel about the psychological attraction of car crashes made into a feature film by David Cronenberg in 1996. In the environmental disaster series, Ballard adapts the British science fiction/adventure narrative form made popular by H. G. Wells and H. Rider Haggard to issues of climate change and its effects on human behavior. Wells and Haggard emphasized strong, intelligent male protagonists forced to make moral choices in exotic environments. All of Ballard's early works are variations on that theme.

As in all of Ballard's environmental disaster novels, *The Wind from Nowhere* opens with an example of nature's mutability. In this case, a wind blowing west around the world suddenly increases in strength. The westward wind, blowing strongest about the equator, increases to the point that air travel becomes impossible, leaving Dr. Donald Maitland, the novel's protagonist, stuck in London and unable to take up a new position in Canada.

London itself is in chaos. What began as unpleasantness turns into catastrophe as the wind increases. Travel aboveground becomes impossible. Communication becomes difficult as lines are blown down. Food and water become scarce. Finally, even the buildings begin to fall apart as flying debris bombards them. What might be considered normal at the height of a hurricane becomes a daily factor of life.

Throughout the world, the radical change of climate forces people to move underground to survive; those that cannot do not survive. Large bodies of water, including the Caspian Sea and the Great Lakes, evaporate, adding to the

already grim water shortage. Special nongovernmental organizations are set up to meet the crisis. In London, a Central Operations Executive Committee is set up, with Simon Marshall in charge. Maitland works for Combined Rescue Operations, assisting people injured by or trapped in falling buildings. After finding Marshall injured by a falling piece of a building, Maitland helps him home and discovers that Marshall has been assisting a Mr. Hardoon, a multimillionaire, in constructing a huge pyramid-shaped underground bunker as well as funneling military supplies to him.

As the wind continues to destroy London, the Central Operations Executive Committee and Combined Rescue Operations personnel are ordered to leave. Maitland, a journalist, and an American submarine officer begin leaving London in a large, armored vehicle. Maitland directs the group to Hardoon's pyramid. Inside, they learn that Hardoon has been building his underground survivalist bunker and army for years, waiting for a catastrophe to start. Ballard's depiction of apocalyptic survivalism may be one of the first representations of this phenomena in fiction. As Hardoon explains his plans to take over what is left of England when the wind ceases, the pyramid, which has been built on tunnels that run throughout London, collapses, killing Hardoon and his soldiers but allowing Maitland, the submarine officer, and the journalist to survive. As they leave the pyramid, they discover the wind has stopped blowing.

J. G. Ballard's series of early novels does not indicate what causes the dramatic climate change that occurs in them, nor does Ballard mention humanity's role in the environmental disasters he depicts. Global warming and climate change were subjects of science fiction not scientific analysis in the 1960s. Nevertheless, Ballard is considered one of the first writers to take the idea of climate change seriously as he examines human responses to climate catastrophes. His work is being read and discussed with new interest today, as climate change and radical changes in climate are now recognized as very real threats.

Later in his life, Ballard admitted that *The Wind from Nowhere* was not his best work. The novel is flawed. It is plot driven, the characters are one-dimensional, and Hardoon's pyramid-shaped underground bunker could have been lifted out of an episode of *Dr. Who*. Nevertheless, *The Wind from Nowhere* is of more than academic interest. In his first novel, Ballard examines the impact dramatic climate change will have on human life, and the results are catastrophic. He will continue to examine that impact in a more complex manner in his other early environmental disaster novels.

See also: *Burning World, The*; *City Where We Once Lived, The*; *Crystal World, The*; *Drowned World, The*; *New York 2140*; *Odds against Tomorrow*; *Sherwood Nation*

Further Reading

Luckhurst, Roger. *The Angle between Two Walls: The Fiction of J. G. Ballard.* Liverpool: Liverpool University Press, 1998.

Stephenson, Gregory. *Out of the Night and into the Dream: A Thematic Study of the Fiction of J. G. Ballard.* Westport, CT: Greenwood Press, 1991.

WINDUP GIRL, THE

The Windup Girl (2009) is a dystopian climate change thriller by American writer Paolo Bacigalupi. The novel won the Hugo, Nebula, John C. Campbell, Seiun, Compton Crook, and Locus Awards, and it was named the ninth-best fiction book of 2009 by *Time* magazine.

The Windup Girl is set in twenty-third-century Thailand after global warming has radically changed the earth's climate, resulting in massive sea rise, the deaths of millions of people, international wars and migrations, and the outbreak of new diseases that attack both plant and animal life worldwide. After many nation-states fail, mega corporations, called calorie companies, control trade and food distribution through the introduction and promotion of bioengineered foods. Thailand—ruled by a child queen supported by various military and religious factions—is the exception; it has retained its own genetically viable seed bank, which the calorie companies wish to exploit. Thailand has also imposed a ban on most imports, fearing that calorie companies will make the country dependent on their products. Bangkok, the capital of Thailand, is below sea level and kept dry only with the help of levees and pumps.

In Bangkok, Anderson Lake is an agent for AgriGen Corporation but posing as an owner of a kink-spring factory. As fossil fuel use has been banned worldwide, kink-springs have become a standard energy storage device. His real goal is to convince the Thai government to allow AgriGen products into the country. Former businessman Hock Seng is a Chinese refugee who runs Lake's factory. Sing is an illegal refugee, or "yellow card," who survived the killing of hundreds of thousands of Chinese in Malaysia during a purge of ethnic Chinese. Emiko is an abandoned windup, a genetically modified human being who feels human emotions, is programmed to obey human commands, and is unable to procreate; she has been forced to work in a sex club. Emiko informs Lake of the Thai government's hidden reserve of viable seeds, and Lake tells her of a place in the north of Thailand where windups, or "new people" as they call themselves, live away from humans and control their own destiny.

Thrillers are plot driven, and *The Windup Girl* begins when Jaidee Rojjanasukchai, an honest leader of the Environmental Ministry's police force, called White shirts, leads a raid on a dirigible landing pad where illegal goods are entering the country after foreign importers bribed members of the Trade Ministry.

Jaidee's actions initiate a war between the two ministries that takes place against the background of an environment and society weakened by climate change. Prior to the conflict between ministries, Bangkok existed in a fragile state. Only the levees and pumps keep the ocean out, the city was flooded by refugees from throughout Southeastern Asia, and new diseases swept through the population. Genetically modified cats, called "cheshires," roam the city, attacking animals and small children. And without internal combustion engines, the city relies on kink-springs, solar power, and tens of thousands of bicycles to move people and goods.

The raid on imports coincides with an outbreak of a deadly fever that begins to spread throughout the city. Foreign importers attempt to bribe members of both the Environmental and Trade Ministries. Hock Seng is forced to shut the factory down and flee from an angry anti-Chinese mob that believes the fever was caused by foreigners. Lake continues to track down the illusive seed bank, offering bribes to government officials. Emiko tries to discover more about the sanctuary for new people but is attacked when she ventures outside because people fear that she is a foreign import designed to kill Thai citizens.

The Thai regent's unintended death at the hands of Emiko, whom Lake introduced as an exotic sexual bribe, is the spark that ignites the volatile situation. Jaidee is accused of assassinating the regent. He is stripped of his authority and ordered to become a Buddhist monk. He agrees, hoping to have his wife and children spared from execution, but when he learns his wife is dead, he leaves the monastery and orders his followers in the Environmental Ministry to arrest foreign importers. In the process of leading his followers, he is killed. However, as a ghost, he remains, sometimes taunting and sometimes advising his protégé, Kanya, who takes over the White shirts. She continues his raids on foreign traders and discovers a new plague has broken out and traces it to Lake's factory. Lake is arrested and beaten, along with other importers.

The head of the Trade Ministry decides to settle old scores and orders troops to attack Kanya and the Environmental Ministry's White shirts, accusing them of being the force behind the assassination of the queen's regent and starting a civil war. Hock Seng, wanting only to survive, tries to leave the city but is caught by Trade Ministry soldiers. He leads Kanya to the kink-spring factory, the source of the infection. Emiko is discovered, but instead of being composted, the fate of unwanted windups, she is taken to meet a mysterious scientist named Gibbons, a former AgriGen geneticist who has been hiding in Thailand and advising the government and coordinating the county's biogenetic work.

The Trade Ministry's forces, with the help of heavy weapons smuggled in by Lake and other foreign importers, quickly overwhelm the Environmental troops. Deals are quickly made. The Trade Ministry opens the country to

foreign trade, including the calorie companies who are given contracts to sell genetically modified food in Thailand, and Lake is given access to the seed bank to provide samples for AgriGen. Hock Seng is told his expertise will be needed by the new regime to work with the foreigners. Gibbons tells Emiko he will be able to create new people who will be able to have children from her genetic material, making her the mother of a new and stronger form of humanity. However, before the foreign importers and the leaders of the Trade Ministry can enjoy the fruits of their cooperation Kanya and the Buddhist monks who have been keeping the seed bank smuggle the seeds out of Bangkok. As they leave, they deliberately open the levees to the city and turn off the city's pumps. Kanya, the monks, and others who survived in the Environmental Ministry have decided that Thailand can exist without trade or its capital. If AgriGen and the Trade Ministry ruled, Thailand would have no future.

The Windup Girl is much more than its plot. Reviewers have praised both Bacigalupi's invention and his use of language. More significantly, critics have pointed out how effectively Bacigalupi employs the conventions of science fiction to present a fast-paced critique of the failure to respond to climate change. In *The Windup Girl*, Thailand is the last country to avoid either the domination by large agricultural conglomerates or the devastation of starvation and disease. However, even a country with a deep Buddhist faith, devotion to a beloved monarch, and a willingness to adapt to a world with rising seas and without fossil fuels is eventually no match for international capitalism.

Perhaps the most impressive aspect of *The Windup Girl* is Bacigalupi's world-building. His Bangkok is a city surrounded by rising water and encroaching capitalist adventurers, but it is alive with genetically modified elephants, tens of thousands of refugees with doubtful status and futures, and ghosts who refuse to leave until their work is done. At the center of this world that is both fantastic and unfortunately possible, there is Emiko. In this dark fairy tale, she is a genetically modified human working as a sex slave who, like Pinocchio, just wants to be real, even if in a dystopian world.

See also: *A.I. Artificial Intelligence*; *Blade Runner*; *New York 2140*; *Odds against Tomorrow*; *Ship Breaker*; *Water Knife, The*

Further Reading

Cokinos, Christopher. "*The Windup Girl*." *Orion Magazine*. Retrieved November 31, 2020. www.orionmagazine.org/review/the-windup-girl/

Grossman, Lev. "9. *The Windup Girl* by Paolo Bacigalupi." *Time*. December 8, 2009.

Masad, Ilana. "Rethinking Dystopian Fiction: Paolo Bacigalupi's *The Windup Girl*." *New Orleans Review*. Retrieved November 31, 2020. www.neworleansreview.org/the-windup-girl-by-paolo-bacigalupi/

Y

YEAR OF THE FLOOD, THE

The Year of the Flood (2009) is the second of a trilogy of climate change novels by Canadian author Margaret Atwood. Atwood is an established poet, novelist, literary critic, feminist, and environmentalist. Her work in a variety of genres is well known worldwide. Perhaps her most famous novel is *The Handmaid's Tale*, winner of the Arthur C. Clarke Award and later adapted into a feature film and an acclaimed television series. The other two novels in her climate change trilogy are *Oryx and Crake* (2003) and *MaddAddam* (2013). Calling much of her work speculative fiction, a broad genre that includes elements that do not exist in recorded history or observable fact, she employs elements of science fiction, myth, and the fantastic in much of her work. She has also called her series adventure romance. *The Year of the Flood*, like the other two novels in the series, is one of the most significant climate change novels written to date.

The Year of the Flood is centered on two characters, Toby and Ren, who survived the apocalyptic disaster that resulted from the bioengineered plague described in *Oryx and Crake*. Prior to the plague, climate change and environmental degradation had depleted natural resources, population growth was out of control, and society was divided into the privileged, who lived in corporate compounds and had access to unlimited resources, and the masses, who lived in crime-ridden and violent neighborhoods called pleeblands. Unlike *Oryx and Crake*, which is primarily set in corporate compounds, *The Year of the Flood* is primarily set in pleeblands, where the two main characters live. Both are members of an environmental religious sect called God's Gardeners, led by Adam One, a charismatic leader who teaches nonviolent ecological opposition to the corporate world, that believers should respect the earth, and that a waterless flood that will destroy the old world and usher in a new one is imminent.

Oryx and Crake is told from a male point of view; *The Year of the Flood* is told from the points of view of two women: Ren, a trapeze dancer at a sex club who was locked in a safe room at the time of the pandemic, and Toby, who isolates herself at a luxurious spa. Both women were at times members of God's Gardeners, and both are isolated at the beginning of the novel. Atwood's choice of narrators is significant in this second novel of environmental degradation and

corporate dystopia, as she has said on more than one occasion that women will be the main victims of climate change.

The novel opens after the pandemic as Toby is attempting to plant a garden but is threatened by Pigoons, genetically engineered pigs with human brain cells. Ren is locked in the safe room of the sex club. Much of the plot occurs as they reminisce about their lives.

During Toby's childhood, her mother dies, and her father commits suicide. She eventually finds work at a restaurant with connections to the mob, where she is both physically and sexually abused by her employer, Blanco. One day, members of God's Gardeners come to the restaurant, and they persuade her to join them. She becomes a member of the group and lives at Edencliff Rooftop Garden, eventually becoming a respected member of the organization.

At Edencliff, she meets Ren, who was brought to the sect by her mother. Ren's mother eventually leaves God's Gardeners and moves to a corporate compound, where she meets Jimmy, one of the central characters in *Oryx and Crake*. She eventually gets a job at AnnooYoo Spa, which is run by God's Gardeners. Toby is found living with God's Gardeners by her abusive ex-boss, Blanco. To protect her, they send her to a clinic, where her voice, skin tone, and eye shape are changed. Eventually, she ends up at the AnooYoo Spa working with Ren, who fails to recognize her. Toby, tired of the routine work, eventually leaves the spa to work as a trapeze dancer at the Scales and Tails sex club. Ren remains at the spa, storing food for the approaching waterless flood.

As in *Oryx and Crake*, the pandemic erupts, killing most of humanity and leaving the damaged environment to bioengineered creatures and the few surviving humans. Freed from the spa and the sex club, Toby and Ren reunite and join a group of survivors that call themselves MaddAddam. At the end of the novel, Ren and Toby come across Jimmy, now called Snowman. While the three of them are together, they hear another group of survivors approach.

The Year of the Flood covers the same time frame and the same catastrophic events as *Oryx and Crake* but from an entirely different perspective. In *Oryx and Crake*, Atwood follows the lives of two young men, one a survivor of the genetically induced pandemic and the other the bioengineer of the pandemic. She provides personal histories of both, including their use of violent video games, pornography, and drugs, suggesting their privileged status and detachment from reality may be contributing causes of their actions.

In *The Year of the Flood*, Atwood focuses on the lives of two women who live through the same catastrophic events leading up to and including the pandemic. Their perceptions and experiences are quite different. Toby and Ren have far less control over their own lives; they live outside the corporate compounds established for the rich and talented and live in the pleeblands (land of the plebeians), which are both dangerous and exploitive. Both are seen in gendered

terms, as sexual objects, as nurturers, or both. Fortunately for them, they are isolated when the bioengineered outbreak occurs. They survive because they have been forced to hide from others.

Reviewers and readers responded positively to *The Year of the Flood*. Writing in the *New York Times*, for example, Jeanette Winterson notes that Atwood is both funny and clever in this book about an impending apocalypse. She particularly points to Atwood's creation of God's Gardeners, the apocalyptic cult preaching the waterless flood, and the bioengineered creatures that live in and survive the apocalypse, as both insightful and entertaining. It is interesting to note that both the title of the novel and the prophecy of God's Gardeners refer to Noah's flood in the biblical book of Genesis, in which God destroys the earth because of the wickedness of humankind. The same wickedness is present in all the novels in the trilogy. Perhaps the most remarkable aspect of *The Year of the Flood* is that Margaret Atwood is successful in telling the same story twice, each from a different perspective.

See also: *A.I. Artificial Intelligence*; *Blackfish City*; *Handmaid's Tale, The*; *Madd-Addam*; *Orleans*; *Oryx and Crake*; *Windup Girl, The*

Further Reading

Cooke, Nathalie. *Margaret Atwood: A Critical Companion*. Westport, CT: Greenwood Publishing Group, 2004.

Howells, Coral Ann. *The Cambridge Companion to Margaret Atwood*. Cambridge: Cambridge University Press, 2006.

Nischik, Reingard M. *Engendering Genre: The Works of Margaret Atwood*. Ottawa: University of Ottawa Press, 2009.

Winterson, Jeanette. "Strange New World." *New York Times*. September 17, 2009.

Index

Page numbers in **bold** indicate the location of main entries.

About the Author

James Craig Holte is an emeritus professor of English and Film Studies at East Carolina University. He is the editor of *The Fantastic Vampire: Studies in the Children of the Night* (2002) and the author of *The Ethnic I: A Sourcebook for Ethnic American Autobiography* (1988); *Dracula in the Dark: The Dracula Film Adaptations* (1997); *The Conversion Experience in America: A Sourcebook on Religious Conversion Autobiography* (1992); and *Imagining the End: The Apocalypse in American Popular Culture* (2019).